Before Cortés

SCULPTURE OF MIDDLE AMERICA

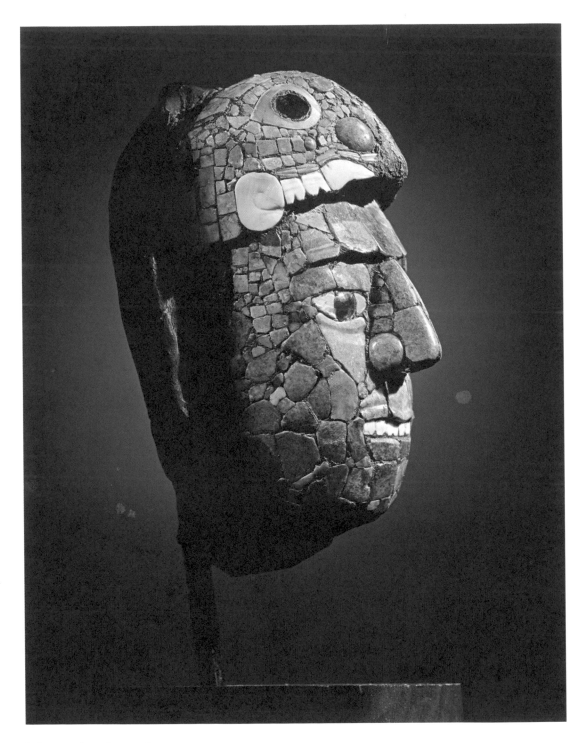

Mosaic head pendant

NUMBER 188

Before Cortés SCULPTURE OF MIDDLE AMERICA

A CENTENNIAL EXHIBITION AT
THE METROPOLITAN MUSEUM
OF ART FROM SEPTEMBER 30, 1970
THROUGH JANUARY 3, 1971

Catalogue by Elizabeth Kennedy Easby
and John F. Scott

Foreword by Thomas P. F. Hoving

Preface by Dudley T. Easby, Jr.

The Metropolitan Museum of Art
Distributed by New York Graphic Society Ltd.

This Centennial Exhibition is presented at
The Metropolitan Museum of Art through
the generosity of O L I V E T T I

Contents

Foreword

The course of pre-Hispanic or, as it is frequently called, pre-Columbian art, has come full circle in our own twentieth century. It amazed the Spanish conquistadors four hundred fifty years ago, and, when first seen by European audiences, it evoked the spontaneous admiration and extravagant praise of such Renaissance figures as Dürer, Cellini, and Peter Martyr, an Italian cleric who wrote the first history of the New World. But all too soon it lapsed as art in Europe, to continue there merely as exotica in some princeling's *Wunderkammer* and still later in museums narrowly confined to ethnology and anthropology.

It is only in the United States that this art has been included in the collections of the most significant fine-arts museums and begun to be recognized by a few graduate schools of art and art history in our universities—a twentieth-century development of fairly limited acceptance. We at the Metropolitan are now proud to present it with other great art of the world.

Like the men of the Renaissance, the founding fathers of this Museum paid high tribute to the ancient art of the New World, which they felt was neither "savage" nor "barbarian," but showed "a cultivation of the love of beauty, measured by an independent standard which, however distinct from ours, nevertheless proves the presence of intellectual and art loving races of men." Some fine works were acquired and exhibited briefly, but the profound wisdom and farsightedness of the founding fathers were soon forgotten when most of these treasures were lent elsewhere (as anthropological or ethnographic material), and acquisition stopped. However, in the past two decades the pendulum has swung back, with international loan exhibitions from Colombia and Guatemala and the reciprocal loan agreement with Mexico, the great exhibition of masterpieces from The Museum of Primitive Art last year, the recent enrichment of our collections by important gifts from Mr. and Mrs. Nathan Cummings, Mrs. Harold L. Bache, and Mrs. Jacob Kaplan, and, of course, the truly notable agreement with the Honorable Nelson A. Rockefeller and The Museum of Primitive Art under which the superb collection of that museum will come to the Metropolitan in its entirety upon completion of the new wing to house it.

With the creation of a new Department of Primitive Art and the present exhibition we have not only come full circle but more than redeemed a pledge made in

our Annual Report for 1883, wherein the President, John Taylor Johnston, stated: "The antiquities of our own continent should form a prominent feature in an American Museum, and we are charged with a special duty to make here a Museum of old American art for the study of American scholars as well as scholars from abroad."

Olivetti has made this great international exhibition possible by a generous grant just as it sponsored in 1968 *The Great Age of Fresco*. We are indeed grateful to this manufacturer of business machines whose corporate interests span the entire world centering in both Europe and the United States.

The present exhibition has been organized by the former Secretary of the Museum and first head of the new department, Dudley T. Easby, Jr., and his wife, Elizabeth Kennedy Easby, formerly Curator of Primitive Art at The Brooklyn Museum, assisted by John F. Scott and Curt Muser. Dr. Daniel F. Rubín de la Borbolla and J. Alfred Barrett, special representatives of the Metropolitan Museum in Mexico and Guatemala, also have been of the greatest assistance. Others who have contributed, both to the planning of the exhibition and the preparation of catalogue information, are the members of the Advisory Committee; their names appear elsewhere in this publication. To all of them and especially to the generous lenders to the exhibition, both here and abroad, we extend our warm thanks.

THOMAS P. F. HOVING
Director

ADVISORY COMMITTEE

9

LENDERS TO THE EXHIBITION

Mr. and Mrs. Alvin Abrams,
Woodmere, New York

The American Museum of Natural
History, New York

The Art Institute of Chicago

Mrs. Harold L. Bache, New York

The British Museum, London

The Brooklyn Museum

Arthur Bullowa, New York

The Cleveland Museum of Art

Mr. and Mrs. Juan Dada,
San José, Costa Rica

Dallas Museum of Fine Arts

Isaac Delgado Museum of Art,
New Orleans

Hugo Droege,
Telemán, Alta Verapaz, Guatemala

Mr. and Mrs. Dudley T. Easby, Jr.,
New York

The Ernest Erickson Foundation,
New York

Field Museum of Natural History,
Chicago

Valerie B. Franklin, Beverly Hills,
California

Carlos H. García Archila, Guatemala City

Germanisches Nationalmuseum,
Nuremberg

Joya Hairs, Guatemala City

Hamburgisches Museum für Völkerkunde
und Vorgeschichte

Mr. and Mrs. John H. Hauberg, Seattle

Mr. and Mrs. Ricardo Hecht, Guadalajara

Herrera Hermanos, Guatemala City

Oscar Herrera Mata, San José, Costa Rica

Mrs. Jorge Hine, Key Biscayne, Florida

John Huston, County Galway, Ireland

Mr. and Mrs. William B. Jaffe, New York

Alfonso Jiménez-Alvarado,
San José, Costa Rica

Mr. and Mrs. Samuel Josefowitz,
Lausanne

Mr. and Mrs. Jacob M. Kaplan, New York

George C. Kennedy, Los Angeles

Mr. and Mrs. Justin Kerr, New York

Howard Leigh, Mitla, Oaxaca, Mexico

Dr. and Mrs. Milton Arno Leof,
Mexico City

Margaret Lourie, New York

Miles J. Lourie, New York

Dr. and Mrs. Ambrosio Malagón,
Mamaroneck, New York

Arnold H. Maremont, New York

Guennol Collection of
Mr. and Mrs. Alastair Bradley Martin,
Katonah, New York

Robin B. Martin, Katonah, New York

Morton D. May, St. Louis

Memorial Art Gallery of the
University of Rochester, New York

Middle American Research Institute,
Tulane University, New Orleans

Milwaukee Public Museum

Mr. and Mrs. Jan Mitchell, New York

Munson-Williams-Proctor Institute,
Utica, New York

Musée de l'Homme, Paris

Museo Arqueológico Regional de
Chichicastenango, Guatemala

Museo de América, Madrid

Museo de Antropología, Historia y Arte,
Universidad de Puerto Rico, Río Piedras

Museo de Arqueología de Yucatán,
Mérida, Mexico

Museo de la Municipalidad de
La Democracia, Guatemala

Museo Frissell de Arte Zapoteca, Mitla,
Oaxaca, Mexico

Museo Nacional de Antropolgía, Mexico

Museo Nacional de Arqueología y
Etnología, Guatemala

Museo Nacional de Panamá

Museo Nazionale Preistorico ed
Etnografico Luigi Pigorini, Rome

Museo Regional de Chiapas, Tuxtla
Gutiérrez, Mexico

Museo Regional de las Artesanías
Populares Problanas, Puebla, Mexico

Museo Regional de Oaxaca, Mexico

Museo Sylvanus G. Morley, Tikal,
Guatemala

Museo Universitario de Ciencias y Arte,
Universidad Nacional Autónoma
de México, Mexico City

Museum für Völkerkunde, Berlin

Museum für Völkerkunde, Vienna

The Museum of Primitive Art, New York

Museum of the American Indian,
Heye Foundation, New York

The New York Public Library

Joseph V. Noble, Maplewood, New Jersey

Karl-Heinz Nottebohm, Guatemala City

Fred Olsen, Guilford, Connecticut

William P. Palmer, Portland, Maine

Peabody Museum of Archaeology and
Ethnology, Harvard University,
Cambridge, Massachusetts

Philadelphia Museum of Art

Mr. and Mrs. Alfonso Ramírez Horta,
Mexico City

The Redo family, Mexico City

Dr. and Mrs. Josué Sáenz, Mexico City

Alvaro A. Sánchez, Guatemala City

Schatzkammer der Residenz München

Mr. and Mrs. Alan E. Schwartz, Detroit

Millard Sheets, Claremont, California

Smithsonian Institution,
Washington, D.C.

Proctor Stafford, Los Angeles

Mr. and Mrs. Paul Tishman, New York

Tucson Art Center

The University Museum, Philadelphia

Raymond Wielgus, Chicago

Württembergisches Landesmuseum,
Stuttgart

Two anonymous lenders

12

Preface

Ancient Middle America was, in the words of the late Miguel Covarrubias, the Mexican artist, archaeologist, and art historian, "the intellectual and artistic focus of Indian civilization . . . the leading Indian cultural center of the hemisphere." It was here that the major arts of architecture, mural painting, and, especially, sculpture reached heights seldom equaled at any time or in any place.

To give a broad picture, sculpture from the West Indies, Columbus's first landfall, and from all of Central America as far south as Panama has been included in this exhibition, although, strictly speaking, the area of allied advanced Middle American cultures, referred to as Mesoamerica, is considered to extend only from central Mexico approximately to Nicaragua. Also, since even the smallest objects may display great virtuosity and have a monumental quality, gold and lapidary work, carving in wood, shell, and bone, and ceramic figures have been included. Notwithstanding the unstinted generosity of our many lenders, the exhibition is not an encyclopedia of all Middle American sculpture. The finest pieces in some styles, such as the stone sculptures of the Olmecs from Tabasco and Veracruz and those of the Huastecs from Tamaulipas and northern Veracruz, have had to be omitted for reasons beyond our control. Special mention must be made, however, of the great treasures lent by European museums: none of these has made the westward crossing of the Atlantic before, and many of them were not recovered during archaeological explorations but were above ground, in use, and sent to Europe at or shortly after the time of the Spanish Conquest in the sixteenth century.

Despite the diversity in art styles at different times and in different areas, the Mexican archaeologist Ignacio Bernal has suggested that one common thread runs through practically all Middle American cultures, beginning with the Olmec at San Lorenzo, Veracruz, in 1200 B.C., and extending down to the Spanish Conquest: "the feeling for order and exact proportion, the real mania for ritual" of a ceremonial society. This is perhaps an oversimplification, but still an acceptable rule of thumb. By later times art in the Valley of Mexico and other regions under Aztec domination was based largely on religion and a complicated cosmology.

For any real understanding or appreciation of an unfamiliar art, some knowledge of the cultural level of the people who produced it is helpful. (Trying to interpret

13

the early art of the New World in the light of European traditions and prejudices can yield some pretty absurd results.) Every schoolboy knows that the Aztecs practiced human sacrifice as part of their religion, but that, unfortunately, is about all that many persons know concerning them or the people of Middle America in general. The Aztecs, about whom we are best informed, did not appear on the scene in the Valley of Mexico until the fourteenth century and did not assume importance until about 1428, only a century before the Spanish Conquest, when the triple alliance of the city-states of Tenochtitlán (present-day Mexico City), Texcoco, and Tlacopan was created, forming the nucleus of the Aztec empire. Lacking any cultural tradition of their own, the Aztecs appropriated one from their predecessors and added borrowings from regions they conquered. This eclecticism and our own greater knowledge of the Aztecs aid materially in placing much of Mesoamerican art in its cultural context.

By the time of the Conquest the gifted peoples of Middle America, especially the Maya, had been studying the heavens for centuries and had made such progress in astronomy that they were able to predict eclipses and the movements of Venus and other heavenly bodies. That and their mathematical genius enabled them to develop a highly accurate calendar; in their calculations they not only used position numeration but also had arrived at the concept of naught, or zero, long before Europe received it from India by way of the Arabs. Picture and hieroglyphic writing were used to record history, land titles, genealogies, astronomical data, tribute rolls, and rituals in screen-fold books made of buckskin or beaten bark paper. Nearly all of these important documents were tragically lost when the early Christian missionaries burned them as "works of the Devil."

The herbal medicine of the Aztecs, although having many overtones of magic, produced some efficacious remedies still in use, and their surgery—particularly in the treatment of sprains or dislocations, fractures, wounds, and abscesses—was surprisingly modern. Their personal hygiene and their cleanliness were years ahead of their time.

Cortés, Bernal Díaz del Castillo, and other eyewitnesses at the time of the Conquest reported that Moctezuma's zoological garden was so extensive that over six hundred men were employed in caring for the animals, birds, and fish assembled from every corner of the realm. Long before the establishment of the first European botanical garden at Padua, about the middle of the sixteenth century, the rulers of Tenochtitlán and nearby Texcoco had huge botanical gardens in the accepted sense of being not only places of recreation with rare and beautiful plants but centers of research on medicinal plants.

These rulers had developed a body of laws based, not unlike our own Common Law, on custom, and had courts of primary and appellate jurisdiction. Justice was stern, prompt, and impartial, without regard to the rank of the litigant. For example, even members of the ruling families who transgressed received the death penalty in cases of adultery or other capital offenses.

Incredible as it may seem, vast engineering projects, such as leveling off an entire mountaintop at Monte Albán to erect the great Zapotec ceremonial center there, were carried to completion without beasts of burden, wheeled vehicles, or metal

tools. Over the centuries a few animals for food and plants were domesticated. The entire world is indebted to Middle America for corn, vanilla, avocados, chocolate, and tomatoes. In fact, our names for the last three are borrowed from the Aztec: *ahuacatl* (Spanish, *aguacate*), *chocolatl,* and *tomatl.* Even that boon to gumchewers, *tzictli,* or chicle, came—and still comes—from Middle America. (However, in ancient times to chew it in public was regarded as a sign of ill-breeding.)

Finally, enough has survived to show that the Aztecs had a true literature. Their poetic tongue, Náhuatl, is so rich in metaphors that the learned eighteenth-century Italian Lorenzo Boturini considered it to be "superior in elegance to Latin."

Even these few random glimpses of the cultural level of the peoples who produced the splendid works in this exhibition bear out the words of Covarrubias with which we began. Further confirmation of his assertion will appear in the chapters that follow.

On another ceremonial occasion the poet-king of Texcoco, Nezahualcoyotl (1402–1472), said: "We hope that when our friends return to their homes in distant lands they will keep in their mind's eye the image of our fair realm. . . ." It is our hope that our Centennial visitors may "keep in their mind's eye" some of the glories of the great Middle American past that we are privileged to exhibit on this occasion.

DUDLEY T. EASBY, JR.
Consultative Chairman
Department of Primitive Art

Relative Chronology of Middle America

		WESTERN MEXICO	CENTRAL MEXICO	OAXACA	GULF COAST
POSTCLASSIC	1520	Tzintzuntzan	Aztec III-IV	Monte Albán V	Cempoala
	LATE		Chichimec		
			M I X T E C A - P U E B L A		
	1200				
	EARLY	Aztatlán Complex	Toltec		Isla de Sacrificios I
	950			Monte Albán IV	
CLASSIC		Middle Chametla	Xochicalco		Upper Remojadas II
	LATE		IV Metepec	Monte Albán IIIb	
			IIIa		
	550		Xolalpan		Lower Cerro de las Mesas
	EARLY	Ixtlán Polychrome	III	Monte Albán IIIa	
			Tlamimilolpan		
	A.D. 250		II Miccoatli		Lower Remojadas
PROTOCLASSIC		Shaft-tomb Complex	I Tzacoalli	Monte Albán II	
					Middle Tres Zapotes
	B.C. 100				
PRECLASSIC	LATE	Chupícuaro	Ticomán	Monte Albán I	Lower Tres Zapotes
		El Opeño	Late Tlatilco		
	550		Zacatenco	Guadalupe	La Venta
	MIDDLE	Guerrero Olmec (Tepecoacuilco, Juxtlahuaca)	El Arbolillo		
				San José	San Lorenzo
	1150		Ixtapaluca	Tierras Largas	Pre-San Lorenzo
	EARLY			Ajalpan	
	2300	Puerto Marqués		Purrón	

(Central Mexico Classic/Protoclassic column marked vertically: TEOTIHUACÁN)

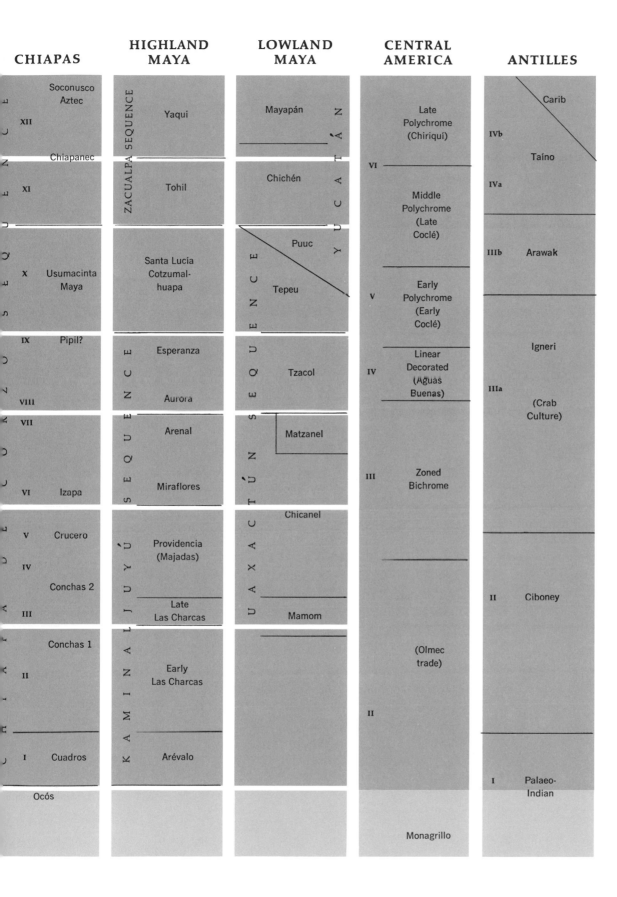

Color Illustrations

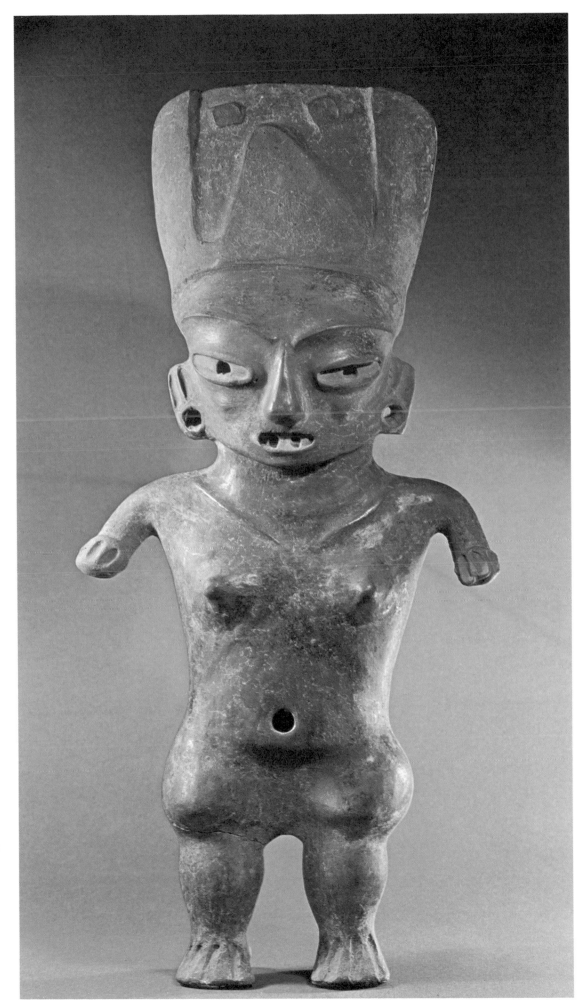

Standing figure

NUMBER 17

Seated child

NUMBER 19

OPPOSITE

Figure holding
a jaguar baby

NUMBER 41

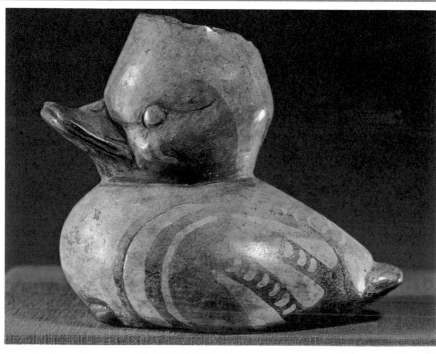

Duck

NUMBER 24

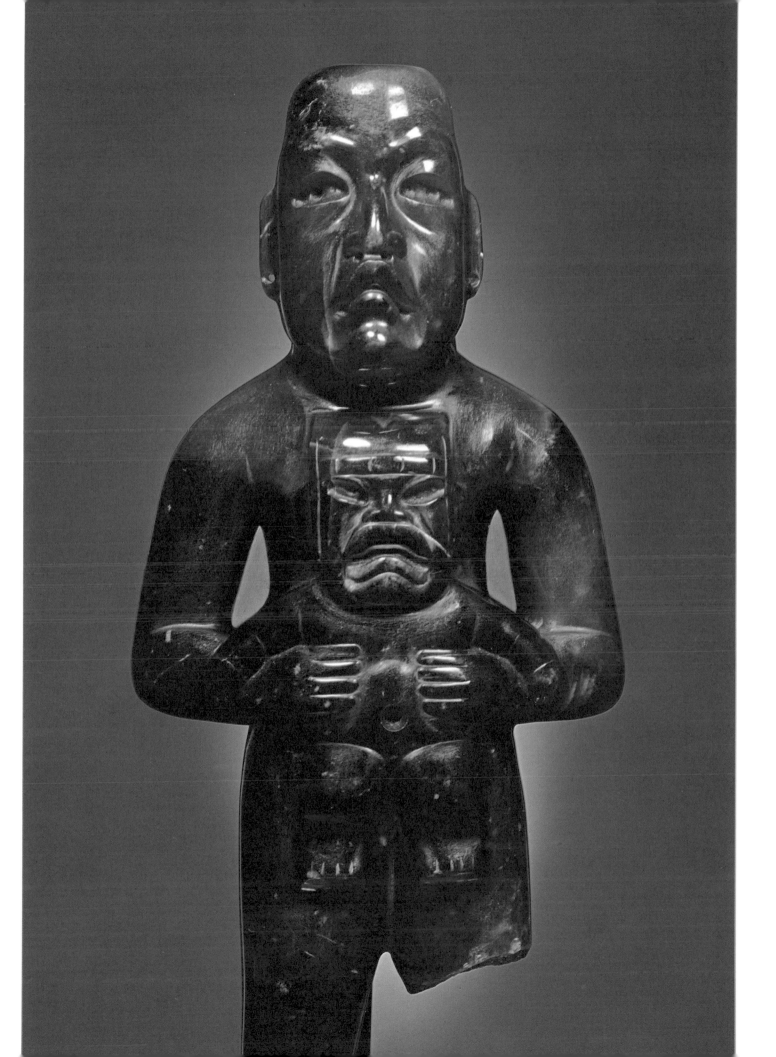

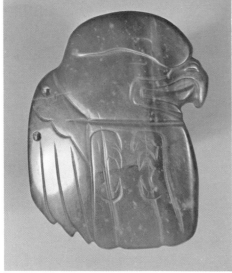

Bird pendant

NUMBER 46

Large duck-head pendant

NUMBER 48

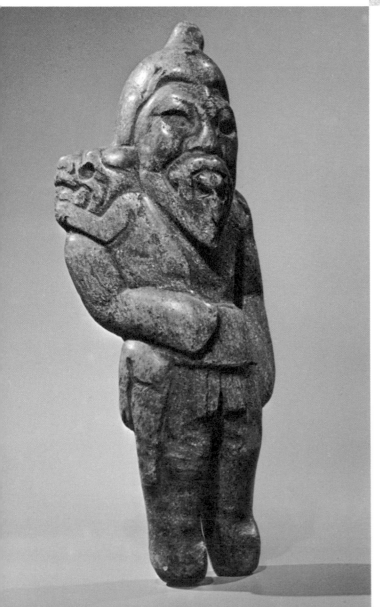

Man holding a jaguar cub

NUMBER 68

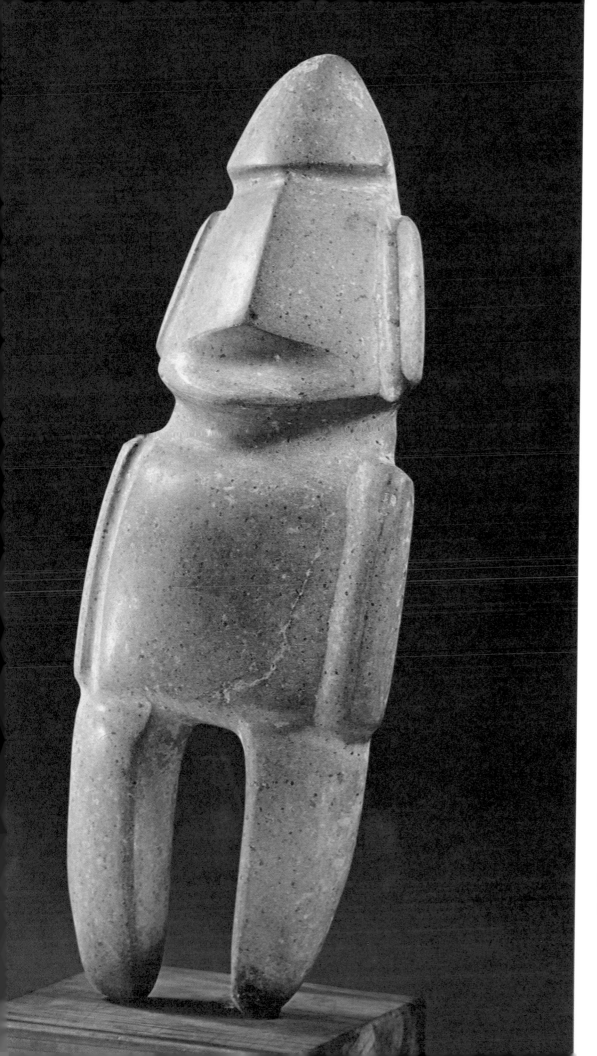

Standing figure

NUMBER 79

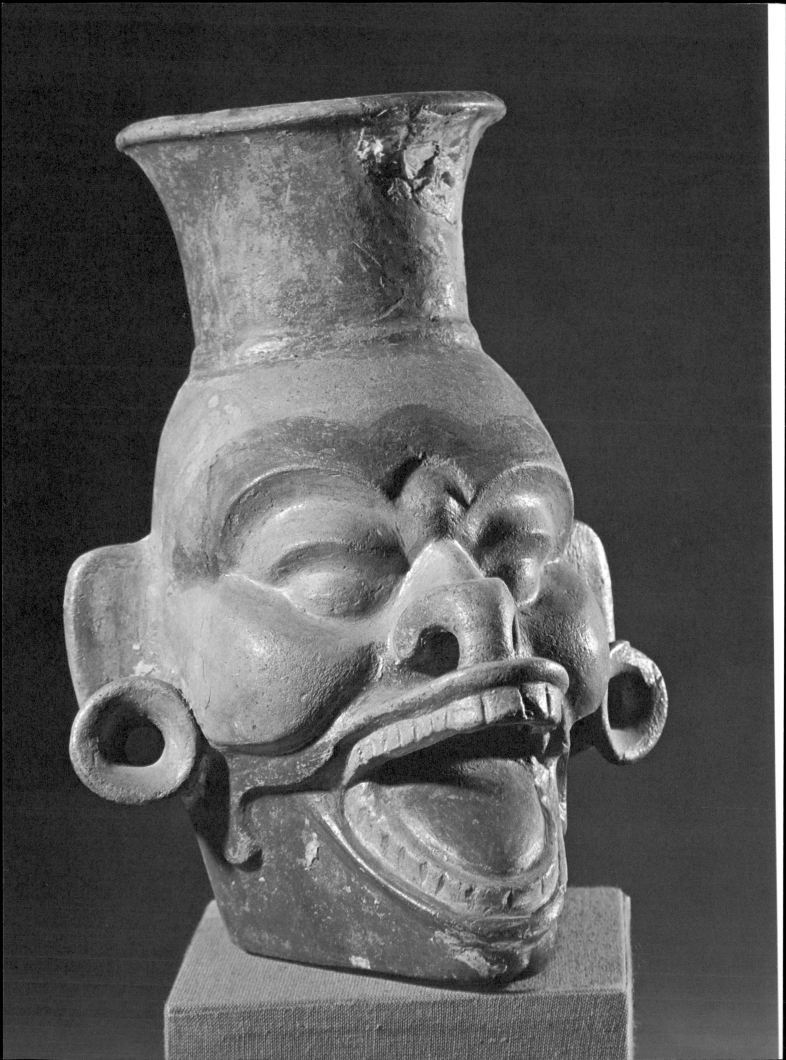

OPPOSITE
Jar with the head
of a wind god

NUMBER 78

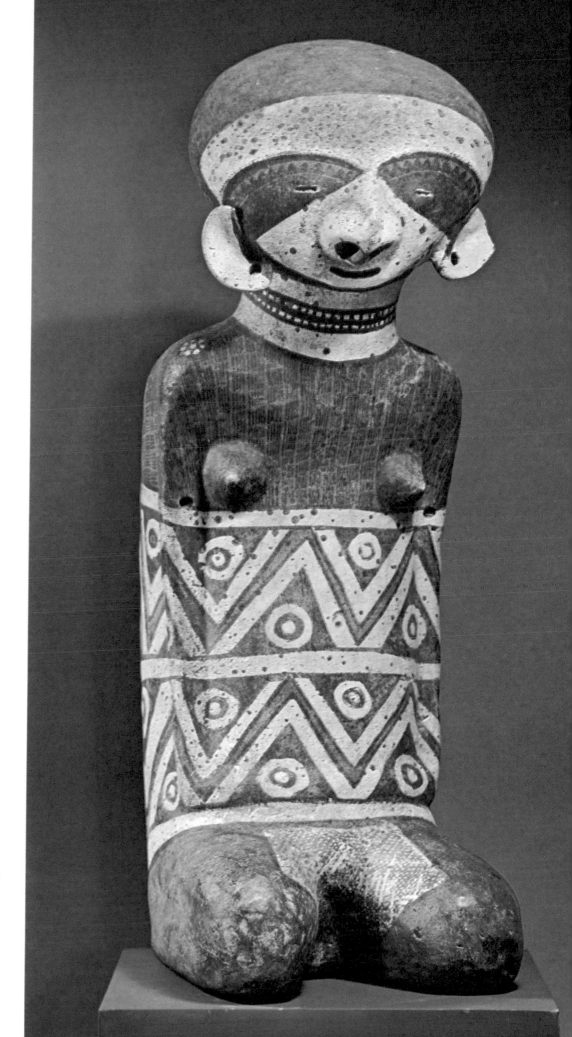

Kneeling Chinesca woman

NUMBER 101

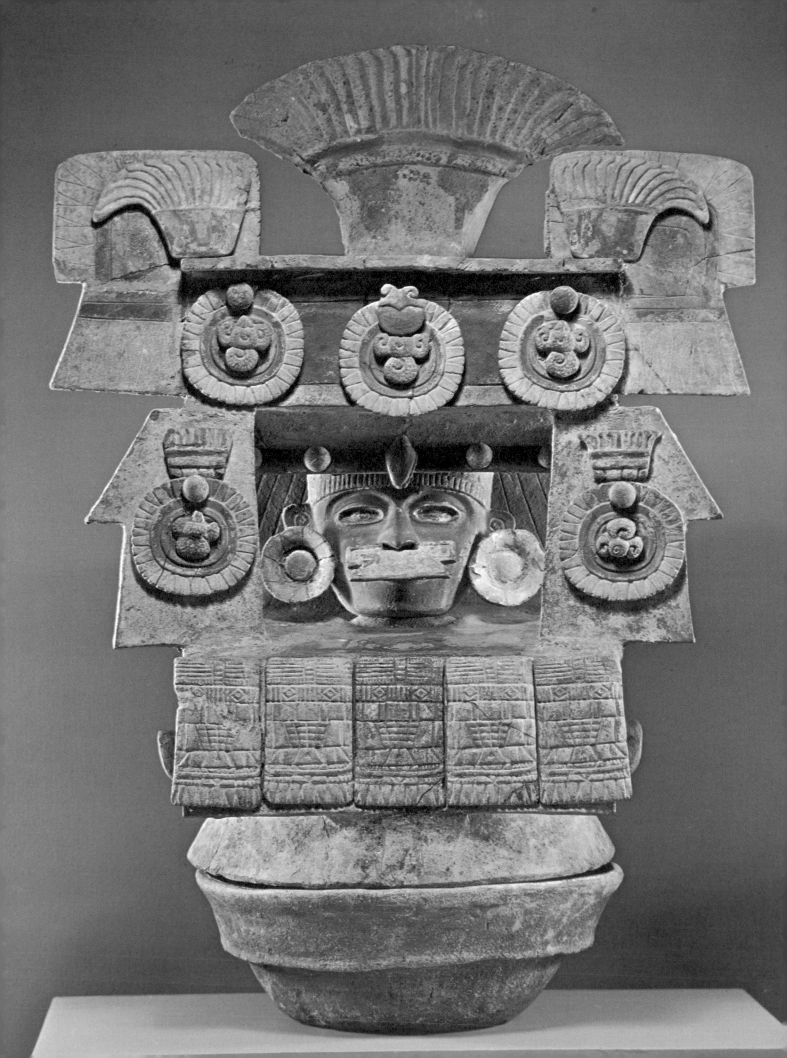

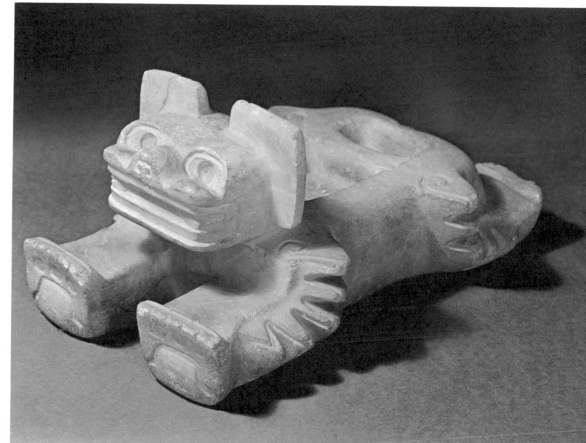

Plumed jaguar

NUMBER 109

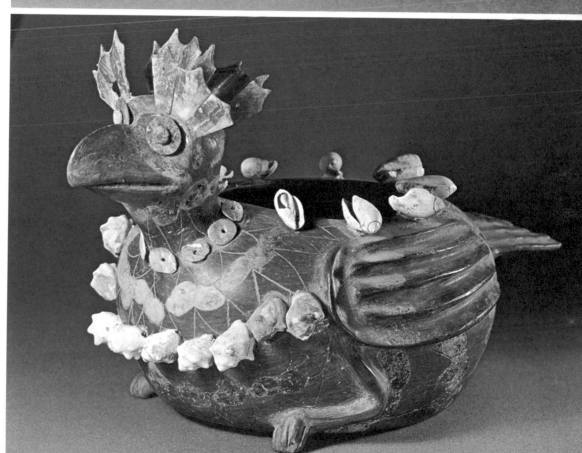

"Pato Loco"

NUMBER 126

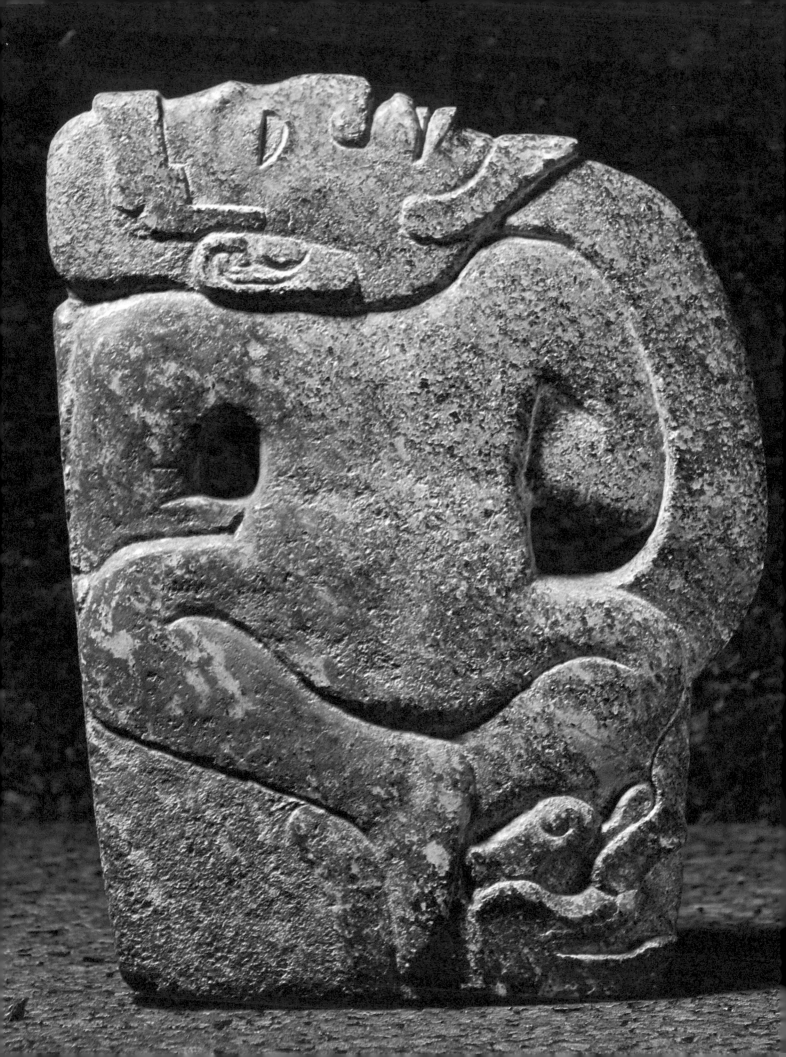

OPPOSITE

Openwork hacha of a man struggling with a snake

NUMBER 152

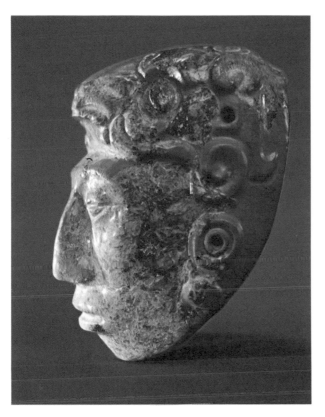

Head pendant

NUMBER 187

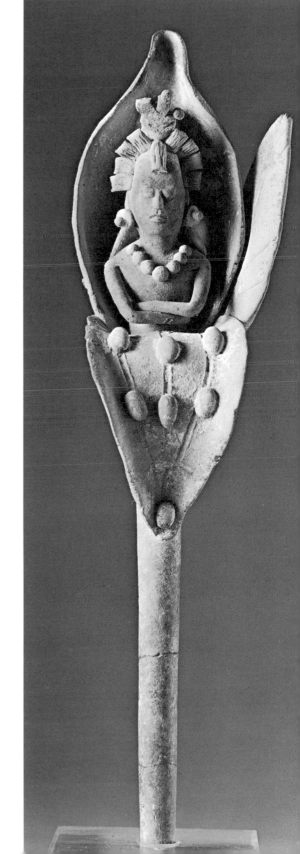

Water-lily spirit

NUMBER 177

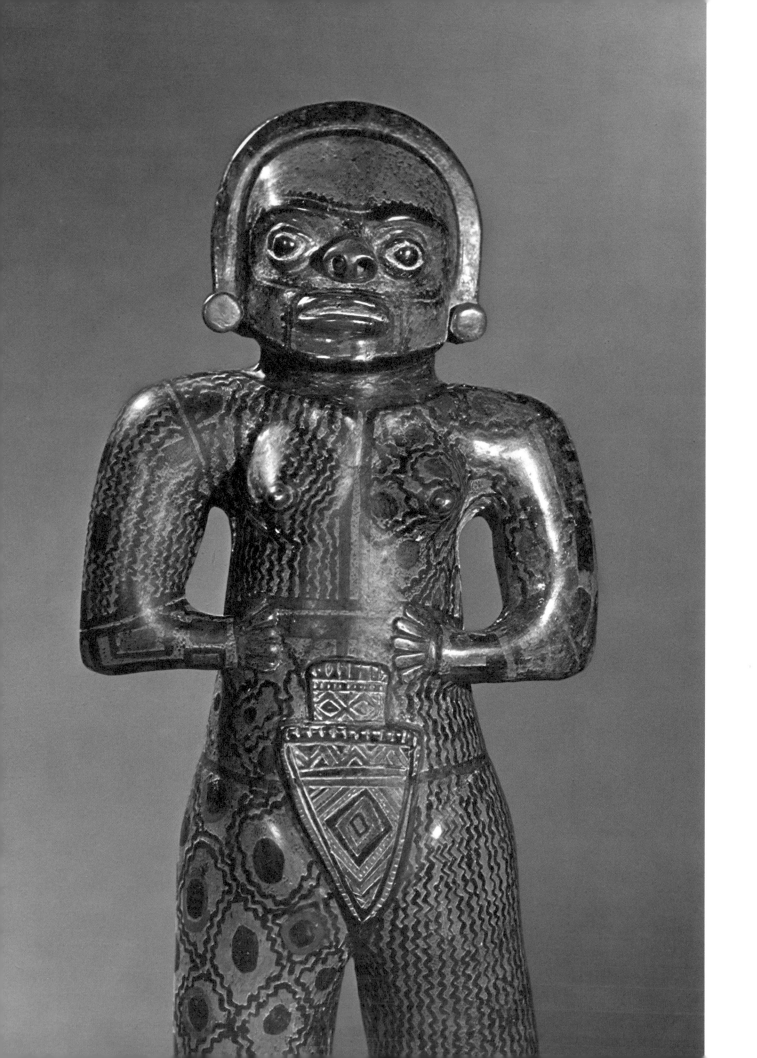

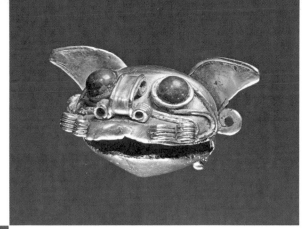

Animal-head bell

NUMBER 232

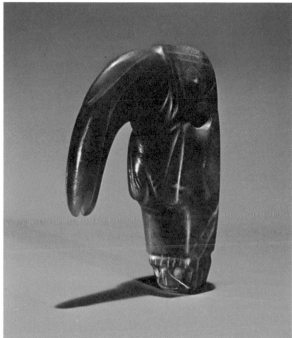

Long-beaked bird pendant

NUMBER 220

Twin-warrior pendant

NUMBER 228

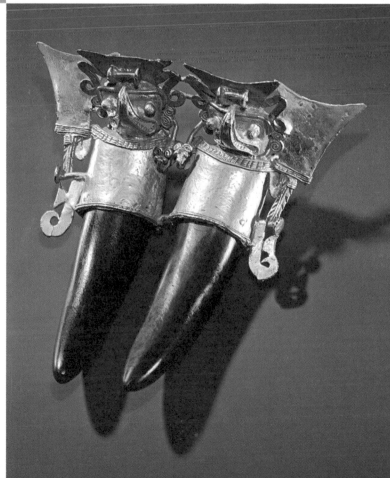

OPPOSITE
Standing woman

NUMBER 215

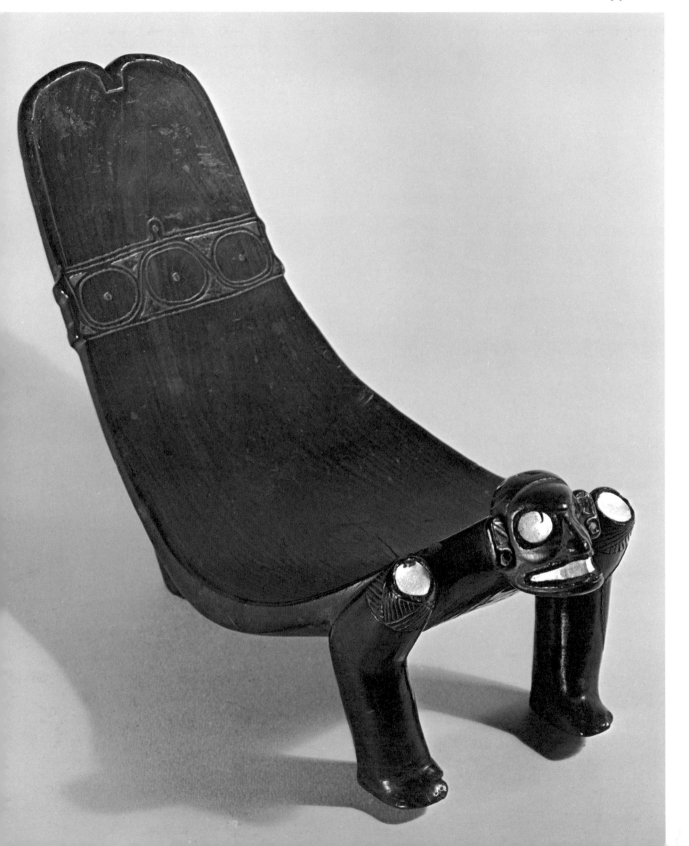

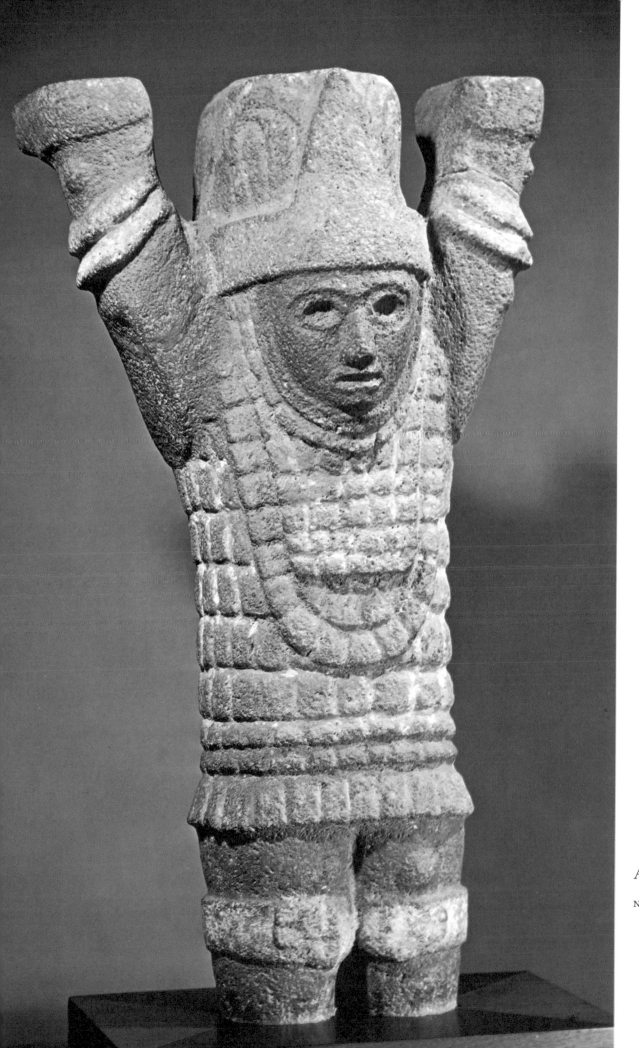

Atlantean warrior

NUMBER 249

Pectoral(?)
in the form of Xolotl

NUMBER 291

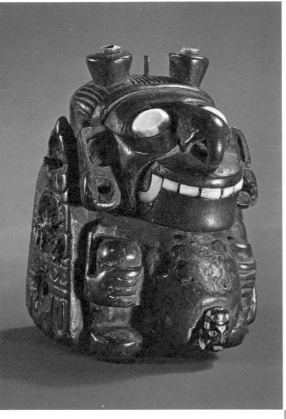

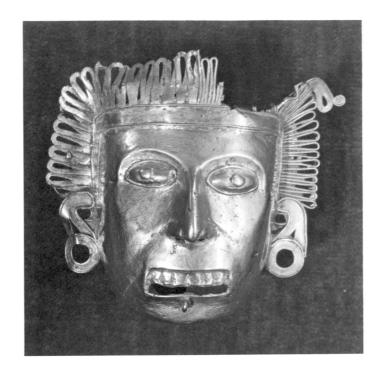

Pectoral

NUMBER 298

Handle from a sacrificial knife

NUMBER 295

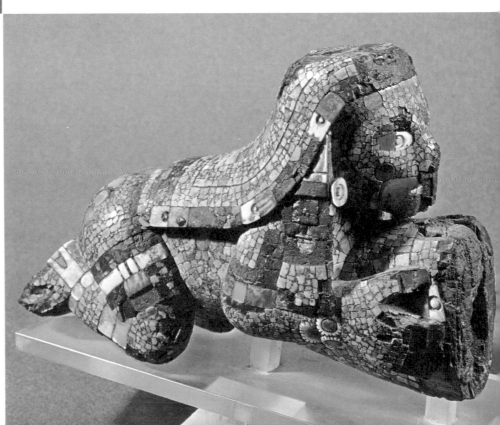

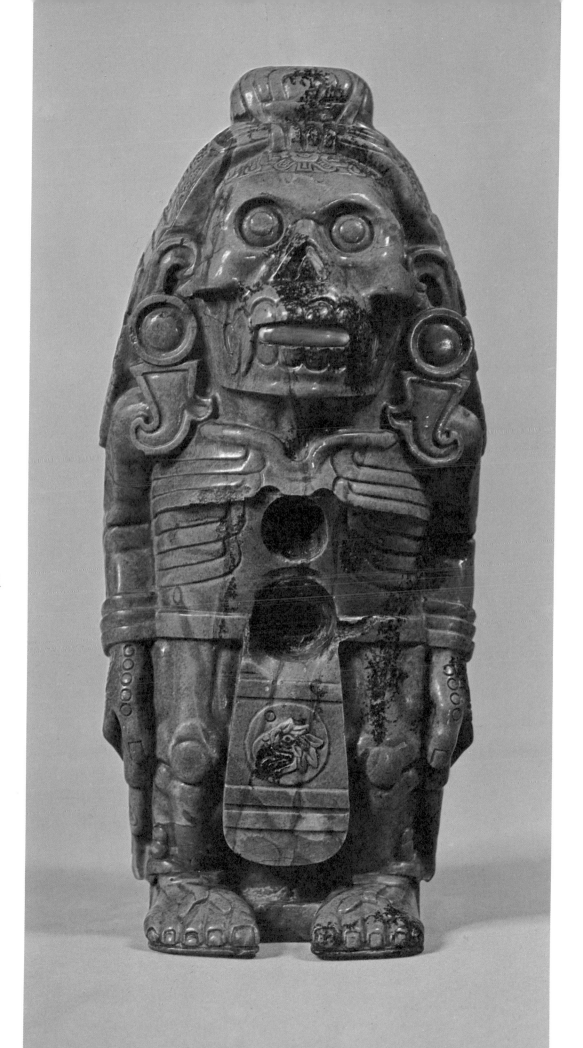

Greenstone Xolotl

NUMBER 281

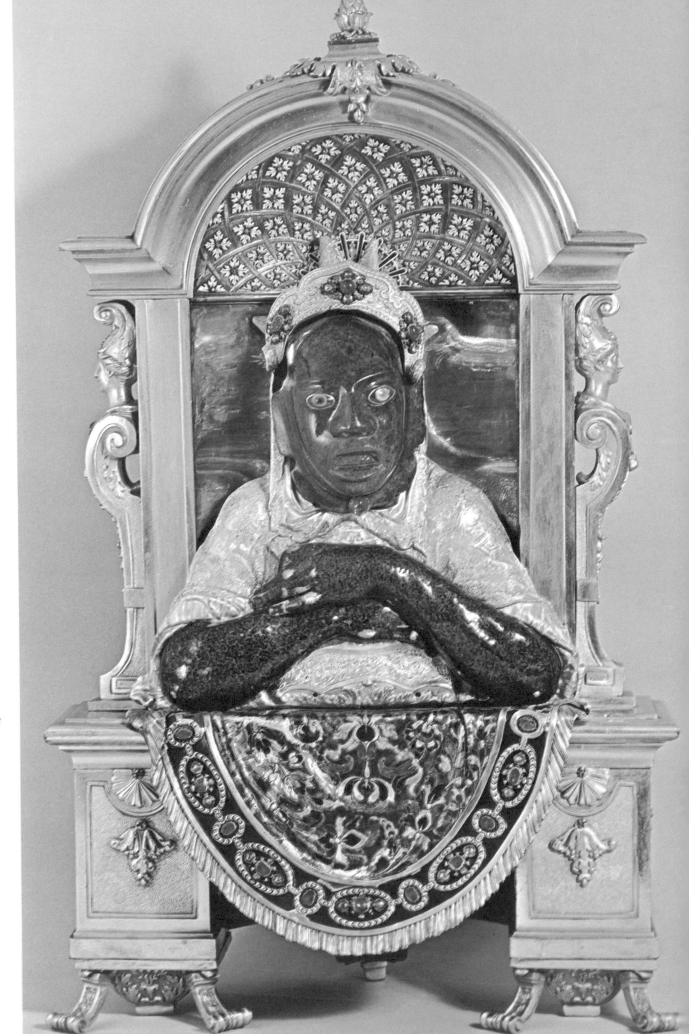

Niche figure

NUMBER 307

1

High Cultures
of Middle America

Five hundred years is only a little time in the long sweep of history; still less within the longer span of archaeology. In Europe and many other parts of the Old World, business, ceremony, and ordinary life go on uninterrupted in buildings of the fifteenth century. In some of them, especially churches and government buildings, even the ornaments and furniture remain essentially unchanged. We see nothing strange about this; to our eyes such places may be beautiful, or interesting for their historic associations, but not remarkable for age alone. But by the same standards, our New World, as we see it now, is indeed new. Not one building in all of North and South America, unless it was already in ruins in the fifteenth century, stands today as it did five hundred years ago.

The arrival of the Spaniards instantly arrested the development of the indigenous cultures of the Americas. Not only the technical superiority of European weapons but also the devastating spread of European diseases caused the sudden prostration of the pre-Columbian civilizations. The areas earliest affected were the Antilles, discovered by Columbus between 1492 and 1494. Following the discovery of Honduras and Panama on Columbus's fourth and last voyage in 1502, Balboa arrived in 1511 and began to ravage the gold-producing Panamanian chieftaincies. Then, in 1519, Cortés landed in Veracruz and marched on the Aztec capital of Tenochtitlán, the modern Mexico City, thus ending the isolation of the fully civilized part of Middle America. During the next quarter century, the conquistadors ruthlessly subjugated all but the most inaccessible zones of Middle America and the Andes, effectively decapitating the civilizations they found there by eliminating the religious, political, and intellectual leadership and destroying the written or oral wisdom accumulated over millennia.

Middle America, the area represented in this exhibition, includes the present politico-geographic areas of Mexico, Central America through Panama, and the island chain of the Antilles. Its focal point in pre-Hispanic times was Mesoamerica, the area from central Mexico south to Nicaragua, where the Indian population reached, by anyone's definition, the stage of true civilization. In spite of the great

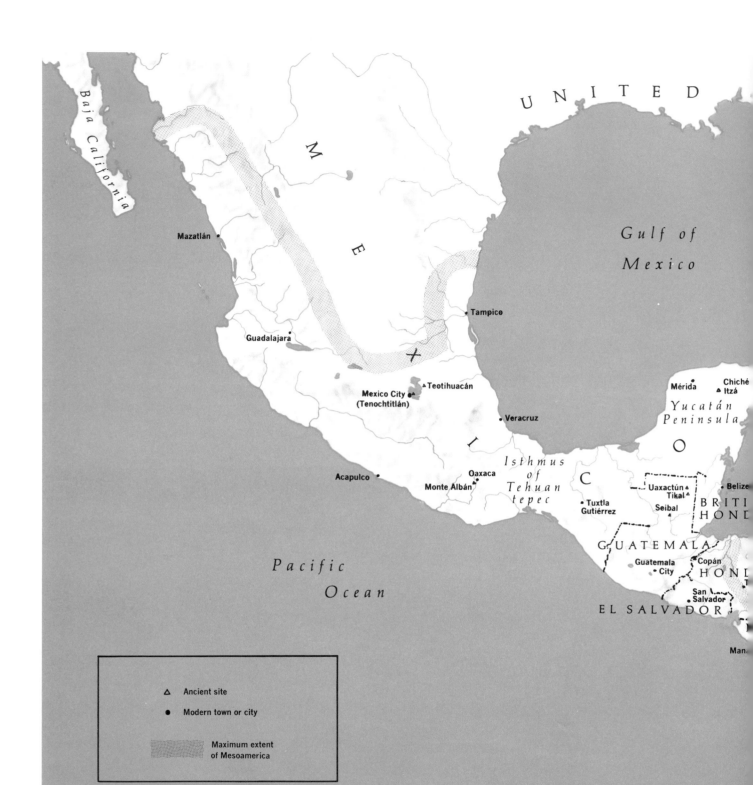

Baja California

M
E
X
I
C
O

UNITED

Gulf of
Mexico

Mazatlán

Tampico

Guadalajara

Mexico City
(Tenochtitlán)

Teotihuacán

Veracruz

Mérida

Chiché
Itzá

Yucatán
Peninsula

O

Acapulco

Oaxaca

Monte Albán

Isthmus
of
Tehuan
tepec

C

Tuxtla
Gutiérrez

Uaxactún
Tikal

Seibal

Belize

BRITI
HOND

Pacific

Ocean

GUATEMALA

Guatemala
City

Copán

HOND

San
Salvador

EL SALVADOR

Man

△ Ancient site

● Modern town or city

Maximum extent
of Mesoamerica

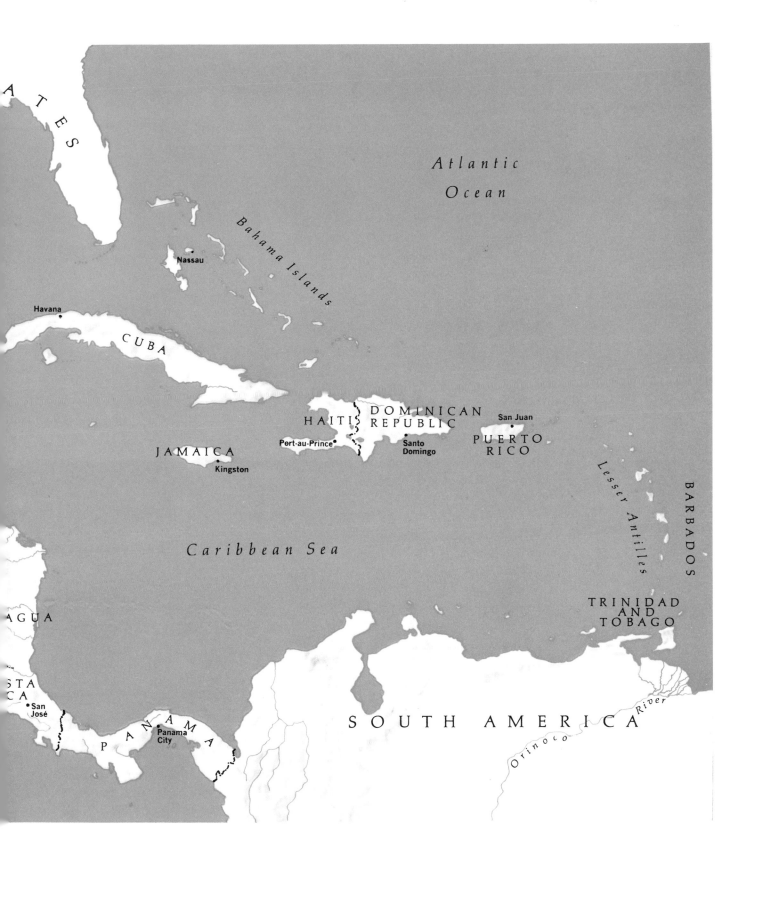

A T E S

Atlantic

Ocean

Bahama Islands

• Nassau

Havana •

C U B A

J A M A I C A

Kingston •

H A I T I

Port-au-Prince •

D O M I N I C A N
R E P U B L I C

Santo •
Domingo

San Juan
•

P U E R T O
R I C O

Lesser Antilles

B A R B A D O S

Caribbean Sea

T R I N I D A D
A N D
T O B A G O

A G U A

S T A
C A

San •
José

P A N A M A

Panama
City •

S O U T H A M E R I C A

Orinoco *River*

variety of languages and cultures within Mesoamerica, considerable interrelationship between groups forged many links that joined all together into one civilization. A similar situation existed in the classical Mediterranean world, where the differences between Ptolemaic Egypt, Ionic Anatolia, Phoenician Carthage, and Etruscan Italy did not preclude many common bonds. The twenty-five-hundred-year ebb and flow of cultures in Mesoamerica parallels the transformation of the Mediterranean world from the Minoan Empire into the Byzantine. Similar to the barbarian fringes of the Roman Empire, where certain elements of Mediterranean civilization were known and imperfectly copied, the fringes around Mesoamerica had some but far from all of the traits of that civilization.

The Antilles, although their culture was essentially South American in origin, from the Amazon and Orinoco and the northern littoral, had some contact with Mesoamerica, as evidenced by archaeological finds in Puerto Rico of protective gear for the ubiquitous ceremonial ball game. Mesoamerica and the Andean region, the other great center of high culture in the New World, were quite separate; nevertheless, recent archaeological studies have shown undoubted contacts and mutual influences in such matters as pottery and figurine design, metalworking, the religious importance of the jaguar, corn as a major item of diet, and thin copper replicas of axes used as a medium of exchange.

Although there were regional differences, all of Mesoamerica came to share a number of exclusive features, which gave it a basic unity. Among these were ceremonial plazas with impressive stone and stucco architecture and towering pyramids with majestic stairways; elaborate systems of picture and hieroglyphic writing; arithmetical calculations based on a vigesimal system, and at least among the Maya, the use of zero and placement numeration; a complex calendar in which a ceremonial year of 260 days was intermeshed and ran concurrently with a solar year of 365 days in such a way that the same combination of days in the two calendars reappeared only once every 52 years, a cycle that assumed supreme ritual importance; a ceremonial ball game played in specially constructed courts with a solid rubber ball; screen-fold manuscripts or books of buckskin and bark paper in which the wise men made records, the contents including rituals, astronomical data, legal matters, genealogies, history, and maps; large periodic markets with a wide variety of domestic and imported products; confession of sins and penance; and auto-sacrifice, drawing of blood with thorns or stingray spines.

The cross-fertilization and integration among the various cultures of Mesoamerica were achieved by a combination of proselytizing, trading, and conquest. These activities were not mutually exclusive; in fact, records from the Aztecs indicate that all three proceeded simultaneously. Art undoubtedly played an important role in both trade and religion. Religious symbolism in jade, ceramics, and other portable goods transmitted the iconography of the home area to other zones. Trade focused primarily on luxuries for use by the priests and rulers, since the whole region produced similar foods and raw materials for daily use.

The distinctive features of Mesoamerican civilization had appeared throughout the area by the beginning of what the archaeologists call the Classic period, roughly from the latter half of the third century to the beginning of the tenth century of

our era. (During a large part of this splendid golden age of the New World the Europeans who were later to destroy Indian civilization were passing through the Dark Ages.) There are no precise dates for the beginning and the end of this Classic period in any of the several regions of Mesoamerica. The lowland Maya area centered in the northern half of Guatemala, for example, has many monuments bearing exact dates expressed in a definite, day-to-day calendric system, which ran cumulatively from a fixed base date (much as we use the birth of Christ) and is known as the Maya Long Count. The period during which that system was employed has traditionally been considered to coincide with the Classic period there. This is approximately so, but there remains the complex and controversial problem of correlating Long Count dates with our calendar. Two principal correlations, 260 years apart, have been proposed, one by the late H. J. Spinden and the other primarily by J. Eric S. Thompson. However, recent Carbon 14 analyses of a series of wood samples from buildings at Tikal in the Petén jungle of northern Guatemala, taken together with historical, astronomical, and archaeological evidence, support the Thompson correlation, which would put the base date in 3113 B.C., rather than 260 years earlier. On the basis of the Thompson correlation, most experts have fixed the Classic period at about A.D. 250 to A.D. 950. Such general agreement on this vexing correlation problem is fortunate, for in the last analysis all archaeological chronologies of Mesoamerica are based on some links with the Maya Long Count, as well as on archaeological and laboratory evidence.

Unhappily for us, the practice of erecting monuments with Long Count dates stopped at various sites in the central lowland area between A.D. 800 (Copán in Honduras) and A.D. 889 (Seibal, Tikal, and Uaxactún in Guatemala), signaling the approaching collapse of the great Maya city-states and the end of the Classic period. Had the Long Count continued in use in the northern Maya area of the Yucatán down to the time the Spaniards arrived, there would have been no correlation problem. Instead, however, the earlier and less precise method of recording dates only in the Calendar Round cycle of 52 years was resumed. In this abbreviated method a recorded date might fall on any one of a number of days 52 years apart. A parallel situation would exist if some archaeologist of the future were faced with a date in '70 without more to identify the year. His day might then fall in any one of our 100-year cycles from A.D. 70 to 1970, or onward.

Having established the Classic period as a base or point of departure, the archaeologists, quite logically, refer to the period from the end of the Classic to the arrival of the Spaniards and the fall of Mexico in 1521 as the Postclassic, and, *pari passu*, the developmental period from the appearance of pottery, about 2300 B.C., to the beginning of the Classic is known as the Preclassic or Formative.

Before Middle American man settled permanently in villages, he had already firmly established the agricultural underpinning upon which his civilization was to be built. Its staple crops were beans, squash, and—most important of all—maize, or Indian corn. During the Archaic period, which followed the receding of the last glaciers, man in Middle America had to abandon his reliance on big game as his primary source of food, since large animals such as the mammoth became extinct. Slowly he learned to domesticate some of the wild plants that he had previously

searched out and collected. He scattered the seeds, departed, and later returned to the same spot to harvest the crop. Perhaps because maize was difficult to domesticate and required care to grow and because it was the "staff of life," it became associated with one of the major deities of the Mesoamerican pantheon. The continuing importance of maize to the Indian diet can be seen in the variety of foods based on corn in modern Mexican cooking, including *tortillas*, steamed *tamales*, fried *tacos*, and a rich gruel, *pozole*.

Small animals, such as the turkey, the duck, and the hairless dog, were domesticated and found their way into the Middle American's diet as well as into his art. More frequent in artistic representation, however, were the wild animals, perhaps because they retained elements of power and the supernatural that resisted domination by man. These animals were frequently representatives of deities and used as patronymics in ruling families. Among the principal animals immortalized in Mesoamerican art are the coyote, the rabbit, the white-tailed deer, and, especially important, the jaguar and the serpent. However, other animals, birds, fish, reptiles, and even insects appear in such profusion that one can find in this art a veritable catalogue of the fauna of the area. From the vegetable world, in addition to corn, there are realistic sculptures and other representations of pumpkins or squash, cactus, cacao, and, of great importance among the Maya, the water lily.

In the religion of Middle America, as in that of most polytheistic cultures, the supernatural and cosmic aspects of the world were personified and deified. Great spiritual power was assigned to such natural features as the sun, the moon, the morning star, weather conditions, and earthquakes. Many forces of nature, such as the rain and the wind, have a dual aspect for good or evil. The same rain god who brought life-giving water for the crops might bring disastrous floods, while the wind god was capable of unleashing terrible hurricanes. This duality, or benevolent and malevolent aspect of much of the natural world, and the conceptual pairing or coupling of related natural events that followed a rhythmic pattern, came to influence religion, politics, art, philosophy, and science. Ritual and religion were oriented to the necessity of appeasing and propitiating these erratic and unpredictable deities by offerings. The most precious gift was man's blood; indeed the Aztec word for blood is *chalchíhuatl*, literally "the precious liquid." That involved auto-sacrifice, and the supreme offering, human life.

Human sacrifice was not inspired by cruelty nor by hatred of the victim. For example, death in battle or death on the altar of the war god (reserved for prisoners of war) were on a parity in Aztec times, and assured the victim of a place in the Indian equivalent of Valhalla. His life blood provided nourishment and sustenance for the sun upon which all life depended, and thus saved mankind in a constantly threatened and unstable world. However, behind this holy messianic urge of the Aztecs to save mankind with the blood of prisoners taken in ceremonial warfare lay less noble motives of political and economic expediency.

By Aztec times the concept of duality had pervaded religion to such an extent that the creator god, who had a masculine and feminine ambivalence, was called "Our Lord of Duality." More often than not, the principal gods who thronged the Aztec pantheon had goddesses as consorts or companions. The same god might

have different guises or aspects, portrayed in art or ceremonies by the use of masks and the addition of attributes of a second or third deity to his costume.

The unpredictability of nature, the constant menace of cataclysms, was in marked contrast with the regular movements of heavenly bodies. All this led to attempts, beginning in the Preclassic period and continuing down to the Conquest, to foretell the future by astrology and omens and portents, which, in turn, resulted in the accumulation of an astonishing amount of calendric and astronomical data. Observatories were erected with definite orientations to line up with some major celestial phenomenon, such as sunrise or sunset on the days of the equinoxes or solstices. Fine examples of observatories still may be seen at Chichén Itzá, in the Yucatán, and at Monte Albán, near the city of Oaxaca. Other existing structures and the great plazas at ceremonial centers throughout Mesoamerica have an axial placement related approximately to the compass points, which must stem from the commonly held belief in a universe oriented to the four directions with different colors and deities assigned to each cardinal point and to the center.

The precise observation and recording of movements of the heavenly bodies and changes in the heavens at different seasons became a prime intellectual endeavor, both in connection with planting crops and, more significantly, as a means of perceiving the divine plan. For this purpose, generations of priests devoted their lives to the calculation of the cycles of the celestial bodies. So important were the duties of the priesthood to the whole culture that young noblemen, especially those destined to rule, spent some time training for the priesthood, as is the case with Buddhists in Southeast Asia. In Maya art especially, rulers cannot be distinguished from priests, as they were often represented in their sacerdotal role. The importance and the duties of priests and wise men were given after the Conquest by a learned Aztec elder defending his beliefs to a group of Spanish friars:

> There are those who guide us;
> They govern us, they carry us upon their backs
> And instruct us how the gods must be worshiped; . . .
> The experts, the knowers of speeches and orations,
> It is their obligation;
> They busy themselves day and night
> With the placing of the incense,
> With their offering,
> With the thorns to draw their blood.
> Those who see, those who dedicate themselves to observing
> The movements and the orderly operations of the heavens,
> How the night is divided.

Not only did the priest-astrologer-astronomers determine the length of the day, the lunar month, and the solar year, they also noted the cycles of planets and predicted eclipses. The cyclical view of the universe is reflected in the belief in the earth's five eras, or "suns," four of which had already terminated in catastrophe. According to Aztec dogma the fifth or modern era would also end thus, unless the sun were constantly nourished with sacrifices. The completion of the annual cycle signaled a time of great concern. The five days necessary to round out the solar

year, which did not fit into their pattern of eighteen months of twenty days each, were unlucky and marked with foreboding. The close of the fifty-two-year cycle was a time that might mark the end of the world, a time when man and all his works had to be renewed. Household utensils were destroyed and even the fires were extinguished in Aztec times, to be relit from a single fire kindled with great ceremony by the priests on the Hill of the Star, near Mexico City, and then passed from village to village throughout the realm.

The older view that most Mesoamerican ceremonial centers were populated only by priest-astrologer-astronomers and their retinues has fallen in the wake of recent archaeological work, notably at Teotihuacán and Tikal. House remains of large populations have been found beyond the temple zones, making these centers worthy of being called true cities. These cities should be visualized as ceremonial plazas surrounded by gleaming pyramids with bustling markets set up in or near this temple zone and large areas of humble thatched dwellings extending in every direction. In addition to the resident population large numbers of Indians came to these centers on pilgrimages, to attend the markets, and to visit friends and relatives. Their descendants today follow the same practice at Catholic shrines and market towns.

The resident population at ancient ceremonial centers must have included the merchants who brought imported items to the market, a wide range of highly specialized craftsmen, artisans, and artists, and what we would call common laborers and farmers. Those who became artists were highly favored people. Aztec records indicate that they should be born on one of the favorable days in order to be granted the talent for their work. But this alone was not enough, for they must also cultivate this talent, as an Aztec informant related to the Spaniards:

> The artist: disciple, abundant, multiple, restless.
> The true artist, capable, practicing, skillful,
> Maintains a dialogue with his heart, meets things with his mind.
> The true artist draws out all from his heart;
> Works with delight; makes things with calm, with sagacity; . . .
> Arranges materials; adorns them; makes them adjust.

Although this passage suggests that the artist must draw his inspiration from within, this was seldom the case. He was a servant of religion and the community, reflecting and supporting the society for which he worked. Unlike recent Western art, creation was not a matter to be left only to the artist's own inspiration. Rather, the Middle American artist followed closely the rigid canons of those artists who preceded him and taught him. For this reason, very similar objects were produced by different hands, even over the course of centuries. The artist was careful not to depart from what his priest and noble patrons expected nor to endanger the proven efficacy of religious images.

Art created purely for the pleasure of the owner or the artist would have been meaningless to Mesoamerican man. Although the artists surely had an aesthetic awareness, we cannot judge the meaning by the formal expression of a piece alone. The iconography and symbolism gave the primary meaning to the work. It is only

when we understand the fantastic cosmic symbolism in such a work as the Calendar Stone that the Indian aesthetic comes through. For that understanding we must turn to the surviving literature of Indian thought and philosophy.

IN THE preceding chapter, as well as in the Preface, the Aztecs are referred to so frequently as to give a misleading idea of their importance among Mesoamerican peoples. Theirs was an eclectic culture created from traditions and ideas of their predecessors, as well as from wholesale borrowings from the cultures of neighboring peoples subjugated by them. Their surviving records, therefore, provide a fruitful, although chronologically indeterminate, source of information about all Mesoamerican thought. Fortunately, we are not restricted to the handful of pre-Conquest codices that were not destroyed. Some of the earliest missionaries not only learned Náhuatl, the *lingua franca* of the Aztecs and their neighbors, but also taught the Indians how to use the Latin alphabet to record, in their native tongue, the songs, poetry, rituals, and traditions that they or their fathers had learned by rote before the Conquest. (Náhuatl, it should be noted, is a living language, still spoken in many parts of Mexico.)

The Franciscan friar Bernardino de Sahagún conducted extensive, on the spot interviews with leading Indian elders and recorded—and had a battery of Indian scribes record—what he learned of Aztec literature, law, medicine, philosophy, religion, education, and ideas in general. His justly famous *Historia General de las Cosas de Nueva España*, written between 1547 and 1582, is still considered a model of ethnographic and sociological research. An excellent translation of this work from Náhuatl into English, suggesting all the elegance and lofty metaphors of the original, has been made by Arthur J. O. Anderson and Charles E. Dibble; it is published jointly by The School of American Research at Santa Fe and The Museum of New Mexico.

Miguel León-Portilla, a Mexican scholar and linguist, has made a painstaking study of the depth and range of Aztec thought and philosophy based on "the literal translation of more than ninety native documents," transcribed in the sixteenth century. His work, entitled *Aztec Thought and Culture*, was published by the University of Oklahoma Press in 1963.

2

The Beginnings of Sculpture

Clay is a common but remarkable material. Found almost anywhere, it can be shaped without elaborate tools into any number of useful or beautiful things, then transformed by firing into a material virtually as hard as stone. While almost indestructible, pottery is highly breakable, and this is what makes archaeologists appear to be so fond of potsherds; constant breakage requires a continuous production, in which gradual or sudden changes in style and technique are reflected. Broken and discarded, or preserved in burials, pottery accumulates over the centuries, recording man's history more truly and universally—and more durably—than any other material.

The commonness of pottery leads, nevertheless, to an oddly distorted view of ancient times and gives the impression that clay modeling was in many places the first art to be developed. This was probably not so anywhere. The earliest piece of sculpture known from Middle America was made some ten or twelve thousand years ago from the sacrum of a now extinct ancestor of the llamas and alpacas. A little thoughtful shaping when the bone was fresh brought out its natural resemblance to an animal head (Figure 1). Except for another bit of ancient bone that bears lightly incised drawings of animals, nothing else that can be called art appears for many centuries afterward, even among the remarkably preserved wood, bone, fiber, and foodstuffs discovered in the dry Tehuacán Valley of southern Puebla. The archaeological record there, stretching back to around 7200 B.C., reflects Middle America's advance into civilization. The first steps are represented by the remains of plants, now grown worldwide, that were brought under cultivation and improved by selection through countless generations before the introduction of pottery between 2300 and 1500 B.C.

Little clay figures begin to appear in the Tehuacán sequence soon after 1500 B.C. and within a few centuries of that time in Veracruz, the Valley of Mexico, Guerrero, Oaxaca, Chiapas, and the Pacific coastal area of Guatemala. They are the first of a long line of figurines, and the beginning of clay sculpture, an art that reached great

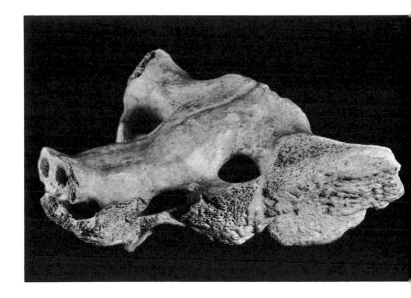

FIGURE 1

Animal head

Now fossilized, this worked bone was found nearly forty feet deep in Upper Pleistocene deposits, dating from about 10,000–8,000 B.C., at Tequixquiac, in the north of the Valley of Mexico. Height: 6 in. (15.4 cm.). Museo Nacional de Antropología, Mexico.

heights in later times. The figurine cult soon spread throughout Middle America, as related but distinct styles developed in different regions. Divisible into numerous types and subtypes, the figurines have yielded more information about ancient life than other excavated ceramics, partly because their liveliness and charm, as well as their many classifiable differences, make them impossible to ignore. The various types found in Central Mexico, designated by a system of letters and numbers, were defined on the basis of thousands of examples excavated from the ruins of Preclassic villages that grew up around the shores of Lake Texcoco, which in those days stretched miles beyond its present marshy remnant.

Though most of these figurines stand in a simple symmetrical pose with nothing in their arms or hands, their tiny faces and stance convey a sense of animation. With admirable economy of means and practiced craftsmanship, their makers symbolized the human figure without copying its real proportions and details. This disregard for naturalism continued to be a basic element in the more ambitious styles developed later.

The majority of the figurines, and of larger Preclassic figures, represent women, wearing nothing but necklaces, bracelets, anklets or sandals, earspools, and elaborate headdresses or hairstyles. Some were enhanced after firing by touches of red, white, yellow, or black paint to emphasize the ornaments and show various patterns of body painting. A few are mothers holding children (Number 1). Certain figurines reflect the importance of religion and ceremony. These are costumed as priests, dancers, or perhaps ball players or warriors. Masked figurines from Central Mexico illustrate how the small clay masks also found there were worn, covering only the lower part of the face (Numbers 3, 4).

Made in tremendous quantity, these figurines obviously played an important role in Preclassic life. They are well made, often covered with a slip of finer clay, and fairly standardized at any one time and place, as if made by practiced potters rather than in every household. The great majority are found broken and discarded

47

with other trash, perhaps after they had been used in a curing, fertility, or agricultural ceremony. At some places, however, they are found undamaged in burials (Figure 2). These grave offerings may have been regarded as symbolic companions for the afterlife, like the tomb figures of the more complex societies of ancient Egypt and China, but there is nothing about them to suggest that they represented servants or retainers. No single explanation can account for all the figurines; it seems rather that their manufacture became something of an art in itself, which was applied to different uses.

The intended role of most of the smaller standing figurines did not require them to stand upright on their own feet, since few of them can be made to do so without additional support (Numbers 1–3, 13, 28, 30). The rare reclining figurines (Numbers 8–10) and those in seated positions (Numbers 5, 12, 14) support themselves naturally, but this characteristic may also indicate that they were made for a differ-

FIGURE 2

A burial at Tlatilco

Reconstructed accurately for display at the Museo Nacional de Antropología in Mexico, this burial contains a group of seven figurines of the type called D-1 (Number 2), two larger, hollow figures, a marine shell, and pottery vessels that contained perishable offerings. Middle Preclassic, 1150–550 B.C.

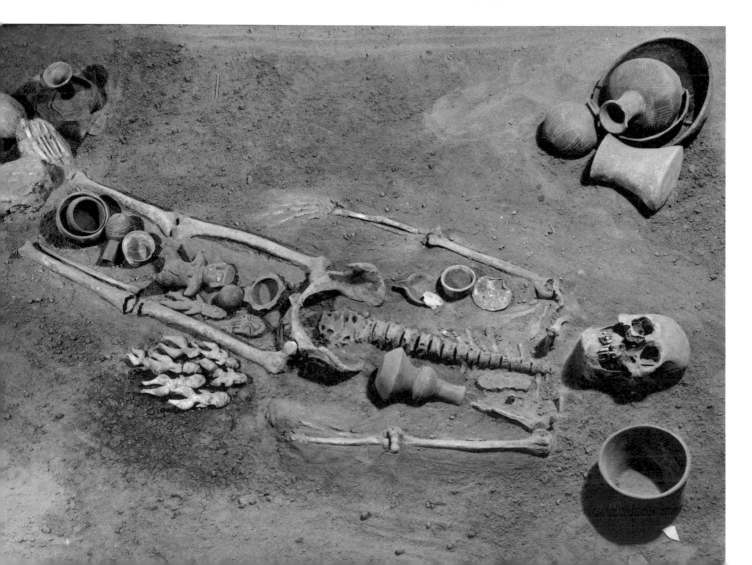

ent purpose. Among the larger clay figures, many more sit or stand unaided and could thus have been displayed on an altar for worship or during ceremonies of some other nature. They were not necessarily cult images, and very few present any recognizably supernatural features or any kind of group uniformity that might identify them as representing deities.

Larger effigies, which had already begun to appear before 1400 B.C., were made possible by an important technical innovation: they are partly or entirely hollow. While it is not impossible to make solid figures fairly large, they tend to crack during manufacture because most clays shrink by about ten percent of their volume in drying and firing. To produce a figure taller than eight or nine inches, it is necessary either to add extra temper, such as sand, to the clay (Number 31) or to adapt the form itself to the natural limitations of the material by modeling a flat "gingerbread man," as was sometimes done in Western Mexico. Hollow construction, though far more difficult, permitted greater size while giving the artist more choice in design and proportion.

Hollow figures were formed in more or less the same manner as pots, with care that none of the solid parts should be too much thicker than the walls, which themselves were generally thinned slightly toward the top. All but the smallest hollow figures have perforations, which served as vents for the escape of moisture and air during drying and firing. Though usually placed inconspicuously, these perforations were sometimes used decoratively to emphasize the eyes or mouth (Numbers 15, 17–20, 27). Alternatively, a large opening might be left in the top of the head, so that the figure was in effect an effigy jar, the form that probably gave rise to hollow sculpture. As might be expected, the large figures have the same handsomely finished surfaces as contemporary pottery vessels, covered with polished slips in shades of red, buff, cream, gray, or black. Some are varied by contrasting areas left rough, cut away, or textured in various ways, or by paint added after firing.

In spite of a rather stiff formality, the hollow standing figures are impressive, not for size and technical excellence alone, but as sculptures. Unconcerned with naturalism, the artist simplified or omitted details and altered proportions to achieve a satisfying composition and to emphasize the head and face (Numbers 15–17).

Large seated figures, while equally impressive and in some cases superior technically to known standing examples, appear to be derived more directly from the naturalistic tradition of the Olmecs (Chapter 3), who occupied southern Veracruz and Tabasco in Middle Preclassic times. A possible transition can be traced among Central Mexican seated figures, from those very like the stylized, standing types to others in the purest Olmec style (one shown between the knees of the skeleton in Figure 2, and Numbers 18–20). Whether such a series represents change through a considerable time or a range of nearly contemporaneous types is not at all clear yet; even the well-studied Valley of Mexico continues to present archaeological surprises.

The Olmecs were the most advanced people of their time, and their pervasive influence is evident everywhere in the form of imported objects and borrowed stylistic elements and symbols. Something more than distant influence began to appear in Central Mexico with the discovery nearly forty years ago of extraordi-

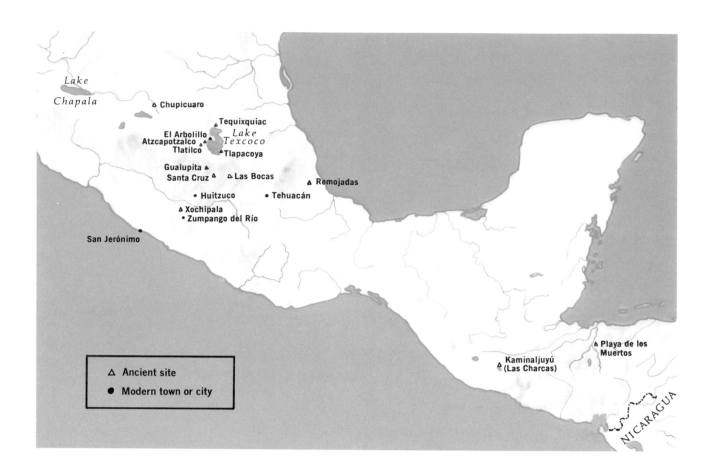

nary locally made Olmec ceramics at Gualupita, and then at Tlatilco, Tlapacoya, Las Bocas, and certain other sites that now appear to have been Olmec colonies. Their age remained uncertain because no such pottery had been made at any time in the other early villages on whose products the chronological sequence was based. New excavations at Tlapacoya, however, not only confirm that the colonies were as old as the southern Olmec centers, but also reveal, in a surprising subphase named Bomba, beginning about 975 B.C., that the purely Olmec pottery is even older there than the earliest known from the villages (Paul Tolstoy and Louise I. Paradis, "Early and Middle Preclassic Culture in the Basin of Mexico," *Science* 167, 1970, pp. 344–351).

Although the figurines once considered ancestral to all others in the Valley of Mexico (Number 1) thus appear to have lost that status, they and their descendants do not seem entirely Olmec-derived. The new chronological order still leaves room for another stylistic tradition, the expressionistic and less refined "folk art" strain formerly thought to have originated in the lakeside villages already excavated.

Two strains seem to merge in Middle Preclassic animal sculpture, which took the form of effigy jars and small flasks. Various birds and animals were so honored, and even turtles, frogs, and fish; no doubt they all had a place in village mythology. The jaguar, supreme symbol of Olmec religion, is not among them, though the

50

humble duck, a minor Olmec subject of unknown significance, is prominent and rendered in the finest wares (Numbers 23, 24).

After the Middle Preclassic, the art of ceramic sculpture declined from its first peak of excellence in Central Mexico, but in the region of Chupícuaro, northwest of the valley, much of the old tradition was preserved, and a new decorative technique added (Numbers 27, 28). Hollow figures, effigy jars, and other vessels produced there are among the first polychrome ceramics. Glossy red clay slip, formerly used to cover an entire surface, was applied as ceramic paint over white slip to create large-scale angular patterns, which were then outlined and elaborated by linear painting in black. Modeled figurines without this new paint were decorated in the customary way after firing. The most attractive type of their time, they were traded to the villages and larger towns growing up around Lake Texcoco. Farther west, in Colima, Jalisco, and Nayarit, still other styles of hollow sculpture and small unslipped figures carried on the Preclassic tradition (Chapter 5).

In many parts of Middle America the ancient figurine cult continued, more variations being produced than might seem possible in simply modeling the human figure in miniature. In some places the tradition was interrupted, as in the Maya region during the Late Preclassic period, only to reappear in new styles and with new uses, notably as whistles or rattles. In other areas, such as Central Mexico and Veracruz, one type followed another in unbroken succession up to the Conquest. Though the figurines were apparently more an art of the people than of the formal religions, all the grander forms that clay sculpture achieved can be traced back ultimately to the first crude clay figures that are almost as old as the remains of the first villages.

1 Figurine with baby

Buff clay with traces of red and white pigment
Height: 6⅞ in. (17.5 cm.)
Tlatilco, state of Mexico
Middle Preclassic, 1150–550 B.C.
Museo Nacional de Antropología, Mexico, 1–2465

The practiced hand of the early potter, working with bits
of clay and a punch tool, shows clearly in this figurine.
Its short "flipper" arms with wide fingers divided by
pressed lines, its tall head, and its headdress made of
fillets and pellets are characteristic of the type designated
C-1. To form the eyes, the potter stuck pellets onto the
head mass and then tooled indentations at each side,
deftly creating a highlight in the center.

2 Figurine

Polished buff clay with pale yellow and red paint
Height: 3¾ in. (9.5 cm.)
Tlatilco, state of Mexico
Middle Preclassic, 1150–550 B.C.
Mr. and Mrs. Jan Mitchell, New York

Type D-1 figurines from Tlatilco are the most delicate
and beautifully made of all. Though uniformly stylized,
they are never perfunctory, but finished back and front
and covered with a fine slip. Predominantly female, in
fact very feminine, they display a variety of hair and
headdress styles, in this case a filleted and tasseled cap
with long streamers over finely combed hair done with a
short pigtail in back and a curl over the forehead to break
the symmetry. The hair, ear ornaments, and patterns
painted on the face and body are red.

3 Masked male figurine

Polished buff clay with yellow and red pigment
Height: 3¾ in. (9.6 cm.)
Tlatilco, state of Mexico
Middle Preclassic, 1150–550 B.C.
Museo Nacional de Antropología, Mexico, 1–2169

The face is partly covered by a small mask with tiny ears,
like the real mask (Number 4), the square chin showing
below it. This figurine was found in a tomb with a simi-
larly dressed and masked figurine, accompanied by two
figurines of fat dwarves, possibly depicting shamans
with their helpers (Román Piña Chán, *Las culturas pre-
clásicas de la cuenca de México*, Mexico City, 1955, pp.
60, 73, figs. 9, 11, pl. 17; Miguel Covarrubias, *Indian Art
of Mexico and Central America*, New York, 1957, pp. 25,
26, fig. 6).

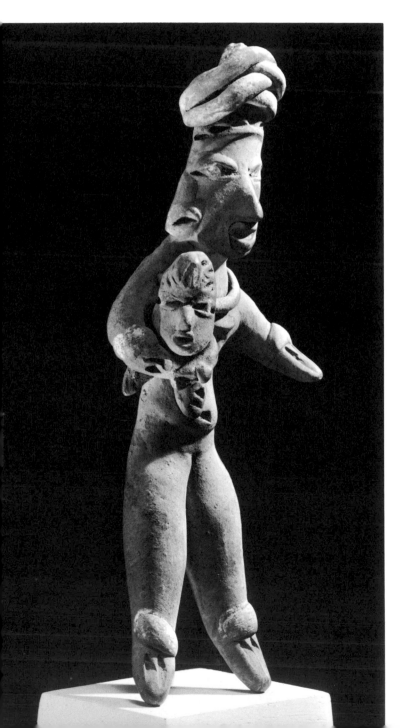

4 Face mask

Buff clay with white pigment
Height: 5⅞ in. (15 cm.)
Tlatilco, state of Mexico
Middle Preclassic, probably before 550 B.C.
Museo Nacional de Antropología, Mexico, 1–2696

The open eyes and attachment holes at the edge of the
mask imply that it was intended for actual use, worn as
on Number 3. Possibly it served in impersonations of the
Olmec man-jaguar (Chapter 3); the proportions and the
configurations of the eyes and brow are Olmec, though
the fangs appear more crocodilian than feline.

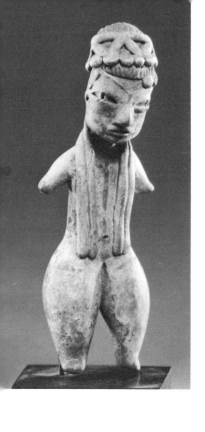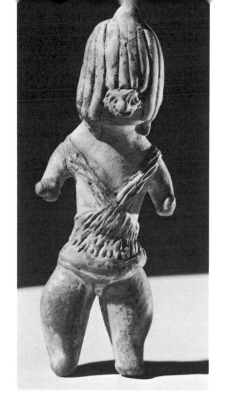

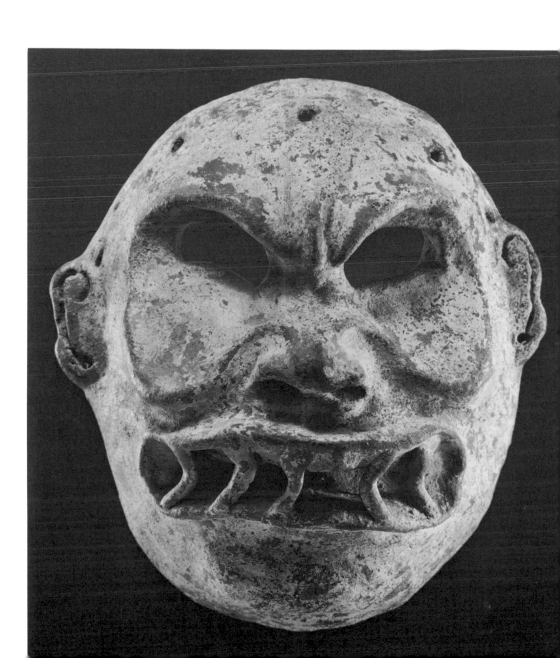

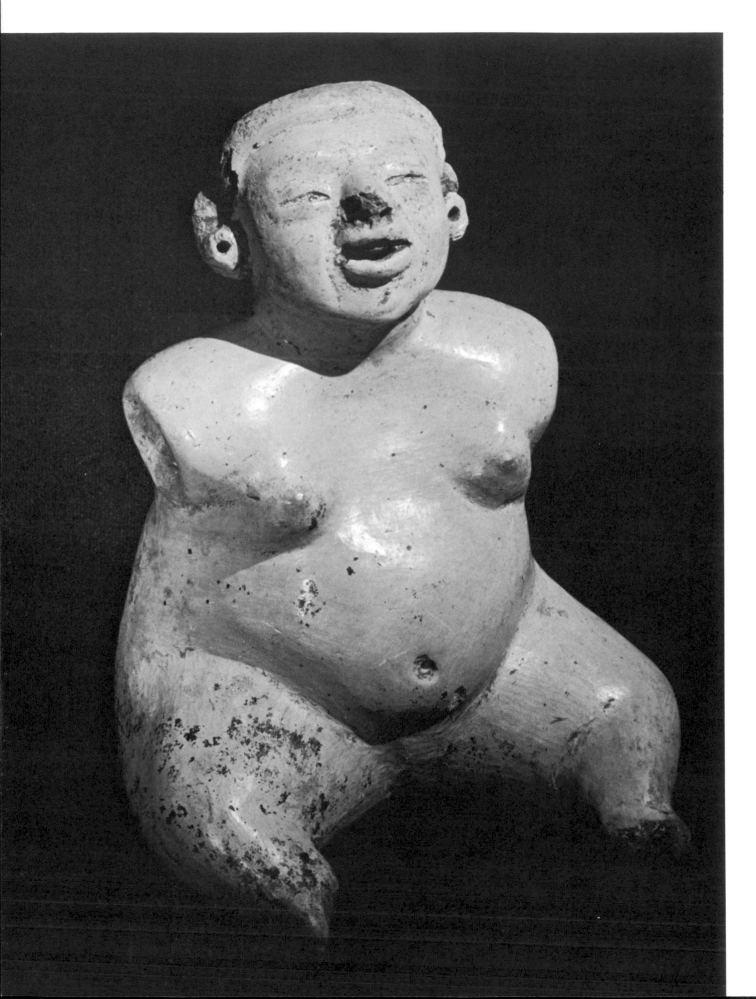

5 Seated figurine

Buff clay with polished white slip
Height: 6 in. (15 cm.)
Kaminaljuyú, Guatemala
Middle Preclassic, Las Charcas phase, 1000–550 B.C.
The University Museum, Philadelphia, 53.38.1

This lively, naturalistic figure shows Olmec derivation in its white slip, fleshy torso, and cross-legged seated posture. The face, however, retains a local flavor, with the filleted and punched features softened by further modeling (Alfred V. Kidder, "Preclassic Pottery Figurines of the Guatemalan Highlands," *Handbook of Middle American Indians*, ed. Robert Wauchope, II, Austin, 1965, pp. 146–155; app., fig. 1 c).

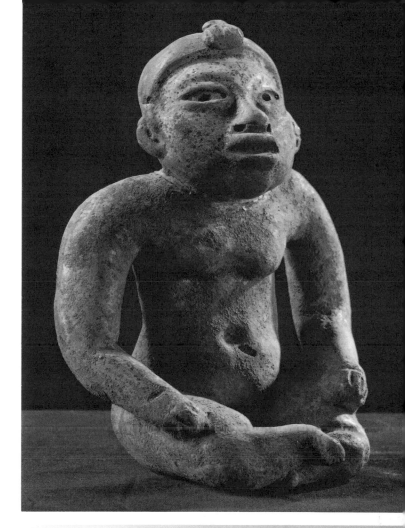

6 "Muñeca Kidder"

Buff clay with white slip
Height: 9 in. (23 cm.)
Kaminaljuyú, Guatemala
Middle Preclassic, Las Charcas phase, 1000–550 B.C.
Museo Nacional de Arqueología y Etnología, Guatemala, 4469

Discovered by construction workmen in suburban Guatemala City, the "doll" was acquired for the Museo by S. W. Miles and Joya Hairs, in memory of Alfred V. Kidder. It is extraordinary both for its size and for its empty arm sockets that are perforated for the cord by which separately made arms were attached. Articulated clay figures appeared later in the Teotihuacán style and in the Remojadas style of Veracruz (Number 132), and this one demonstrates that the idea was probably much older in both areas. Though adult and female, it recalls the hollow Olmec "babies" (Numbers 19, 20), and also a male stone statue with sockets for arms adjustable to different positions (Michael D. Coe, *America's First Civilization*, New York, 1968, p. 83).

7 Seated figure

Buff clay with burnished orange slip
Height: 7 in. (18 cm.)
Nicaragua
Protoclassic, 100 B.C.–A.D. 250
Museo Nazionale Preistorico ed Etnografico Luigi
 Pigorini, Rome

Although the reddish orange slip and distinctive nose form, with deeply indented nostrils, relate this piece to the Arenal-phase figurines of highland Guatemala, its other features are characteristically Nicaraguan. The unusually large head, firmly seated position, and proud bearing give it a commanding presence.

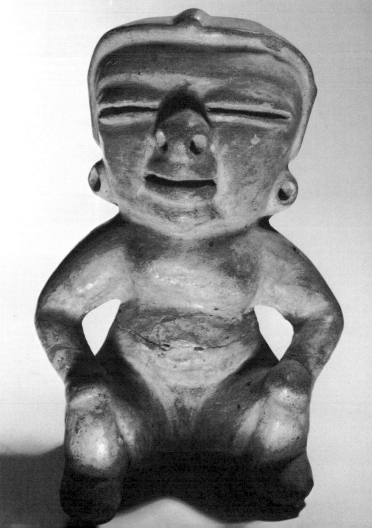

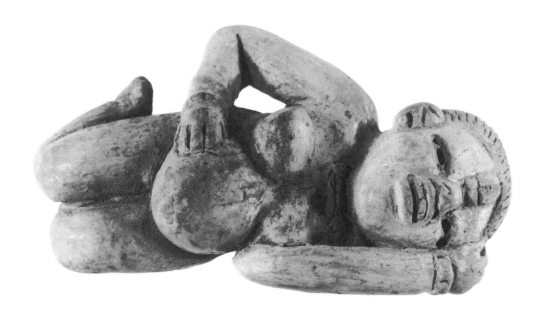

8 Reclining figurine

Buff orange clay with cream slip
Length: 4⅛ in. (10.5 cm.)
Playa de los Muertos, Ulua Valley, Honduras
Middle or Late Preclassic, 1150–100 B.C.
Peabody Museum of Archaeology and Ethnology, Harvard
 University, Cambridge, Massachusetts, C/10961

9 Figurine leaning on pillow

Orange buff clay with burnished cream slip and red
 pigment
Length: 3½ in. (8.8 cm.)
Central Mexico
Middle Preclassic, 1150–550 B.C.
Mr. and Mrs. Paul Tishman, New York

10 Reclining figure

Brownish clay with traces of red pigment and white slip
 or paint
Length: 8½ in. (21.5 cm.)
Central Mexico
Middle Preclassic, 1150–550 B.C.
Dr. and Mrs. Milton Arno Leof, Mexico City

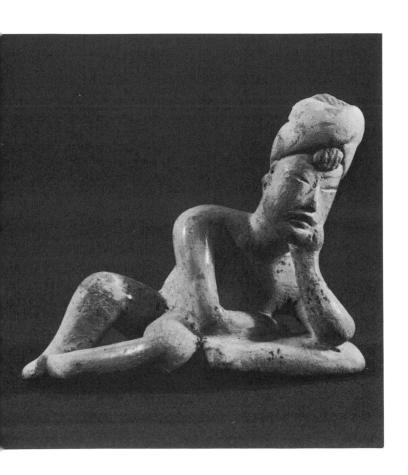

The seemingly casual poses assumed by these rare reclining figurines probably had a specific meaning. Though such a position, with hand to head, might appear only a random variation when rendered in clay, it is represented by at least five figure pendants carved of jade (Number 11). It may have implied a trancelike state produced by hallucinogenic mushrooms or other substances. The antiquity of this cult is documented by carved mushroom stones (Numbers 63, 64) and hollow pottery mushrooms that have been found from Tlatilco to El Salvador.

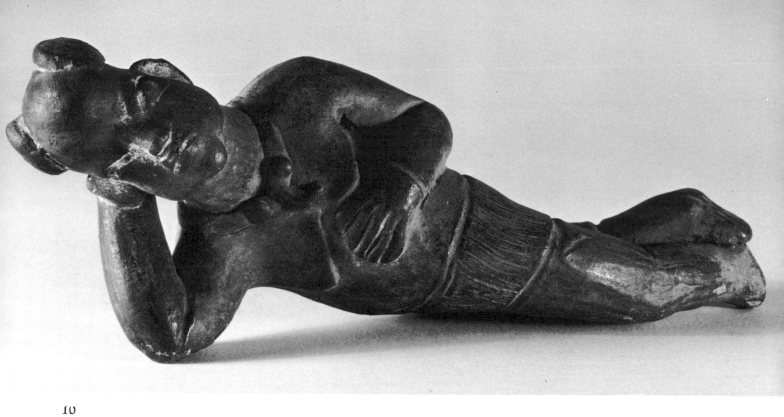

10

11 Reclining figure pendant

Pale blue green Jadeite
Length: 3⅞ in. (9.8 cm.)
San Jerónimo, Guerrero, Mexico
Middle Preclassic, 1150–550 B.C.
The American Museum of Natural History, New York,
 30.2/3456

Olmec figurines carved of stone usually stand or sit, and
with only a few exceptions they are freestanding minia-
ture sculptures, not pendants. This one is perforated at
the neck and hip to hang horizontally, as do the typical
clamshell and spoonlike pendants. The nasal septum and
earlobes are pierced also, and the openings that free the
limbs from the body are cut out by drilling and string-
sawing.

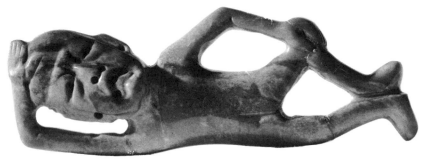

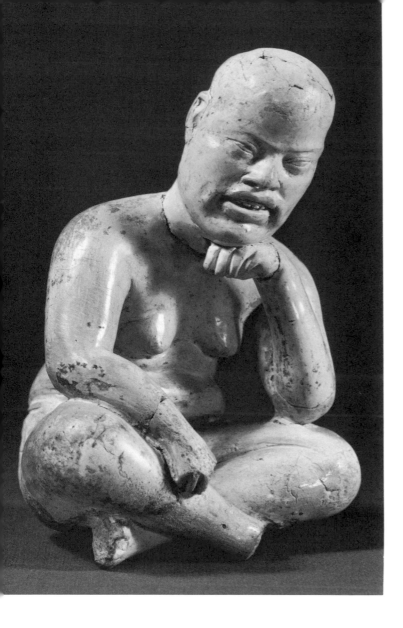

12 Seated figure

Polished white-slipped pottery with traces of red
 pigment
Height: 5⅛ in. (13 cm.)
Las Bocas, Puebla, Mexico
Middle Preclassic, 1150–550 B.C.
Dr. and Mrs. Josué Sáenz, Mexico City

Large for a figure of solid clay, but small for a sculpture
of such realistic expressiveness, this benignly contempla-
tive personage refuses to be categorized in any of the
recognized types. One other very beautiful figure of simi-
lar style from Tlapacoya resembles this one in the sense
that they both give the impression of being strongly in-
dividualized portraits (Michael D. Coe, *The Jaguar's
Children*, New York, 1965, no. 190).

13 Helmeted figurine

Sandy buff clay with red pigment
Height: 6¾ in. (17 cm.)
Xochipala, Guerrero, Mexico
Preclassic, 1150–100 B.C.
Dr. and Mrs. Milton Arno Leof, Mexico City

Vigorous and naturalistically proportioned, this figure
has Olmec facial features, delicately modeled within the
round helmet. His strange animal feet and a "tail" hang-
ing from his elaborate belt indicate that he may be cos-
tumed as a jaguar for some dance or ceremony.

14 Seated figurine

Buff clay with traces of red and yellow pigment
Height: 4 in. (10.3 cm.)
Xochipala, Guerrero, Mexico
Preclassic, 1150–100 B.C. (?)
Dr. and Mrs. Josué Sáenz, Mexico City

Though from the same locality as Number 13 and similar
in technique and realism of portrayal, this casual lady
does not look at all Olmec. The fringed wraparound skirt
and shoulder cape would have been stylish in Veracruz
on a figure of the Protoclassic Remojadas style (Chapter
7). The Xochipala figurines, of unknown age, seem to
represent a local style related more closely to Olmec
canons of naturalism than to the more expressionistic
conventions of Central Mexico.

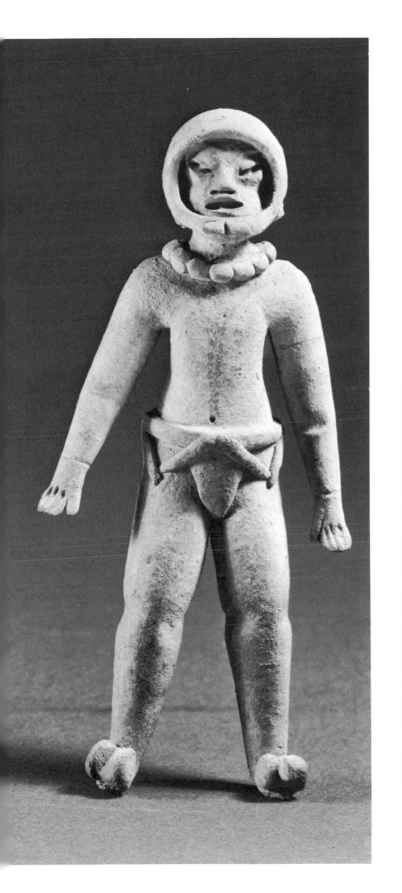
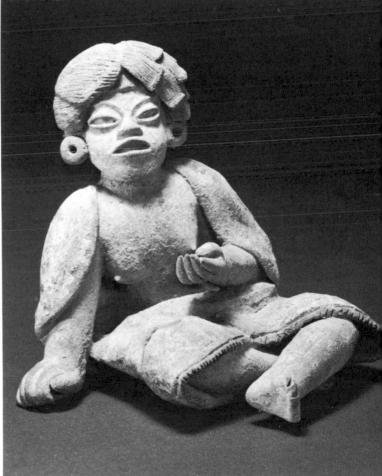

15 Standing figurine

Sandy buff clay with red and white pigment
Height: 13⅜ in. (34 cm.)
Xochipala, Guerrero, Mexico
Preclassic, 1150–100 B.C. (?)
Dr. and Mrs. Milton Arno Leof, Mexico City

The chubby childlike figure is hollow, with open mouth, perforations at the temples, and a slit in the head reminiscent of that in a piggy bank. The face, though babyish, is not Olmec but realistic, as in Number 14, while the helmet and suggested ligatures above the knees are unusual elements shared with Number 13. All three are from ruins near Xochipala, at the center of the region famous for Mezcala stone sculpture (Chapter 5), but still almost unknown archaeologically.

16 Standing figure

Orange buff pottery with burnished red slip and red,
 white, and yellow pigment
Height: 13½ in. (34.2 cm.)
Tlatilco, state of Mexico
Middle Preclassic, 1150–550 B.C.
Museo Nacional de Antropología, Mexico (field
 identification: IV Cala XLIX Obj. 11)

Standing firmly on stumpy feet that are open at the bottom, this large, hollow figure is stiffly symmetrical, as are others of its type (known as D-3), but most effective as a sculpture; the concave, shield-shaped face is tilted slightly upward, its lines emphasized by the tall, curving earbars and repeated by the inward slope above the abdomen and that of the arms. The figure was discovered face down in a burial offering in the huge and richly stocked ancient cemetery used by an Olmecoid settlement (Arturo Romano, "Exploraciones en Tlatilco," *Boletín del Instituto Nacional de Antropología e Historia* 14, 1963, pl. 20).

17 Standing figure

Orange buff clay with burnished red-washed surface
Height: 21⅝ in. (55 cm.)
Santa Cruz, Morelos, Mexico
Middle Preclassic, 1150–550 B.C.
Dr. and Mrs. Milton Arno Leof, Mexico City

Vent holes for the firing of this astonishingly large figure are placed in the navel, in the eyes, and at three points across the back. For balance, the stubby feet have heels projecting as far behind the legs as the toes project in front. The boldly abstract two-plane decoration of the headdress, which recalls Olmecoid roller-stamp patterns known from Tlatilco, was emphasized by leaving the higher headdress surface unburnished and uncolored, as are the depressed surfaces of the eyes and mouth as well. (See Color Illustration.)

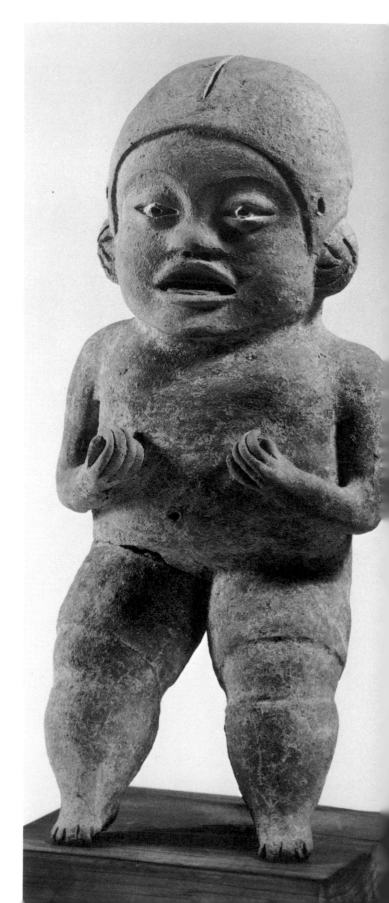

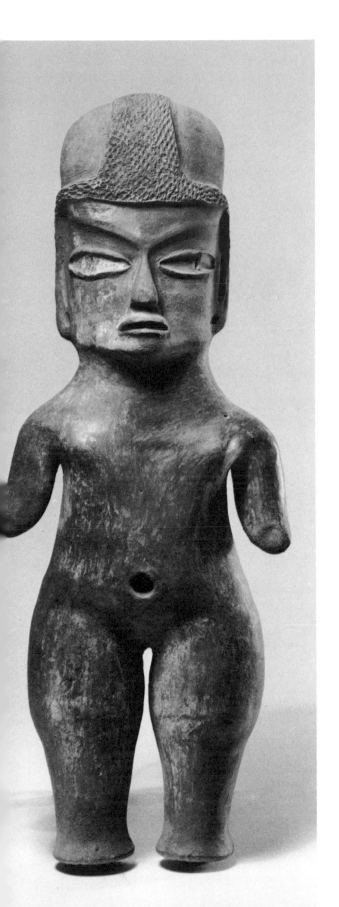
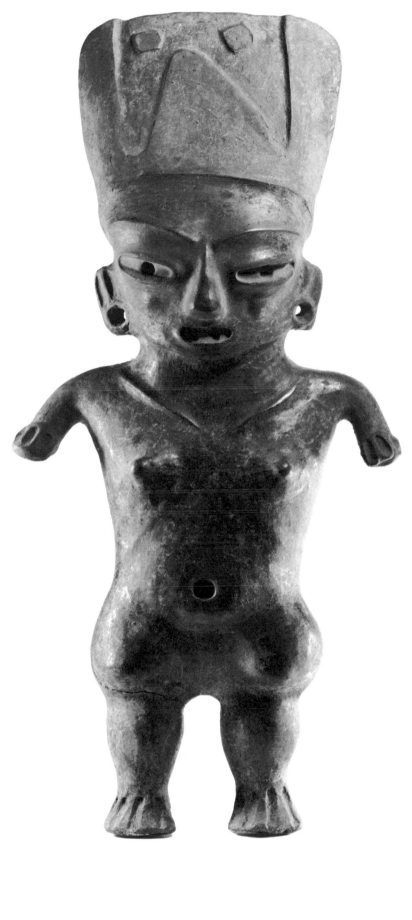

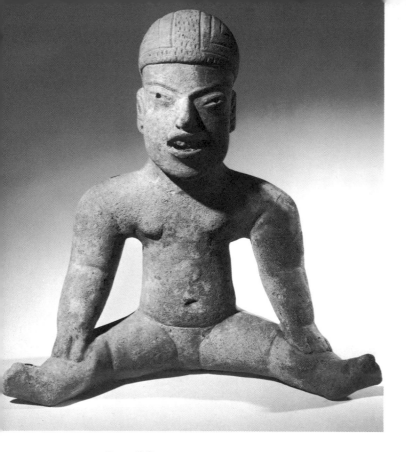

18 Seated figure

Yellowish clay with remains of buff slip
Height: 14½ in. (37 cm.)
Central Mexico
Middle Preclassic, 1150–550 B.C.
Millard Sheets, Claremont, California

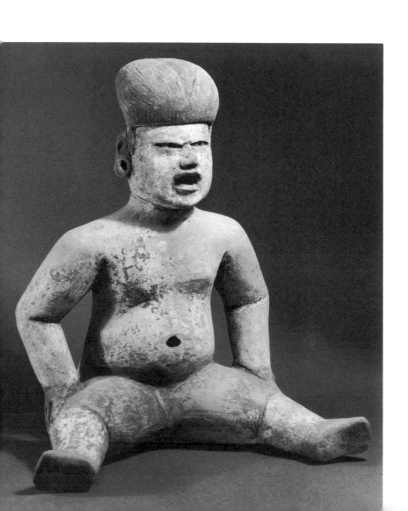

Emphatically geometric yet full of life, this figure seems to hold his pose with the disciplined energy of a dancer or acrobat. Though obviously related to Olmecoid childish figures (Numbers 19, 20), he has nothing soft or infantile about him, but rather the stylized quality seen in Number 16. The open mouth with slightly extended lower jaw, which gives the impression of speech, served as one of the technically necessary openings; others are incorporated in the eyes and the incised and textured pattern of the cap.

19 Seated child

Pale orange clay with eroded ivory slip and red pigment
Height: 13¼ in. (33.7 cm.)
Central Mexico, possibly Tlatilco
Middle Preclassic, 1150–550 B.C.
Dr. and Mrs. Josué Sáenz, Mexico City

As animated as Number 18, but more realistically proportioned, this figure is stylized in a different spirit, emphasizing the characteristically Olmec head deformation. The mystifying cleft head of the jaguar-children, seen in Olmec sculpture, lapidary work, and incised representations (Chapter 3), was clearly indicated here by a smooth-surfaced V shape, painted red, cut in the textured un-slipped surface of the head or cap. The earlobes are pierced for added ornaments, and the hollow body is perforated at the navel, at the back of the shoulders and head, and at the mouth. (See Color Illustration.)

20 Seated baby

Buff orange clay with polished cream slip and red
 pigment
Height: 13 in. (33 cm.)
Reportedly from Zumpango del Río, Guerrero, Mexico
Middle Preclassic, 1150–550 B.C.
Dr. and Mrs. Josué Sáenz, Mexico City

The Olmec presence in Central Mexico is most clearly evident in magnificent hollow figures that depict the child or dwarf deity seen so often in the art of the Olmec heartland in southern Veracruz and Tabasco. They are strikingly naturalistic (if the term can be applied to portrayals of a supernatural being), beautifully made, and finished in a fine polished cream or buff slip. Almost all are seated with the legs apart and lack any indication of sex, clothing, or jewelry, except for ear ornaments and headgear. The head of this one has cross-shaped perforations within an incised pattern that traces a zigzag across the brow and a cleft trapezoidal shape on the back of the rounded head. A close counterpart of this figure is in The Museum of Primitive Art, New York (Michael D. Coe, *The Jaguar's Children*, New York, 1965, no. 184).

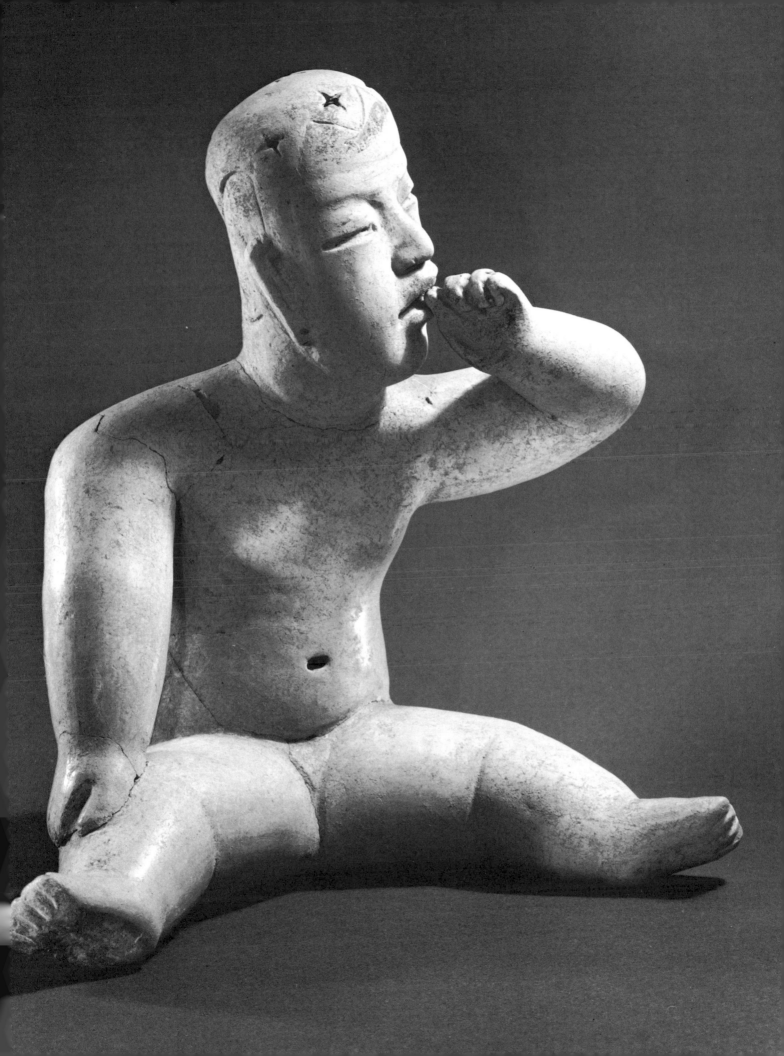

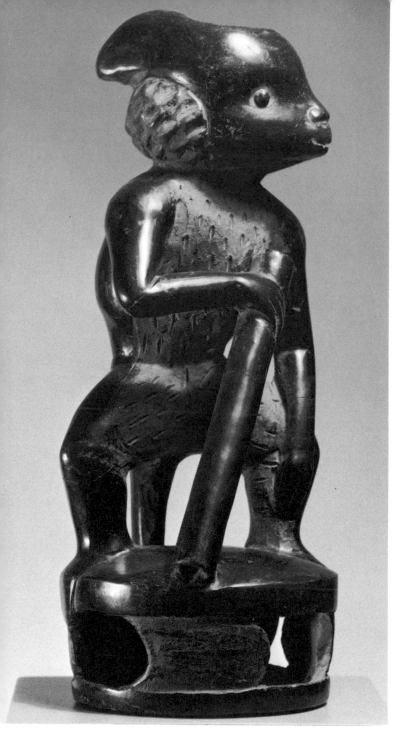

which curls against the base to give added support. The lustrous black surfaces contrast with sections of the base, the front of the body, and the ear ornaments, which were left rough and painted red. The monkey, known in a few Olmec works (Number 47) and many later ones, seems to be represented in anthropomorphic form here, with a belt in back and ear ornaments.

22 Opossum on squash

Polished black pottery
Height: 4¾ in. (12 cm.)
Las Bocas, Puebla, Mexico
Middle Preclassic, 1150–550 B.C.
Dr. and Mrs. Josué Sáenz, Mexico City

With graceful realism, this small flask celebrates one of the most ancient cultivated plants together with an animal associated, at least in later times, with the earth's fertility. The front of its body has the same textured matte surface as that of Number 21.

23 Duck

Burnished black-slipped pottery
Height: 8⅝ in. (22 cm.)
Tlatilco, state of Mexico
Middle Preclassic, 1150–550 B.C.
Museo Nacional de Antropología, Mexico, 1–2518

Certain other blackware duck vessels are richly decorated or realistically detailed, but none has such simple elegance as this. The duck was also accorded special treatment by the Olmecs of Veracruz, who carved duck-head pendants from jade of the highest quality (Numbers 48–50).

22

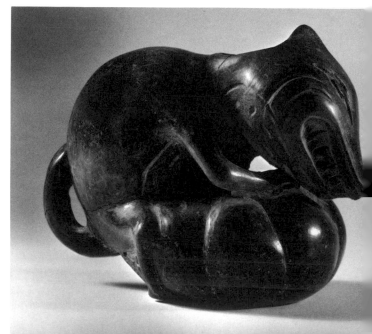

21 Monkey (?)

Blackware with red pigment
Height: 10⅝ in. (27 cm.)
Las Bocas, Puebla, Mexico
Middle Preclassic, 1150–550 B.C.
Dr. and Mrs. Josué Sáenz, Mexico City

Standing so casually on his openwork base, the creature is a masterpiece of the potter's craft. The hollow figure, an effigy vessel opening at the top of the head, is supported ingeniously by the legs, the staff, and the tail,

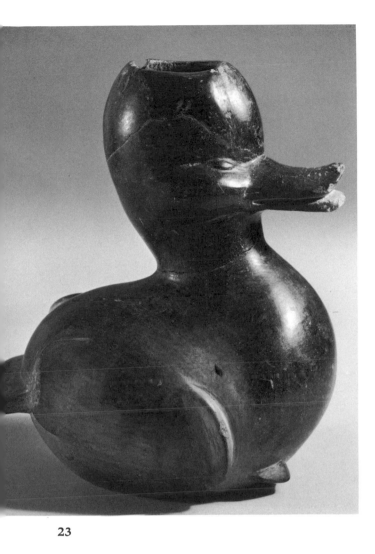

24 Duck

Polished pearl gray surface with resist decoration
Height: 4⅝ in. (11.8 cm.)
Tlapacoya, state of Mexico
Middle Preclassic, 1150–550 B.C.
Dr. and Mrs. Milton Arno Leof, Mexico City

Stylized so that it is a less forbidding bird than Number 23, this one is extraordinary for its resist decoration, a technique rarely seen on effigies. Though formerly thought to be a Late Preclassic introduction, it appears on still undated bowls incised with Olmec profile faces, on flat-based dishes also found at Tlapacoya (Muriel Porter Weaver, *Tlapacoya Pottery in the Museum Collection,* Indian Notes and Monographs, misc. ser. 56, New York, 1967), and on recently discovered gray-paste whiteware sherds from the earliest levels at the site, predating 950 B.C. The technique consists of painting the pattern on the already-fired surface in a material such as slip or wax that protects it from a color applied over it (in this case, black). When the resistant material is removed, the pattern appears in the original color. (See Color Illustration.)

25 Laughing peccary pot

Buff orange pottery with red-on-cream slip decoration
Height: 4¼ in. (10.7 cm.)
Atzapotzalco, Federal District, Mexico
Late Preclassic, Patlachique phase (Proto-Teotihuacán)
 100–1 B.C.
Museo Nacional de Antropología, Mexico, 9–3068

Sherds of the same kind of pottery, decorated in red with incised outlines and cross-hatching, were found scattered through the earth in the Pyramid of the Sun at Teotihuacán (Figure 17), and at other settlements that predate the city's phenomenal growth. This amusing effigy has more verve than the handsome but rather stereotyped ceremonial wares of later times.

23

24

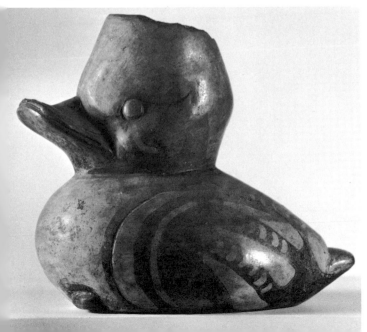

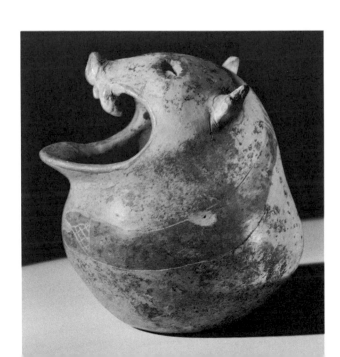

27 Standing figure

Buff clay with polished red slip on white, overpainted in
 black
Height: 19¼ in. (49 cm.)
Chupícuaro (?), Guanajuato, Mexico
Late Preclassic, 550–100 B.C.
Dr. and Mrs. Josué Sáenz, Mexico City

After the Lerma River was dammed, inundating the type
site, fine ceramics of the same style appeared in other
localities, including figures even larger than had been
known before. This giant has, like others of its kind, a
tall rectangular head, creased up the center and curved
backward, emphasizing the facial features. The back,
finished as handsomely as the front, is decorated with the
customary stepped X pattern in black-edged white and
with a black rectangle at the base of the concave head.

28 Standing figurine

Buff clay with polished red slip on white, overpainted in
 black
Height: 4 in. (10 cm.)
Provenance unknown
Late Preclassic, 550–100 B.C.
Mr. and Mrs. Dudley T. Easby, Jr. New York

Each slip-painted Chupícuaro miniature, down to an inch
in height, displays all the standard technical and decora-
tive elements there was room for. Made in the same size
range as the freely modeled unslipped figurines, they are
clearly the work of a different group of potters.

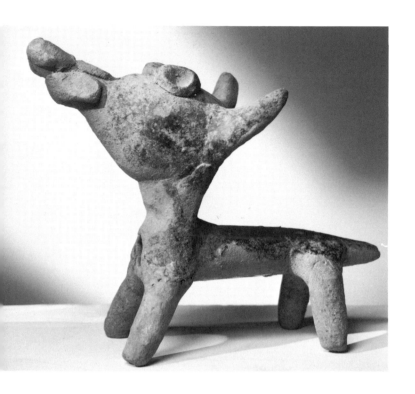

26 Coyote

Buff orange clay with black asphalt paint
Length: 6½ in. (16.5 cm.)
Reported to be from Remojadas, Veracruz, Mexico
Protoclassic, 100 B.C.–A.D. 250 (?)
Milwaukee Public Museum, 52947/18696

Though there are other vigorous animals of this same
breed, all very much alike, each has the air of being an
inspired improvisation that brought the clay to life and
caught the very essence of the subject. The shiny black
paint applied casually over the back and face adds to the
impression of vitality and naturalness. Formed with ad-
mirable economy, the head is simply a hollow cone left
open in back and attached to the solid body.

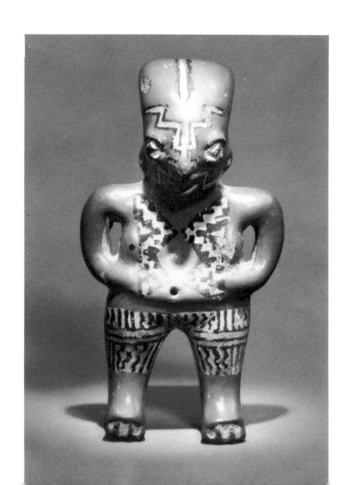

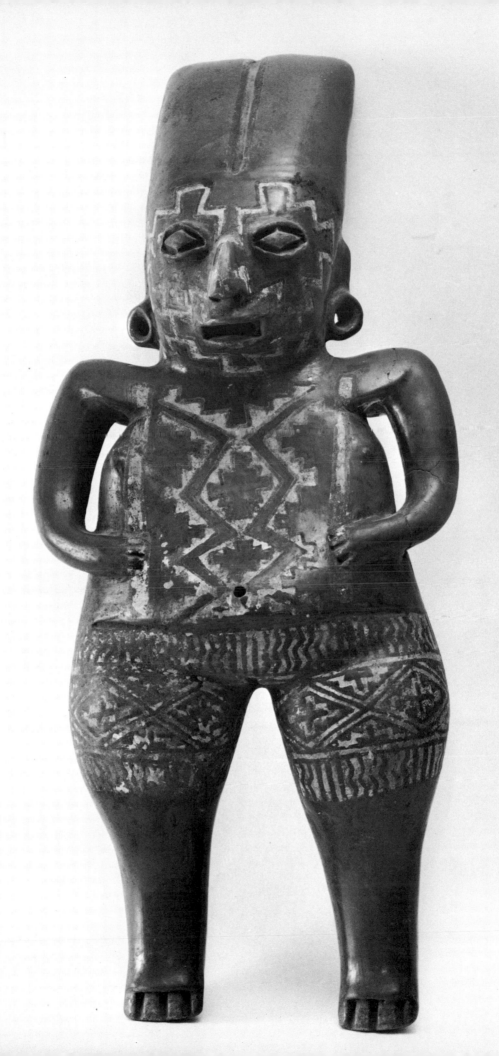

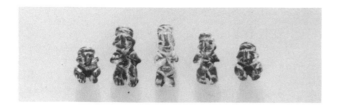

29 Miniature figurine beads

Reddish brown clay
Height: ⅜ to ⅝ in. (1 to 1.7 cm.)
Lake Chapala region, Jalisco, Mexico
Late Preclassic, 550–100 B.C. (?)
A: Mr. and Mrs. Dudley T. Easby, Jr., New York; B–D:
The American Museum of Natural History, New York,
30.3/129a–c; E: Joseph V. Noble, Maplewood, New
Jersey

Found in matching groups, these tiny modeled figurines
are pierced through the head for stringing, and the seated
ones are also pierced between arms and body. Each wears
a twisted turban, and the tallest even shows the odd fold
across the lower abdomen that is often seen on larger
figures from the region between Chapala and Chupícuaro
(Numbers 27, 28).

30 Female figurine

Yellow orange clay
Height: 6¾ in. (17 cm.)
San Jerónimo, Guerrero, Mexico
Preclassic, 1150–100 B.C.
Museo Nacional de Antropología, Mexico
Ex coll. Miguel Covarrubias

Not closely related to Central Mexican types, figurines
from the Pacific coast west of Acapulco are characterized
by elegantly elongated heads, matte surfaces, and deco-
ration that depends primarily on textured areas and pits
punched into the wet clay.

31 Standing figure

Coarse orange clay with grayish surface
Height: 15¾ in. (40 cm.)
Xalitla, Guerrero, Mexico
Probably Late Preclassic, 350 B.C.–A.D. 250
Dr. and Mrs. Josué Sáenz, Mexico City

Figures of this peculiarly dramatic type have also been
found, sometimes in large groups, at Huitzuco and Tlax-
malac, northwest of Mezcala. The long vertical gash on
the torso, which accounts for the common name "Caesa-
rean figure," probably represents decorative mutilation,
accentuated by artistic license. While the pattern of small
pellets on each shoulder may connect this type to the
early flat-figure style of Colima, its age has not been es-
tablished (André Emmerich, *Art Before Columbus*, New
York, 1963, pp. 48, 49).

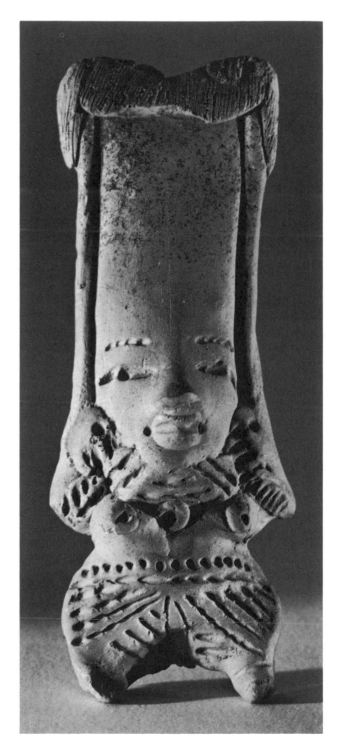

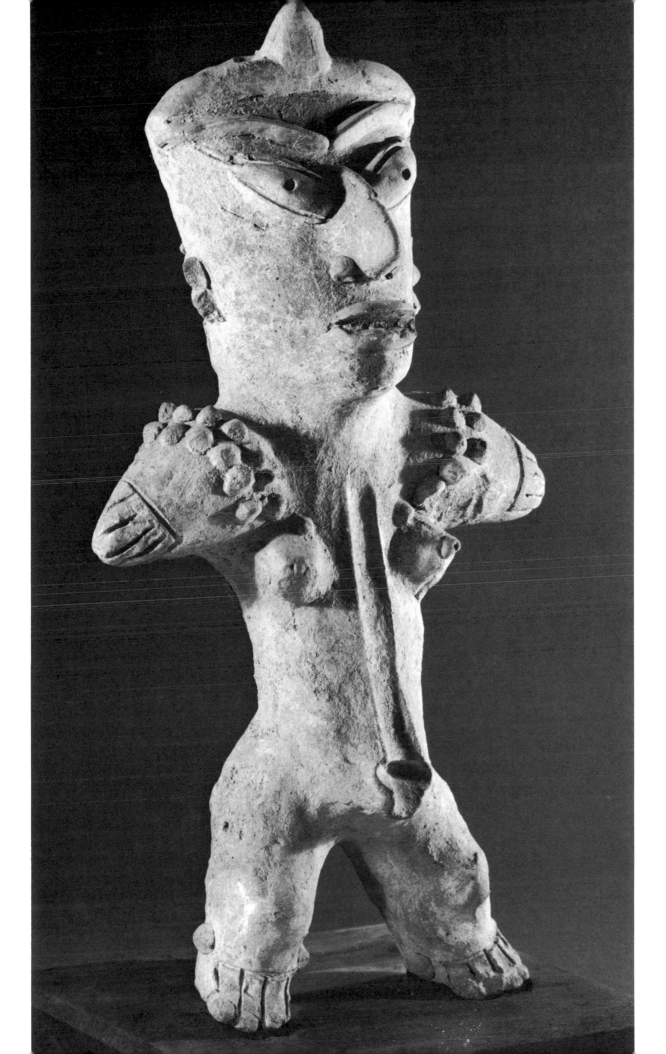

FIGURE 3

Colossal head (Monument 1 from La Venta)

Though superficially alike, the monolithic heads appear to be idealized portraits, differing subtly in facial proportions, expression, and the motifs carved on their great round helmets (here, the jaguar paw print that was later to become an emblem of the deity called Tlaloc, seen in Numbers 109 and 111). Heads at La Venta and Tres Zapotes were found facing outward at the bases of mounds, an arrangement observed later in the placement of Maya stelae that portray rulers. (C. William Clewlow et al., *Colossal Heads of the Olmec Culture,* Contributions of the University of California Research Facility 4, Berkeley, 1967). This head, nearly eight feet high, was transported some years ago with other large sculptures from the site, which is dated 1000–600 B.C., to the Parque La Venta, Villahermosa, Tabasco.

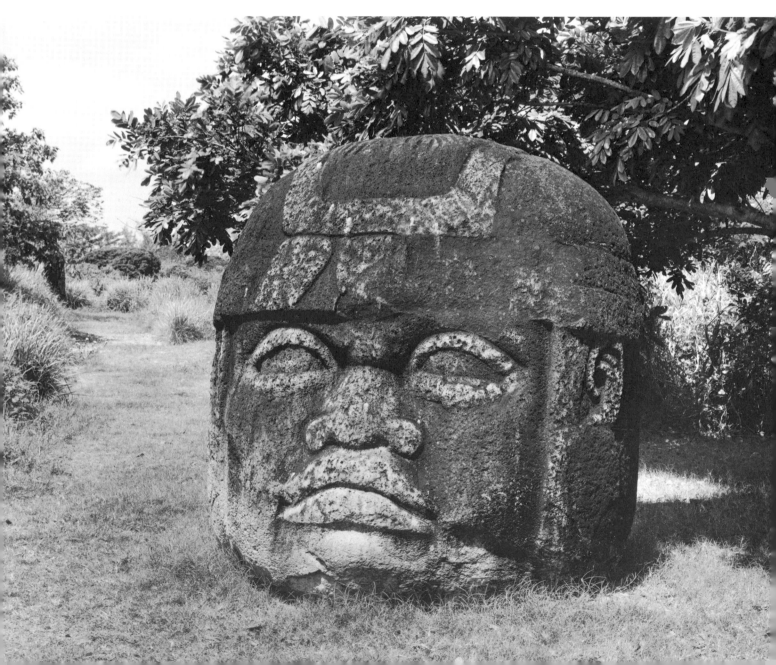

3

Olmec Leaders, Sculptors, and Lapidaries

Most archaeologists would probably admit that even to them the Olmec civilization seems as remote and monolithic as the great stone heads that are its most impressive monuments (Figure 3). One of these enormous sculptures was discovered just above the Isthmus of Tehuantepec in 1862. Though a drawing of it was published a few years later, it dropped from scientific attention while the yet unnamed culture that had produced it began slowly, as decades went by, to be recognized as the source of certain exquisitely carved jades and as a sort of mysterious presence far in the past that made itself felt in early ceramics all over Middle America. During the last thirty years excavations at several sites in the lowlands along the gulf coast of the isthmus and into eastern Veracruz have revealed about twenty heads and many smaller sculptures as well as offerings of magnificent jades in the same monumental style. The best-known sites, near the small towns of La Venta, Tres Zapotes, and San Lorenzo, are the remains of great ceremonial precincts with man-made terraces and building platforms of startling size and age. Dates that at first seemed unreasonably early now appear, after more digging and radiocarbon determinations, not early enough. As the dates assigned to the Olmec culture thus receded through the first millennium B.C., the term *Archaic Period* went out of favor, to be followed by *Formative* and *Preclassic,* used in a specialized sense but nevertheless quaint when applied to the perplexing achievements of the Olmecs. Though remarkably little is yet known about them and their contemporaries, there is no doubt that their monuments mark the beginning of civilization in Middle America.

Whether in basalt or jade, the Olmec style has a deceptive simplicity. Its apparent naturalism appeals immediately to the eye but soon troubles the mind with a disquieting sense of meaning not understood. Any of the colossal heads would have this effect because of its size alone. Who can help wondering whether Olmec sculptors humanized their god into this brooding but beneficent form, or whether

they served rulers who were American counterparts of Rameses the Great? (His grandiose portraits may have been staring out over the Nile for less than a century when the first huge head was carved at San Lorenzo.) Precious material lends mystery to some of the small carvings. The "crying baby" (Number 40) expresses vividly the breathless fury that every parent, aunt, and uncle can recognize instantly, even when portrayed in deep green jade. Yet why should so familiar a moment be memorialized in so beautiful and valuable a stone? In spite of its obvious charm, the little figure is wholly unbelievable as an ancient example of the gilded-baby-shoe custom.

The enigmatic quality of sculptures in unremarkable materials and sizes may become apparent only when a single one that seemed perfectly comprehensible, taken at face value, is compared with others of its class. A natural-looking pose takes on significance as something more than a casual choice of the sculptor, for example, when one realizes that only a very few poses are ever represented. Similarly, a face with the open trapezoidal mouth often seen in Olmec art no longer looks merely babyish after comparison with faces in which the same kind of mouth reveals fangs.

The impact of ancient Olmec art upon the modern beholder, nevertheless, is not entirely a matter of size, preciousness, or mystery. It comes also from a persuasively literal mode of symbolization. Realistic human and animal elements are often joined together in a single figure, but with such grace and assurance that the unreal seems believable. The style seems to convey the artist's conviction in every form and line, giving a forcefulness that is moving but at the same time obscure.

The conspicuous symbolic figure in Olmec art is the jaguar. Yet this is not to say that the actual animal was held sacred, for it was seldom portrayed without human characteristics. The man-jaguar concept permeates Olmec art, and appears in contemporaneous and later styles as well, usually in less explicit form. It was current at the time of the Conquest and survives to the present day in endless variation. The extraordinary vitality of this concept offers valuable aid toward understanding the original nature of Olmec religion, but little prospect of a clear or simple interpretation.

Belief in a deity with the form or attributes of the jaguar, symbolic of power and life force, may have existed in pre-Olmec times; such a belief is reflected in the Chavín art of Peru and the Shang of China, suggesting a common origin that was more ancient than the early art styles in which it first appears in each of these widely separated parts of the world. This ancient god may have become to the Olmec one of several manifestations of a supreme deity. Jaguar attributes were employed seemingly as symbols of divinity. They appear in a bewildering variety of composite figures that vary too much to be clearly identifiable as distinct gods in a pantheon, and on figures that are hard to view as deities at all. Many of these figures have no jaguar traits, but appear entirely human, and wear or carry jaguar insignia, such as the paws and paw prints sometimes carved on the helmets of colossal heads (Figure 3).

Sculptures that depict more than one figure or face offer the best hope of understanding how the various types of representations are related, but they are rare.

Clearly differentiated faces are shown one above the other in Figure 5. The face of the half-kneeling figure, though damaged now, was relatively naturalistic, contrasting as strongly as aesthetic harmony permits with the larger face above. Its huge trapezoidal mouth, its broad nose, its slanting almond eyes, and the V-shaped cleft in the forehead are features that seem to characterize the supernatural jaguar, here represented clearly as a mask attached to an elaborate helmetlike headdress. The figure wearing it is probably not another deity, but a human being considered to have divine power; temporal power as well is implied by his portrayal on such an imposing monument. Mask headdresses continued to appear, often in the form of a jaguar or jaguar-serpent head (Number 33), which in time evolved into the elaborate monster-mask headdress of the Classic Maya. Since the Maya figures shown wearing it are known to have been rulers, not deities, the same may well have been true of their Olmec predecessors.

Another group of sculptures that show different facial types seems to illustrate a theme of enormous significance in Olmec dogma, the child born of a jaguar and a woman. The jaguar-baby appears in many stone, clay, and jade versions; the most explicit are the rare sculptures that depict this strange creature in the arms of an adult. The only such adult known that is portrayed standing (Number 41) is very much like other naturalistic standing figures carved in jade and lesser stones, while the baby he holds so formally in front of him has jaguar features. The rigidly frontal composition emphasizes the difference between the two figures, and, by

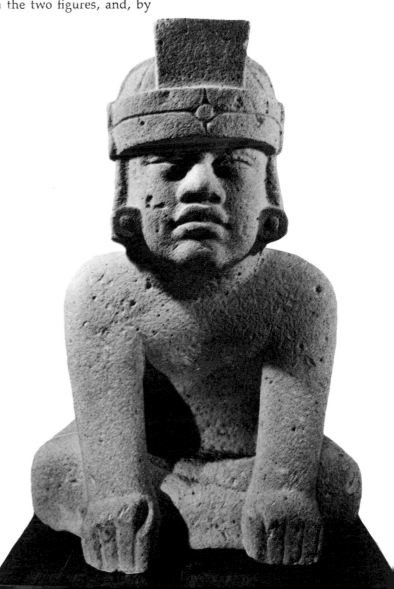

FIGURE 4

Seated figure

Though among the most convincingly realistic of Olmec works, this handsome figure has no feet and sits in a stylized, jaguarlike pose often represented but actually impossible for man or beast. The brief costume consists of a knee-length skirt or kilt, lapped over at its right side, semicylindrical earspools, and a relatively simple headdress made up of a vertical plaque and buckled bands over and around the head. Cruz del Milagro, Sayula, Veracruz. 1150–600 B.C. Height: 51 in. (1.30 m.). Museo de Antropología de la Universidad Veracruzana, Jalapa.

means of the cross formed by the torso and forearms of the large figure, calls further attention to the small one. The importance of the theme is implied by the exceptional quality of the jade in which the sculpture is carved and its large size. A sculpture from Las Limas in sparkling pale greenstone (Figure 6) presents the same two figures. The adult who sits holding the jaguar-baby across his knees, again rather stiffly, is modeled with the utmost naturalism, the lifelike impression heightened by obsidian disks set arrestingly in the eyes. The small figure is almost identical in facial features to the one held by the standing jade figure and wears the same type of headband with notched sidepieces.

The two figures also appear on at least four large Olmec monuments. The most interesting, Altar 5 at La Venta, has four profile adult-and-baby groups carved in low relief on the ends in addition to a seated figure set in a niche, holding the jaguar-baby and wearing on his headdress a mask with features like the baby's. On every such monument with the faces well preserved, the adult of each pair looks more human than his charge, whom he holds in a careful but in most cases curiously unnatural way, just as a living priest-ruler might be imagined to hold a supernatural infant.

Single figures add another dimension to the complex relationship between the jaguar being and the humans who seem to assume or partake of his power. Though some appear to be straightforward representations of human beings, or of the

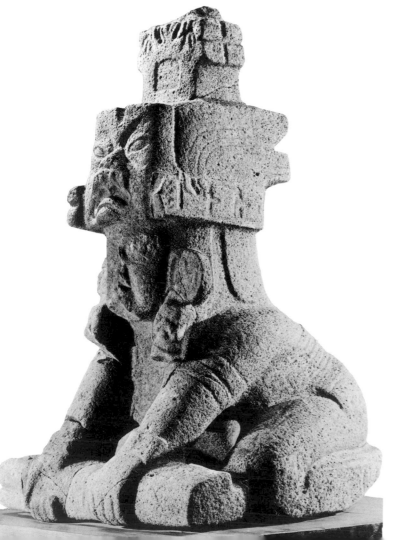

FIGURE 5

Half-kneeling figure with mask headdress

Three additional masks decorate the ear ornaments and loincloth, and six faces in profile are in the headdress, looking upward at each side of the headband and, chins together, on the front and back of the crest. Crosses cut on each end of the crest denote the characteristic cleft head of the jaguar-child. A larger cross appears on the back of the headdress itself, and another on the left end of the club or scepter, with traces of still another face. The figure was discovered in 1897 near the peak of San Martín Pajapán volcano in the Tuxtla Mountains by a surveyor who moved it, breaking the arms in the process, and finding a modest offering beneath. The broken pieces were rediscovered beneath the figure, with jades and pottery of all periods, when it was brought down from the mountaintop (Alfonso Medellín Zenil and Manuel Torres Guzmán, "El dios jaguar de San Martín," *Boletín del Instituto Nacional de Antropología e Historia* 33, 1968, pp. 9–16). By means of a nearly identical head made of the same basalt (Monument 44), this figure can be dated 1000–600 B.C. (R. F. Heizer et al, "The 1968 Investigations at La Venta," *Contributions of the University of California Research Facility* 5, 1968, pp. 127–203, pls. 11e, 12a). Height: 53 in. (1.35 m.). Museo de Antropología de la Universidad Veracruzana, Jalapa.

FIGURE 6

Seated man with jaguar-baby

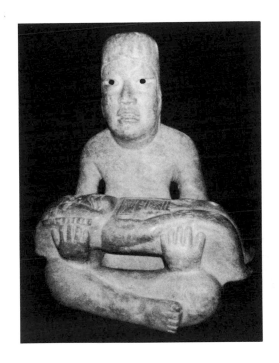

Four different profile heads and other symbolic motifs are incised on the knees, shoulders, and face of the adult figure, which is well modeled in back, showing shoulder-length hair, belt, and loincloth. The baby, carved less realistically, wears a pectoral inscribed with the crossed-band motif, a matching belt ornament, and a headband with notched sidepieces. His cleft head, elongated and turned back over the arm of the adult, is shaped somewhat like a modern claw hammer. Discovered by children at the village of Las Limas, Veracruz, this sculpture was reported to museum officials who on their arrival only ten days later found it already enshrined with flickering candles and a crown of flowers. (Alfonso Medellín Zenil and Alberto Beltrán, "La escultura de las Limas," *Boletín del Instituto Nacional de Antropología e Historia* 21, 1965, pp. 5–16; Michael D. Coe, *America's First Civilization*, New York, 1968, pp. 111–115). Height: 21⅝ in. (55 cm.)., 1150–600 B.C. Museo de Antropología de la Universidad Veracruzana, Jalapa.

jaguar-child seen in two-figure compositions (Number 34), the little creature from Necaxa has characteristics of both (Number 42). It is certainly one of the jaguar-children, wearing the characteristic crossed-band chest ornament and headband with notched sidepieces, yet its pose is very like that of the adult figure identified by his costume as human (Figure 5). He was clearly no ordinary human, however, and the half-kneeling (or "running-kneeling") position, one still assumed in shamanistic rites, tends to confirm his priestly role in real life. The small, similarly posed jaguar-child may thus be a metaphorical portrayal of a priest (even though the same infantile image was used in the two-figure compositions as a separate symbol). The concept is reflected somewhat differently in a powerful kneeling figure that leans forward in the same way (Number 43). In his extraordinary face, man and jaguar are indeed one, yet there is a pair of ears for each. While both these figures can be interpreted as priests mystically transformed, a charming infant (Number 44) appears at first glance to be transformed simply by a costume, yet has a feline claw on each heel.

Except for headdresses, pectorals, and belt fastenings, which seem to symbolize the wearer's supernatural power, most Olmec figures carved in the round wear only the simplest clothing and jewelry, or nothing at all. Some wear loincloth or a short skirt, but there is seldom any indication of sex even on nude figures. Sculptors were nevertheless keenly aware of body structure, depicting it with the utmost naturalism otherwise. This custom of suppressing sexual characteristics in hieratic images has no true parallel in the more literal traditions of Western art. Figures in Olmec relief sculpture, though similarly undifferentiated as to sex, often wear elaborate costumes (Number 33) and lack specific jaguar features.

Another aspect of jaguar symbolism is connected with important Olmec beliefs

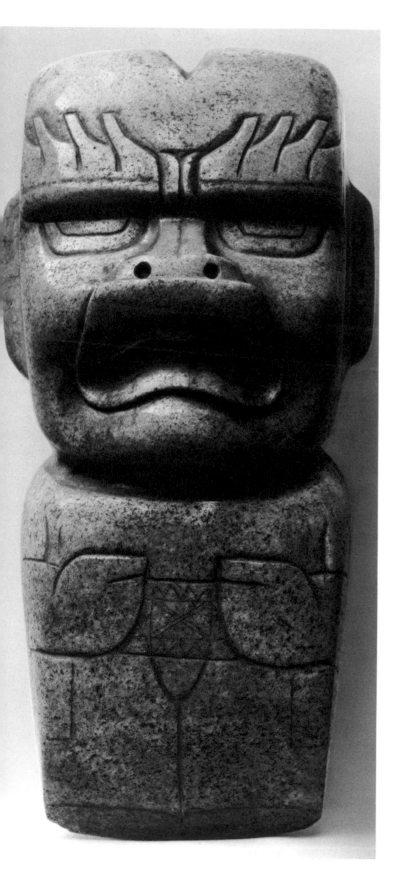

FIGURE 7

Votive axe

Shaped like a huge celt, this sculpture in light green jade-ite is at the same time an axe and a figure with the cleft head and crossed-band chest ornament that character-ize representations of the jaguar-child. Though lacking fangs, it has "flame eyebrows" and the feline eye that is more common in the Chavín art of Peru than in any Mid-dle American style. The sculpture is one of the treasures of the Christy Collection, formed in the nineteenth cen-tury, and is said to be from Oaxaca. The only figural axe from a controlled excavation was found at La Venta in a phase IV offering dated 700–600 B.C. (Ignacio Bernal, *The Olmec World*, Berkeley, 1969, pl. 38). Height: 11⅝ in. (29.5 cm.). The British Museum, London, St. 59.

FIGURE 8

Ceremonial mask

The only wooden object of Olmec style known, this life-size mask was reportedly found in a cave that opens high on a nearly vertical cliffside of the Cañon de la Mano near Iguala, Guerrero. Several pieces of polished jade ad-here to it, and inlays were once set in the forehead and cheeks. The same peculiar L-shaped eyes (which are open slits in the mask) appear occasionally on fine ceramic fig-ures from Central Mexico as well as on several stone figures at San Lorenzo, suggesting a date of 1150–950 B.C., but leaving the place of manufacture uncertain. Height: 6¾ in. (17.2 cm.). The American Museum of Natural History, New York.

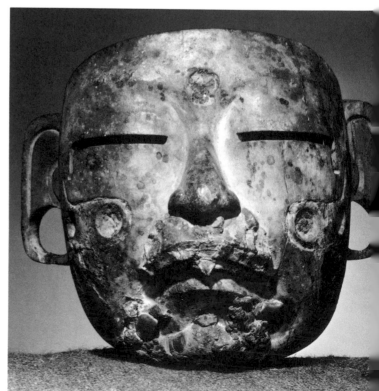

about polished stone axes or celts, found in great numbers in La Venta ceremonial offerings. Large celts of greenstone and jade were carved to embody a supernatural jaguar (Figure 7), often shown with fangs. In later times, this jaguar face evolved into forms identifiable with the Maya and Aztec rain gods, while stone celts, in surviving Maya mythology, are their thunderbolts. The Maya conception of Chac, the Rain God, as being at the same time one deity and four may also come down from Olmec times or earlier. Both the sculpture from Las Limas (Figure 6) and the La Venta altar mentioned in connection with it present the jaguar-child not only as the main subject but also in four lesser representations, all different. To the later Maya, however, the jaguar's many associations were apparently not so much with the Chacs as with the underworld, and the complexity of their beliefs hints at corresponding depths of meaning in Olmec man-jaguar symbolism.

Olmec art, so far as it is known now, has few other subjects. The bat (Number 45), the serpent (Number 33), and the bird of prey (Number 46) had begun to appear, often as composite figures, such as the bird-jaguar-serpent. The monkey had some significance (Number 47), and the duck, or a bird with a ducklike bill, was a symbol important enough to be carved in the material the Olmecs treasured most, translucent deep emerald jadeite (Numbers 48–50). All these motifs were carried on into later styles, but none preserved the formal qualities that distinguish the art of the Olmecs. None achieved the sense of scale that lends monumentality to their smaller sculptures and even to jade carvings; large and small, Olmec forms are composed of ample masses subtly shaped and balanced to give an impression of solidity. Though often symmetrical and poorly finished in back, they are fully three-dimensional in concept, intended to be seen from more than one angle. The most essential quality perhaps is the restraint that varies an angle or line only a little, and leaves some surfaces undecorated, some spaces empty.

As mastery of technique was a basic element of the style, so also was fine material, much of it obtained from surprising distances. Basalt for most of the monuments (the largest ones weighing twenty-five tons or more) came to the central Olmec sites overland and by water from the Tuxtla Mountains, which lie about fifty miles to the northwest in a straight line. Magnetite and similar materials used for beads and mirror pendants came twice as far from the Valley of Oaxaca, green metadiorite from some source in Guerrero, and different varieties of jadeite from now unknown deposits possibly as far away as Costa Rica. (In all these places, sculpture or portable objects of Olmec style have been found, including Figures 7 and 8 and Numbers 45, 50, and 51.)

In exchange the Olmec region could offer, then as now, such tropical luxuries as chocolate, vanilla, copal incense, and rubber, products that may account in large measure for the prosperity implied by the profusion of Olmec art. Its content, however, reflects not only economic wealth but a strong religious impulse that ultimately spent itself, leaving the region no richer or more influential than others. The only Olmec exports that survive are works of art, easily portable but heavy with religious symbolism. While some—jewels beautifully carved of jade, for example—had value apart from their meaning, others appear to have had no use other than as ritual paraphernalia. These include statuettes and figurines (Numbers 42,

43), perforators (Number 38), and a mask evidently intended for actual wear (Figure 8). Though not necessarily brought from any great distance to the cave in Guerrero where it was found, this rare wooden mask hints at the wealth of ceremonial equipment that once accompanied the imperishable works of art known to us.

Objects of Olmec style and bearing Olmec symbolism were not merely acceptable far beyond the central area; more than we yet suspect may in fact come from other places. The finest Olmec ceramics have been discovered in Central Mexico at "colonial" settlements now recognized to be as ancient as those in the Olmec heartland (Chapter 2). Cave paintings have come to light in Guerrero, and reliefs carved on living rock in Morelos (Number 32). These are clearly Olmec in style, though nothing has yet been found in the heartland to compare with them. Across the Isthmus of Tehuantepec, Olmec rock carvings and freestanding stone sculptures (Number 35) appear here and there along the Pacific coast as far south as El Salvador. All these places at the very least acknowledged the rulers who seem to be the principal theme of Olmec art, and probably shared the religious concepts behind the imagery used to denote their supernatural or divine powers.

Until relative chronology becomes much firmer than it is now, no one can say whether the Olmecs of Veracruz and Tabasco created or in some way transformed the politico-religious system embodied in their art, or whether, becoming more ambitious and successful than their contemporaries, they were able to express widely held beliefs in more eloquent and lasting artistic forms. Whatever its initial spark or place of origin, Olmec art manifests a spiritual as well as worldly power that had a profound effect on all Middle America, advancing and binding together its peoples.

32 Colossal jaguar mask

Brownish gray stone (probably granodiorite)
Height: 72 in. (1.83 m.)
Near Chalcatzingo, Morelos, Mexico
Middle or Late Preclassic, probably 800–100 B.C.
Munson-Williams-Proctor Institute, Utica, New York

Striking as it now appears, this relief, reconstructed from fragments, should be visualized in what was probably its original setting, carved on bedrock, its great mouth the opening of a cave. Just such a cave is represented in the largest of the series of hillside relief carvings at Chalcatzingo, shown in side view with a figure seated inside the quatrefoil mouth, from which scrolls issue. The Izapan character of the scrolls (Chapter 4) suggests that this relief may be later than certain of the other rock carvings and pottery found in the vicinity, and that the important Olmec settlement there endured for centuries. Both reliefs seem to illustrate the ancient association of the jaguar with caves, the underworld, and the earth with its growing plants. (David C. Grove, "Chalcatzingo, Morelos, Mexico: A Reappraisal of the Olmec Rock Carvings," *American Antiquity* 33, 1968, pp. 486–491, fig. 7.)

33 Relief of man and serpent (Monument 19 from La Venta)

Gray basalt
Height: 37½ in. (95 cm.)
La Venta, Tabasco, Mexico
Middle Preclassic, 1000–600 B.C.
Museo Nacional de Antropología, Mexico, 13–599

The serpent, which was to become the outstanding symbolic theme of the Postclassic period, was not yet a common motif in Olmec times. It makes an early appearance in this relief, without the plumage it later acquired but unmistakably identifiable by the rattles on its tail. Its stylized head, repeated in the mask-helmet of the human figure, combines features of serpent, jaguar, and bird of prey. Rearing emblematically behind the man, it has been called "beyond a doubt one of the meanest looking reptiles in Mesoamerican art" (Philip Drucker, Robert F. Heizer, and Robert J. Squier, *Excavations at La Venta, Tabasco, 1955*, Bureau of American Ethnology Bulletin 170, Washington, D.C., 1959, pp. 197–199). Basalt boulders like this one, transported to the central Olmec sites with tremendous effort, were usually carved in the round. This rare relief was discovered during construction of the local airstrip and cannot be connected with any one of the four chronological phases established at La Venta by excavation.

34 Jaguar-child (Monument 52 from San Lorenzo)

Basalt
Height: 35½ in. (90 cm.)
San Lorenzo, Veracruz, Mexico
Middle Preclassic, 1150–900 B.C.
Museo Nacional de Antropología, Mexico

The headband with its fluted sidepieces and the pectoral with crossed-bands symbol identify this sculpture with the jaguar-babies held by adult figures in Number 41 and Figure 6, as well as with the puzzling figurine from Necaxa (Number 42). The symmetrical pose and blocky, unrealistic feet are characteristic of jaguar-babies but not of sculptured Olmec figures that seem to be portraits. This one was evidently carved for some special purpose; it is not solid, but completely hollowed out vertically. Seen from the back, it resembles the laboriously cut trough-shaped stones found at both San Lorenzo and La Venta laid out end-to-end and covered wtih flat slabs to form drainpipes. Possibly this creature was part of the mysteriously elaborate hydraulic system of drains and pools, serving as a purely emblematic figure, unconnected with any real person.

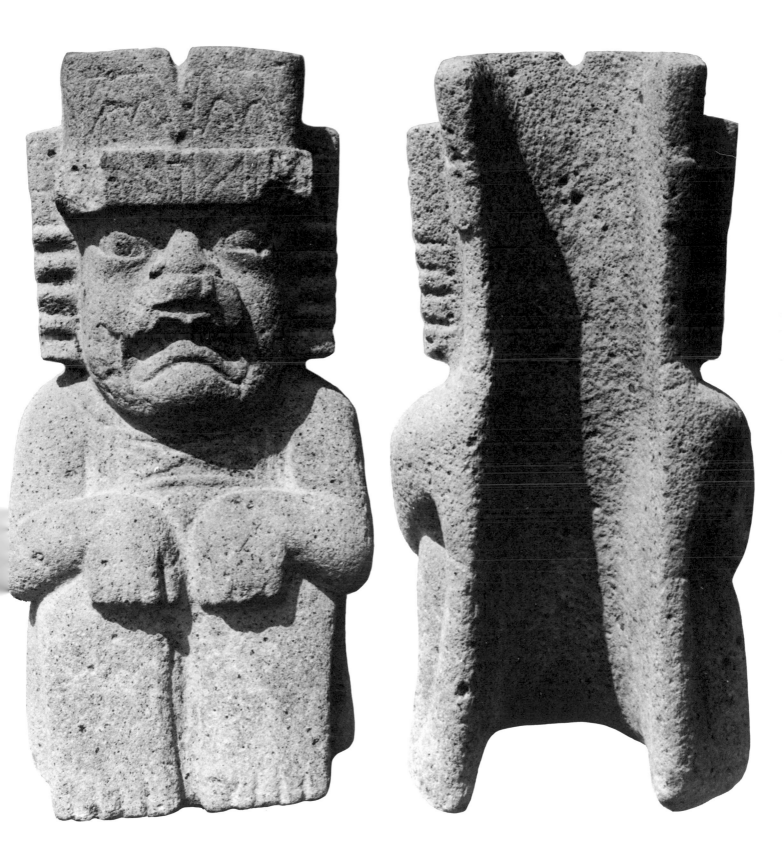

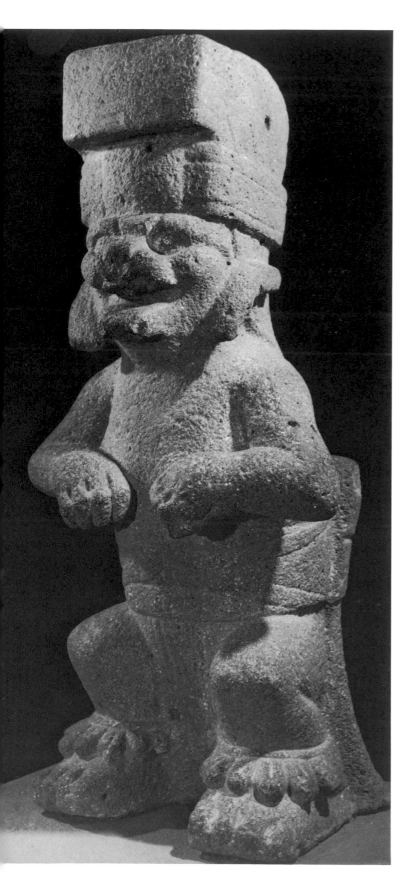

35 Man-jaguar, "El Danzante"

Basalt
Height: 40¼ in. (1.03 m.)
Tuxtla Chico, Chiapas, Mexico
Middle Preclassic, 1150–550 B.C. (?)
Museo Regional de Chiapas, Tuxtla Gutiérrez, Mexico

The age of this sculpture is unknown and, for lack of comparable works, difficult to guess; the rarity of relief carving in the central Olmec region is more than matched by the rarity everywhere else of three-dimensional sculpture in purely Olmec style. Because of its vigor, body proportions, and fine modeling, however, this figure would not look out of place at La Venta itself. Above all, it shows the characteristic melding of realistic human and jaguar traits into a totally convincing image that portrays a ruler and his supernatural power as one. Also typically Olmec is the emphasis on the belt and on the headband with its superstructure, which originally rose even higher. To find an Olmec sculpture of first quality in the Pacific Coast region is not surprising: though the site of Izapa has given its name to the Protoclassic style developed later (Chapter 4), it had long been an important ceremonial center. By 600 or 550 B.C. it already boasted a temple set impressively on a thirty-foot pyramidal base (Figure 11). Pottery found within it records a still earlier history of close alliance with the eastern Olmec centers (Susanna M. Ekholm, *Mound 30a and the Early Preclassic Sequence of Izapa, Chiapas, Mexico*, Papers of the New World Archaeological Foundation 25, Provo, Utah, 1969).

36 Crouching figure

Polished black stone
Height: 9¾ in. (25 cm.)
El Quiché department, Guatemala
Middle Preclassic, 1150–550 B.C.
Museum of the American Indian, Heye Foundation,
New York, 15/3560

An unrecorded find, this figure offers no indication whether it was made somewhere in highland Guatemala or carried there. Its dating is equally uncertain. It is by far the largest in a class of childlike or dwarflike figures distinguished by a crouching pose, raised hands, and, usually, an upturned face. The earlobes and nasal septum were pierced for ornaments with a fine drill, and the opening between the knees was made with a very large tubular drill, probably a section of cane or bamboo used with abrasive powder. The top of the head appears to have been hollowed out centuries later to convert the figure into an incense burner like those made in El Quiché during Early Classic times.

37 Boulder figure

Deep green serpentine
Height: 8 in. (20.3 cm.)
Provenance unknown
Middle Preclassic, 1150–900 B.C.
The Metropolitan Museum of Art, Harris Brisbane Dick
 Fund, 1970.56
Ex coll. Gabriel Ritter von Max, Munich

The figure seems to emerge from the very substance of the stone, an unusual translucent serpentine, left roughly pecked over most of its surface in contrast to the dark polish of the raised arms and ear ornaments and of the face carved in low relief on a lower plane. The sculpture probably expresses the theme of the ruler-priest, wearing ear ornaments marked with a cross (Figure 3 and other colossal heads), holding in one hand a scepter or torch and in the other an unidentified emblematic object that was among those engraved on the lost Humboldt Celt (Michael D. Coe, "The Olmec Style and its Distribution," *Handbook of Middle American Indians*, Robert Wauchope, ed., III, Austin, 1965, fig. 18). The motif of a face carved as though within the stone appears on several jade pendants and on a circular stone relief discovered in Veracruz with pottery of the same age as the San Lorenzo sculptures (María Antioneta Cervantes, "Dos elementos de uso ritual en el arte Olmeca," *Anales del Instituto Nacional de Antropología e Historia* 1, 1969, pp. 37–51, figs. 1, 2).

38 Handle of a ceremonial perforator

Blue green jadeite
Height: 4⅝ in. (11.9 cm.)
Said to be from the Tecpán area, east of Lake Atitlán,
 Guatemala
Middle Preclassic, possibly 700–600 B.C.
Anonymous loan to The Metropolitan Museum of Art,
 L. 68.35.107

The animated little face gives the impression of being within the object, an integral part of it rather than an added decoration. The same unity of the figural representation, the physical object, and the precious material appears in Number 37 and, even more strongly, in the votive axes (Figure 7). Other jade handles, like this one but uncarved, and a complete awl-like perforator were included in phase IV offerings at La Venta, along with shark teeth, stingray spines, and a jade replica of one of these spines. Separate jade points and another type of perforator with a smaller trapezoidal handle are also known. There was in later times an investiture ceremony that involved piercing the nose (Chapter 11); a similar Olmec custom may explain the purpose of the various types of perforators as well as the delicately pierced noses and ears of nearly all Olmec statuettes that appear to represent human beings. The face on this handle seems purely symbolic, like the jaguar-babies (Figure 5, Numbers 34, 41, 42). All of these share the distinctive eye form that was used in the great jaguar-mask relief (Number 32).

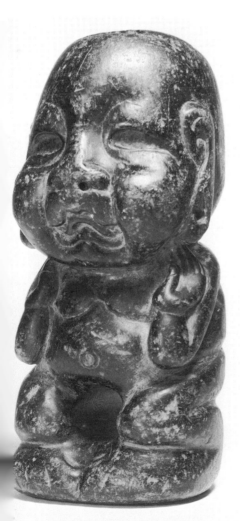

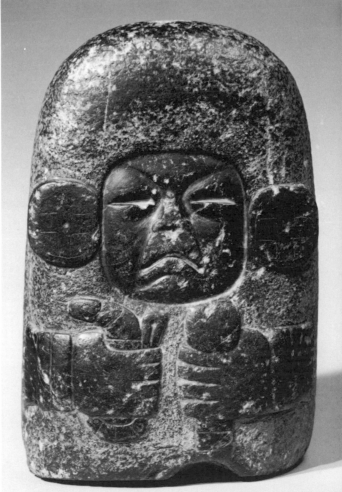

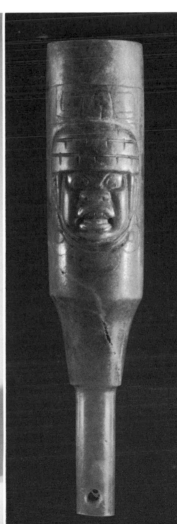

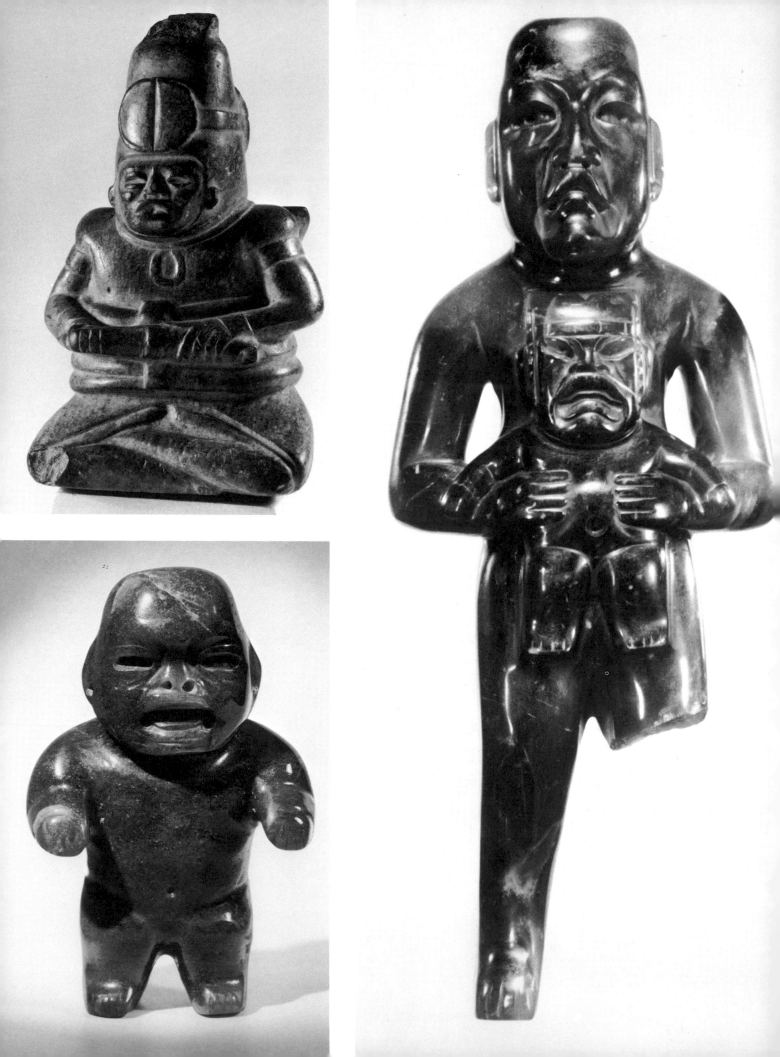

39 Seated dignitary

Gray green serpentine
Height: 5 in. (12.7 cm.)
Said to be from Tabasco
Middle Preclassic, 1150–550 B.C.
Dr. and Mrs. Milton Arno Leof, Mexico City

Surely one of the best dressed of Olmec statuette figures, this personage sits holding a tapered bar in a manner that makes evident its ritual or emblematic importance. A similarly posed, headless figure was found at San Lorenzo (Monument 11: Matthew W. Stirling, "Stone Monuments of the Río Chiquito, Veracruz, Mexico," *Bureau of American Ethnology Bulletin* 157, 1955, pl. 16a). In both of these, and in Figure 5, a bar is held in the same odd way in the left hand, the right hand being shown in an unnatural position, palm upward.

40 Jaguar-baby

Translucent sea green jadeite
Height: 4¾ in. (12.1 cm.)
Cerro de las Mesas, Veracruz, Mexico
Middle Preclassic, 1150–550 B.C.
Museo Nacional de Antropología, Mexico, 13–416

Either an heirloom or a find by ancient grave robbers, this beautifully shaped and polished jade was found by archaeologists beneath the steps of an Early Classic temple mound in an offering of 782 fine stone ornaments carved in styles perhaps as late as A.D. 600. The offering also included a model dugout canoe of similar bluish "Olmec" jade, just wide enough for the figurine to stand in. Though the canoe was perforated to hang horizontally as a pectoral, the figurine has only the finest of perforations in the earlobes and septum of the nose for attaching small ornaments; it was not itself a piece of jewelry. (Phillip Drucker, "The Cerro de las Mesas Offering of Jade and Other Materials," *Bureau of American Ethnology Bulletin* 157, 1955, pp. 25–68.)

41 Figure holding a jaguar-baby

Translucent sea green jadeite with cloudy spots and deep
 emerald veins
Height: 8⅝ in. (21.8 cm.)
Provenance unknown
Middle Preclassic, 1150–550 B.C.
Guennol Collection of Mr. and Mrs. Alastair Bradley
 Martin, Katonah, New York

Of the three minerals properly called jade (nephrite, jadeite, and chloromelanite), only jadeite was used for fine carvings in Middle America. It occurs in many varieties and in mixtures with other minerals such as diorite and albite. The two varieties seen in this piece, though both almost pure jadeite, are very different in appearance. Ol-

mec lapidaries usually worked the rare emerald-colored parts of a stone separately (Numbers 48–50), but here, instead of removing the precious vein across the center, they used it to enrich the figure of the jaguar-child. The history of this Olmec masterpiece remains a mystery; thought to have been taken to France in the 1860s, it was first illustrated in 1901. (Herbert J. Spinden, "An Olmec Jewel," *Brooklyn Museum Bulletin* 9, 1947, pp. 1–14.) (See Color Illustration.)

42 Jaguar-baby

Blue green jadeite
Height: 3⅜ in. (8.7 cm.)
Necaxa, Puebla, Mexico
Middle Preclassic, 1150–550 B.C.
The American Museum of Natural History, New York,
 31.1/2168

This appealing carving, known since 1909, offers an uncommon amount of iconographic detail for so small an object. It has the cleft head, headdress, pectoral, and eyes that seem to identify supernatural figures, the jaguar fangs seen on votive axes and masks, and beautifully carved human arms and hands, as well as legs and feet clearly depicted on the base. (With both knees bent, the figure sits on its right foot and covers the left with its right hand. The pose differs from that of Figure 5 and others in which the left leg is bent back instead and the right knee raised.) Fine incising defines profile faces on each cheek, other patterns on the "ribbons" that hang over the belt, its knot, and a U-motif on the back. Though it does not seem to be a pendant, the figurine is perforated under the crest, in the rump, and through each knee.

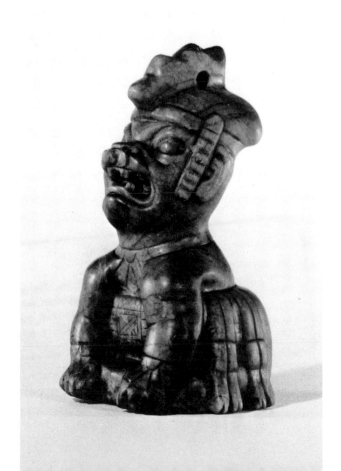

43 Kneeling figure

Olivine-serpentine with traces of red pigment
Height: 7⅝ in. (19.5 cm.)
Puebla, Mexico
Middle Preclassic, 1150–550 B.C.
Mr. and Mrs. John H. Hauberg, Seattle
Ex coll. Ferdinand Ries, Frankfurt, Germany

Wonderfully "realistic," yet totally unreal, this bearded figure has a human body and a face in which human and jaguar features combine so harmoniously that it seems only natural to see a pair of ears for each identity. In back, the finely incised hair appears as if parted in the middle to suggest a cleft head. The figure has much in common with several interpreted as having the human face "peeled away to reveal the jaguar beneath" (Peter T. Furst, "The Olmec Were-jaguar Motif in the Light of Ethnographic Reality," *Dumbarton Oaks Conference on the Olmec*, Elizabeth P. Benson, ed., Washington, 1968, pp. 143–178). The eyes, left unpolished for inlay, appear to have been hollowed with a tubular drill, and the nasal septum is pierced.

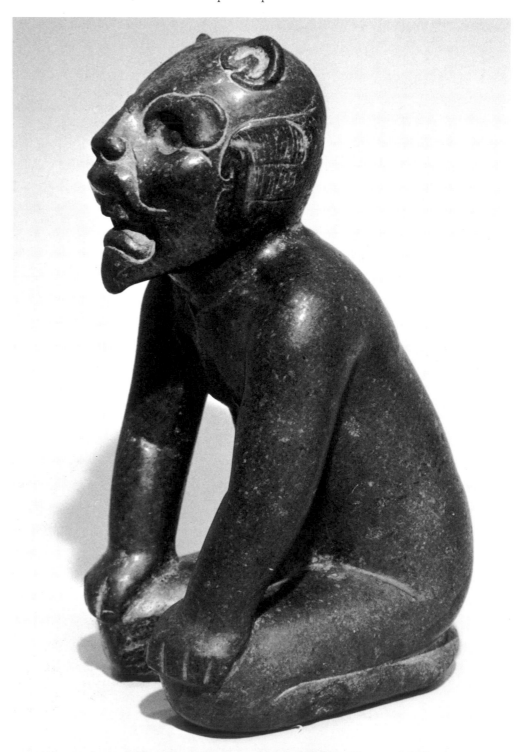

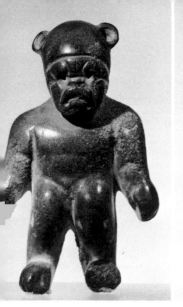
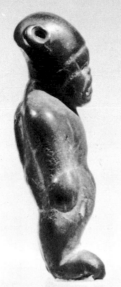
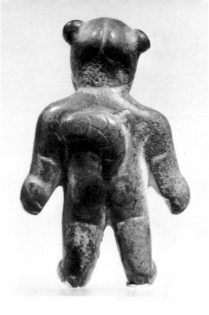
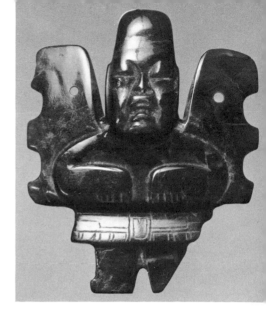

44 Jaguar-baby

Reddish brown felsite with traces of red pigment
Height: 2¼ in. (5.8 cm.)
Said to be from southern Veracruz, Mexico
Middle Preclassic, 1150–550 B.C.
Guennol Collection of Mr. and Mrs. Alastair Bradley
 Martin, Katonah, New York

In this tiny figure, the real and the supernatural are again mystically blended. The feline ears seem, in front view, to be part of a close-fitting cap or helmet, but its clearly marked edge is not carried around to the back, where the head is jaguarlike and cleft. The feet are shown as paws, and there is a fine bushy tail.

45 Winged-figure pendant

Blue green jadeite
Height: 2¼ in. (5.7 cm.)
Nicoya Peninsula, Costa Rica
Middle Preclassic, 1150–550 B.C.
Guennol Collection of Mr. and Mrs. Alastair Bradley
 Martin, Katonah, New York

This and another winged half-figure are the only known Olmec representations of the bat. Both are carved in jadeite of exceptional quality, and both were found in Costa Rica. Locally made naturalistic bat pendants are found there, along with the stylized types of winged pendant that also occur southward into Colombia and Venezuela and in the Antilles. Except for its subject, this pendant gives no clear indication of its place of origin. In addition to the holes through the wings, there are perforations for suspension in each wing where it joins the shoulder, and in the nasal septum. Fine drilled pits in the earlobes probably held tiny inlays.

46 Bird pendant

Blue green jadeite
Height: 3⅝ in. (9.1 cm.)
Provenance unknown
Middle Preclassic, 1150–550 B.C.
John Huston, County Galway, Ireland

Stylized birds of prey or bird-monsters are incised on several jade and obsidian objects from La Venta and represented on spoon-shaped pendants, but none is as naturalistic as this. The caruncle of the king vulture appears on the beak, and incised lines mark the divisions between the actual bird's colored head, white shoulder plumage, and black wing feathers. In most representations the bird is characterized, as it is here, by its head rather than by its spectacular silhouette in flight, so it would probably be overimaginative to view this one as a chick. (See Color Illustration.)

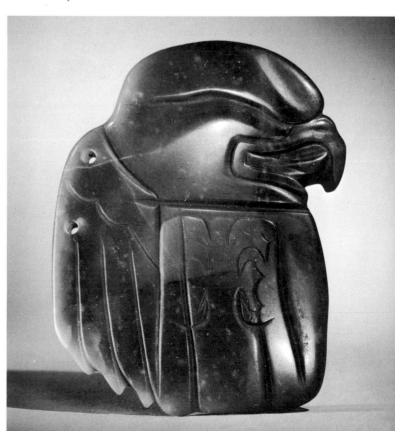

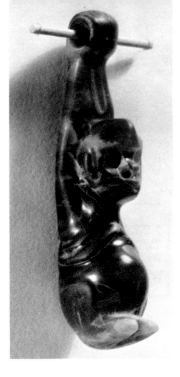

47 Monkey pendant

Blue green jadeite
Height: 2½ in. (6.2 cm.)
Guerrero, Mexico
Middle Preclassic, 1150–550 B.C.
Anonymous loan to The American Museum of Natural
 History, New York, T109/256

However appealing to the modern eye, few Olmec works of art seem to have been intended to amuse. Even so, it is hard to take this swinging monkey seriously, and perhaps it was not meant to be so regarded; the monkey keeps reappearing as a minor motif in Middle American art and was considered a symbol of pleasure in the sixteenth century. A ceramic monkey from Tlatilco appears no more solemn than this one (Number 21), though a life-size monkey sculpture at La Venta (Monument 12), depicted in the same pose as this with arms above the head and scrolled tail against the back, wears a belt and collar incised with jaguar motifs. This monkey pendant has fine perforations in the ears, nose, and left foot, as well as a suspension hole in the hands.

48 Large duck-head pendant

Emerald-colored jadeite with traces of red pigment
Height: 1⅞ in. (4.9 cm.)
Provenance unknown
Middle Preclassic, probably 700–600 B.C.
Mrs. Harold L. Bache, New York

49 Duck-head pendant

Emerald-colored jadeite
Height: 1⅛ in. (2.9 cm.)
La Venta, Tabasco, Mexico
Middle Preclassic, probably 700–600 B.C.
Museo Nacional de Antropología, Mexico, 13–255

50 Miniature duck-head pendant

Emerald-colored jadeite
Height: ⅝ in. (1.7 cm.)
Said to be from Guerrero, Mexico
Middle Preclassic, probably 700–600 B.C.
Mr. and Mrs. Dudley T. Easby, Jr.

Imperial or jewel jade from Burma differs mineralogically from the material most treasured by the Olmecs, but the eye alone cannot distinguish between them. The American variety was first recognized at La Venta by Matthew Stirling, who writes: "The limpid transparent beauty of imperial jade when first exposed in an Olmec tomb embedded in moist, vivid red cinnabar is almost beyond description" ("The Olmecs, Artists in Jade," in S. K. Lothrop and others, *Essays in Pre-Columbian Art and Archaeology*. Cambridge, Massachusetts, 1961, pp. 43–59). It has been found only in worked objects of Olmec or Costa Rican styles, Preclassic in date. Though sometimes seen as veins and spots in translucent "blue" jade (Numbers 41, 45, 47), it was more often cut painstakingly into separate ornaments like these three. Number 48 is one of the largest known, but Number 50 is by no means the smallest; many even tinier pendants or spangles are mere scraps, delicately shaped to suggest jaguar fangs or claws, or duck heads. Most jewel-jade pieces are cut very thin or hollowed out in back (Numbers 49, 50), the better to display the material's clarity and brilliant color. They seem to have more perforations than most Olmec ornaments: Number 48 has seven needle-fine holes around the edges, the remains of five others, and one in the center; Number 49, three around the top of the head, one in the beak tip, and perforated eyes; and Number 50, the usual minimum of two, through the head and beak. (See Color Illustration of Number 48.)

51 Gourd-shaped bowl

Aragonite (tecali) with red pigment
Length: 9¼ in. (23.5 cm.)
Tepecoacuilco River valley, Guerrero, Mexico
Middle Preclassic, 1150–550 B.C.
Mr. and Mrs. Jacob M. Kaplan, New York

Stone bowls were carved before the introduction of pottery and continued to be made for ceremonial use into Aztec times, often of the soft translucent tecali of Puebla and Guerrero. This is the only one known that can be clearly identified, by its symbolic motifs, as Olmec. Its oblong shape imitates that of a cup made from the hard-shelled fruit of the calabash plant. The small interlocked scrolls on the rim at the narrowest part of each side, representing the marks of stem and blossom, appear in most bowls that copy it, in pottery and even gold. The bowl reportedly came from a burial offering that included an Olmec figurine, a hematite mirror, and ornaments of blue and jewel jade.

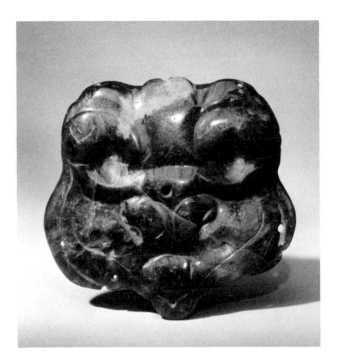

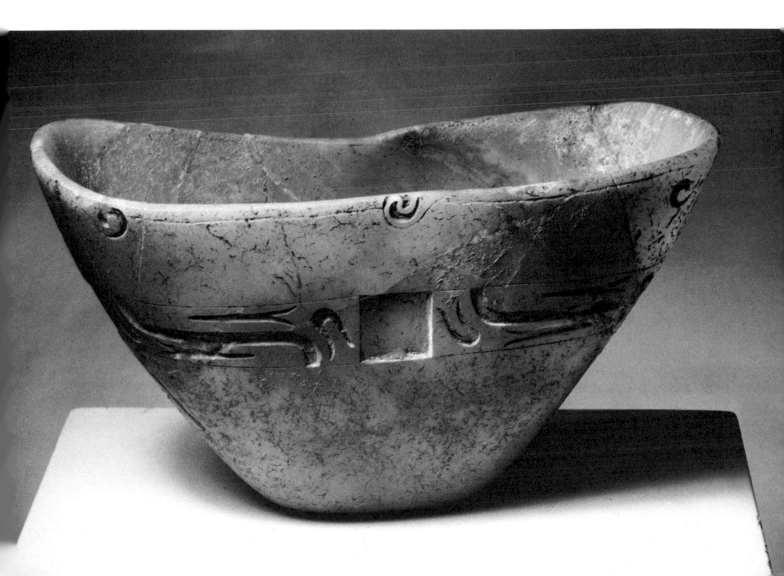

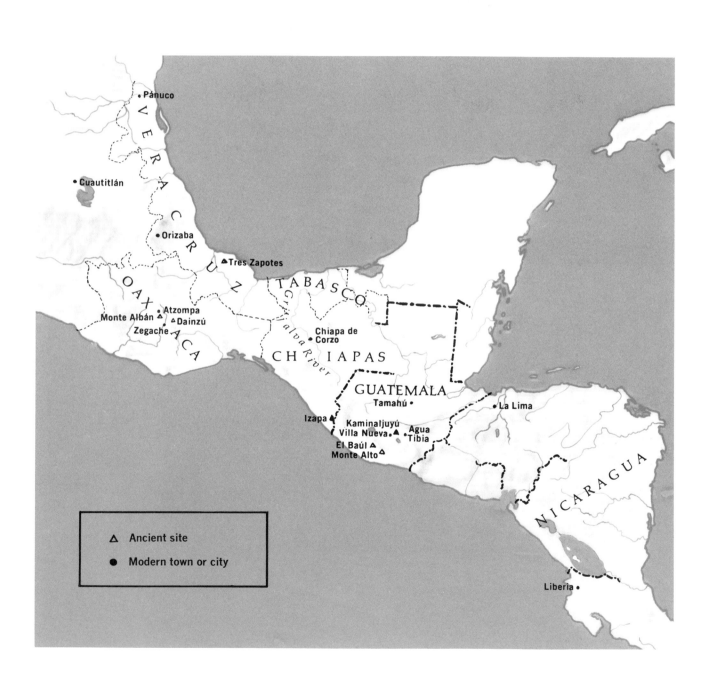

• Pánuco

V E R A C R U Z

• Cuautitlán

• Orizaba

△ Tres Zapotes

O A X A C A

Monte Albán △ • Atzompa
△ Dainzú
Zegache

TABASCO

Grijalva River

Chiapa de
Corzo

CH I APAS

GUATEMALA

Tamahú •

• La Lima

Izapa △

Kaminaljuyú
Villa Nueva △ Agua
Tibia

El Baúl △
Monte Alto △

N I C A R A G U A

Liberia •

△ Ancient site

● Modern town or city

4

Post-Olmec and Izapan Art

The spread of the Olmec culture established a common style and subject matter throughout Mesoamerica. Regional variations occurred in the emphasis given to certain subjects and techniques: hollow ceramic baby figures were the dominant art form in Central Mexico, greenstone effigy axes in Guerrero, and stone relief sculpture in the Maya highlands and on the Pacific slope. When the power of the Olmec heartland over these provincial regions weakened, each developed its own distinctive style out of the common artistic tradition. Since all these regional styles are clearly descended from the Olmecs, they are often called *Olmecoid*. But because this term can also mean contemporary deviation from Olmec canons established at San Lorenzo and La Venta (1150–600 B.C.), styles postdating the end of Olmec art in the Veracruz-Tabasco heartland will be referred to here as *post-Olmec*.

With the disintegration of the Olmec hegemony in the sixth century B.C., the vitality that characterized the Olmec style of art suffered a noticeable slackening. Figures in relief seem to float instead of standing on a groundline. Lines that once formed crisp, stiff curves relax in more limp ones. Scrolls, employed by Olmec artists to symbolize water, wind, or fangs, for example, proliferate in the Late Pre-classic as decorative motifs. These features, however, did not coalesce into a unified style throughout Mesoamerica; they were simply the result of the absence of centralized control, which had earlier restrained regional variations of Olmec art.

Occasionally Olmec concepts survived in artistic programs long after Olmec forms had been forgotten. The colossal heads discovered at Monte Alto, on the Pacific slope of Guatemala, must have been inspired by the memory of similar heads at San Lorenzo and La Venta, since the Guatemalan heads were also intended to be set on the ground, with no suggestion of a body. But, as a Monte Alto monument (Number 52) well demonstrates, the rendering of the facial features shares nothing with the Olmec heads, except for the heavy cheeks. And even the cheeks were probably derived not from Gulf Coast sculptures, but from the baby-faced features of earlier Las Charcas figurines (Number 5). The closed eyes of this and other Monte Alto heads suggest death. Given their considerable variation in features, they may all be considered commemorative portraits of deceased leaders. The carving technique, rough when compared to that of the finest Olmec colossal heads, employs shallow modeling to define the features, leaving much of the sides of the

FIGURE 9

**Developed drawing
of Stela 9 from
Kaminaljuyú
(Number 56)**

stone unworked. This suggests a decline in technical competence, or at least an unwillingness to spend long months laboring over a work of art. Perhaps the patrons of the art wished only to recall the Olmec style, without having to duplicate the Olmecs' extravagant outlay of manpower.

In a few cases Olmec forms were clearly revived. Olmecs of the heartland rarely placed the image of the man-jaguar on anything as common as vessels. But in Oaxaca, jaguarlike features appeared in the Late Preclassic period on ceramic containers bearing the faces of rain and fire gods. For example, during the earliest period of occupation of the Oaxacan acropolis site of Monte Albán (Figure 24), cylindrical incense burners like Number 76 were produced; they have faces with wide rectangular eyes, snub nose, and the curled feline mouth with wide upper lip, features seen on Olmec votive lapidary carvings (Figure 7). Since there was no precedent for these forms in the Olmec period in Oaxaca, the potters must have used lapidary heirlooms for models, coincidentally reflecting Olmec greatness (John F. Scott, "Post-Olmec Art in Preclassic Oaxaca," Ph.D. dissertation, Columbia University, 1970).

Except for such revivals, the use of sculpture in the round became much more restricted in the post-Olmec era (approximately 550–100 B.C.). Among the few examples are crudely carved "potbellied" sculptures of southern Guatemala, associated with the colossal heads at Monte Alto, which often retain the shape of the boulders from which they were formed. These and other sculptures show a carving technique that was less precise than in Olmec sculpture; forms were often only pecked out in post-Olmec art, not sharply defined. Even later, when a thorough technical mastery of stone carving was again achieved, fully three-dimensional sculpture was rare (Numbers 54, 55).

Relief carving was the major means of sculptural expression from the Late Preclassic period through the Classic. Two examples of stone relief in the exhibition reveal the variety of post-Olmec carving, yet both have elements in common. An early monolith from Kaminaljuyú, a suburb of Guatemala City, shows very well the dissolution of the vitality of Olmec sculpture. In this relief (Number 56, Figure 9), the human figure is angular and elongated, made to conform to the restrictions of the tall, narrow, irregularly cut stone. The visual impression is complicated by subsidiary motifs, including a scroll curling up from the mouth, indicating speech, a common later motif that appears for the first time here. The headdress, scrolls, and what must be glyphs spill over onto the two side planes. The nude male form, unlike Olmec figures in having its genitals clearly delineated, assumes a contrapposto that is curiously without tension.

A low-relief figure from Monte Albán (Number 57) displays much the same flaccidity, its legs loosely sprawling against the background, as if viewed from above while it lies flat on the ground. On very few of the three hundred known Preclassic relief carvings of male figures at Monte Albán are the genitals rendered; this one is typical in that they are replaced by a circle surrounded by flowing scrolls, probably representing blood due to emasculation. The face has the closed eyes and slack jaw of a dead man. All these features justify an interpretation of this figure

and others of the same type as slain men. Their varied headdresses, as well as the later use at Monte Albán of severed heads as symbols of conquered towns, suggest that the figures on the reliefs represent captured foreign warriors, humiliated, mutilated, and even slain during ceremonies in the temple complex.

Glyphs, evident on both the Monte Albán and the Kaminaljuyú reliefs, were used widely on sculpture of the post-Olmec era, although simple glyphs first appear on a unique Olmec work, Monument 13 from La Venta. Apparently, the geographic diffusion of this form of writing throughout southern Mesoamerica, and the consequent increase in the number of glyphs on each monument, took place only after the abandonment of La Venta.

While large stone sculpture continued to be a major art form only in the south in post-Olmec times, small sculpture in fine stone, the other important medium in Olmec art, remained important throughout Mesoamerica, especially in Guerrero (see Chapter 5). A large lapidary carving from highland Guatemala (Number 66), representing a bearded man seated on a bench, has a blockiness that robs it of the vital force characteristic of Olmec jade figures. At La Venta, two atypical monuments show a similar blocky style, one of them even portraying a figure sitting on a bench. Thus, this mode may have evolved even before the abandonment of that nuclear Olmec site.

Other types of sculpture from the highlands of Guatemala are quite unrelated to the Olmec style and may reflect a local folk tradition. Pedestal figures, with sharp, angular features, represent animals and captives, possibly sacrificial (Figure 10). "Mushroom stones," named for an umbrellalike hemisphere that surmounts a narrower support, often carved into a figure, seem closely related by their blockiness and angularity to the bench figures; in fact, one mushroom stone in the Museum of the American Indian shows a sharp-featured figure seated on a bench. Excavated mushroom stones date mainly from the Late Preclassic. Number 63 is angular and has pinched biceps like the bench figures, but is thinner and displays a more sensitive facial expression. No trace of Olmec features exists on the face,

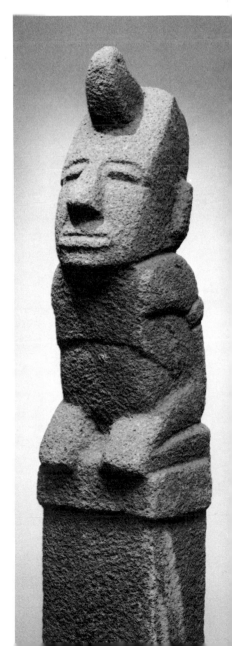

FIGURE 10

Pedestal stone with figure of a captive

A foot-high prisoner, his arms tied behind his back, is carved at the top of the 52-inch-high, slender, tapered stone stake in the collection of Mr. and Mrs. Jorge Castillo of Guatemala City. A fine representative of the squared style of pedestal sculpture from highland Guatemala, the figure has projecting from its forehead an extraordinary hornlike appendage, which might be a symbol of a shaman, a man who has the special ability to communicate with the spirits while in a trance (Peter Furst, "West Mexican Tomb Sculpture as Evidence for Shamanism in Prehispanic Mesoamerica," *Antropológica* 15, 1965, pp. 47 ff.).

emphasizing the sculpture's separation from the Olmec tradition in time. The non-Olmec style of the carvings suggests a local origin of the cult of the mushroom stones, which most likely began among the local population before the Olmec style arrived and was adopted by the provincial elite. Very possibly that cult involved the eating of hallucinogenic fungi to produce psychedelic effects, a practice still existing among isolated Indian groups in Mexico.

Following the transitional post-Olmec era, a new style of carving appeared in southern Mesoamerica, emphasizing softer, curved lines and more elaborate compositions. Since well-preserved monuments in this style are found in their original settings at the site of Izapa, on the Pacific slope of Mexico almost at the Guatemala border, the style has been named *Izapan*. At Izapa, stelae were set up in front of pyramidal mounds facing the central plaza; often they had a plain or zoomorphic altar stone placed in front of them (Figure 11). Three radiocarbon dates, all of 150 B.C., obtained from organic remains from the stela-producing level at Izapa, correspond to the transition from Late Preclassic to Protoclassic at the type site. The Izapan style can be recognized at the previously Olmec site of Tres Zapotes, Veracruz, and appears in great strength at Kaminaljuyú, where in later times many monuments were damaged and moved, and their architectural setting obliterated.

What seems to be the earliest form of Izapan carving has thick detail, executed in uniformly low relief; the composition usually centers on one figure, who is often engaged in combat (Number 59). The main figure on these stelae often brandishes a weapon or threatens a lesser figure. In fact, the subject matter of Izapan reliefs is much more violent than that of Olmec carvings. The taking of trophy heads, as

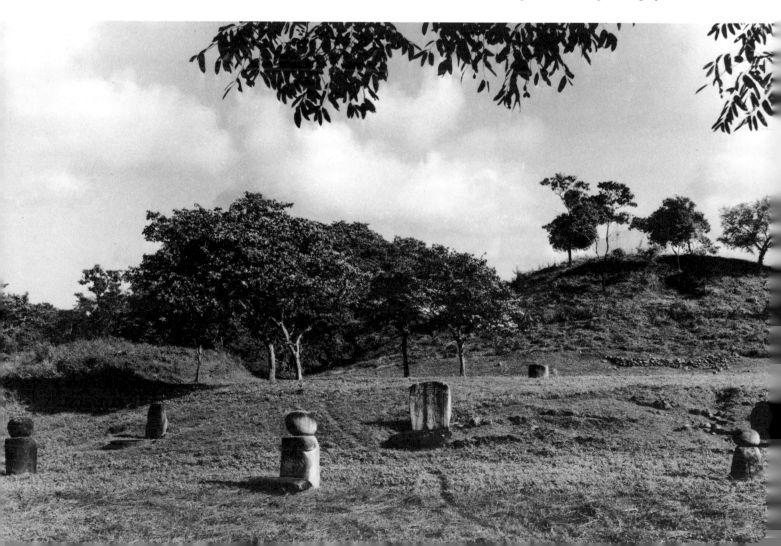

shown in Number 58, may even be a practice introduced in the Late Preclassic period. Figures are consistently dressed in elaborate costume, comprised of feathers, complex masked headdress, thick belt, and the ubiquitous brandished weapon. In what must have been unsettled times following the collapse of the central power of the Olmec heartland, the successor states in the various provinces may have violently disputed each other's claims over areas formerly dominated by the Olmecs.

In the apparent course of its evolution, Izapan relief carving developed a new fineness in the precision of cut forms, in the addition of delicate textures, and in the regularity of the stone shape. The blocks of stone were more evenly dressed, to conform to the geometric regularity of the carving, which often had a border completely framing the scene. Some relief carvings from the highlands of Guatemala have neither background nor framing border, the stone having been cut away along the outline of the figure to leave a silhouette. Portions of the stone within the outline were often cut away as well (Number 62). Precision in cut stonework was reflected in Protoclassic architecture, in which the low pyramidal temple platforms were faced with dressed blocks of stone or evenly modeled stucco, quite unlike the shaped earth of Olmec architecture or the rough boulders of post-Olmec.

Beginning late in the first century B.C. the Izapan style produced its most sophisticated monuments. The number of participants in the events depicted on a stela increases, but the artists carefully controlled their compositions by using a framing border and by having all the figures in a scene face in a common direction, as seen on Stela 10 from Kaminaljuyú (Number 60, Figure 12). The depth of the carving also varies, the very fine rendering of texture being subordinated to the deep main

FIGURE 11

Plaza in front of Mound 30 at Izapa

In the rear, echoing the shape of the Tacaná volcano, which is located nearby on the border between Mexico and Guatemala, is Mound 30, one of the main constructions at Izapa. It has recently been found to contain evidence of building and rebuilding beginning in the Middle Preclassic period. The present outline dates from the Protoclassic, when the carved monuments in the foreground were produced. In front of the raised terrace, three stelae stand in a row, with a circular altar stone directly in front of each. Facing the stelae is a row of unexplained cylindrical monuments topped by stone balls.

FIGURE 12

Drawing of Stela 10 from Kaminaljuyú (Number 60)

outlines of the figures. Glyphs appear on the Kaminaljuyú slab, with a large glyph in relief similar to those on the Monte Albán stone (Number 57) directly above smaller incised glyphs that seem to be the body of the text; all the glyphs remain undeciphered, but they appear to be ancestral to Maya writing. In this period, glyphs render the earliest written dates discovered in the Americas, all of them clustering between 35 B.C. and A.D. 36. The southern-highlands stelae with inscribed dates all have carvings in the Izapan style.

FIGURE 13

Carved stela at Dainzú, Oaxaca

The front façade of the main mound at Dainzú is decorated along its base by a row of over fifty carved slabs. Although the large majority depict tumbling ballplayers, four stelae show seated figures in elaborate costume and headgear, presenting offerings. All have anthropomorphic physiques, but only two are actually human beings; the other two are felines with long tails. On this slab, 51 inches high, the figure wears the mask of a long-nosed god and offers a jaguar head on a platter. The mound itself dates to late Monte Albán I / early Monte Albán II, according to the ceramics found beside it (Ignacio Bernal, "The Ball Players of Dainzú," *Archaeology* 21, 1968, p. 250). But the façade was probably constructed in the later of these periods, during the first century B.C., a dating substantiated by stylistic parallels with Izapa.

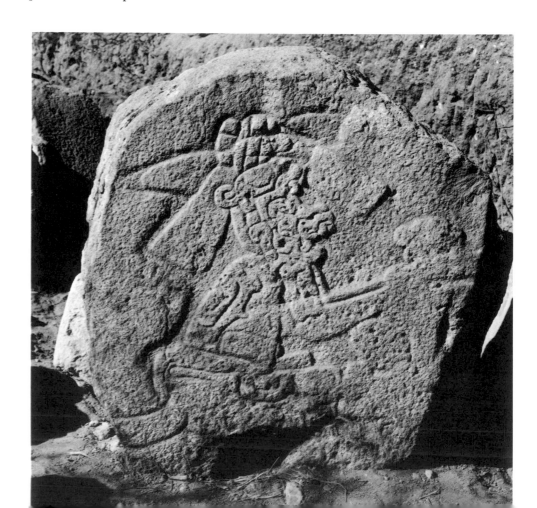

The fine quality of the developed Izapan style also appears on monuments from the south-central Gulf Coast of Veracruz. Finely carved low relief enhanced by engraved details characterizes a thin monument in the exhibition (Number 61). The facial traits, especially the thick upper lip and fleshy nose, hark back to the Olmec style of that same region, but the loose scroll pattern incised on the bottom border foreshadows later developments in Classic Veracruz art. The Veracruz center of the Izapan style must have been in close contact with the southern centers in Chiapas and Guatemala, perhaps via the Grijalva River valley or across the Isthmus of Tehuantepec.

Until recently, Oaxaca would have been included with Central Mexico and Guerrero as areas whose art lacked specific Izapan stylistic traits. But the carved stone slabs recently discovered in quantity at Dainzú display the rubbery limbs and prolific scrolls characteristic of the Izapan style (Figure 13). The deep carving and precise lines of the Dainzú reliefs recall Izapan technique, as does the sideways seated posture of the priest in Figure 13. Nevertheless, the form of the cut slabs and their use as facing for the base of a pyramid also relate the reliefs to the carved stones of early Monte Albán (Number 57).

Although Izapan sculptors directed their major effort to monumental reliefs, smaller objects received the attention of skilled craftsmen. A stone bowl (Number 74) shows great ingenuity in conception as well as finesse in execution and combines typical Izapan relief with a bird-necked handle carved in the round. A few works in fine stone can be attributed to the Izapan style, although the medium was certainly no longer as popular as in the post-Olmec style. A jade profile head (Number 69) shows many of the Izapan characteristics seen in large stone sculpture. A silhouette relief, it has the typical loose curves and relaxed lines of the Izapan style, plus the backward scroll used as a headdress, a motif also seen in a stela from Izapa (Number 58). Its low-relief carving and shaped outline display a similarity to silhouette reliefs typical of Izapan Guatemala.

Ceramics at Izapa, although usually decorated with abstract patterns rather than with representational images, included a few effigy jars, for example, a lively head with loosely hinged jaw (Number 78). A bird-head effigy jar from Oaxaca (Number 77) has many of the same features as the Izapa jar, such as the pug nose with perforated septum and the bulbous forms of which the face is composed. The short rounded scrolls that cover the face recall those on Izapan reliefs. The head thus must be later than the post-Olmec revival of Monte Albán I, which shows no Izapan traits. Yet the art of the second phase at that site does retain a few Olmec features (Number 155): the snarling jaguar mouth and the uptilted almond-shaped eyes, which, except for the dotted pupils, are Olmec in form (Figure 7).

The refined, sophisticated Izapan sculpture in clay and stone prefigures the dominant art of the Classic era in eastern Mesoamerica. The stelae of the Izapan centers, with their finely carved low relief, their depiction of elaborately costumed human beings in profile, and their use of hieroglyphic writing as an important element in the composition, introduce most of the dominant motifs found in stelae of the Classic Maya, which will be discussed in Chapter 9.

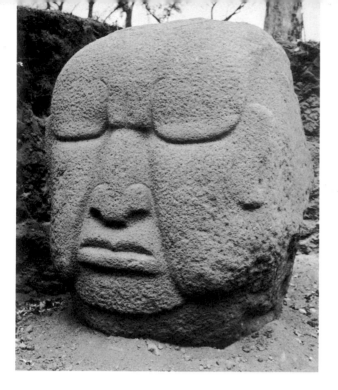

52 Monument 10 from Monte Alto

Light gray volcanic stone
Height: 59 in. (1.50 m.)
Monte Alto, Escuintla, Guatemala
Late Preclassic, 550–100 B.C.
Museo de la Municipalidad de La Democracia,
 Guatemala

This is the most naturalistically proportioned of the colossal heads discovered at Monte Alto, near La Democracia, where three are presently exhibited in the main square. All of the heads are roughly pecked, have partially unfinished sides, and show sharply defined closed eyes and mouths. There are no traces of headdress or other adornment except circular earspools, and even these are lacking in the head on exhibition. For a discussion of the identification of the Monte Alto sculptures as post-Olmec, see Lee Parsons and Peter Jenson, "Boulder Sculpture on the Pacific Coast of Guatemala," *Archaeology* 18, 1965, pp. 132–144.

53

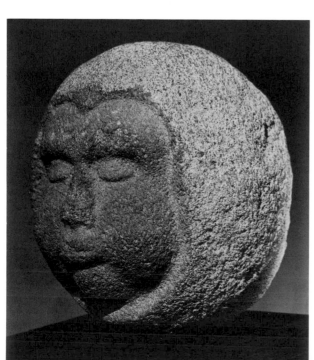

53 Round human head

Dark gray volcanic stone
Height: 13⅜ in. (34 cm.)
Kaminaljuyú, Guatemala
Protoclassic, Arenal phase, A.D. 100–250 or earlier
Joya Hairs, Guatemala City

The carver of this sculpture shaped a boulder into a sphere. The face was sunk slightly into the sphere, leaving the brow line, nose tip, and protruding lips abruptly cut off at the original circumference. The eyes are open, unlike those on the earlier, colossal heads from Monte Alto, but the carving technique is essentially the same. The head received a gouge in back when it was accidentally uncovered by a bulldozer.

54 Piggyback monkey group

Stone
Height: 15 in. (38 cm.)
Kaminaljuyú, Guatemala
Protoclassic, Arenal phase, A.D. 100–250 or earlier
Joya Hairs, Guatemala City

Found in 1961 with Number 53, this handsome composition is one of the few known examples of fully realized sculpture in the round from the Izapan period. The flattened circular shapes, abstract in themselves, combine to form a naturalistic image of a mother monkey carrying her half-grown offspring on her shoulders.

55 Jaguar from El Baúl

Stone
Height: 73 in. (1.85 m.)
El Baúl ranch, Santa Lucía Cotzumalhuapa, Escuintla,
 Guatemala
Protoclassic, Miraflores phase, 100 B.C.–A.D. 100
Herrera Hermanos, Guatemala City

In spite of its huge size, bared fangs, and exposed claws, this feline sits up and begs like a tame dog. The presence of the double-tiered collar reinforces the impression of a domesticated animal; perhaps it is a sign of anthropomorphism, since many "potbellied" human figures in stone from the Guatemalan highlands wear similar collars. The rounded eyes connect this piece to a Protoclassic frog altar from Kaminaljuyú, which has a similar combination of swelling, rounded forms. The tail of the jaguar, shaped like a backward question mark, looks like the loose Izapan curves. Known as Sculpture 14, it reputedly came from the same mound as a stela dated by the Maya Long Count to A.D. 36. The precision of the carving marks this figure as a masterpiece of Izapan sculpture in the round.

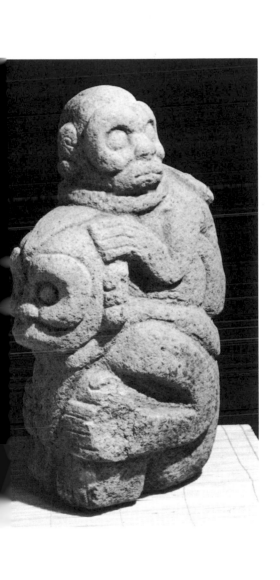
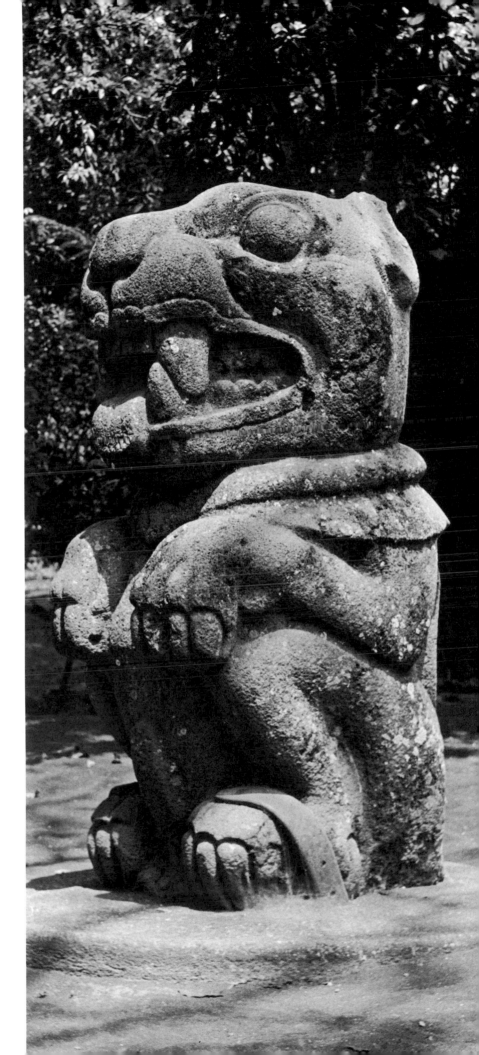

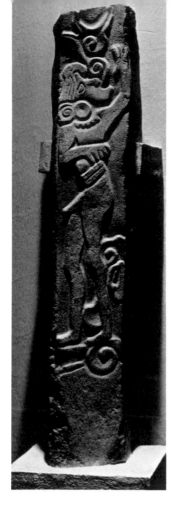

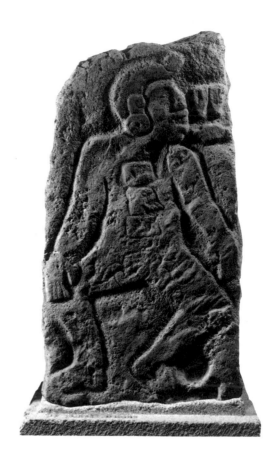

56 Stela 9 from Kaminaljuyú

Light gray columnar basalt
Height: 58⅛ in. (1.45 m.)
Kaminaljuyú, Guatemala
Late Preclassic, Majadas phase (?), 450–300 B.C.
Museo Nacional de Arqueología y Etnología,
 Guatemala, 2359

Controversial because of its unusual shape, its unique carving, and its intrusive placement into an earlier mound, this monolith has not yet been firmly dated. The cache of which this stone formed a part was placed into a Las Charcas phase mound, but contained pottery of the subsequent Majadas style. However, the five-sided, slightly irregular piece of basalt, a stone used frequently for enclosures at La Venta, was the only column among several found in the cache that was carved. This suggested to Edwin Shook, its excavator ("Guatemala," *Carnegie Institute of Washington Yearbook* 50, 1951, pp. 240–241), that the stone had been reused, having previously served as a doorjamb or possibly a lintel. The exceptional nature of the carving, formed of concave swirls and rubbery low relief (Figure 9), has already been discussed in the chapter text. The non-Olmec style and the use of a shell-like speech scroll, the earliest other examples of which appear among the Danzantes (beginning about 300 B.C.; Number 57), strongly favor a date contemporary with that of the pottery with which it was found.

57 Slab with relief of a Danzante

Gray stone
Height: 48 in. (1.22 m.); thickness: 16 in. (41 cm.)
Mound E, Monte Albán, Oaxaca, Mexico
Late Preclassic, Monte Albán I phase, about 200 B.C.
Museo Nacional de Antropología, Mexico, 6–6050

Figures of this type have been traditionally known as *Danzantes*, Spanish for "dancers," because of the flexed position of their legs. But this slab probably represents one of the conquered peoples who were tallied on a long wall with four rows of Danzantes. Subsequently it was incorporated into a Classic construction on the North Platform at Monte Albán (Figure 24). The identity of this figure may possibly be given by the three glyphs (only one, a feline head, identifiable) carved in very low relief on his chest, an unusual placement. In front of his face, perhaps indicating speech, are three more glyphs, two of which are grouped in a pair. Most of the relief is quite flat within the outline of the body, with little indication of bone or muscle. The neck muscles, however, tauten as the head strains forward, and in certain light one readily sees the heavy brow, the fleshy cheeks, the thick lips, the pair of large teeth, and the rounded eye orbit with closed lid incised.

58 Stela 21 from Izapa

Basalt
Height: 70 in. (1.78 m.)
Izapa, Chiapas, Mexico
Protoclassic, 150–1 B.C.
Museo Nacional de Antropología, Mexico, 5–1753

Discovered some eight years ago, this piece has broadened understanding of the culture of which Izapa is the type site. It renders in detail a decapitation, perhaps a form of trophy hunting; the blood spouting from the severed neck of the victim forms five streams, interspersed with bubbles. The presence of a spectator, who looks eagerly out of a litter supported by two men with a recumbent jaguar on top, places this scene outside the realm of ordinary combat. Judging from the heavy belts worn by both attacker and victim, the scene may represent an early version of the ritual ball game, which was played for very high stakes, as seen in the Late Classic relief at El Tajín (Figure 23). The overhead band framing the scene is carved with what may represent the fangs and snout of a sky monster.

59 Stela 19 from Kaminaljuyú

Stone
Height: 43 in. (1.09 m.); thickness: 3⅛ in. (8 cm.)
Kaminaljuyú, Guatemala
Late Preclassic, Providencia phase, 300–100 B.C.
Joya Hairs, Guatemala City

The human figure on this stela wrestles with a large constrictor, perhaps a sky serpent, and the knots on his belt and anklets terminate in snake heads. Two distinctive Izapan masks are represented: the mask of the long-nosed god is worn by the central figure; and the head of the snub-nosed dragon, usually associated with the earth, is the base for the arching snake body. The knobbed joints and patches on the lower portion of the limbs are characteristic of figures on early Kaminaljuyú stelae. The chest ornament is a variant of a symbol on a Providencia vessel. The stela, discovered in 1963, resembles Kaminaljuyú Stela 4, on which snake motifs also predominate (Suzanne Miles, "Sculpture of the Guatemala-Chiapas Highlands and Pacific Slopes, and Associated Hieroglyphs," *Handbook of Middle American Indians*, ed. Robert Wauchope, II, Austin, 1965, pp. 248–250).

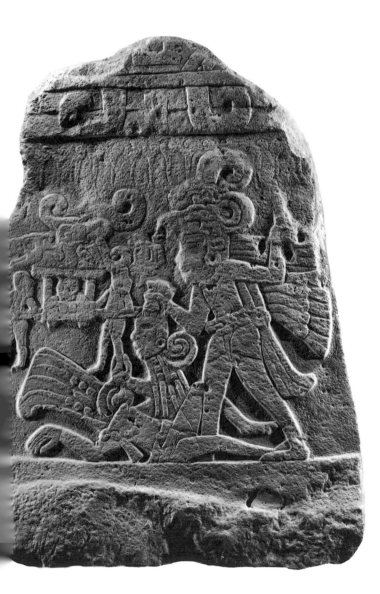

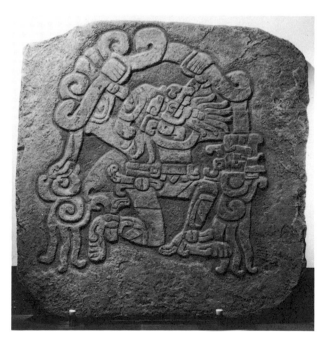

60 Stela 10 from Kaminaljuyú

Black basalt
Height: 48 in. (1.22 m.)
Kaminaljuyú, Guatemala
Protoclassic, Miraflores phase, 100 B.C.–A.D. 100
Museo Nacional de Arqueología y Etnología,
 Guatemala, 8138

This massive carving (see also Figure 12), broken and
then thrown into the fill for a pyramid, may once have
formed a square altar. Although it reads best vertically,
its thickness and weight mitigate against its having been
mounted like a stela or an architectural panel. The com-
plex representation cannot be fully understood since we
do not have the complete composition, which must have
been about five feet square. Rafael Girard (*Los mayas
eternos*, Mexico City, 1962, p. 400) has interpreted the
disembodied head in the upper right corner as the wind
god. The more human figure at the upper left, called the
rain god by Girard because he wields the axe of lightning
and has a cacao necklace, can be identified with the cen-
tral figure shown combating a serpent in other Izapan
stelae. His weapon looks like an eccentric flint (Numbers
200–202). The bottom figure, the most mortal-looking of
the three, has a snub-nosed masked head on his back in
the same position and with the same proportions as the
jug on the water carrier depicted on Izapa Stela 1. Be-
neath his upraised hands, originally presenting an offer-
ing, are what may be the earliest examples of writing
with what are clearly Maya glyphs according to J. Eric S.
Thompson ("Maya Hieroglyphic Writing," *Handbook of
Middle American Indians*, ed. Robert Wauchope, III,
Austin, 1965, p. 651).

61 Thin carved stela

Gray serpentine
Height: 47 in. (1.19 m.); thickness: 2¼ in. (5.7 cm.)
Orizaba region, Veracruz, Mexico
Protoclassic, 100 B.C.–A.D. 250
Tucson Art Center, gift of Frederick Pleasants
Ex coll. Pierre Matisse

While the dating of this stela has been debated, it can be
assigned to the Protoclassic style because of its similarity
to a stela from Tepatlaxco, in the municipality of Orizaba,
which has border bands related to those on Izapa stelae.
The border beneath the figure of a man on the stela on
exhibition has an incised design featuring the profile of
the snub-nosed masked head, bracketed by limp scrolls,
between bands of curvilinear stepped frets. The man
holds a tasseled spear (and possibly a spear-thrower) in
his lower hand; the small tasseled object in his upper
hand remains unidentified. In spite of the awkward man-
ner in which the shoulders are depicted, the whole carv-
ing is beautifully composed, with a good balance between
textured and plain surfaces and incised and low relief.

62 Silhouette relief

Light gray stone
Height: 43¼ in. (1.10 m.)
Kaminaljuyú, Guatemala
Protoclassic, A.D. 100–300
Alvaro A. Sánchez, Guatemala City

One of the most spectacular openwork carvings from
highland Guatemala, this piece seems to be intermediate
in style between the rippling-outline silhouette carvings
of the early Protoclassic (discussed and illustrated with
this piece in A. V. Kidder, J. D. Jennings, and E. M.
Shook, *Excavations in Kaminaljuyú, Guatemala*, Car-
negie Institute of Washington Publication 561, 1946, p.
103) and the openwork hachas of the mid-Classic (Num-
ber 152). The double-looped sandals, the hatchet, the
three-part belt with pendant head, and the sideways
striding position all suggest a date on the eve of the Clas-
sic period. The scrolls surrounding the lower part of the
figure, giving bulk to the composition, are firmer and
more regular than those in the Izapan style.

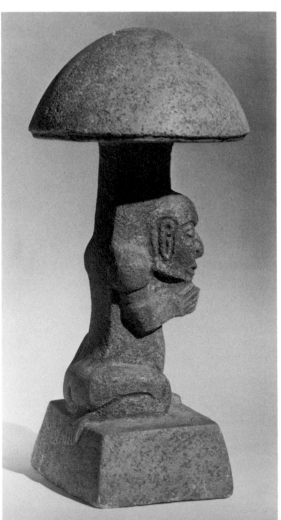

63 Mushroom sculpture

Gray volcanic stone
Height: 13 in. (34 cm.)
San José Pinula, Guatemala
Late Preclassic, about 300–100 B.C.
Carlos H. García Archila, Guatemala City
Ex coll. Carlos Galluser

Mushroom stones like this one, with a double edge on the underside of the cap, have been dated to the Late Preclassic by Stephan Borhegyi, based on the few that have been excavated in context at Kaminaljuyú (V. P. and R. G. Wasson, *Mushrooms, Russia, and History,* II, New York, 1957, fig. 19d). The liveliness of the figure that supports the mushroom cap derives from the graceful composition of its angular form, seen, for example, in the half-kneeling position of the legs, with one foot overlapping the base in a flattened plane.

64 Group of ten miniature mushroom stones and two metates

Gray stone
Height: 5½ to 7½ in. (14 to 19 cm.)
Kaminaljuyú, Guatemala
Protoclassic, Miraflores phase, 100 B.C.–A.D. 100
Karl-Heinz Nottebohm, Guatemala City

Nine of these mushroom stones were found in a cache in the Verbena cemetery outside Guatemala City; the tenth, seen in the center rear of the illustration, was found nearby. Nine miniature grinding boards (*metates*) with hand rollers reportedly came from the same cache; two of them are exhibited here. Although three seated human figures, two birds, and one animal are depicted, and four of the stones merely bear geometric decorations, Stephan Borhegyi suggested that they represented the nine Maya lords of the night ("Miniature Mushroom Stones from Guatemala," *American Antiquity* 26, 1961, p. 501).

65 Kneeling bearded man

Dark jade
Height: 3½ in. (9 cm.)
La Lima, Ulúa Valley, Honduras
Late Preclassic, 600–400 B.C.
Middle American Research Institute, Tulane University, New Orleans, gift of Doris Z. Stone

The pear-shaped head, the negroid cast of the face, and the forward kneeling posture relate the figure to monumental Olmec stone sculpture of the Veracruz-Tabasco heartland, but the protruding features and exaggerated deep lines of the face recall the Tres Zapotes monumental heads, considered to be post-Olmec. Ultimately, the sculpture appears transitional between true Olmec art and the blocky Guatemalan bench figures (Number 66), which it resembles in its massive shoulders, hunched posture, and short beard.

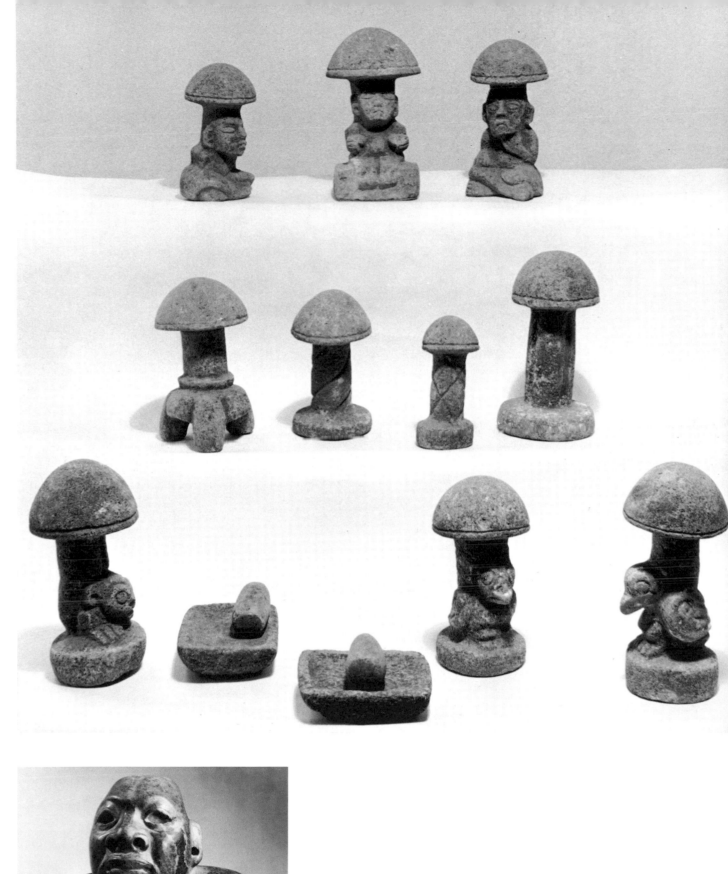
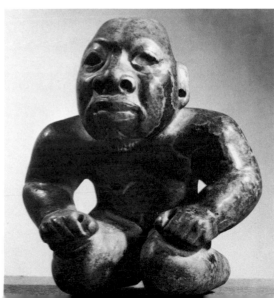

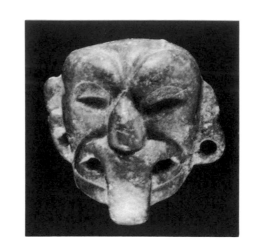

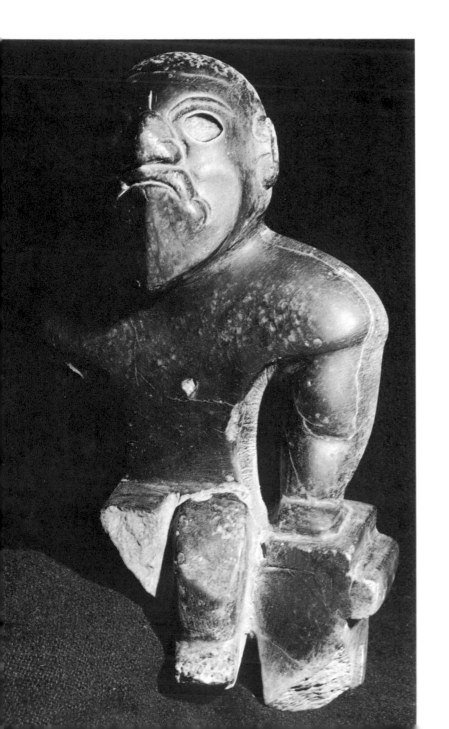

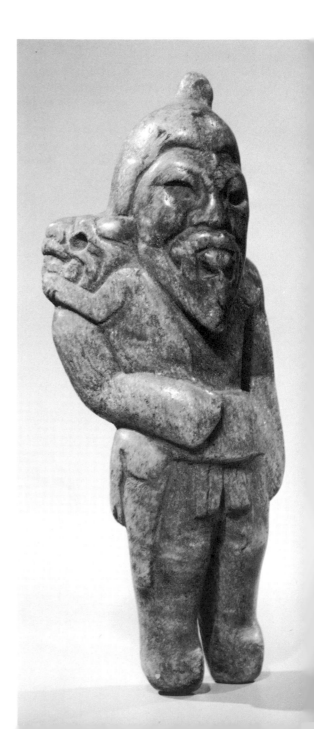

66 Bench figure

Polished black stone
Height: 10½ in. (26.5 cm.)
Villa Nueva, Guatemala
Late Preclassic, Providencia phase (?), 300–100 B.C.
Museo Nacional de Arqueología y Etnología,
 Guatemala, 3488

The muscular shoulders and large-featured, bearded face of this figure give it a monumentality that belies its size and makes us ignore the absence of the right arm and most of the right leg. The technique of saw cutting is evident in the groove between the thighs. The hair and rear portions of the figure are not polished, in contrast to the smooth front.

67 Long-nosed head pendant

Bright blue green fuchsite
Height: 1¼ in. (3.2 cm.)
Highland Guatemala
Late Preclassic, 450–1 B.C.
Anonymous loan to The Metropolitan Museum of Art,
 L.68.35.72

This head is a tiny version of the common Izapan motif of the long-nosed god, who wears a downturned mouth mask and has semielliptical plaques over the eyes (note the masked head on the back of the lower figure on Number 60). Fuchsite, a material the color of jade but much softer, was apparently very popular in the Late Preclassic, but ornaments made of it are rarely discovered in any later style.

68 Man holding a jaguar cub

Pale green fuchsite
Height: 7¾ in. (20 cm.)
Tamahú, Alta Verapaz, Guatemala
Late Preclassic, 400–200 B.C.
Museo Nacional de Arqueología y Etnología,
 Guatemala, 5095
Ex coll. Dieseldorff

Clearly Olmec-derived in its theme of a jaguar cared for by a man with slightly feline features, this figure nevertheless has a heaviness in proportion and detailing that relates it to bench figures like Number 66. The textureless, pointed beard may be a characteristic feature of post-Olmec renderings. Two pairs of holes in the back indicate that the figure served as a pendant (Alfred V. Kidder, "Miscellaneous Archaeological Specimens from Mesoamerica," *Carnegie Institute of Washington Notes on Middle American Archaeology and Ethnology* 117, 1954, fig. 9b). (See Color Illustration.)

69 Profile head pendant

Brown green jadeite
Height: 4½ in. (11.5 cm.)
Nicaragua (?)
Late Preclassic, 200–1 B.C.
Museum für Völkerkunde, Berlin, IV Ca 4175
Ex coll. Dr. Behrund

The drilled hole that pierces the septum of the nose extends as a channel across the upper lip. On the forehead, the band that gives the impression of surrounding the face seems to pass through the buckle directly over the nose and then turns down as it would on the unseen right cheek. This treatment of the upper lip and the headband gives the effect of a three-quarter view, almost unknown in early art.

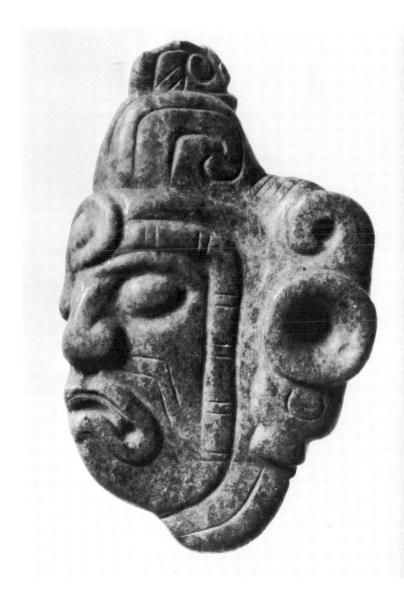

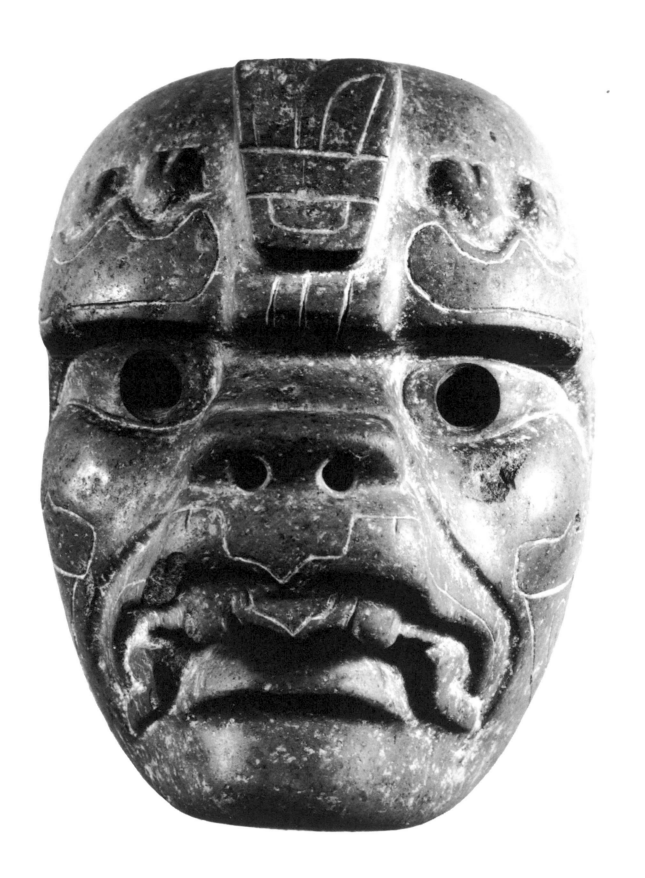

70 Mask of man-jaguar

Dark green serpentine with white earth incrustations
Height: 7⅛ in. (18 cm.); thickness: 4⅜ in. (11 cm.)
Pánuco region, Veracruz, Mexico
Late Preclassic, 300–100 B.C.
Peabody Museum of Archaeology and Ethnology,
 Harvard University, Cambridge, Massachusetts, gift
 of A. M. Tozzer, 1937, 4891
Ex coll. Mrs. Elsie MacDougall

When this mask was purchased in Mexico City in 1927, it was said to have come from an hacienda in the Huasteca, but this provenance could be explained only by long-distance trade. In fact, a medallion in the same style is often seen in the center of the forehead on effigy vessels from Monte Albán, Oaxaca (Number 77). The flaming eyebrows, an Olmec feature, were also revived in Late Preclassic Oaxaca; a rain-god jar from the Small Ball Court at Monte Albán has similar eyebrows. The snub nose and downturned mouth corners are standard Olmec iconography, but the awkward incising suggests an archaistic rendering of the life-size masks produced in Olmec times (Figure 8).

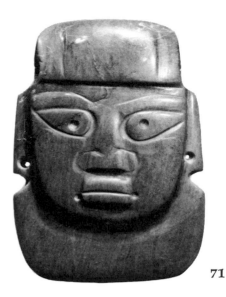

71

71 Bib-head pendant

Deep green streaked jadeite or prase
Height: 2¾ in. (6.9 cm.); thickness: ⅝ in. (1.7 cm.)
Cuautitlán, state of Mexico
Late Preclassic–Protoclassic, 300 B.C.–A.D. 250
Mr. and Mrs. William B. Jaffe, New York

Although bib-head forms are found in a wide area, from the Valley of Mexico (where this piece was discovered in a group including at least seven others) and Guerrero down into Central America, it seems most probable that they were made somewhere in the Maya zone. Their Preclassic date is proved by the association of a shell bib-head pendant with Chicanel ceramics (including a spouted jar with the profile of the Izapan long-nosed god excised on the side) in a tomb near El Bellote, Tabasco (Matthew Stirling, "An Archeological Reconnaissance in Southeastern Mexico," *Bureau of American Ethnology Bulletin* 164, 1957, p. 232, pls. 65–66). It is clear that a simplification of the Olmec method was used in cutting the face, which is constructed around a raised triangle that defines the nose and mouth and that terminates in drilled pits at the corners of the mouth. The incised, pit-centered eyes, however, are not an Olmec feature, and the bib-shaped collar is also distinctive. Known examples of bib-heads are rarely as delicately carved as this one or of such fine stone.

72 Mask pendant

Polished brownish green stone
Height: 3½ in. (9 cm.)
Provenance unknown
Protoclassic, 100 B.C.–A.D. 250
Museum of the American Indian, Heye Foundation,
 New York, 23/8497

Stylistically, this piece is related to the bib-heads (Number 71) by the squared headdress with raised central crest, flanged ears with perforations near the bottom, and incised teardrop eyes with small drilled pupils. The nose and mouth are more fully realized, however, and the back of the pendant has been hollowed out, leaving large circular drill marks. Possible use over the lower part of the face is suggested by the deeply bored cavity behind the nose, with two tiny perforations at the nostrils. A mask pendant of similarly hybrid character, but slightly more Mayoid, was excavated in the southern Cayo district of British Honduras, and a number of bib-heads have come from that region and from the Yucatán Peninsula (Adrian Digby, *Maya Jades*, London, 1964, pl. xv).

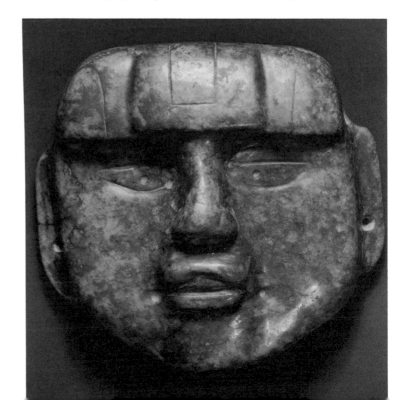

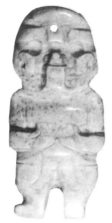

73 Standing masked figure

Whitened albitic jadeite
Height: 2¾ in. (7 cm.)
Potrerillos de Liberia, Guanacaste, Costa Rica
Protoclassic, 200 B.C.–A.D. 250
Mr. and Mrs. Juan Dada, San José, Costa Rica

This figure from the Nicoya Peninsula region—traditionally the southern end of Mesoamerica—displays an interesting combination of features from different areas. The plaques that form the face mask, especially the cheek scrolls, resemble those of a colossal head from Cerro de las Mesas. The pinched upper arms and the blocky carving of the shoulders recall the style of bench figures from Guatemala (Number 66). The double-strand loincloth and heavy belt appear on Number 68, also from Guatemala. Costa Rican in character are the large drilled eyes and the flatness of the figure, probably used as a pectoral.

74 Bowl with bird-neck handle

Gray green chlorite schist
Length: 8¼ in. (21 cm.)
Tomb 1, Kaminaljuyú, Guatemala
Protoclassic, Miraflores phase, first century B.C.
Museo Nacional de Arqueología y Etnología,
 Guatemala, 2780

This ladlelike carving was among 345 objects of ceramic, jade, and stone that were left as offerings for the nobleman who was buried with a slain retainer at the bottom of the pit of Tomb 1 at Kaminaljuyú. The tomb was stepped down in a series of concentric rectangles into the

body of an earlier construction (Edwin Shook and Alfred V. Kidder, "Mound E-III-3, Kaminaljuyú, Guatemala," in Carnegie Institute of Washington Publication 596, 1952, pp. 108–109).

75 Bowl with child's face

Burnished orange clay with dark gray firing smudges
Height: 5 in. (12.5 cm.)
Atzompa, Oaxaca, Mexico
Preclassic, 900–1 B.C.
Howard Leigh and Museo Frissell de Arte Zapoteca,
 Mitla

The ware of this bowl has been attributed to the Middle Preclassic period, possibly the Guadalupe phase (900–450 B.C.) by Kent Flannery, who recently defined the Preclassic sequence in the Valley of Oaxaca. However, the style looks like that of early Monte Albán II (150–1 B.C.). The upward-slanting incised eyes with iris and pupil indicated, the softly modeled face, and the lip that curves as though a feline were being depicted are all seen on Number 155. The abstract flange of the ears recalls an Izapa jar (Number 78). The sensitive face brings to mind the wide-eyed Zapotec children of present-day Oaxaca.

76 Effigy-head brazier

Tan clay with white slip
Height: 7 in. (17.8 cm.)
Nazareno, Oaxaca, Mexico
Late Preclassic, Monte Albán I, 200–150 B.C.
Museo Nacional de Antropología, Mexico, 6–61

Cylinders of this type have a raised floor, at the level of the forehead band, making it probable that they were used as braziers. Evidence indicates that the portion under the floor shielded the fire, and the perforations in the sides and in the pupils of the eyes allowed the air to enter. Because of its association with fire, this head has traditionally been identified as a young fire god (Alfonso Caso and Ignacio Bernal, *Urnas de Oaxaca*, Mexico City, 1952, pp. 326–330, fig. 486a).

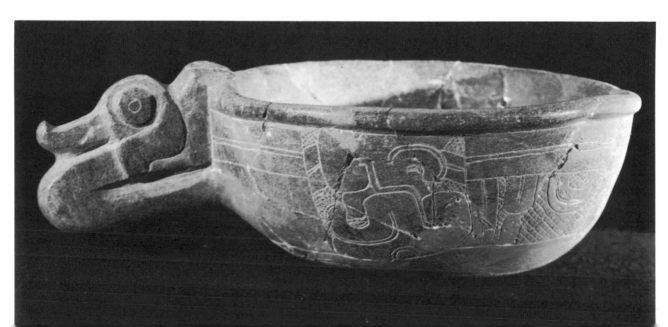

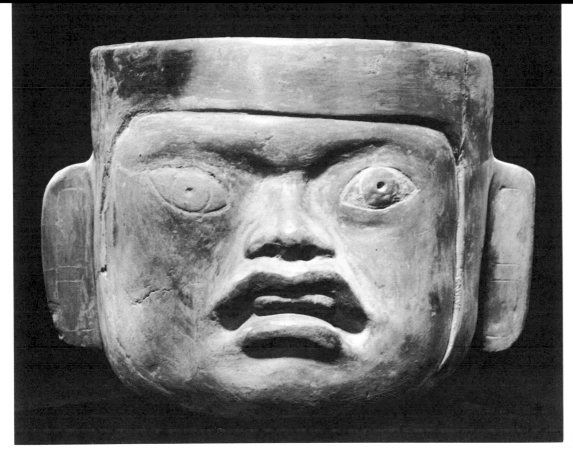

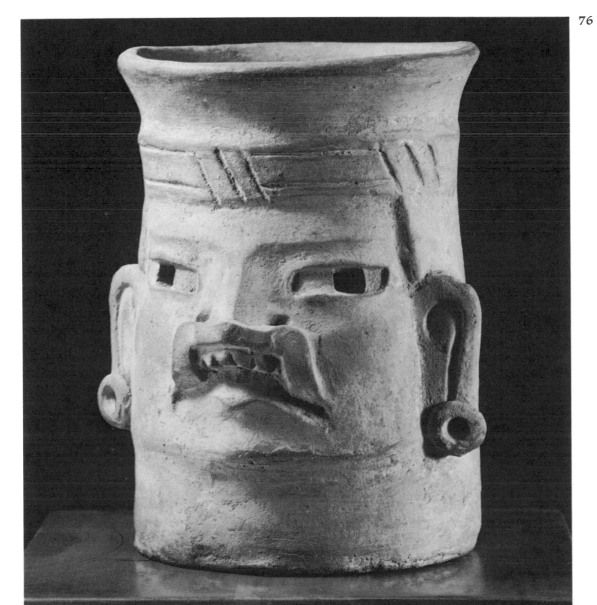

77 Vase with bird-head mask

Incised and modeled gray clay
Height: 7½ in. (19 cm.)
Zegache, Oaxaca, Mexico
Protoclassic, early Monte Albán II phase, 150–1 B.C.
Museo Nacional de Antropología, Mexico, 6–1478

Although Alfonso Caso and Ignacio Bernal (*Urnas de Oaxaca*, Mexico City, 1952, pp. 202–203) placed this vase, from an uncontrolled excavation, in the Monte Albán I style, it more probably dates from the very beginning of phase II at Monte Albán. The rounded curls reflect the Izapan style in Oaxaca rather than the post-Olmec style of Number 76, with its squared lines. The rounded forms of eyes and cheeks, and snub nose with perforated septum, relate it to Number 78.

78 Jar with the head of a wind god

Clay with red and ocher slip
Height: 11⅜ in. (29 cm.)
Izapa, Chiapas, Mexico
Protoclassic, 100 B.C.–A.D. 100
Museo Nacional de Antropología, Mexico, 5–1447

This effigy jar with wide-open mouth was found in 1962 in the rich Urn Burial 6 from Mound 30 at Izapa (Figure 11), where the excavations of the New World Archaeological Foundation revealed the first ceramics firmly associated with the type site. Also in this burial was a jade necklace terminating in a pendant of a human face with a large hollow circle as a mouth. The wide-open mouth motif on the jade pendant and the jar may indicate an early manifestation of the wind god. The jar seems to show a mask covering the upper lip and hooked under the ears. A flaky layer of stucco, poorly preserved, was removed from the jar when it was excavated. (See Color Illustration.)

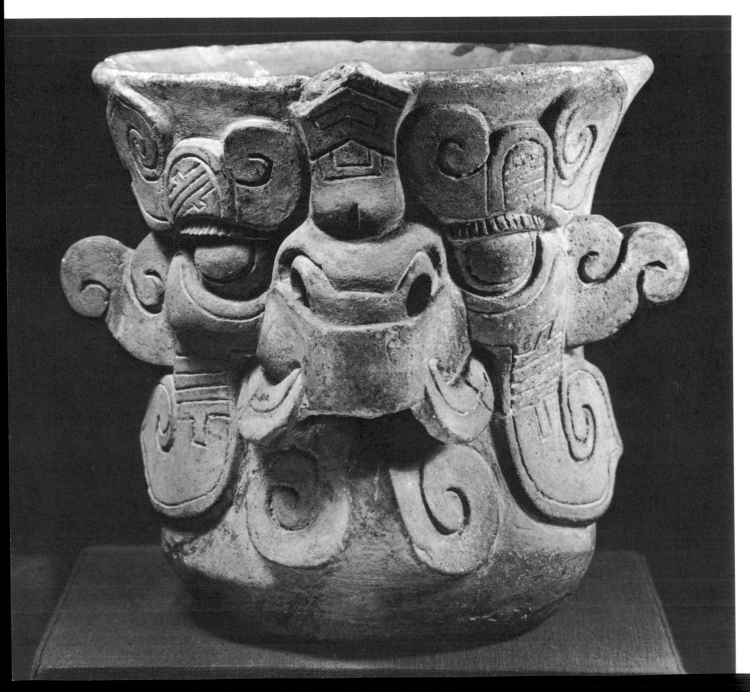

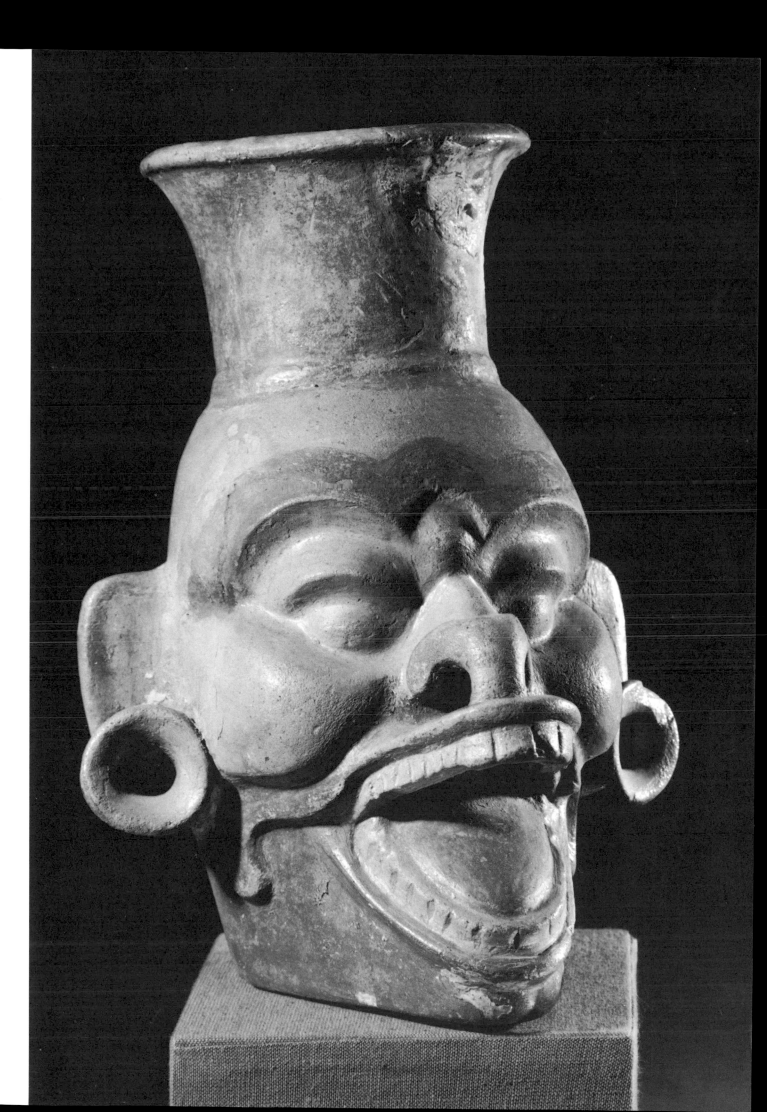

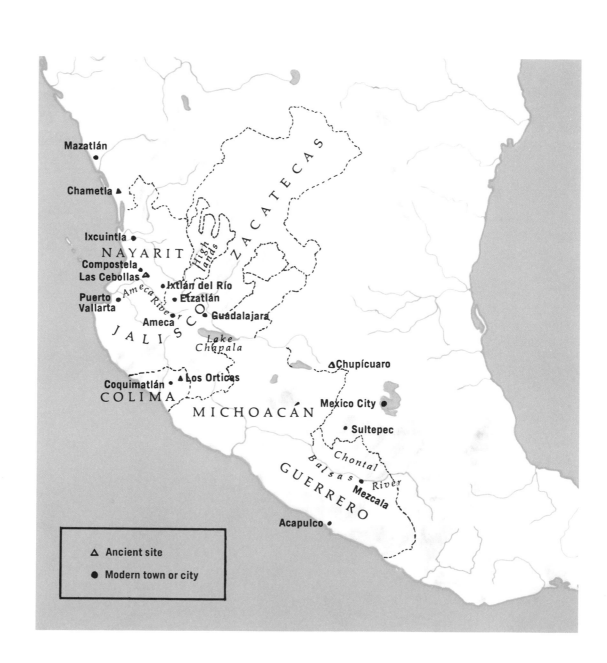

Mazatlán

Chametla ▲

Ixcuintla ●

NAYARIT

Compostela

Las Cebollas ▲

Ixtlán del Río ●

Puerto
Vallarta ●

Ameca River

Etzatlán ●

J A L I S C O

Guadalajara ●

Ameca ●

Lake
Chapala

Coquimatlán ●

▲ Los Ortices

COLIMA

MICHOACÁN

ZACATECAS

High lands

△Chupícuaro

Mexico City ●

● Sultepec

Chontal

GUERRERO

Balsas River

Mezcala ●

Acapulco ●

△ Ancient site

● Modern town or city

5

The Western Fringe

Beneficiaries of a gradual and selective filtration of Olmec techniques and cultural traits, the ancient populations of the remote western areas of Mexico slowly became partially incorporated into Mesoamerican civilization. The present-day state of Guerrero, the southernmost portion of the region termed *Western Mexico*, was influenced mainly by the center of Olmec culture in Veracruz, directly to the east. Only one characteristic Olmec art form was widely adopted in Guerrero: the working of jade and other greenstones. Paintings in Olmec style are also known in the caves of Juxtlahuaca and Oxtotitlán. To the northwest, in the modern states of Colima, Jalisco, and Nayarit—the other major area traditionally included in Western Mexico—the source of Olmec influence was the northern extension of that civilization in Central Mexico, again directly to the east. Since Central Mexico excelled in the production of clay figures, both solid and hollow, this became the most distinctive art form of the region.

Although these two major Western cultural-stylistic areas, Guerrero and Colima-Jalisco-Nayarit, apparently had no communication with each other when their distinctive arts evolved, they nevertheless can be considered approximately contemporary, even in view of the great scarcity of good archaeological dating throughout the area. Developing along separate lines after the weakening of Olmec hegemony, they refined their art forms during the Post-Olmec period, achieving in the Protoclassic a dazzling florescence. The large production and high quality of execution are especially impressive when one considers the restricted area in which each regional style was created.

At the time of the Conquest, both Guerrero and Colima-Jalisco-Nayarit were inhabited by people speaking dialects of the Nahua linguistic group, which includes the languages of the Aztecs and their forebears who lived in the desert areas of northern Mexico and the United States. The state of Michoacán, between Guerrero and Colima-Jalisco, was inhabited by an entirely different ethnic group, the Tarascans. Important for their Postclassic kingdom, which maintained its independence from the Aztecs and exerted control over many other Western peoples, the Tarascans cannot be easily distinguished from the other inhabitants of Western Mexico through archaeological remains from earlier periods. (For examples of Postclassic

Tarascan art, see Numbers 270, 271.) The first man to study the ancient remains from the West, the Norwegian naturalist Carl Lumholtz, concluded at the beginning of the twentieth century that the general similarity of figurines found throughout the area proved that they all were produced by the Tarascans. Since that time, the distinctiveness of each regional style has become more apparent. Rather than attempting to identify the ethnic group that produced each style, this chapter will refer to the geographic regions from which the objects came, avoiding both the old-fashioned term *Tarascan art* for the entire group, and the more popular belief that the art was produced by the Nahua-speaking Cora and Huichol, who now reside only in the mountains of Nayarit and Jalisco.

Guerrero, which extends from Taxco in the north to Acapulco on the coast, is traversed from east to west by the great Balsas River (Figure 14). Midway along its course, spectacular art in fine stone has been uncovered during extensive tomb hunting. Because a considerable number of carvings from just north of the Balsas are in the purest Olmec style (Number 51, Figure 8), a few scholars have proposed that Guerrero or the adjoining states were the original home of the Olmecs prior to their settlement in Veracruz-Tabasco. Although this theory has not been disproved, the apparent absence of Olmec ceremonial centers and large stone sculpture suggests that Guerrero's principal contribution to the Olmec style was in the art of lapidary work. Since jade and fine greenstone were unavailable in the low-lying Olmec heartland, they had to be obtained from such mountainous regions as Guerrero, this trade providing the means by which that aspect of Olmec culture took root. Rather than transporting the stone in uncarved form from Guerrero, the Olmecs may have preferred to have many objects carved locally by native artisans, thus introducing their lapidary techniques without most other aspects of their civilization.

After the departure of Olmec traders, Guerrero artists evolved two local styles, each of which was apparently confined to a very small territory. The figures discovered north of the Balsas River, in the territory of the finest Olmec finds, are in the more naturalistic Chontal style, named for a shadowy ethnic group once inhabiting that area. Some Chontal figures turned up in an Early Classic Veracruz (Cerro de las Mesas) jade cache, which included several heirloom Olmec pieces, confirming the relationship of the Chontal region with Veracruz.

South of the Balsas, in the hinterland behind the town of Mezcala, appear objects

FIGURE 14

The Balsas River near Mezcala, Guerrero

A torrent in the rainy season, the river (viewed here from the Mexico City–Acapulco highway) cuts through the rugged mountains of Guerrero. South of the near bank, the early inhabitants carved abstract greenstone figures and temples. Across the river, on the north shore, is the beginning of the Chontal area.

in a more abstract style. Only fragmentary archaeological evidence exists concerning the date of the Mezcala style. Although Mezcala figures and Chontal masks appear in late Aztec tombs, these imported pieces may have come as tribute exacted from Guerrero residents, who had to loot older tombs to fulfill the demand, much as they do today to fill the demand of the international art market. The earliest Mezcala figures that can be dated were unearthed beneath a wall built at the beginning of the Classic period in the Central Mexican metropolis of Teotihuacán. The fine stone carving in the Teotihuacán style (Numbers 112, 116) was perhaps inspired by Mezcala lapidary work. A reverse influence from Central Mexico into Guerrero during the Early Classic explains why certain Mezcala greenstone figures have Teotihuacán features; these seem to mark the end of the distinctive regional style of Mezcala. However, the Mezcala carvings may also have helped form the style of Postclassic *penates,* or talisman figures, in neighboring Puebla and Oaxaca (Number 267).

The inherent beauty of Mezcala stonework, so attuned to today's taste because of its dramatic abstraction of the human form into planes and grooved lines, has attracted both collectors and artists. As the first to study it seriously, the artist and art historian Miguel Covarrubias pointed out the Olmec derivation of Mezcala carving and its transition into Teotihuacán forms (*Mezcala, Ancient Mexican Sculpture,* New York, 1956). Carlo Gay subsequently provided a tentative classification of Mezcala carving into thirteen types (*Mezcala Stone Sculpture: The Human Figure,* The Museum of Primitive Art Studies 5, New York, 1967) and suggested that the sculptures closest in shape to the simple celt or hand axe were the earliest.

Most of the carvings in the Mezcala style depicting human beings have a basic elliptical shape, like a hand axe, perhaps derived from Olmec celts (Figure 7). Grooves and intersecting planes define the forms, thereby making fussy detail and representation of texture unnecessary (Number 79). Eyes and mouth are often not even indicated, while the nose is formed by the juncture of three planes, those representing the two cheeks and the mouth area. Grooves cut into the mass define essential details such as the mouth and arms. Horizontal grooves separate the figure into several zones: the forehead, the face, the torso, and the legs. This planar quality and division into zones continues in the rendering of temples. Typically, a flight of steps in front leads up a tiered platform to the temple proper, made of four piers supporting a roof often capped by a vertical architectural comb (Number 84).

Figures in the Chontal style, which occurs in northern Guerrero and the southwestern part of the adjoining state of Mexico, have considerably more detail on the face, hands, and clothing (Number 86) than the Mezcala figures. In addition, the backs are carved, the legs flexed, and the heads set forward in Olmec fashion. This contrasts with early Mezcala figures, which have completely unworked backs, while figures in the late Mezcala style have carved backs and flexed legs reminiscent of the Chontal style, suggesting a convergence of the two. Another variety of Chontal lapidary carving consists of face masks, some with eye holes (Number 87), but many without any facial openings. These masks have squared forms and are relatively flat, with the exception of the sharply protruding nose. Widely traded,

Chontal objects appear in tombs of many periods throughout Mesoamerica, possibly indicating a long-lasting tradition.

One of the few vague connections between Guerrero and the area further to the northwest can be seen in a luminous chalcedony mask from Colima (Number 88), which shares the sharp nose and simplified features with the Chontal masks. However, its rounded form and ear flanges, as well as its carved headband, certainly set it apart from anything in the Guerrero tradition as well as from the Teotihuacán style. This fine mask is not, however, isolated within the artistic orbit of Colima; it forms a variation in stone of the more common masks executed in clay (Number 89), the medium in which the most spectacular artistic achievements of Western Mexico were executed.

The clay tradition in the West clearly relates to the widespread figurine cult of Preclassic Mesoamerica. This tradition encompassed both solid figurines and larger, hollow figures. Both forms occur simultaneously at Chupícuaro, a site halfway between the Valley of Mexico and the Colima-Jalisco-Nayarit area (Number 27). In fact, the concept and techniques of manufacturing figurines to be placed in tombs may very well have been transmitted in the Late Preclassic by the Chupícuaro culture from Central Mexico to the Western region, where Chupícuaro trade ware appears in tombs.

Potters of each district maintained distinctive local styles, many of which were coeval. Although further controlled excavations will no doubt result in the identification of many local styles and sequences, at this point we can distinguish four main regional styles, found at Los Ortices, Colima; Ameca, Jalisco; Ixtlán del Río, Nayarit; and Compostela, Nayarit. Yet the contents of single tombs reveal considerable exchange among the four main regions, with figures of one style appearing in tombs of more than one region. Tombs apparently were reused over a period of centuries, probably by members of the same lineage, which complicates the establishment of a sequence.

The tombs of all these areas were entered by a long vertical shaft sunk into the ground until it reached a layer of hard rock, at which point a horizontal passageway led off to one side and opened up into an arched chamber. The entrance to the tomb was filled and sealed with a slab flush to the ground, rendering it invisible, although a low mound was occasionally added. In Colima, stones with hemispherical depressions are considered by some to have been "maps" for locating the tombs, which were clustered in cemetery zones away from the habitation centers. The handsome pottery sculptures provided in abundance as offerings for the dead do not appear among the refuse of the villages, indicating that they had a purely funerary purpose.

Among the Western solid figurines, surely one of the liveliest is the feathered dancer from Colima (Number 90), whose movement and extended limbs distinguish him from the more common flat figures. Nevertheless, details were added to both by means of pressing lines into lumps of clay. The resulting "coffee-bean" eyes can be considered a hallmark of the early Colima style. Similar eyes appear on the faces of large hollow figures from Colima (Number 91), which are slipped with red and highly burnished. Western hollow figures often have the same simplicity

of form as the large Chupícuaro figures, but without the latter's geometric rigidity. Instead, their flowing forms extend into space in asymmetrical compositions, which give them a lively grace.

Recent excavations undertaken in Colima, Jalisco, and Nayarit by the University of California have greatly supplemented the scanty earlier work in the region. For the first time, it has been established by means of radiocarbon dating that the large figures were produced not in the Classic period, as had been previously thought, but in the Late Preclassic. One tomb in Jalisco (San Sebastián) yielded a range of radiocarbon dates suggesting that the different styles of figurines in the tomb should be arranged chronologically (Stanley Long, "Archaeology of the Municipio of Etzatlán, Jalisco," Ph.D. dissertation, University of California at Los Angeles, 1966). Nude redware figures of Nayarit style (Number 102) were the earliest in the tomb, and date perhaps from the second century B.C. Interestingly, their red slip and protruding, horizontally incised eyes correspond quite closely to those of Colima figures, suggesting that the two styles were not yet wholly distinct during this early phase.

Found in the same tomb, and given a later date, were grayware figures of a type identified with Ameca, Jalisco (Numbers 94–96). Their more naturalistic proportions and well-modeled details are in strong contrast to the elephantine, unornamented shapes of the Nayarit redware figures. Eyes on the Ameca figures are more complex anatomically, the eyeball being formed by a pellet and surrounded by fleshy lids.

The latest figures in the tomb were angular, with considerable painting of tattooing and clothing, indicating that the artist was as attentive to the depicting of details in lines as to the modeling of large forms (Number 97). The eyes are more flattened, the facial features harsher. This style was dated by radiocarbon to the third century A.D., at the time of transition between Preclassic and Classic. Similar qualities are evident in figures from Ixtlán del Río, Nayarit, not far to the north (Number 104). Many figures from Ixtlán, presumably later, have exaggerated pop-eyes, huge noses and ears pierced and bearing rings, flattened torsos with thin, undersized limbs, and gaudy paint applied after firing in three or four colors, creating grotesque images at once ugly and arresting. Deformed and diseased people are frequently represented; their detailed pathological depiction may indicate that such figures had some curative or protective purpose.

Another recent radiocarbon date, A.D. 115 ± 100, from a tomb at Las Cebollas, near Compostela in the southwestern part of Nayarit, confirmed the Protoclassic dating of hollow clay figures (Peter Furst, "Shaft Tombs, Shell Trumpets, and Shamanism" Ph.D. dissertation, University of California at Los Angeles, 1966, p. 140). The tomb also gave the best location and association of the recently designated *Chinesca* style. Figures in this style characteristically have wide faces with a serene expression and slit eyes and mouths. They have the same vaguely Chinese cast to their faces as many Mexican children, called *chinescos* by their parents. As in the case of the Jalisco tomb, the tomb at Las Cebollas contained examples of several styles, suggesting both considerable trade between artistic regions and a prolonged period of continuing interment into the same tomb. Figures of the most

119

common Chinesca type (Number 99) have slit eyes and negative paint, recalling the figures in the Nayarit style from the other tomb (Number 102). The most handsome type has well-modeled eyes and very little body paint (Figures 15, 16), suggesting contemporaneity with the Ameca Grayware figures (Number 96). The strangest type of Chinesca, apparently from the northern part of Nayarit, has a flat, broad head with a dip in the crown and boldly contrasting paint, creating a bizarre, masklike image (Number 101).

The distinctive shaft-and-chamber tombs of Colima, Jalisco, and Nayarit occur nowhere else in Mesoamerica but are characteristic of the Andean civilizations of South America, as are the stone "maps" with circular depressions from Colima. Many other elements also suggest a possible connection with inhabitants of the northern Pacific coast of South America, who could have sailed north on balsa rafts. For example, squash and crustacean forms rendered in polished red ceramics from the North Coast of Peru could easily be confused with similar forms from Colima, were it not for different spouts. The numerous ear and nose ornaments on the Western clay figures (Number 99) look like South American metal rings; however, no metal has been found in Protoclassic Western tombs. Phallic themes occur in both areas, although they are rare in other American artistic traditions. Textile patterns rendered on shirts of Nayarit figures strikingly recall those on Mochica warrior effigies from northern Peru, who also wear helmets of the same shape as those of Jalisco. Northern South America and Western Mexico are among the very few places where entire scenes, including buildings and their inhabitants, were represented. Roofs shaped like saddles, with high peaks and low centers, such as in a Nayarit scene (Number 105), occur in the art of Ecuador, the natural jumping-off point for any direct voyage to Mexico. In view of the strong differences between the culture of Western Mexico and that of the rest of Mesoamerica, and the several points of similarity to South America, some form of direct contact between northern Peru or Ecuador and the West of Mexico seems likely during the Protoclassic period.

The art of Western Mexico does not suggest the worship of a hierarchy of deities, each with special attributes. Instead, religion apparently revolved around shamans, who interceded in the spirit world and could defend men's souls in battles against the powers of darkness. The prevalence of shamanism would explain many representations in Western Mexican art, such as the battling tomb guardians (Number 95) or the plentiful Colima animals (Number 93), which may have assisted the shamans in the underworld. Nevertheless, familiar subjects and humorous vignettes, such as the village scenes from Nayarit and Colima, dominate the art of all Western Mexico. Depictions of family warmth and love emphasize the strong humanity of Western culture. Although some elements of rank surely existed—evidenced by sculptures of men in litters—the common villager was held in greater esteem than in the more rigidly class-structured societies of the rest of Mesoamerica, where priests and princes dominated the iconography.

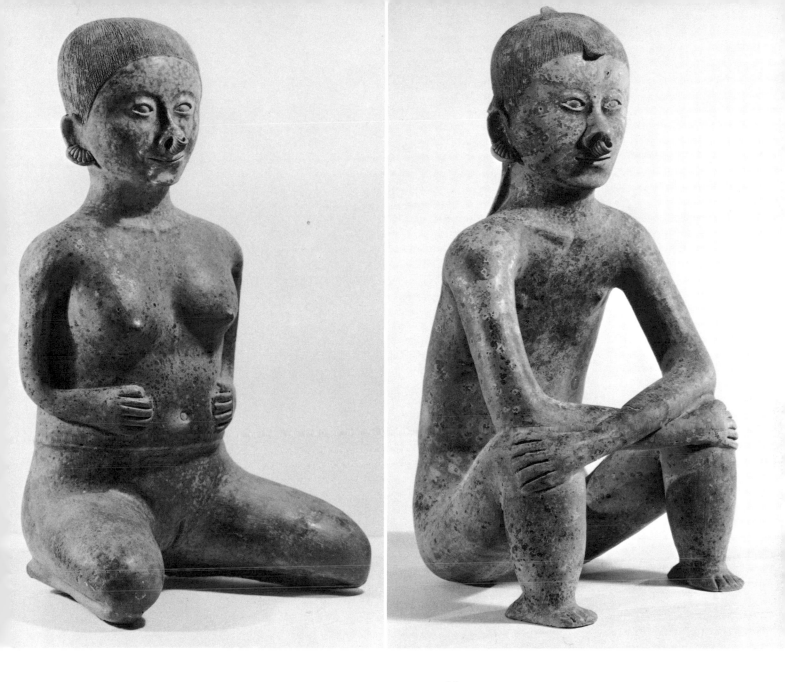

FIGURE 15

Kneeling female Chinesca

FIGURE 16

Seated male Chinesco

This handsome pair probably came from a tomb at Las Cebollas where the University of California recently recorded the discovery of several clay figures identical in style and of a conch shell that produced the radiocarbon date A.D. 115. Both the female, 27½ inches high (Museo Nacional de Antropología, Mexico) and the male, 28½ inches high (on loan to The American Museum of Natural History, New York) have a burnished red surface with spots of manganese oxide; their faces have cream-colored slip exposed in spots where resist material repelled the thin russet wash.

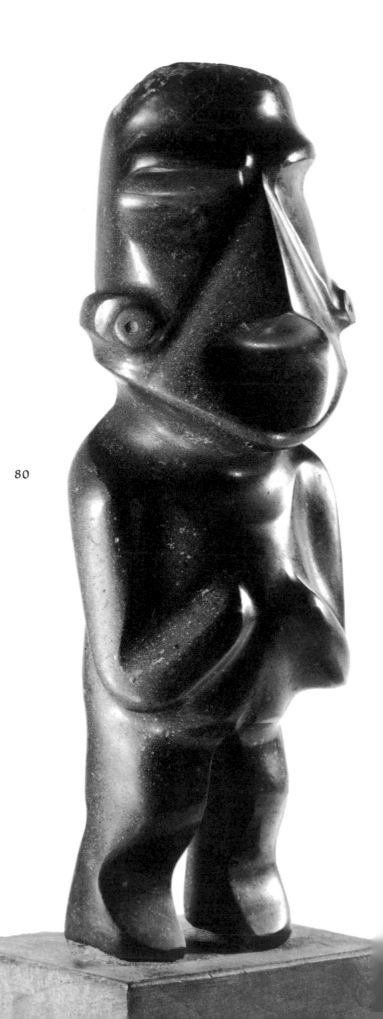

80

79 Standing figure

Pale greenstone with white and dark green speckling
Height: 16⅛ in. (41 cm.)
Mezcala region, Guerrero, Mexico
Late Preclassic, about fourth century B.C.
Dr. and Mrs. Milton Arno Leof, Mexico City

This figure retains the overall form of a hand axe. Sharply edged planes define the facial features, while deep grooves call attention to eyes, ears, and arms. The basic form was probably achieved by chipping and pecking. The grooves were cut with sandstone blades or wedge-shaped tools, used with water and powdered abrasives, and the surface was polished with a fine powder. (See Color Illustration.)

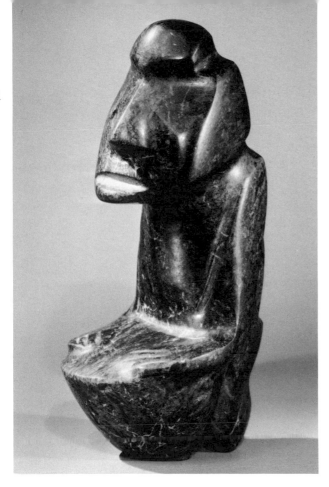

81

82 Seated figure with frog on back

Mottled greenish stone
Height: 5¾ in. (14.8 cm.)
Mezcala region, Guerrero, Mexico
Late Preclassic, about third century B.C.
Dr. and Mrs. Milton Arno Leof, Mexico City

This figure presents an interesting blend of rounded, indistinct modeling on the body with sharp, flat planes on the face. The legs, arms, and shoulders are massive and forceful; the face is linear and angular. In view of the prevalent symbolism of Mesoamerica, the frog may well represent water, and the figure, by inference, a water carrier, as on Izapa Stela 1. Fine greenstone also stood for water, since it is cool to the touch and suggests by its color a deep pool.

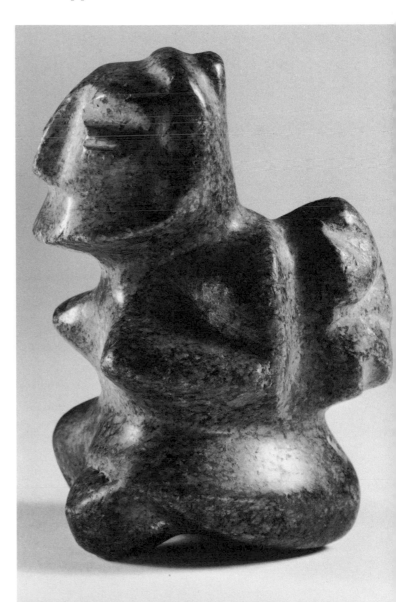

80 Standing figure

Dark green porphyry
Height: 9¼ in. (23.5 cm.)
Mezcala region, Guerrero, Mexico
Late Preclassic, about third century B.C.
Dr. and Mrs. Milton Arno Leof, Mexico City

According to the Mezcala sequence proposed by Carlo Gay, this type of figure, called M-12, differs from the earlier types by the addition of heavy, bisected eyebrows. The uncommon stubby feet remain simple. Only the earplugs and the bent knees are outside the pure linear abstraction of the Mezcala style, suggestive of the greater naturalism of Chontal figures.

81 Standing drummer

Dark veined greenstone
Height: 4⅜ in. (11.1 cm.)
Mezcala region, Guerrero, Mexico
Late Preclassic, about fourth century B.C.
Proctor Stafford, Los Angeles

Mezcala sculptures depicting individuals engaged in ceremonial or other activities are rare, in spite of the preoccupation with such portrayals in neighboring Colima and Nayarit. The figure, related to Gay's type M-10 frontal carvings, may be addressing the spirits with his drum as part of a religious rite.

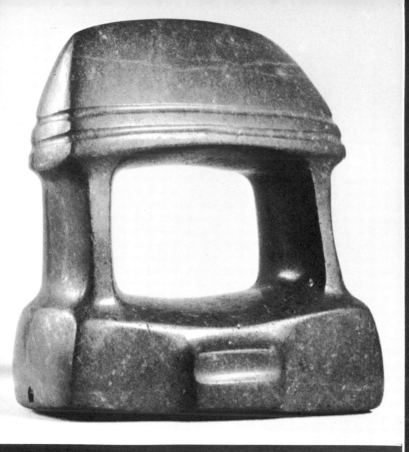

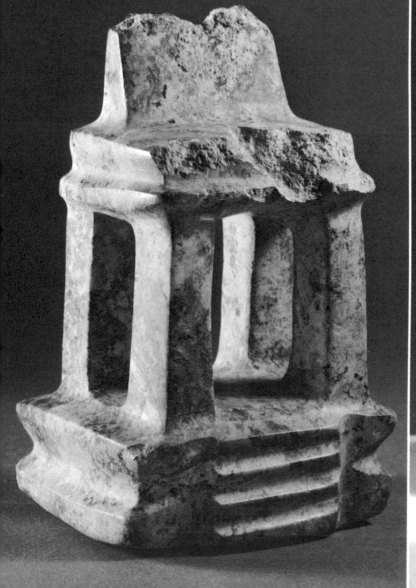

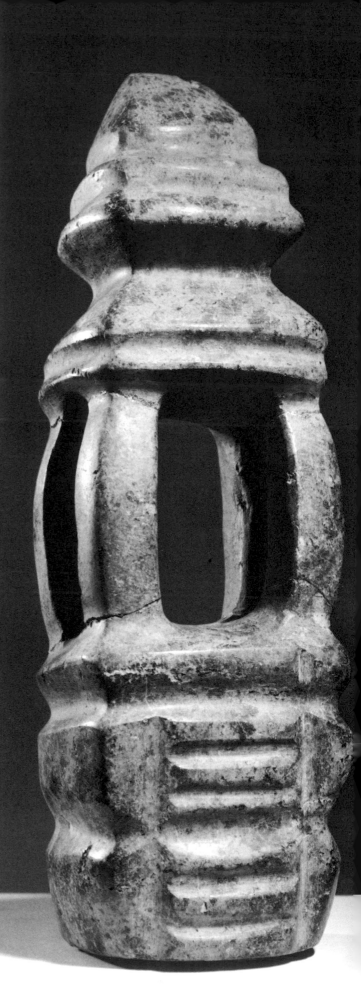

83 Temple model with side walls

Polished gray green diorite
Height: 4⅝ in. (11.6 cm.)
Mezcala region, Guerrero, Mexico
Late Preclassic, about third century B.C.
Arthur Bullowa, New York
Ex coll. William Spratling

84 Temple model with roof comb

Pale greenstone
Height: 6¼ in. (16 cm.)
Mezcala region, Guerrero, Mexico
Late Preclassic, about third century B.C.
Dr. and Mrs. Milton Arno Leof, Mexico City

85 Temple model with central finial

Mottled and veined greenish gray serpentine with red
 paint on the interior
Height: 10½ in. (26.8 cm.)
Mezcala region, Guerrero, Mexico
Protoclassic, about first century A.D.
Museo Nacional de Antropología, Mexico, 2-5989

The absence of temple remains in Guerrero suggests that the structures themselves were of perishable materials and complicates the identification of details in their models. The sculptures feature platforms and steps leading up to them. Some have solid side walls, others four supporting columns. The top of Number 83 suggests a simplified rendition of a thatched roof, while the crest of Number 84 closely resembles the stone roof embellishments of the Maya. The carving of Number 85, with its bent columns and tufted peak, allows no reliable comparison with any existing temple structures.

86 Bearded standing figure

Brownish green stone speckled with deep green
Height: 15¾ in. (40 cm.)
Chontal region, Guerrero, Mexico
Protoclassic, about first century A.D.
Dr. and Mrs. Milton Arno Leof, Mexico City

The outline of this figure and the crossing of the arms closely follow the Mezcala tradition, but the execution is more detailed and naturalistic. This is evident in the observant modeling of knees and stomach, the carefully delineated fingers, and a head that suggests the portrait of a specific individual. This figure is also unlike standard Mezcala pieces in that the rear is carefully worked, showing prominent buttocks and barlike shoulder blades.

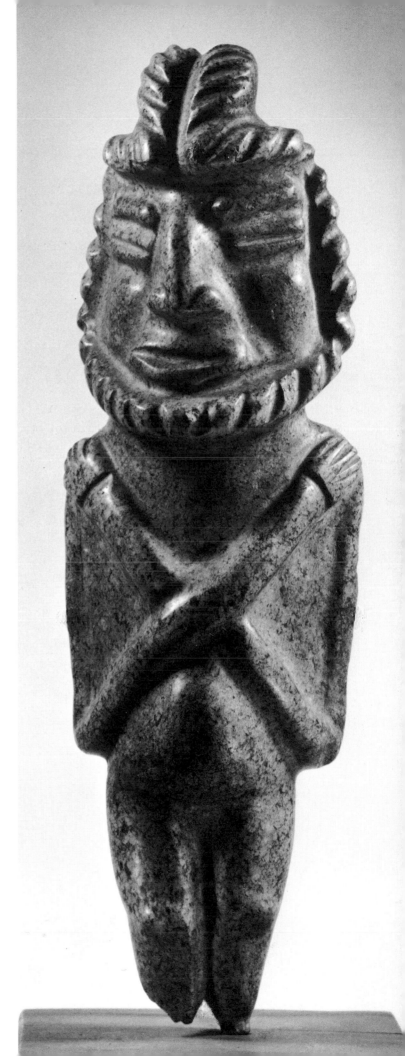

87 Human mask with perforated eyes and mouth

Dark gray serpentine with eroded polish
Height: 8⅜ in. (21.4 cm.); thickness: 2½ in. (6.2 cm.)
Sultepec, state of Mexico
Late Preclassic, 300–100 B.C.
Museo Nacional de Antropología, Mexico, 2–5469
Ex coll. William Spratling

Masks with cutout mouth and eyes are relatively rare. Slightly concave in back, with perforated ear flanges, they may be ancestral to Teotihuacán masks (Number 112). The holes drilled at the temples may have been used in tying the mask to a mummy bundle. This mask conforms to the Sultepec style, the northernmost variant of Chontal, by its thin, sharply projecting nose and heavy "bar" eyebrows.

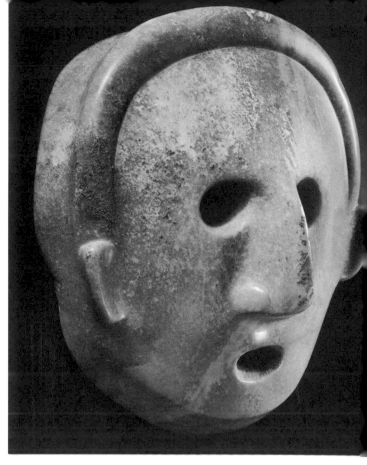

88

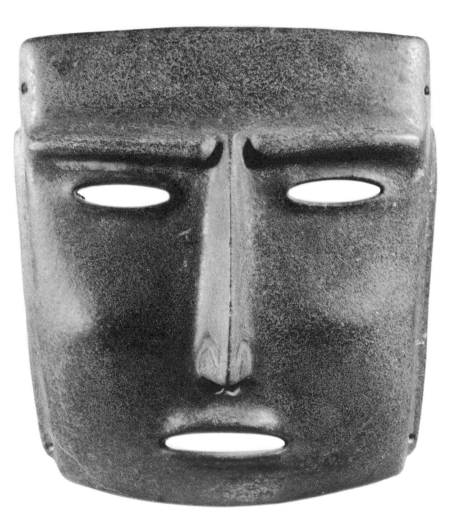

88 Human mask with perforated eyes and mouth

Translucent pale gray chalcedony
Height: 7⅜ in. (18.7 cm.); thickness: 3⅛ in. (8 cm.)
Colima, Mexico
Protoclassic, 100 B.C.–A.D. 250 (?)
Dr. and Mrs. Josué Sáenz, Mexico City

The rarity of this life-size stone mask makes it difficult to date. Besides having the sharp nose and simplified features of Chontal masks, it displays clear parallels with larger clay masks from its reported state of provenance, Colima (Number 89). These include rounded eye sockets, hooked, pointed nose with curves representing nostril wings, elliptical mouth with no cheek creases, wide flanged ears, and simplified headband crossing the forehead from ear to ear. This mask, however, differs from the clay ones in that it lacks eyebrow ridges and has perforations that would permit vision and breathing. Thus, in spite of its heaviness, it may have been worn. The absence of holes for attachment, except for one on top to permit suspension, suggests that the wearer held it in place over his face.

89 Human mask

Burnished black clay
Height: 9 in. (23 cm.); thickness: 3⅜ in. (8.5 cm.)
Colima, Mexico
Protoclassic, Los Ortices phase, 100 B.C.–A.D. 250
Mr. and Mrs. William B. Jaffe, New York

The rounded, simplified, larger than life-size face, the eyebrow ridge, the rounded depressions for eyes, and the arching headband of this mask reflect a Colima regional style. Rings could be inserted in the pierced septum of the sharp nose and in the perforations in the flanged ears. This mask is more naturalistic in proportions than some other Colima masks and lacks the incised geometric "tattooing" on the cheeks that connects them to the Chupícuaro style of decoration. The concave back, the lack of eye and mouth perforations, and the holes in the forehead and temples make this mask's use as a funerary face seem plausible.

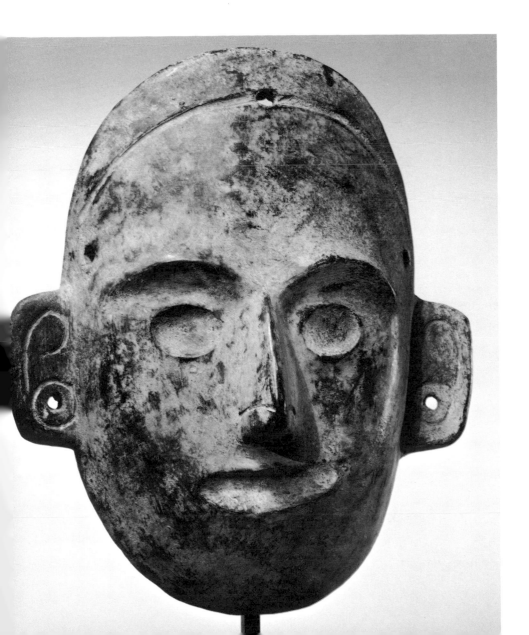

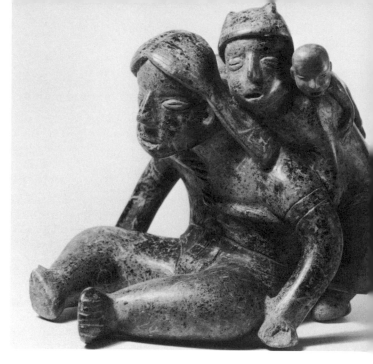

90 Standing dancer

Solid tan clay
Height: 9½ in. (24.1 cm.)
Coquimatlán (?), Colima, Mexico
Late Preclassic, 350–100 B.C.
Morton D. May, St. Louis

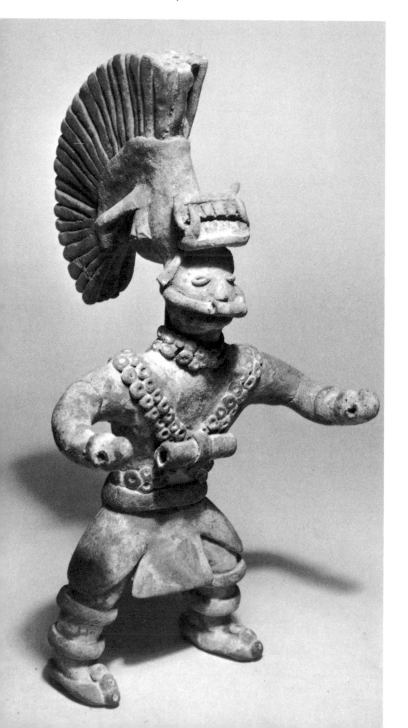

The forward thrust and wide stance of the figure rhythmically balance the backward splay of the headdress of reeds, which itself has a fanged mouth projecting forward over the head of the wearer. His eyes are formed by pellets, pressed with a horizontal line in the middle. A rod or string could be stretched between the pierced hands, possibly to suspend rattles or bells used in the dance (Hasso von Winning, *Pre-Columbian Art in Mexico and Central America*, New York, 1969, no. 63). A group of very similar figurines was recently recovered from the Cerro de la Media Luna in the municipality of Coquimatlán.

91 Three-figure effigy vessel

Reddish buff-slipped clay spotted with black manganese
 oxide deposits
Height: 6½ in. (16.5 cm.)
Colima, Mexico
Protoclassic, 100 B.C.–A.D. 100
Museo Nacional de Antropología, Mexico, 2–5488
Ex coll. William Spratling

This compact group seems to express the solidarity of the family. The basis for the composition is the triangular form of the father, seated and supporting himself and the weight of his wife and child with his hands. His armlets are indicated by incising; only his loincloth is modeled in relief. The wife wears a skirt and clasps him from behind with hands on his chest. Her armlets and girdle are incised, as are the decoration encircling her hat and the herringbone pattern on its peaks. The child, who is straddled froglike on its mother's back, has a charmingly naturalistic head. The open mouths do not connect with the vessel's interior, which is reached by a spout, projecting behind the woman and aesthetically balancing the row of heads.

92 Seated hunchbacked baby

Burnished red-slipped clay with white pigment on the
 eyes
Height: 11 in. (27.8 cm.)
Colima, Mexico
Protoclassic, about third century A.D.
The Metropolitan Museum of Art, x.2.431

Like most Colima figures, this is really a vessel, with its
everted spout on top of the head. Such jars were prob-
ably filled with liquid for nourishing the deceased. But
this purpose served largely as a pretext for their more im-
portant function as figures to accompany the dead. It is
difficult to understand why deformed figures like this
hunchback were produced. Perhaps they were considered
a substitute lodging for the evil spirit that brought the
affliction represented, deflecting it from people by ab-
sorbing it themselves. Perhaps the deformity depicted
was suffered by the occupant of the tomb. Perhaps de-
formed people were considered amusing, like dwarfs in
European courts, and could entertain the occupant in the
afterlife. The lightly swelling eye sockets of this figure,
with eyeballs defined more by thick white paint than by
modeling, suggests that it is coeval with northern figures
with similar eyes (Number 97).

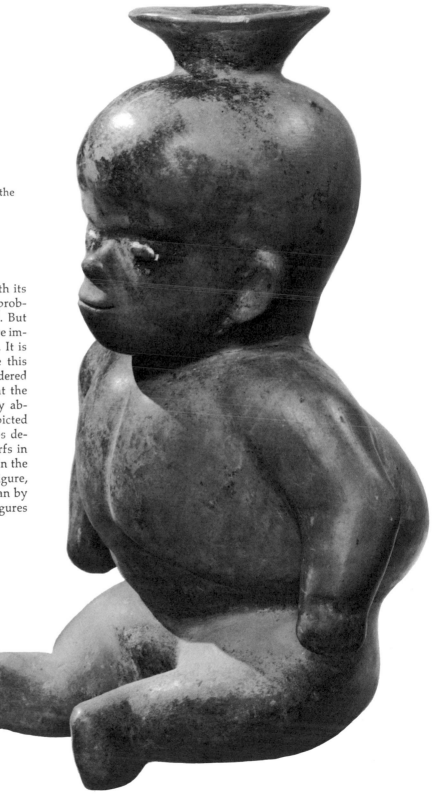

93 Crouching feline

Red-slipped clay with polished blackened surface
Length: 19½ in. (49.7 cm.)
Colima, Mexico
Protoclassic, around A.D. 100
Dr. and Mrs. Josué Sáenz, Mexico City

Animals portrayed realistically and in many different attitudes were favored by Colima potters. Most common and best known are the dogs, in a great variety of types, including fat ones to eat and muscular ones to lead the spirit through the underworld. The image of a feline, however, is quite unusual in Colima ceramics; it may represent a jaguar, with its multiple connotations in Mesoamerican iconography, or a western mountain puma, which would merely be another example of local fauna, represented frequently by Colima potters. Unlike most effigies, this one was not a vessel, even though its opened mouth leads to the hollow interior. Its nose septum is pierced. It has an appealing suggestion of alert strength and an elegance of style.

94 Seated male figure

Cream-slipped clay with blackened firing clouds
Height: 17½ in. (44.5 cm.)
Ameca region, Jalisco, Mexico
Protoclassic, about A.D. 100
Proctor Stafford, Los Angeles

The crisply delineated face seems almost masklike with its long, pointed features and intense, bulging eyes. The enormous ears, set low and protruding far from the head, have the only visible holes into the interior of the figure. The torso displays an extraordinary amount of movement and naturalism for Western Mexican figures, which usually are posed in a limited number of hierarchic positions. The well-modeled torso has clearly defined collarbones, firm pectoral muscles, and a slightly soft-looking abdomen above the heavy belt; the back is muscular, the backbone recessed. The powerful thighs and slender calves strike a fine, naturalistic balance between the flat, elephantine legs of many standing Western figures and the thin legs of most seated ones. Although the head turns toward the left, like that of all tomb guardians in the West, the shoulders pivot slightly to the right, as a result of the position of the hands. Their unusual relationship suggests that some long object once was lightly held in them, probably a club or spear.

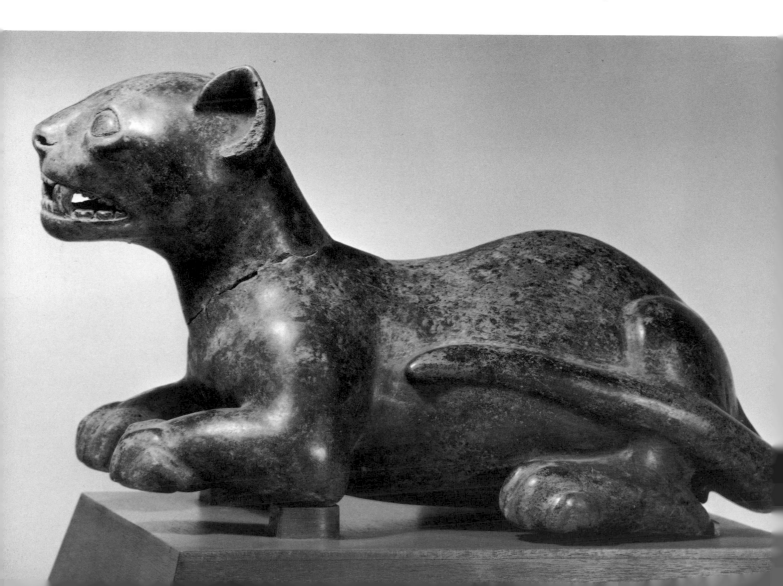

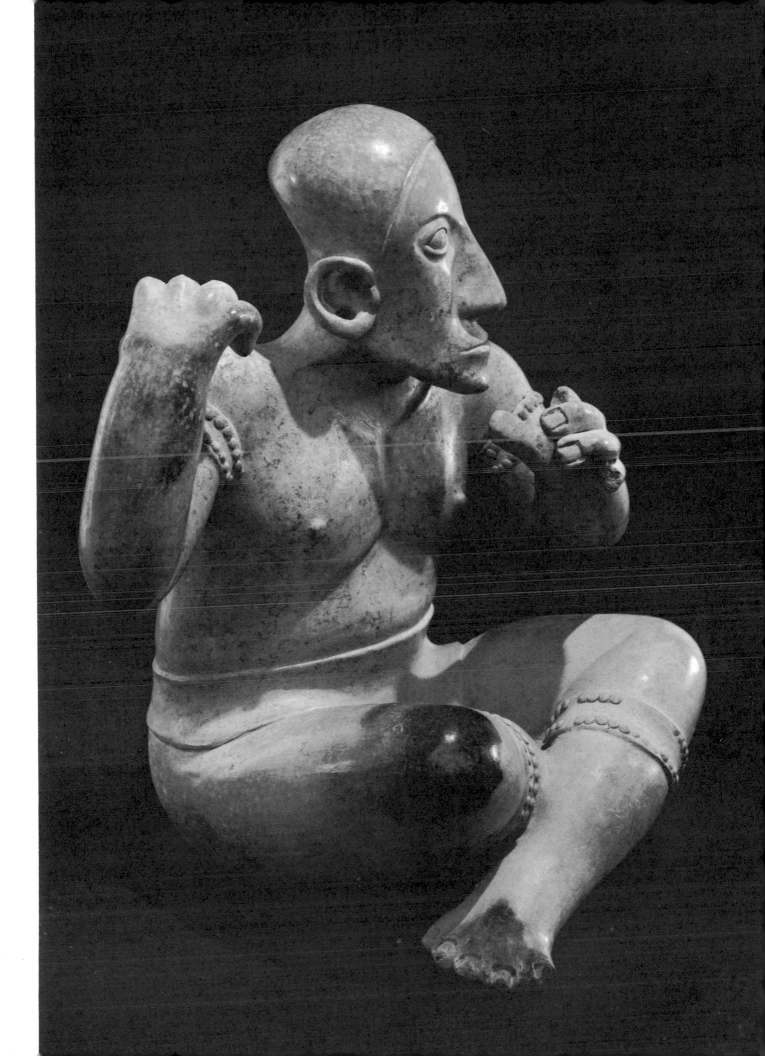

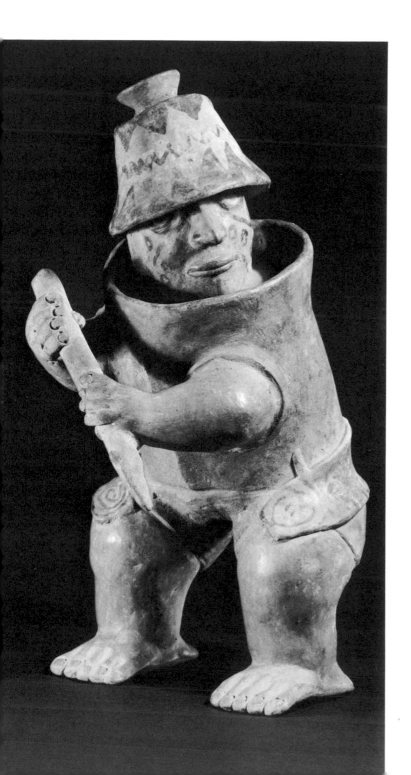

95 Standing armored guardian with spear

Cream-slipped clay with red and black paint
Height: 9⅞ in. (25 cm.)
Ameca region, Jalisco, Mexico
Protoclassic, about A.D. 100
Mr. and Mrs. Alfonso Ramírez Horta, Mexico City

"Barrel" armor, as shown on this figure, was probably made of animal skin stretched over a wooden frame. Similar protection, made of wooden slats, was used by the Indians of the Canadian Northwest, Eskimos, Siberian tribes, and Micronesian islanders. The helmet is topped by what may represent a plume holder. Geometric designs are painted on the skirt of the armor, on the helmet, and on the face. The heavy limbs end in realistic fingers and toes, each showing the carefully rendered nails characteristic of the finely made Ameca Grayware. Peter Furst has concluded that military figures in an "on guard" stance, always turning toward the left, represent tomb guardians ("West Mexican Tomb Sculpture as Evidence for Shamanism in Pre-Hispanic Mesoamerica," *Antropológica* 15, 1965, pp. 44–47).

96 Seated man with arm on knee

Polished white-slipped clay with black manganese
 oxide deposits
Height: 18⅛ in. (46 cm.)
Ameca region, Jalisco, Mexico
Protoclassic, about second century A.D.
Mr. and Mrs. Alfonso Ramírez Horta, Mexico City

Because of the thin torso and the angular placement of the long limbs, this sculpture is a fascinating composition of masses and spaces from every viewpoint. The tall head, with staring framed pellet eyes and large low-placed ears, dominates the apex of the buttressed triangular construction. The exaggeratedly pointed features of the face appear too large for the head. This characteristic appears in the later Ixtlán style, as do the rudely segmented, nailless toes and fingers.

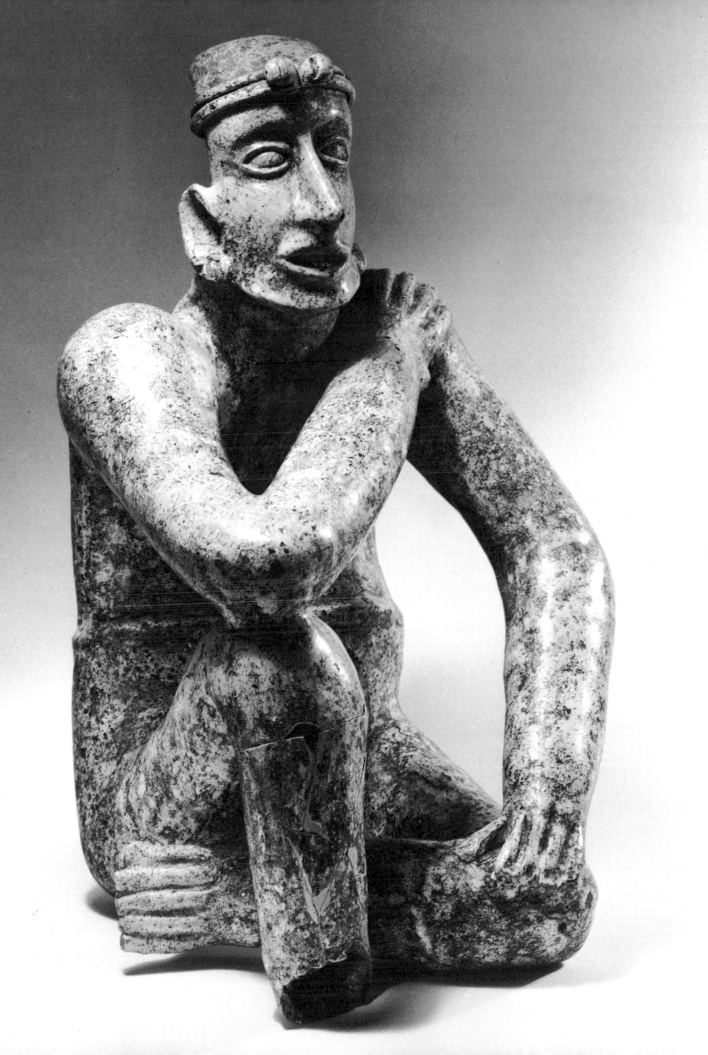

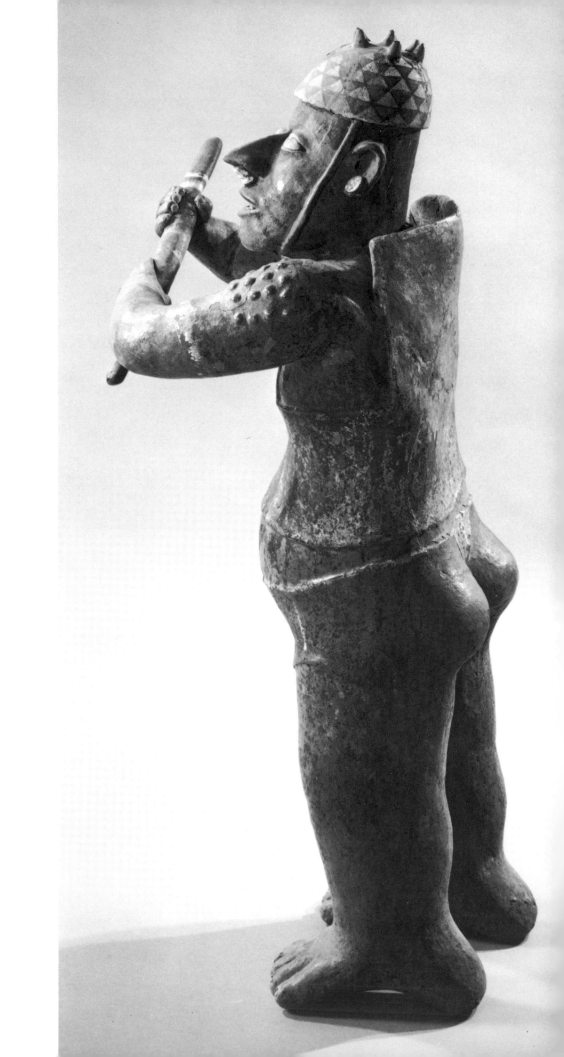

97 Armored standing guardian with club

Red-slipped clay with white and yellow paint and black
 manganese deposits
Height: 37 in. (94 cm.)
Etzatlán region, Jalisco, Mexico
Transitional Protoclassic–Early Classic, about third
 century A.D.
Proctor Stafford, Los Angeles

This figure, extraordinary for Western Mexico because of
its size and its forceful effect, is known as the "Jalisco
king." However, like Number 95, it served as the guard-
ian of a tomb. Similar figures were recovered in the San
Sebastián tomb, and assigned to the latest of the three
periods. Modeled in El Arenal Brown ware, the figure has
a friable red slip and gaudy paint typical of Nayarit fig-
ures. The white-painted eyes no longer have the clearly
defined round pellet eyeballs and thick lids of the earlier
Ameca Gray ware (Number 94). The bulbous shoulders
with patterned round welts are a hallmark of El Arenal
Brown ware.

98 Ten seated figurines

Solid buff clay with red paint
Average height: 2¾ in. (7 cm.)
Colima-Jalisco border area, Mexico
Late Preclassic, about third century B.C.
Museo Nacional de Antropología, Mexico, 2–5435–5444

Straight-backed and cross-legged, these unusual male
figurines appear to participate in a ceremony. Unlike
Nayarit scenes, which are modeled on a platform (Num-
ber 105), those of both Jalisco and Colima are composed
of independent structures and figures, such as these.
Their elongated heads and jutting, wedge-shaped noses
relate them to figurines in the Jalisco tradition, especially
the variety with straight slit eyes that is found near Lake
Chapala. The intersecting lines incised on both the chest
and back of some of them, however, are also typical of
"gingerbread men," the flat standing figures with flexed
legs characteristic of Colima.

99 Seated Chinesca girl

Buff orange clay with red orange slip and black paint
Height: 17½ in. (44.5 cm.)
Compostela region, Nayarit, Mexico
Protoclassic, 100 B.C.–A.D. 250
Mr. and Mrs. Alfonso Ramírez Horta, Mexico City

Gay spirals are painted in black resist technique on the lower torso, rounded buttocks, and outstretched thighs. The hair on the enlarged top of the head is carefully striated, thin incisions radiating from the center and extending down the sides and around the small firing hole (on the top rear of the head) to the nape of the neck. Carelessly rendered openwork ear ornaments curiously suggest multiple metal rings, but no metal from the Protoclassic period has been found. The scarified shoulders are like those on the Etzatlán figure (Number 97), as are the disproportionately small arms. Yet the horizontal slit eyes and smooth face suggest an earlier date.

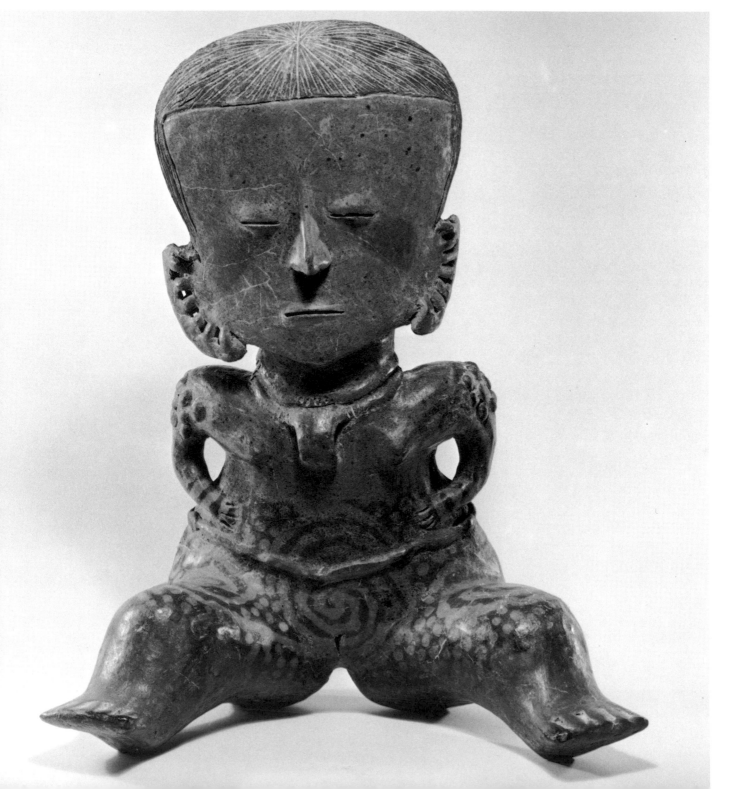

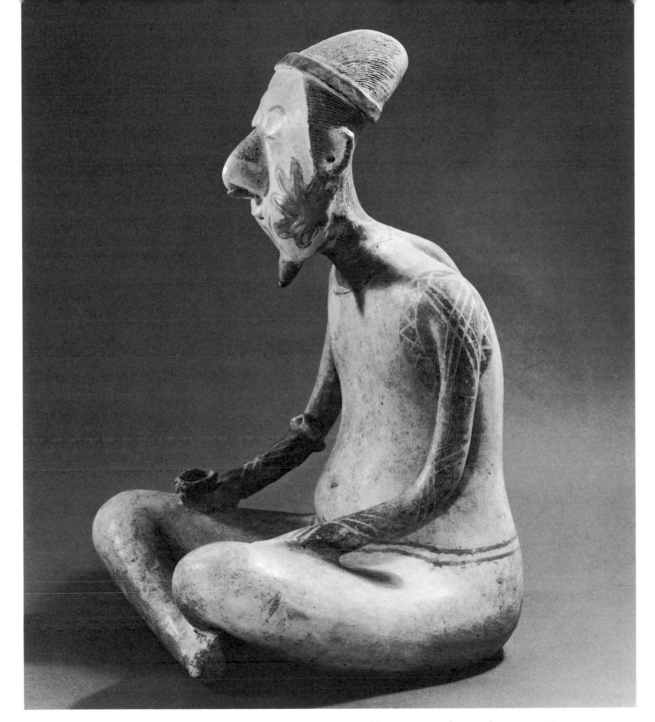

100 Seated bearded Chinesco with cup

Cream-slipped clay with red and black paint
Height: 16⅛ in. (41 cm.)
Compostela region, Nayarit, Mexico
Protoclassic, 100 B.C.–A.D. 250
Dr. and Mrs. Josué Sáenz, Mexico City

Sitting like an Oriental sage, this man with a wispy beard supports a separately modeled cup on his right hand. The slit eyes and hair rendered by incised fine lines are common features of the Chinesco style, and the exaggerated nose indicates that this figure is related to the variety produced further to the north (Number 101). The decoration is restrained in comparison with the gaudiness of Ixtlán painting. It is confined to the red-painted headband, belt, and flower motif in one cheek only, and the black-painted neck, goatee, hair, and geometric decoration of the arms. Arms are thin in contrast to the heavy thighs. The incongruous body relationships are hardly apparent, however, since they contribute most pleasingly to the total composition.

101 Kneeling Chinesca woman

Coarse orange clay with burnished red, black, and
 white paint
Height: 21¼ in. (54 cm.)
Ixcuintla region, Nayarit, Mexico
Protoclassic, early Chametla phase, 100 B.C.–A.D. 250
Dr. and Mrs. Josué Sáenz, Mexico City

Humorously called "Martian" Chinescas because of their
bizarre appearance, figures of this type bring to mind
African masks and costumes. Realism gives way to styl-
ized modeling, the simplified forms enhanced by boldly
varied geometric patterns. The arms, without hands, are
indicated only by a U-shaped ridge, and the feet and
lower legs merely suggested beneath the swelling thighs.
The low ears and long, hooked nose with prominent
pierced septum balance the broad, wide head. Figurine
heads with the same stylization were discovered to the
north of the Ixcuintla region by Isabel Kelly (*Excavations
at Chametla, Sinaloa*, Ibero-Americana 14, 1938). (See
Color Illustration.)

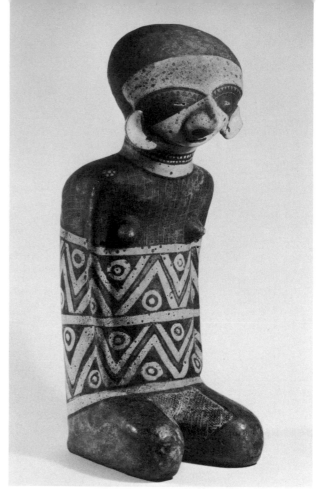

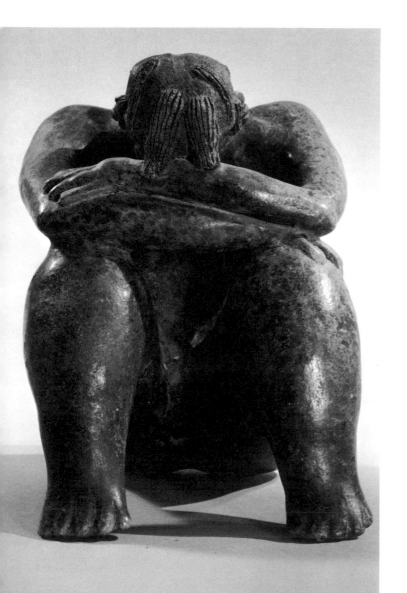

102 Slumped "mourner" effigy jar

Dark red-slipped clay with black manganese oxide
 deposits
Height: 10½ in. (26.5 cm.)
Ixtlán region, Nayarit, Mexico
Late Preclassic, about second century B.C.
Proctor Stafford, Los Angeles

This figure is representative of the San Sebastián Red
ceramic effigies, the earliest variety recovered from the
shaft tombs in Etzatlán, Jalisco. The type is characterized
by massive legs, wide torso, tapered head, a large nose,
and swollen eyelids enclosing deep slit eyes. But, whereas
the standing figures (Number 103) express heavily im-
planted weight, this unusual seated variation achieves
sensitivity with its fullness, recalling a Maillol bronze.
Rare in Nayarit and Jalisco is the existence of a spout,
the low rim of which projects from the base of the neck.

103 Standing pregnant woman

Dark red clay with black resist paint
Height: 27½ in. (70 cm.)
Ixtlán region, Nayarit, Mexico
Protoclassic, about first century A.D.
Valerie B. Franklin, Beverly Hills, California

An evolved form of the San Sebastián type (Number 102), this figure is more massive, has a more developed eye with a pellet for the pupil, and a more carefully rendered nose with a nose ring inserted through the elongated septum. Small bells seem to be represented on each of the rings that make up the ear ornaments. The shoulder scarification and the grotesque facial proportions also are characteristic of later figures. The sculptor has dramatized the condition of pregnancy by exaggerating the swollen abdomen, which presses out the navel, and bracing the woman on massive legs. She clutches her sides, throws her head back, and opens her mouth, signaling the onset of labor.

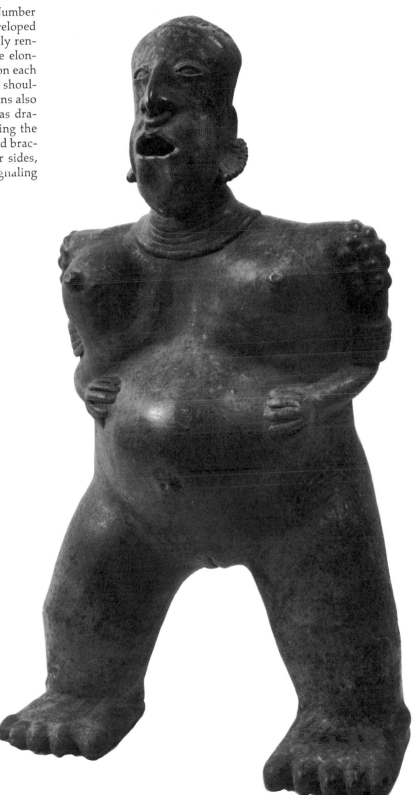

104 Seated couple

Brown clay with red slip and black, yellow, and white
 paint
Height: male: 24⅝ in. (62.5 cm.); female: 22¼ in.
 (56.3 cm.)
Ixtlán region, Nayarit, Mexico
Protoclassic, A.D. 100–250
Mr. and Mrs. Alvin Abrams, Woodmere, New York

Figures in matched pairs frequently appear in the same tomb, as attendants to the deceased, and the similar style and proportions of this pair strongly suggest that they were discovered together. The woman holds a large cup painted with geometric designs, which may have contained refreshment for the deceased. The man, in a pointed hat typical of this style, holds a tortoise shell in his left hand and a curved object in his right, possibly representing a form of musical instrument. The trapezoidal shape of their faces and the large scale of their features suggest that they represent a Nayarit style contemporary with that of El Arenal Brown figures from Jalisco (Number 97).

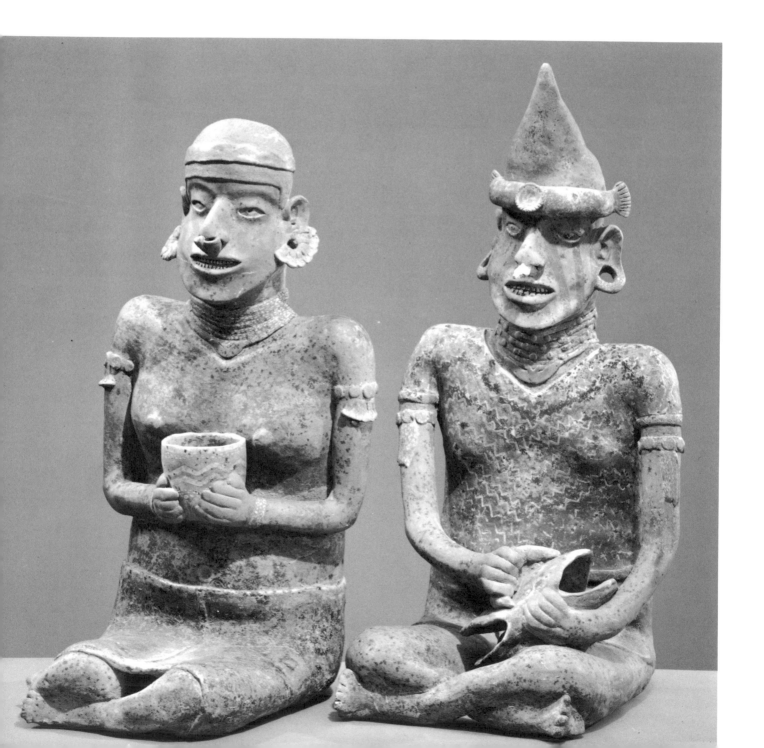

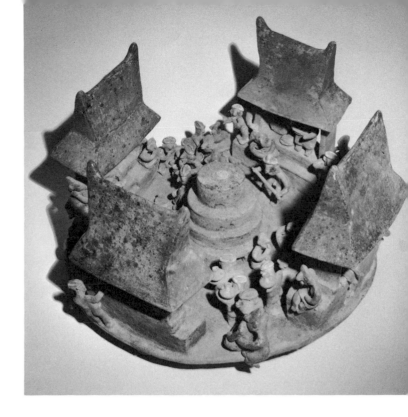

105 Plaza scene

Coarse red-slipped clay with encrusted red spots
Height: 12¼ in. (31 cm.); diameter: 17 in. (43 cm.)
Ixtlán del Río, Nayarit, Mexico
Protoclassic, 100 B.C.–A.D. 250
Mr. and Mrs. Alan E. Schwartz, Detroit

The naturalistic village scenes created as grave offerings in Nayarit are a major source of our knowledge about customs, dress, and housing. This especially large and encompassing scene presents four buildings with peaked roofs around a central spiral altar, or small pyramid, fifty people, and three dogs. It shows a village fiesta at the start of a meal, the people paying no attention to the central ceremonial structure. They are sketchily modeled, but the scene resembles a painting by Brueghel in the way it captures the spirit of genre activities. Faces are flat, with large noses, and eyes are indicated by black rings or spots. There are always four arm rings, whereas necklaces are in one, two, or three rows, possibly denoting rank. Authority is seemingly represented by a chief, identified by three black stripes under his eyes, a triple necklace, and a cape. There appear to be two classes of men. The unclothed ones provide manual labor, serving as water carriers, for example. Clothed men, including a soldier with a staff, wear headbands, breechcloths or long pants, and two have shirts with sleeves. Women wear patterned skirts to the knees, attesting to a well-developed textile art. Close examination reveals various foods, such as tortillas, ears of corn, and fruits, while a conch trumpet, drum, and rasp suggest music at a feast. Everywhere the easy interrelationship of ordinary people is apparent (for further details, see Hasso von Winning, "Eine keramische Dorfgruppe aus dem alten Nayarit in westlichen Mexiko," *Amerikanistiche Miszellen*, Mitteilungen aus dem Museum für Völkerkunde in Hamburg 25, Hamburg, 1959, pp. 139–143).

her hips, the man's arms locked together at the wrists. His arms rest on supports that visually stand for knees but are really projections of horizontal legs. On Zacatecas figures, the colors and their technique of application, and likewise the rounded, deeply modeled buttocks, are similar to those of the Chinescos (Number 99), leading Peter Furst to suggest that the Nayarit people moved up into the mountains of Jalisco and southern Zacatecas in the Classic period and continued to produce these figures. Since shaft-and-chamber tombs could not be made in the sandy highland soil, shallow graves received the supine burials and ceramic offerings.

106 Seated couple

Reddish clay with ivory and red slip and black paint
Height: male: 14 in. (35.8 cm.); female: 12½ in.
(31.8 cm.)
Zacatecas or nearby Jalisco highlands, Mexico
Early Classic, A.D. 250–550
Arnold H. Maremont, New York

Both figures are decorated with black resist patterns applied over areas of dark ivory and red slip. The male has a capped horn on either side of the opening at the top of the head. Both have eyes set wide apart and eyebrows wrapping halfway around the cylindrical head, which is cut off directly above them, giving the impression that the head is all face. The perforated oval eyes and mouth are surrounded by projecting rims, a form echoed in the hollow earspools. Circular forms reappear in the outlines of the limbs: the woman's arms with her hands on

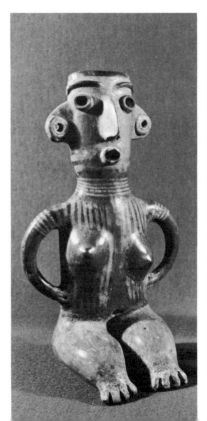
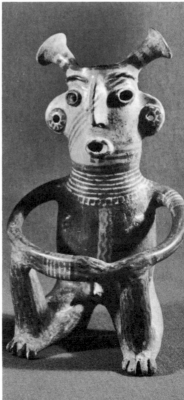

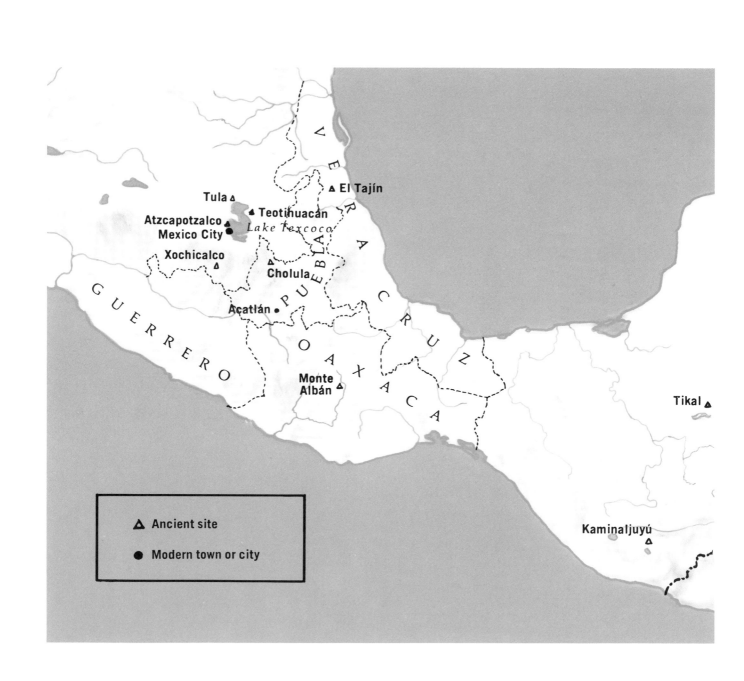

Tula ▲

El Tajín ▲

Teotihuacán ▲

Atzcapotzalco ▲
Mexico City ●
Lake Texcoco

Xochicalco ▲

Cholula ▲

V
E
R
A
C
R
U
Z

P
U
E
B
L
A

Acatlán ●

G U E R R E R O

O A X A C A

Monte
Albán ▲

Tikal ▲

Kaminaljuyú ▲

△ Ancient site

● Modern town or city

6

Urban Teotihuacán

A great metropolis does not necessarily bring forth great sculpture. A profusion of monuments like those dedicated to gods, rulers, and military heroes in ancient Athens and Rome was no more necessary to the life of Teotihuacán than to that of New York or many other cities the world has seen. The glory of Teotihuacán lay in its majestic pyramid-based buildings, the grandeur of its central plan, and the immensity of the city as a whole. To consider such a center of civilization only in terms of art, or of a single art like sculpture, is to miss its real impact on the character and arts of contemporary peoples.

Growing almost explosively at the beginning of our era, Teotihuacán became the earliest true urban complex of Middle America. Its influence, which reached from Western Mexico to the Maya area, is marked in the archaeological record principally by architecture and pottery of the first half of what is called the Classic period, the seven-century span from A.D. 250 to 950 during which expanding population, building activity, and trade, along with excellence in the arts, denote an era of well-being and achievement unequaled at any other time. Regional cultures and styles had been evolving during the Late Preclassic period, incorporating the Olmec heritage spread through Middle America initially from the Gulf Coast. By the third century, they were strikingly distinct from one another, and the center of power, whether it was religious, economic, military, or a potent combination of all three, had shifted to the Mexican Plateau, where it was to remain.

The ruins of Teotihuacán lie some twenty-five miles north of the modern capital in an extension of the Valley of Mexico east of the ancient lakeshore. The heart of the city, known to countless travelers as "the pyramids," is today surrounded by arid countryside, farms, and small villages that were once part of the metropolis. By the time the three greatest temples were finished, in the third century, it spread over an area of nearly nine square miles, twice that of contemporary Rome, but much less crowded. As building, reconstruction, and urban renewal continued unceasingly, the total area decreased slightly, while the population rose to an estimated 85,000. Other towns and settlements over a wide region grew smaller or were deserted entirely as their inhabitants were drawn to the city. Around the end of the seventh century, the ceremonial center of Teotihuacán was destroyed by fire.

The evidence of burning is unmistakable, but what brought on the catastrophe may never be fully understood. Clearly, there was no sudden arrival of alien peoples to explain either the beginning or the end of Teotihuacán. It was never totally abandoned or forgotten; some of its people stayed on, burials were made there, and it remained a holy place of legend and pilgrimage. Its traditions were maintained for a time in such towns as Atzcatpotzalco, across the lake, and absorbed into the rising urban cultures of Cholula, Xochicalco, and Tula.

The gigantic Pyramid of the Sun (Figure 17), the largest and oldest of Teotihuacán's three principal pyramids, was originally over 720 feet square, with a broad stair on the west side rising 210 feet to a temple on the summit. Unlike many other Middle American structures, built up gradually by superimposing a new surface and temple over an older building, it was constructed essentially as a single unit. Something like three million tons of large adobe blocks, facing stone, mortar, and stucco were carried to the building site on the backs of men—stupendous testimony to the spirit that animated Teotihuacán in the first of the four major periods of its history. Also undertaken during period I, before A.D. 150, was the somewhat smaller Pyramid of the Moon, which faces south down the three-mile length of the

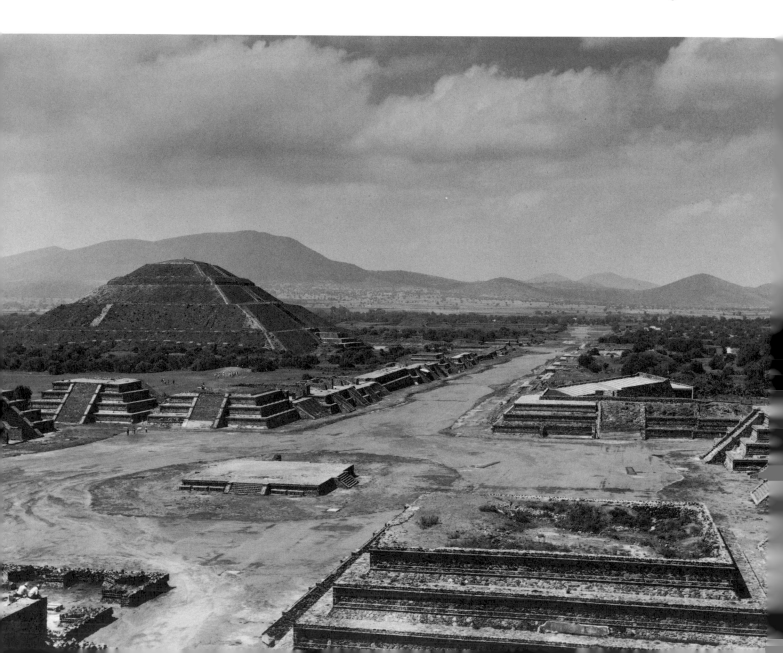

FIGURE 17

Ceremonial center of Teotihuacán

From the Pyramid of the Moon, the Street of the Dead
leads southward past the dominating Pyramid of the Sun,
at left, and the Cuidadela quadrangle, which encloses the
Pyramid of Quetzalcóatl. (The diagonally placed struc-
ture at center right is a modern grandstand.) Extensive
mapping, excavation, and restoration of the city, spon-
sored by the Mexican government, are summarized in a
symposium volume (Sociedad Mexicana de Antropolgía,
Teotihuacán, Onceava Mesa Redonda, Mexico City,
1966).

FIGURE 18

Temple of Quetzalcóatl

The partially excavated Temple of Quetzalcóatl dates
from period II and was entirely covered by a later struc-
ture. The vertical *tableros* are dramatically embellished
with projecting heads of Quetzalcóatl, the Plumed Ser-
pent, and Tlaloc, the Rain God. Between these heads may
be discerned the stylized body of the serpent, representa-
tions of water, snails, and marine shells. The slanting
taludes are decorated with undulating snakes and deco-
rative shells. Additional serpent heads are inserted at
intervals in the balustrade of the stairway.

Street of the Dead, the wide processional avenue that forms the axis of the city.

Farther down the avenue is the Temple of Quetzalcóatl (Figure 18) completed in
period II, still within the Preclassic. Though nothing remains of the temple proper,
the pyramidal base incorporates two important innovations: stone sculpture and
the slope-and-panel design element that was to become a hallmark of Classic archi-
tecture at Teotihuacán and at many other cities where its influence was felt. In this
construction, generally called by its Spanish name *talud y tablero*, each side of a
building unit consists of a low sloping base surmounted by a vertical-faced framed
panel. At the Temple of Quetzalcóatl, both elements carry low relief, and the panels
and stairway balustrades are enlivened with huge projecting heads. All this was
preserved intact with much of its original blue, green, red, yellow, and white paint,
as well as gleaming obsidian eyes, when a larger but more sober temple base was
superimposed over it in the following period. Nothing comparable has been un-
earthed, but broken sculpture of similar style is known from several parts of the
Teotihuacán archaeological zone.

The only other architectural sculpture to be seen is the magnificently carved
interior of the Palace of Quetzalpápalotl (Figure 19), which dates from period III
at the beginning of the Classic. It too is polychromed and set with polished obsid-
ian, and the relief is low and crisply cut. Other buildings of Classic date seem to

have lacked sculpture entirely. Many of them were instead enriched by mural painting on the façades and in the rooms and patios. From the murals, full of supernatural figures and symbolic detail, and from ceramics related to them, comes nearly all we know about the gods of Teotihuacán. Tlaloc, the Rain God, distinguished by a mustachelike feature, round-rimmed eyes, jaguar traits, and symbols of water and agriculture, stands out most prominently, accompanied by Quetzalcóatl, the Feathered Serpent, Quetzalpápalotl, a deity with butterfly attributes, and other gods, all perplexingly interrelated. Some can be identified with the beings represented in contemporary Classic styles of Veracruz, Oaxaca, and the Maya area, and even centuries later in the all-inclusive Aztec pantheon. The paintings seem to be exclusively religious in theme, but in a sense decorative, part of the architecture.

Those freestanding sculptures that do exist from Teotihuacán have an architectonic quality too. The blocky figure of a goddess (Number 107) is a smaller version of the ten-foot monolithic "water goddess" found near the Pyramid of the Moon.

FIGURE 19

Patio of the palace of Quetzalpápalotl

Cleared of rubble and reconstructed to look as it did in period III, the patio has frescoed walls and entablatures and stone-faced columns richly sculptured on three sides, polychromed, mainly in deep red and green, and inlaid with obsidian. The theme is the composite deity, part bird and part butterfly, that gives the luxurious residence its name. Constructed over an earlier building, and destroyed in the conflagration that swept the center of the city, it lies just behind the four-stage platform that faces the Plaza of the Moon at the extreme right in the general view (Figure 17).

The colossal figure has the same square headdress, grooved across the flat top, while the lower and upper portions of its torso suggest strikingly a slope-and-panel architectural unit. Though these figures, large and small, may have been cult statues, some may possibly have served as Atlantean supports for beams or altar slabs, prototypes for the figures typical of Toltec architecture (Chapter 11).

Closely related to the figures are the Teotihuacán stone braziers in the shape of a hunchbacked old man bowed under the weight of the bowl (Number 108). He is the ancient fire god, but perhaps in this form he functioned as an altar accessory rather than as a cult image.

A splendid plumed jaguar (Number 109) epitomizes the geometric massiveness of early sculpture at Teotihuacán, as well as the force and energy of the best of it. So closely does it resemble the forms seen in architectural sculpture and large-scale fragments that it might be a model of some great monument now lost. Though small and carved of soft, translucent tecali, it is a major work of art, reflecting truly the surging vitality of the great city at the time it was made.

A very different aspect of Teotihuacán is revealed by the Stela of La Ventilla (Figure 20), a monument covered with graceful interlacery of the Tajín style (Chapter 7). These elegant patterns, found mainly on ceramics and murals, appear from late period II on, indicating close ties with the Veracruz coast. They are seen only rarely in stone, as in Numbers 110 and 115, and not at all in architectural sculpture, which was going out of favor. With the single exception of the Palace of Quetzalpápalotl, the buildings known from period III, when the city was at the height of its power, were enriched only by color, painted walls and panels or simple red lines on the gleaming white stucco accenting the basic forms. Though the Stela of La Ventilla, which consists of four separately carved elements fit together by a series of tenons and holes, is the only monument of its type found complete, there are other carved stones that resemble its separate parts, including a number of circular sculptures, usually with a shank or base (Number 111). The presence of two disk-topped monuments in a mural scene of figures playing a form of ceremonial ball game suggests that such monuments marked the ends of the

FIGURE 20

Stela of La Ventilla

Found in an outlying residential district of Teotihuacán, this monument had apparently been removed from a small central platform or altar in a patio and its four separately made sections buried ceremonially at the platform's base. Pottery in the offering belonged to early period III (A.D. 375–450). The stela and related monuments and their possible use in the ceremonial ball game are the subject of a study by Luis Aveleyra Arroyo de Anda ("La estela Teotihuacána de La Ventilla," *Cuadernos del Museo Nacional de Antropología*, I, Mexico City, 1963). Stone with white stucco and traces of red paint. Height: 84 in. (2.13 m.). Museo Nacional de Antropología, Mexico, 9–2564.

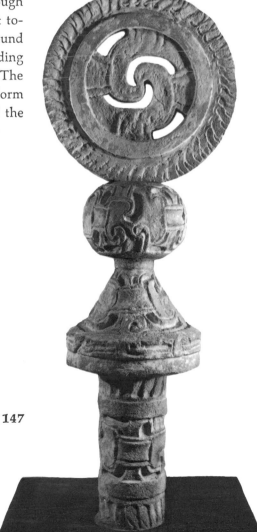

court. Nevertheless, no ball courts have been identified at Teotihuacán, and both the stela and the disk sculptures excavated there had been buried intentionally and reveal no connection with the game. Nearly all, however, are connected in some way with Tlaloc, the patron deity of the city.

The outstanding sculptural expression of Teotihuacán is the stone mask (Numbers 112–115), which in its serene simplicity has few discernible ties to either the monumental works or the Tajín style. The estimated time range, extending at least from period II throughout III, is based primarily on modeled ceramics that share the same naturalistic but idealized facial form. A surprisingly small number of examples is known to have come from the soil of Teotihuacán itself, though it has been lived on, farmed, and dug into as much as any site in the Republic.

The masks are remarkably uniform and rarely carry any decoration. A few have inlaid or painted patterns (Number 112) or a covering of mosaic. Almost without exception the half-open mouths and eye sockets are cut deeply and left unfinished because they were to be provided with inlaid teeth and eyes of shell and either pyrite or obsidian. When still in place these inlays give a lively effect, seeming nearly as startling to the eye accustomed to most ancient art today as might a Greek marble with its original paint or a brightly polished Chinese bronze.

Most of these masks are a little less than life-sized, though some are nearly twice as large and others are miniatures (Number 114). They all seem impractical to wear, lacking eye openings, and are generally believed to have been tied over the faces of the dead or to the outside of burial bundles, as was the custom in Peru with masks of metal, ceramic, wood, and fabric. Ordinarily the masks have perforations at each side in the temple and jaw for attachment to something, and in the earlobes for ornaments. They are cut squarely across the forehead as if to accommodate some kind of headdress.

If the original use of these stone masks is uncertain, the purpose of entire statuettes is no clearer. Both traditions seemingly originated with the Olmecs and were carried on strongly in the Mezcala and related styles of Guerrero and Puebla. These styles, as mentioned in the preceding chapter, are by no means securely dated. Nevertheless, standing symmetrical figures in particular seem to run in an unbroken stylistic sequence from Olmec to Teotihuacán. Olmec statuettes average only four to five inches in height, and though most later examples are also small, the size range increased. Among the largest are some with faces the same size as many of the Teotihuacán masks, and very much like them. Close similarity, which can be seen in Numbers 117 and 118, is rare, but these statuettes suggest another possible context for the masks: they could have been mounted on figures carved of wood.

Burial masks and statuettes were often clothed and decorated with perishable materials in Peru, where the dry climate has preserved wood, cloth, feathers, and hair. Mexican stone statuettes like Number 116, and wooden ones, if they did exist, were probably so arrayed. No clothing is indicated on their bodies, yet the ears are pierced for ornaments and the heads so flattened that a headdress seems necessary to complete the composition. Other figures have carved headdresses, ornaments, and loincloths (Number 119) or women's costume (Number 118).

All along, masks and figures were carved predominantly in green or greenish stone, prized because it was the color of jade, of water, and of growing plants. Jade itself, however, was rarely used after Olmec times for anything except beads, earflares, pendants, and other personal ornaments. The exquisite figurines from the offering discovered at the Temple of Quetzalcóatl (Number 119) are truly exceptional in being carved of jade but not perforated to be worn as jewelry.

Jade and other stone figurines have their humbler counterparts in the little clay figurines found by the thousands at Teotihuacán, generally broken so that only the heads have been recovered. The "portrait-head" figurines (Number 120) mark a technological and stylistic turning point in the long sequence that began with the same simple types found in other Preclassic sites. Over the centuries the small faces were more and more carefully modeled until, at the point when they were perfect miniatures of the Classic stone masks, pottery molds came into use. Hand-modeled bodies and ornaments were added to moldmade faces. Later, though the facial type ceased to change much, the molds came to include earflares, and then the whole body. As mass production met the demands of urbanization and expanding markets, the figurines displayed increasingly elaborate costumes and attributes of different deities.

Molds were also essential in manufacturing complex pottery censer tops that constitute a second stylistic tie between stone carving and ceramics (Number 122). They were assembled of molded units attached to flat cutouts framing the moldmade mask, which itself had separately molded ornaments. Most of the masks resemble the ones carved of stone, but some have the wrinkled face of the aged fire god (Number 123).

The same beautifully molded face is seen on the effigy jar of Thin Orange ware (Number 124). This distinctive pottery was made from a fine clay available in southern Puebla that enabled potters to make exceptionally hard thin-walled vessels of a pleasing color. Though most were of simple shapes, undecorated except by incised lines and pits, they found a ready market and were carried westward to the Pacific coast and throughout Middle America as far south as Copán, Honduras. Because of this wide dispersal Thin Orange is as highly regarded now by archaeologists as it was by the people of Early Classic times, who admired it for its high quality.

Teotihuacán had been supplied since the end of period I with Thin Orange from the production centers in Puebla, which soon came under its sway. During period III, the time of greatest production and widest distribution, they manufactured a small proportion of vessels especially for ritual use, such as the "mask-faced" effigies and cylindrical tripods similar to those made of other wares within Teotihuacán. These ceremonial vessels are found not only in Teotihuacán but also in distant places where the rulers at least must have valued them as religious paraphernalia as well as luxury imports. The presence of Thin Orange ware in distant places is only one indication of Teotihuacán's far-reaching influence. Other wares that have more obvious religious implications sometimes accompanied it, and all the major Early Classic styles of Middle America imitated or incorporated forms and symbols characteristic of Teotihuacán.

107 Standing goddess

Stone, with traces of green and light red paint over
 stucco
Height: 36 in. (91.5 cm.)
Central Mexico
Teotihuacán III, A.D. 250–650
Philadelphia Museum of Art, 50.134.282

The disproportionately large hands seem intended to
hold an object of some sort or to receive offerings. The
forbidding goddess, in her feather-edged skirt and
poncholike *quechquémitl*, is hunchbacked and bent un-
der the weight she supports on her head. (George Kubler,
The Louise and Walter Arensberg Collection, Philadel-
phia, 1954, pl. 2.)

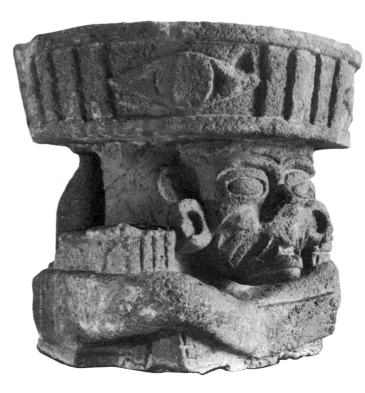

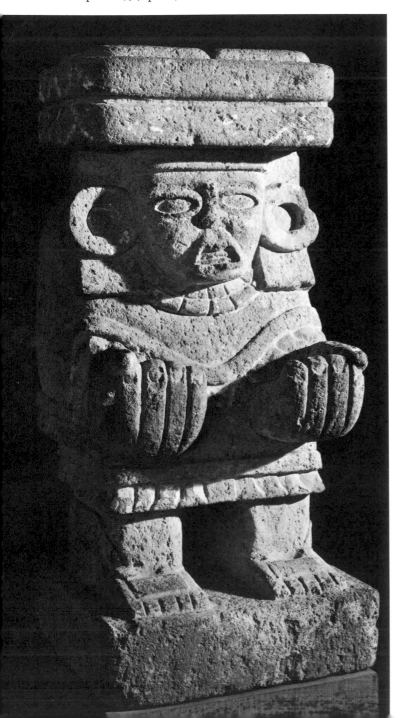

108 Old-fire-god brazier

Stone
Height: 19¾ in. (50 cm.)
Teotihuacán
Teotihuacán III, Early Xolalpan phase, A.D. 450–650
Museo Nacional de Antropología, Mexico, 9–2569

In the Aztec pantheon, one aspect of the fire god was
called Huehueteotl, "the old old god." His wrinkled face
appears in pottery and stone as far back as the Late Pre-
classic, his head already bearing a brazier. At Teotihua-
cán, small images of him seem to have been hearth gods,
while large ones like this were found in patios that served
several households.

109 Plumed jaguar

Creamy white aragonite (tecali)
Length: 13 in. (33 cm.)
Said to have been found at the foot of the Pyramid of
 the Sun, Teotihaucán
Teotihuacán II, A.D. 150–250
The British Museum, London, 1926–22

All four paws display, in place of naturalistic pads, the
abstract pattern seen so often in the art of Teotihuacán
as an emblem of Tlaloc (see also Number 111). The paw
patterns, deeply cut, were originally emphasized by inlay
of stone or pigment, as were the other incised lines and
the eyes. The two holes in the back, oval and rectangular,
suggest that the creature was an offering vessel, or pos-
sibly a kind of reliquary. Another tecali jaguar, prob-
ably of period III but carved with some of the same de-
tails, was found and described by Jorge R. Acosta ("El
Palacio del Quetzalpápalotl," *Memorias del Instituto
Nacional de Antropología e Historia*, X, Mexico City,
1964, figs. 51–54). The same excavation revealed a huge
stone serpent head stylistically like that of the exhibited
piece (Acosta, 1964, figs. 25, 99). (See Color Illustration.)

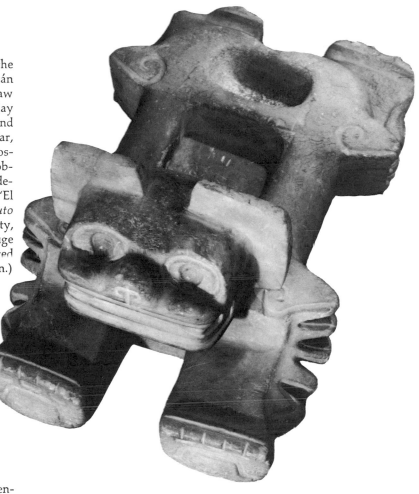

110 Sphere

Pale green aragonite
Height: 7½ in. (19 cm.)
Teotihuacán
Teotihuacán III, A.D. 250–650
Museo Nacional de Antropología, Mexico, 9–2529

Though it resembles the spherical element of the La Ven-
tilla Stela, this sculpture lacks a hole or peg on the base.
The opening in the top shows clearly the marks of the
large tubular drill used in hollowing it out. It is carved of
tecali, the beautifully banded Mexican variety of arago-
nite found principally near the town of Tecali, Puebla,
and often called Mexican onyx, onyx marble, or alabaster.

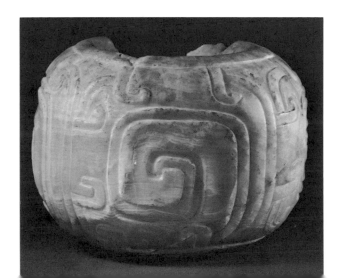

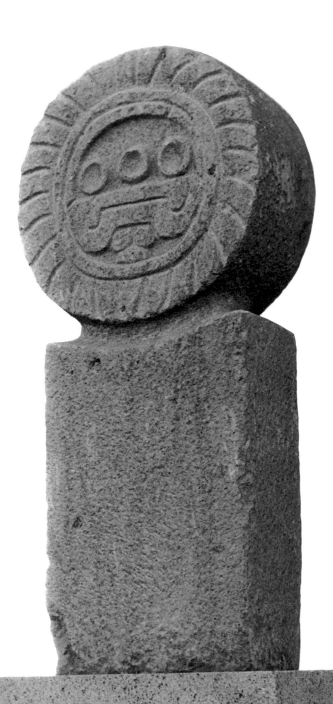

111 Tlaloc stela

Stone
Height: 42 in. (1.07 m.)
Provenance unknown
Teotihuacán II–III, A.D. 150–650
Fred Olsen, Guilford, Connecticut

The disk, bordered by a plume motif, bears a common emblem or glyph of Tlaloc derived from the paw print of the jaguar (see also Number 109). Similarly shaped monuments, also bordered by plumes and set on slope-and-panel bases, are depicted in the mural in the Tepantitla area of Teotihuacán that shows Tlaloc's paradise. His face also appears on plume-edged tenoned disks found in the Palace of Quetzalpápalotl, along with conical stones that have tenons and holes recalling the La Ventilla stela. Such monuments may have been forerunners of those that the Aztecs set up in the manner of roadside shrines or European market crosses, a possibility offered by Doris Hayden ("Algunos elementos de momostlis," *Boletín del Instituto Nacional de Antropología e Historia* 31, 1968, pp. 43–45).

112 Mask

Gray green aragonite
Height: 6¾ in. (17 cm.)
Atzcapotzalco, D.F.
Teotihuacán III, A.D. 250–650
Musée de l'Homme, Paris, 78.1 187

Motifs painted in green on the cheeks and forehead may have simulated precious jade inlay. The paint, originally a lacquer, resisted the erosion that has made the veins of the stone stand out, effectively accentuating the form. This piece was most recently published, with earlier references to it, by the Musée de l'Homme (*Chefs-d'Oeuvre du Musée de l'Homme*, Paris, 1965, no. 61).

113 Mask

Dark greenstone
Height: 5¼ in. (13.5 cm.)
Provenance unknown
Teotihuacán III–IV, A.D. 250–750
The Brooklyn Museum, A. Augustus Healy Fund, 50.150

Modeling and proportions that differ greatly from the trapezoidal Teotihuacán ideal Number 107) make this mask more believable as a portrait, though it is still very much idealized. Because of its rich color and hardness, the stone must have had unusual value.

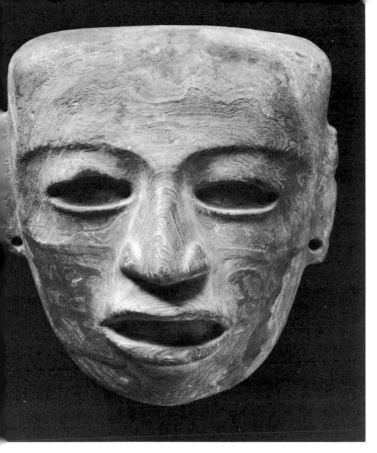

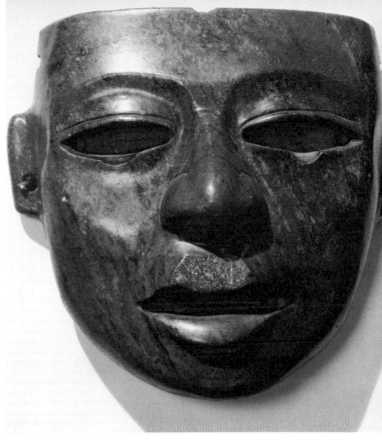

112

113

114 Small mask

> Light gray green serpentine
> Height: 4 in. (10 cm.)
> Metloltoyuca, northeast Puebla
> A.D. 450–750 (?)
> Field Museum of Natural History, Chicago, 95165

With its slanting eyes and animated expression, the mask resembles faces seen on Veracruz sculptures more than it does the typical masks of Teotihuacán, which are very different in proportion and lack ear ornaments.

115 Mask

> Gray brown stone
> Height: 5⅛ in. (13 cm.)
> Holzopal, Acatlán, Puebla
> Teotihuacán-Tajín style, A.D. 450–750 (?)
> Museum für Völkerkunde, Vienna, 59245

Though the basic shape and conception are typical of Teotihuacán, the scroll-enriched relief about the mouth and eyes shows the decorative influence of central Veracruz. It represents, in the Tajín manner, the "spectacles" and mustachelike elements that identify Tlaloc.

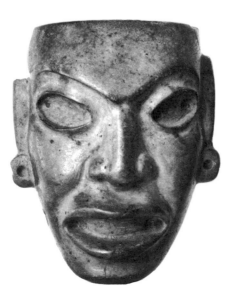

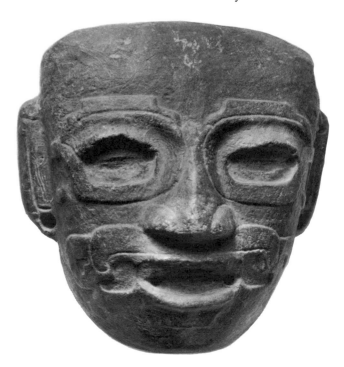

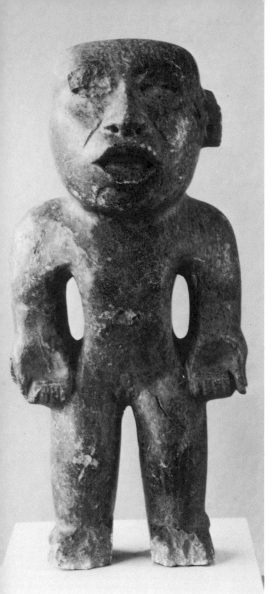
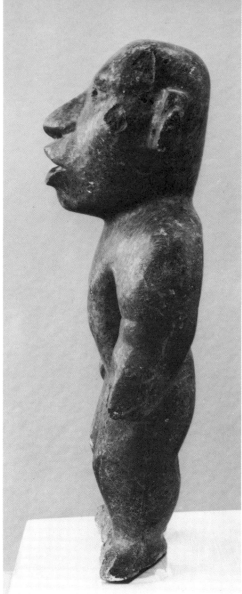
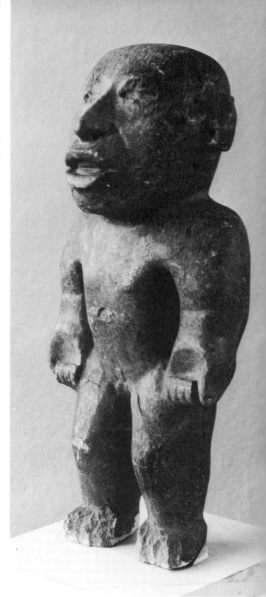

116 Standing figure

Light green metadiorite
Height: 16½ in. (42 cm.)
Provenance unknown
Early Classic, A.D. 250–650
Hamburgisches Museum für Völkerkunde und
 Vorgeschichte, B3627

The distinctive speckled stone of which the figure is carved is found in Guerrero and not often seen in ancient objects identifiable with any other region. The oval openings between the arms and torso are a Mezcala tradition, while the face is in the Teotihuacán mode, and the modeling more naturalistic than is common in either style. Angular perforations below the ear and in front of it may have anchored a large headdress, and the earlobes and septum of the nose are pierced for ornaments. The eyes are deeply cut for inlay and left unpolished. Also unpolished are the interior of the mouth (though teeth are indicated) and the hollowed palms of the hands.

117 Seated man

Pale, green-tinged aragonite
Height: 10½ in. (26 cm.)
Provenance unknown
Teotihuacán III, A.D. 250–650
Raymond Wielgus, Chicago

Though many Teotihuacán masks and a few smaller seated figures are carved of tecali, the material as well as the size and the pose of this figure are rare among Teotihuacán statuettes. The old fire god of the stone braziers (compare number 108) sits cross-legged, as do some clay figurines, but the pose is more characteristic of contemporary clay sculpture of Veracruz and Oaxaca. The figure is fully modeled, but the flattened head suggests that a headdress was added, as were inlaid eyes, teeth, and other adornments. The flat palms of the hands are turned upward as if to hold something.

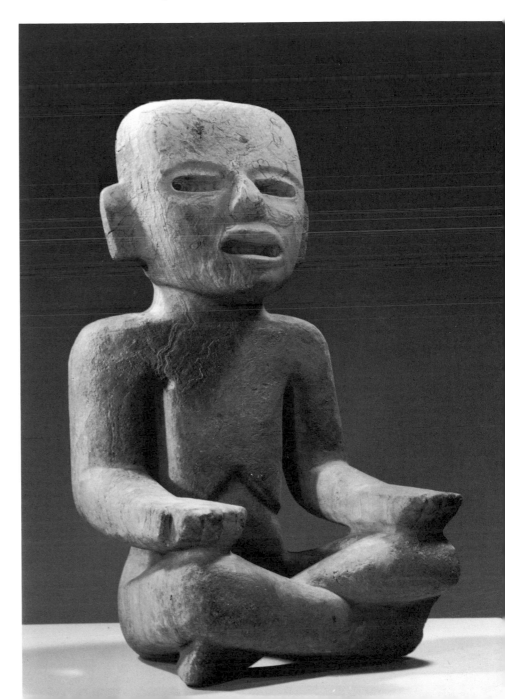

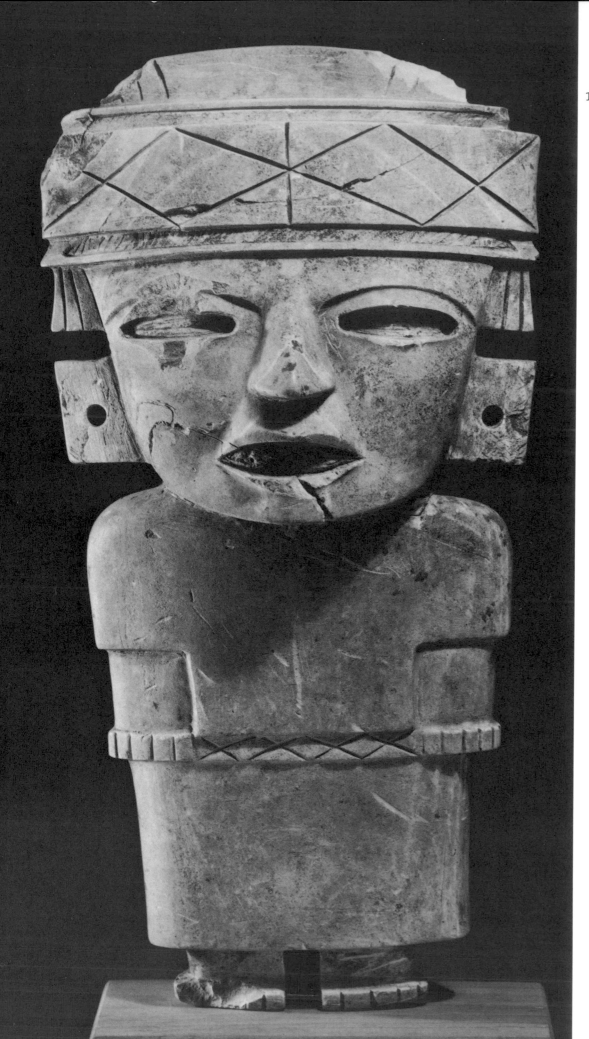

118

119

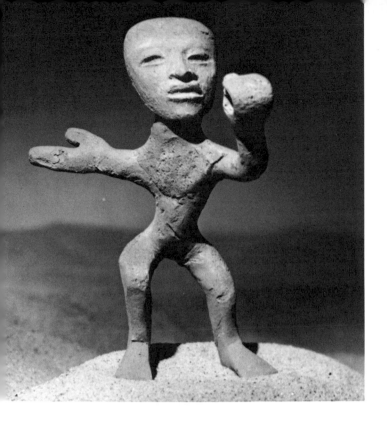

120 Dancing human figurine

Buff clay
Height: 3¾ in. (9.5 cm.)
Valley of Mexico
Teotihuacán II–III, A.D. 150–450
Museum of the American Indian, Heye Foundation,
 New York, 22/1370

Lively slender figurines like this one recall the happy personages depicted in the murals of Tlalocán paradise in Tepantitla, a district of Teotihuacán. While the slender bodies, fashioned by hand, were gracefully but simply rendered, the faces were pressed in tiny molds, so delicately modeled as to suggest portraits. Quantities of such figurines seem to have been made and discarded after playing their role in religious observances in homes and neighborhood shrines, rather than in the great temples.

118 Female figure

Greenstone, probably serpentine
Height: 13⅝ in. (34.5 cm.)
Puebla (?)
Teotihuacán III, A.D. 250–650
Dr. and Mrs. Josué Sáenz, Mexico

Costumed figures are reported to be found sometimes in matched pairs, male and female in the same grave. This stylized lady wears a stepped *quechquémitl* and skirt, with a rather complex headdress that was probably square-cornered originally. The figure is flat in back and has no perforations for added decoration other than inlaid eyes and mouth and ear ornaments.

119 Figurine

Mottled green and buff jadeite
Height: 2¾ in. (7 cm.)
Offering 2, Temple of Quetzalcóatl, Teotihuacán
Teotihuacán III, A.D. 250–650
Museo Nacional de Antropología, Mexico 9–1713

The flat headdress-backing was carved separately, as were the earflares, made with minute pegs at the rim that fit into tubular-drilled holes. This and a crowd of similar figurines were part of a large dedicatory offering placed beneath the new stairway of the temple when it was enlarged in period III. One of the richest offerings recorded at the site, its discovery is described by Daniel F. Rubín de la Borbolla in "Teotihuacán: Ofrendas de los templos de Quetzalcóatl," *Anales del Instituto Nacional de Antropología e Historia*, II, Mexico City, 1947, pp. 61–72.

121 Jaguar

Buff clay painted red
Length: 3⅜ in. (8.5 cm.)
La Ventilla district, Teotihuacán
Teotihuacán II, Miccaotli phase, A.D. 150–250
Museo Nacional de Antropología, 9–1849

The jaguar, symbol of power in the hieratic art of all Middle America, appears here modeled in the same manner as the human figurines made for popular ceremonies, modestly affirming the unifying force of religion in early Teotihuacán. This little creature is a mere scrap of clay, shaped with a sure mastery that gave it vitality rather than fierceness.

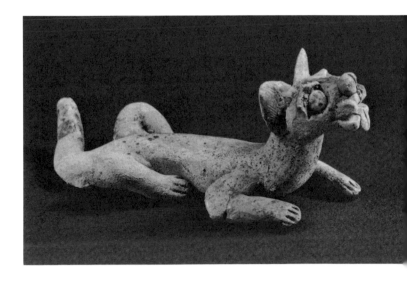

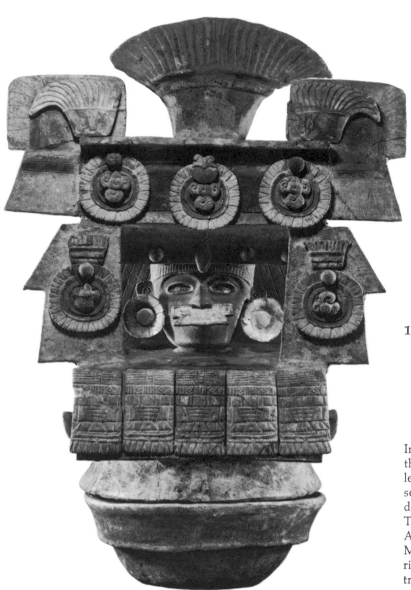

122 Censer

Buff clay with red, yellow, white, and blue paint
applied after firing
Total Height: 23⅝ in. (60 cm.)
Atzcapotzalco, D.F.
Teotihuacán III, Early Xolalpan phase, A.D. 450–550
Museo Nacional de Antropología, Mexico, 9–2407

Incense burned in the thick-rimmed bowl would rise through a chimney opening behind the crest at "roof level." The chimney helps support the framework representing a shrine or temple façade with a mask in the doorway. This "theater type" of censer was popular in Teotihuacán in its heyday, though this one comes from Atzcapotzalco, the colony west of Lake Texcoco (now a Mexico City suburb) where the old traditions were carried on long after the fall of the capital. (See Color Illustration.)

123 Face of an old man

Buff clay with traces of red, yellow, and green paint
Height: 14½ in. (37 cm.)
Provenance unknown
Teotihuacán III–IV, A.D. 450–750
The Art Institute of Chicago, 62.1073

This elaborately decorated mask is reconstructed from fragments of an exceptionally large censer and incorporates the chimney. The wrinkled face, seemingly that of the fire god seen on braziers carved of stone (Number 108), is adorned here with emblems of Quetzalpápalotl: quetzal heads above and below, and the tall forward-curling spiral that represents the proboscis of a butterfly. The entire headdress with its plumes and round eyes can be interpreted as the head of this bird-butterfly deity.

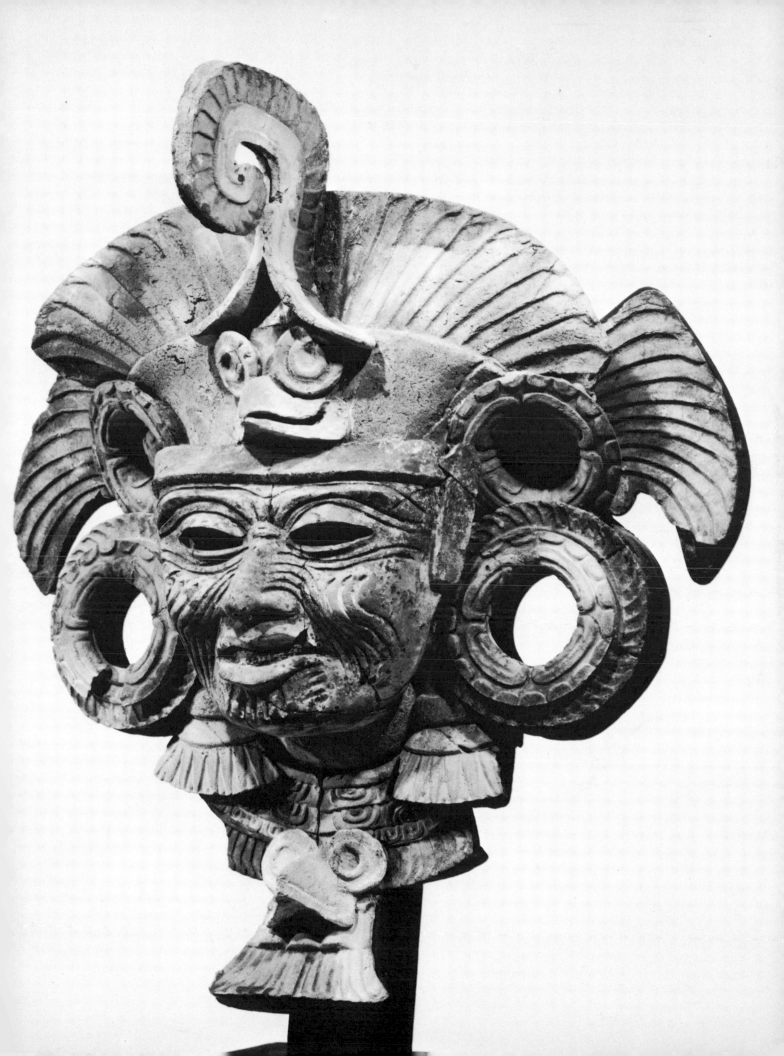

124 Seated-figure jar

Thin Orange ware (fire-clouded orange buff)
Height: 8½ in. (21.8 cm.)
Teotihuacán, state of Mexico
Teotihuacán III, A.D. 250–650
Museo Nacional de Antropología, Mexico, 9–759

The serene masklike face and the earflares were shaped in molds, and the hair tresses cut from sheets of clay. Head, arms, and legs are hollow but not connected to the interior of the jar, which forms the hunchbacked torso, encircled by an incised loincloth strap knotted in back. Most Thin Orange human effigies depict hunchbacks, but, as in the censer tops (Numbers 122, 123), the face may be that of either an old man or a youth. An almost identical jar, found in a tomb outside Guatemala City, is shown in figs. 192a and 193 of Alfred V. Kidder, Jesse D. Jennings, and Edwin M. Shook, "Excavations at Kaminaljuyú, Guatemala," Carnegie Institution of Washington Publication 561, Washington, D.C., 1946, which contains a wise and thorough study of Thin Orange and other proof of ties with Teotihuacán. Additional data is given in Alfredo Sotomayor and Noemí Castillo Tejero,

"Estudio Petrográfico de la Cerámica anaranjado delgado," *Departmento de Prehistoria del Instituto Nacional de Antropología e Historia*, Publication 12, Mexico City, 1963.

125 Sleeping-dog vessel

Thin Orange ware (uniform pale orange)
Height: 8 in. (20.5 cm.); diameter: 16½ in. (42 cm.)
Provenance unknown
Teotihuacán III, A.D. 250–650
Dr. and Mrs. Josué Sáenz, Mexico

The curled-up dog with closed eyes is a common effigy form in Thin Orange, but rarely seen in this size, which denotes a notable technical achievement in such thin pottery. Molds were generally used to form the hollow head and the upper and lower halves of the body, and in this case, the front paws. The vessel is flat on the bottom but supported on three nubbin feet, placed without relation to the anatomy of the animal, whose back legs are omitted entirely.

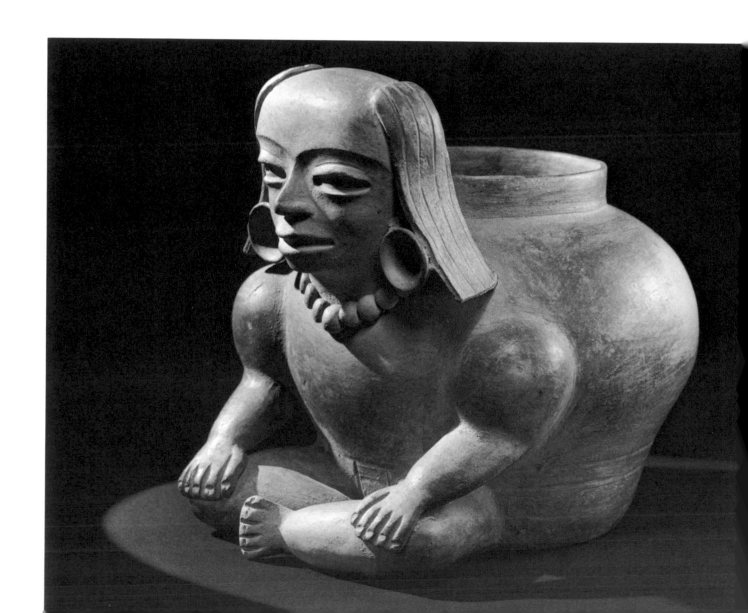

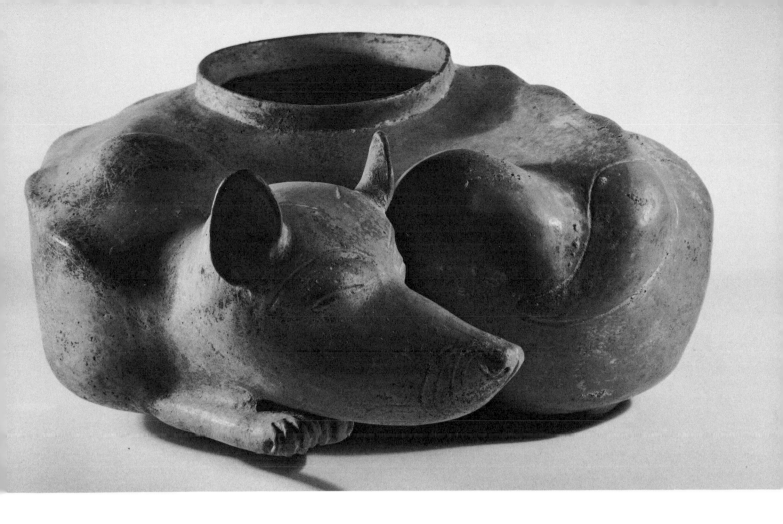

126 "Pato Loco"

Fire-clouded buff clay with white paint, jadeite,
 Spondylus shell, and unworked shells of the Olive
 and Murex families
Height: 9½ in. (25 cm.)
Burial 66, La Ventanilla district, Teotihuacán
Teotihuacán II, Early Tlamimilolpan phase,
 A.D. 250–375
Museo Nacional de Antropología, Mexico 9–2548

Affectionately named by the excavators the "crazy
duck," this surprising bird has the beak of the quetzal,
as seen so often in the art of Teotihuacán (Figure 19 and
Number 123). Since the encircling feather crest and large
eyes were also essential quetzal characteristics, these fea-
tures added in orange shell and jade were certainly part
of the original conception and not a frivolous after-
thought. Additional spots of paint and adhesive on the
body suggest that originally the vessel fairly foamed
with marine shells, which were imported from both
coasts, often placed in offerings, and depicted as symbols
of the major deities. (See Color Illustration.)

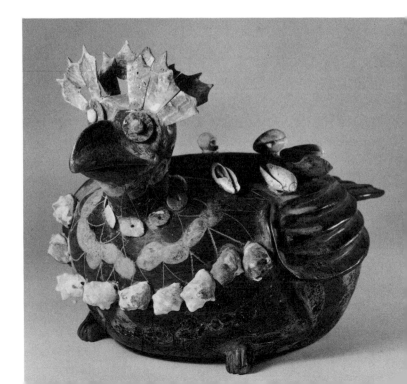

7

Gulf Coast Sculpture
in Clay and Stone

As a full participant in the civilization of the Classic period, the Gulf Coast of Mexico shared many art forms with the dominant northern metropolis of Teotihuacán and the southern centers of the Zapotecs and the Maya. The potters of the Gulf Coast produced some of the greatest works ever achieved in hollow clay sculpture, a mode inherited from the Preclassic. And in relief sculpture, the carvers of the Gulf Coast surpassed in brilliance their Izapan predecessors and invented ceremonial shapes that were to be widely adopted in Mesoamerica.

The area that produced this distinctive art is the central part of Veracruz, a state that curves from north to southeast in a narrow arc extending along the shore of the Gulf of Mexico and inland to the lofty mountains bordering the central highland plateau. Although fertile, central Veracruz is not as lush as the tropical southern part of the state, earlier the heartland of the Olmec civilization, and around Remojadas, center of the Classic ceramic art, is somewhat arid.

The north-central part of Veracruz is still inhabited by Totonac Indians, the same group that welcomed Cortés on his arrival in Mexico and invited him to their capital of Cempoala. Longing to be freed from paying tribute to the Aztec empire, the Totonacs saw the Spaniards as allies in overthrowing the Aztec tyranny. Aztec domination of Veracruz had begun when the Nahua-speaking relatives of the Aztecs migrated into the southern half of the state, probably displacing the Totonac speakers. Maya people inhabiting the area southeast of Veracruz obviously influenced the culture of the Classic Totonacs. The far north of the state of Veracruz and parts of adjoining states are known as the Huasteca, whose Huastec inhabitants speak a language distantly related to Maya. Artistically, however, the Huastecs always maintained a regional identity distinct from Maya, Totonac, or highland Nahua and had little effect on other Veracruz art of the Classic period.

162

In spite of the proximity of the heartland of the Olmec civilization to central Veracruz, few survivals from that early culture occur in the Classic-period art. Large hollow ceramic figures certainly derive from a Preclassic tradition, but in Veracruz they often reach sizes so colossal that their component members had to be formed of regular geometric shapes. The resulting objects, while stiffer than the more graceful, smaller Preclassic figures, achieve an imposing monumentality.

The earliest large clay figure in the exhibition (Number 127) betrays a slight Olmec cast of face, perhaps reflecting the same Olmecoid revival that occurred in neighboring Oaxaca during late Monte Albán I and early Monte Albán II (Numbers 76, 155). The seated clay figure's rectangular eyes and trapezoidal mouth, with its extended upper lip, suggest the facial features of the jaguar babies. Soon, however, all Olmec traits were erased as a result of massive cultural influx from

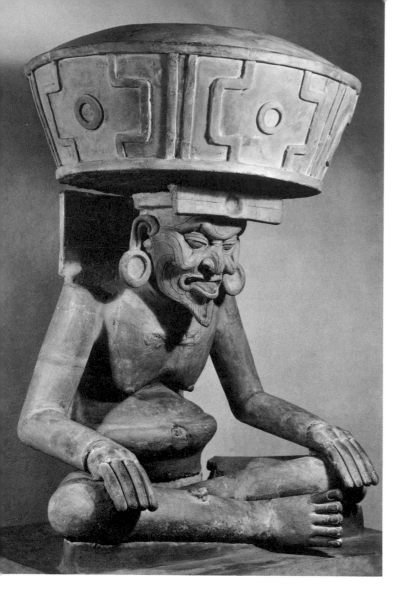

FIGURE 21

Seated old fire god

This large clay figure, now in the Museo Nacional de Antropología, Mexico, was uncovered in excavations at the Early Classic site of Cerro de las Mesas, Veracruz, led by Matthew Stirling ("Expedition Unearths Buried Masterpieces of Carved Jade," *National Geographic Magazine* 80, 1941, p. 292, pl. II). The figure, broken and placed on one of the stucco-faced steps leading up to a sizable platform behind the main plaza, is approximately life-size, 33 inches high as reconstructed. Its large brazier headdress and its bowknot and earspools are decorated with pink paint. Very near to it was a cache of jade that included Number 40, an Olmec heirloom piece.

FIGURE 22

Ruins of El Tajín, Veracruz

Surrounded by unexcavated mounds, only the main ceremonial center has been uncovered and partially restored. The large stepped pyramid to the right has 365 niches, one for each day of the year. Behind the smaller platforms to the left lies the South Ball Court (Figure 23). The large trees with which the site was once overgrown have been cut down to reveal the contours of the still buried structures.

Teotihuacán. The seated clay figure of the old fire god (Figure 21), discovered in fragments during the excavation of Cerro de las Mesas, Veracruz, dramatizes the extent of this influence when compared with a seated stone old fire god from Teotihuacán (Number 108). Nevertheless, the Cerro de las Mesas piece displays a characteristically strong naturalism that distinguishes it immediately from Teotihuacán figures, with their architectonic angularity.

Although the construction of large clay figures may have been suspended after the fall of the Teotihuacán empire, small hollow figures continued to be made in the Late Classic period. Instead of being modeled by hand, most parts of these figures were formed by pressing the clay into a mold, resulting in rounded contours. The better artists sharpened the features by touching them up after removing the clay form from the mold, much as a good sculptor will chase the bronze after casting.

Sculptures of the familiar "smiling-face" type (Number 132), the most charming of the smaller Late Classic figures, exude animated good humor. Their eyes sparkle, and their mouths open in a contagious grin, revealing teeth and sometimes a

tongue. Such representations of human emotion in faces are rare in Middle American art, and in early art in general. The large foreheads, the wide faces, the round and undeveloped torsos, and the short limbs of these little laughing figures indicate that they represent children. Usually found in burials, they perhaps were clay companions for the deceased, to dance and sing for him in the next life. Many of the laughing figures are whistles, indicating that they may also have been used in ceremonial dances. Their active poses with upraised hands, sometimes holding rattles, suggest that they are engaged in musical activities. Since so many were obviously broken at the time of burial, with only the heads, which were buried separately, left intact, their funerary function may well have been secondary to their ceremonial use.

The ceramic art of Classic central Veracruz has traditionally been called Remojadas, after the partially excavated site that yielded hollow clay sculpture of many different types. The exact geographical range of each of the types and their chronological relationships will become clear only after further excavations and careful stylistic analysis.

Stone sculpture in the central Veracruz style, like clay sculpture, has traditionally been called by the name of a single site, El Tajín (Figure 22), although its range equals and perhaps exceeds that of the ceramic sculpture. Despite the coexistence of stone and clay sculpture, the two have very little in common regarding style, use, and subject matter. The most distinctive feature of the Tajín style of stone carving is its elaborate scrollwork, usually with a double outline. The scrolls often cross and curve around one another, forming complex interlaces. Hardly any free-

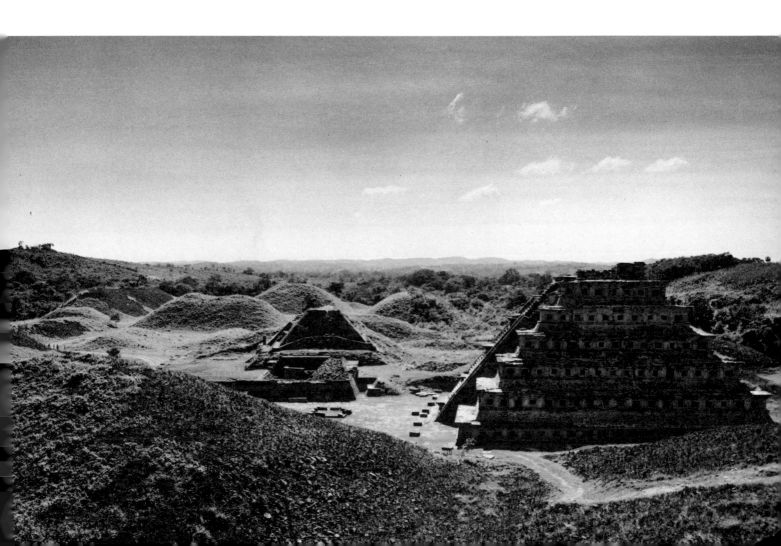

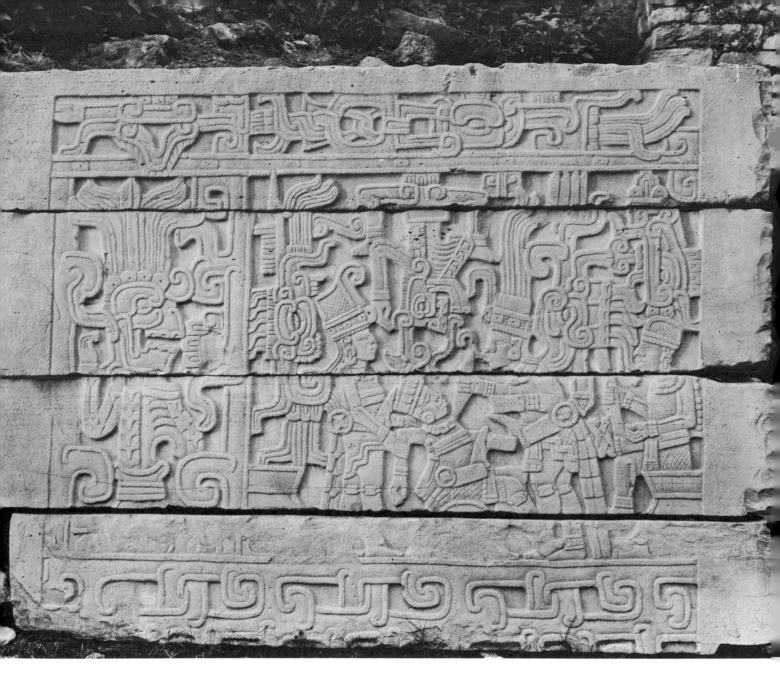

FIGURE 23

Relief Panel 4, South Ball Court, El Tajín

One of a series of six carvings in the vertical side walls of the larger ball court at El Tajín, this panel, 78 inches long, is on the northeast corner. It presents the culminating scene of a cycle depicting the ball game and preparations for it. In this panel, two standing figures, wearing yoke-shaped belts with palmate stones set in front, sacrifice a third, similarly dressed figure by plunging a knife into his upper chest. They stand inside the profile of a ball court, on the right hand bench of which sits an observer. A sky deity hovers over the victim, descending from the upper band of interlaced scrolls, which may represent a sky serpent. In a separate panel to the left, a skeletal figure partially emerges from a jar, like a genie, to watch the sacrifice.

standing figural sculpture exists, reflecting a general hiatus of carving in the round during the Classic period in Mesoamerica. Relief sculpture, the dominant form of carving in stone, was almost always subordinated to the functional shape of the stone that it decorates. For example, the fine low relief on a breast plaque (Number 141) beautifully conforms to its circular shape, like a tondo by Raphael. The most prominent use of relief in architecture occurs on the sides of the ball courts at El Tajín; the plentiful use of scrollwork firmly associates interlaced scrolls with the ball game. On one of the reliefs, two men addressing each other across a large ball at their feet are enclosed within profiles of walls identical to those of a ball court. Another relief represents a scene of a man being sacrificed, again within the profiles of ball-court walls with sloping sides (Figure 23).

Special courts for the game were not constructed of stone until the Classic period, although the ball game had long been part of Mesoamerican culture, as we know from Preclassic figurines wearing the game's distinctive belts and padding. The form of architecture apparently spread from the Maya area, where the earliest known courts occur at Copán, to closely related areas such as Oaxaca and Veracruz. By the end of the Classic period, several variants of the ball game existed, as indicated by the different shapes of the courts. From Conquest-period descriptions and archaeological evidence, Stephan Borhegyi deduced the following general principles: All ball courts have a long alley, which served as a playing surface, bordered by a wall (whose slope varies regionally), off which the ball could rebound. The court itself is often divided into four quarters by markers, sometimes permanently set into the floor or on the side walls. At each end of the alley, where the enclosing walls stop, is a clearing, into which the defense tried to prevent the ball from going. In some courts, this area is also enclosed by a wall, making an **I**-shaped playing surface.

The sacrifice scene on one of the El Tajín reliefs, mentioned above (Figure 23), dramatizes the high stakes involved in the game, which can only be explained by its cosmic significance. The ball itself represented a celestial body such as the sun, which had to be kept aloft through the efforts of both gods and men. The importance of the game is further emphasized in the painted codices, where there are many scenes illustrating the sealing of treaties within a ball court. Myths record that even the gods settled disputes by playing the ball game and that the results of earthly contests were subject to divine influence.

The ubiquitous scrollwork characterizing stone carving in central Veracruz is undoubtedly more than mere decoration. At least as early as the Izapan period, scrolls symbolized flowing water, and by extension, the rain god. The artists of Teotihuacán, from whom Veracruz sculptors derived much inspiration at the start of the Classic era, rendered surface water by a line of wavelike scrolls with double outline, accentuated at the crest by small rows of squared dots. On Veracruz panels and yokes, these scrolls often combine into the figure of a serpent or the Earth Monster, a composite reptilian manifestation of the god of the earth. To the Mexican mind, earth and death were intimately linked. Heavenly bodies, which are gods, sink into the earth when they set in the west and then go to the world of the dead. The failure of a member of either team to return the ball symbolized the

167

sinking of a celestial sphere, whose light would be extinguished while it was imprisoned in the underworld. The scroll iconography of the ball court, a part of the earth, appropriately represented the deities associated with earth and water, the opposites of the celestial gods.

According to sixteenth-century sources, returning the ball without letting it touch the ground was most essential, for which reason players threw themselves at the heavy, solid rubber sphere as it rebounded toward them off the sides of the court. The ball could only be hit with the elbows, knees, or lower torso, which had to be protected by padding or other special apparatus. As mentioned earlier, even Mesoamerican figurines from Preclassic times show players wearing heavy belts. While some from the Classic Maya appear to be leather, strapped around the open end, others like the one on a slender Huastec figure (Number 139) are thick and horseshoe-shaped, identical to stone forms actually found in excavations. These stone belts occur in an area ranging from Central Mexico to highland Guatemala but are concentrated in central Veracruz, where many are decorated with relief carving. Quite commonly the deep relief transforms the yoke into the image of a crouching frog, a guise of the earth god (Number 144).

On the upper ledge of the stone belt, players are frequently represented wearing a projecting flange. Similar in form are the stone carvings with notched backs, by means of which they could be placed upon the stone belts (Number 149). Although these carvings may have served some function, such as deflecting the ball, more likely they were used as ceremonial emblems, either of the team or of the lineage of the player. We cannot definitely say whether these stone forms were actually worn, or whether they are only commemorative translations of leather forms into stone, which then served as trophies. If they actually were worn, the stone protectors would probably have been removed before starting play, as they would be unstable during the action. Their emblematic function may explain types that lack a notch and therefore could not be worn (Number 148). These ceremonial stones may have been placed against the side walls of the court as standards or even as line markers.

These stone forms encompass several types. The earliest are heads that have definite post-Olmec features and ridged crests on the forehead (Number 147). From this type, two distinct later variants developed. In one, the sides narrow to approximate a thin blade, suggesting the common name of axe, or *hacha*. Both sides are worked, usually with the same composition. Subsequently the sculptors of Veracruz developed the other typical form, which had a wide base like the early stone heads but which introduced a lateral spread of the upper portion of the stone, forming a fan like an open palm frond. From its appearance, it is called a palmate stone, or *palma* (Number 153). If worn, either in stone or a lighter material, the spreading form could provide excellent protection for a player's solar plexus, which was extremely vulnerable if hit by the heavy ball; the Spanish chronicler Durán even mentions deaths caused by such a blow. While the back of the palma is wide, the front tapers forward and downward, creating the equivalent of a notch and permitting it to be worn on top of the stone belt, as illustrated in the El Tajín reliefs.

Some ceremonial stone forms of these types are found in the Nahua-speaking areas of Mesoamerica, where the concepts apparently spread from their point of origin in central Veracruz. Horseshoe-shaped belts appeared throughout the Central Mexican area following the collapse of the Teotihuacán empire. The smaller stone forms, originally designed to be worn on top of the belts, were transformed outside central Veracruz into purely emblematic representations. A handsome tapered stone parrot head, said to be from Xochicalco (Number 150), is far larger than any of the Veracruz hachas, suggesting that it served as a ball-court marker or a trophy. In the highlands and Pacific slope of Guatemala, where Nahua-speaking tribes migrated around the middle of the Classic period, thin stone hachas were introduced into the Maya artistic repertoire. Like the Xochicalco piece, these highland forms apparently were not worn in the ball-game ritual, since they lack a notch. Compositions show considerable inventiveness, often featuring scenes of struggle or death (Number 152), and frequently include pierced holes and cutout silhouettes, preserving an old Maya tradition (Number 62). Palmas do not appear outside of Veracruz, since they were developed after the spread of the stone belts and hachas.

The conventional name for the stone belt, "yoke," first employed as a slang expression, was supported by late nineteenth-century Mesoamerican archaeologists, Alfredo Chavero for one. In those days, all the pre-Hispanic Mexican peoples were thought to be as preoccupied with human sacrifice as the Aztecs encountered by Cortés, and the "yoke" was believed to have held a victim in place prior to sacrifice. When in 1924 a burial was discovered that included a yoke stone surrounding the jawless skull, it strengthened the association of yokes with death, suggesting even that they symbolized jawbones. By extension, the notched stones in the same style as the yokes were imagined to be part of some bloodthirsty ritual, since they looked like axes and could perhaps have been used for decapitation. Human sacrifice is a major theme of architectural relief sculpture; even some hachas and palmas have scenes of sacrifice carved on them. But today, now that the great differences among the varied cultures of Mesoamerica are clear, the Aztec excess of human sacrifice stands out as a deviation from the more restrained use of the custom in earlier times. In the Classic period, only prisoners were sacrificed in large numbers, as represented in the columns at El Tajín. For most ceremonial occasions, a small animal was an adequate sacrifice. But, as the scene of human sacrifice on the El Tajín reliefs demonstrate, the ball game was sufficiently important to require the immolation of the losing player who had permitted the symbolic sun to fall to the earth.

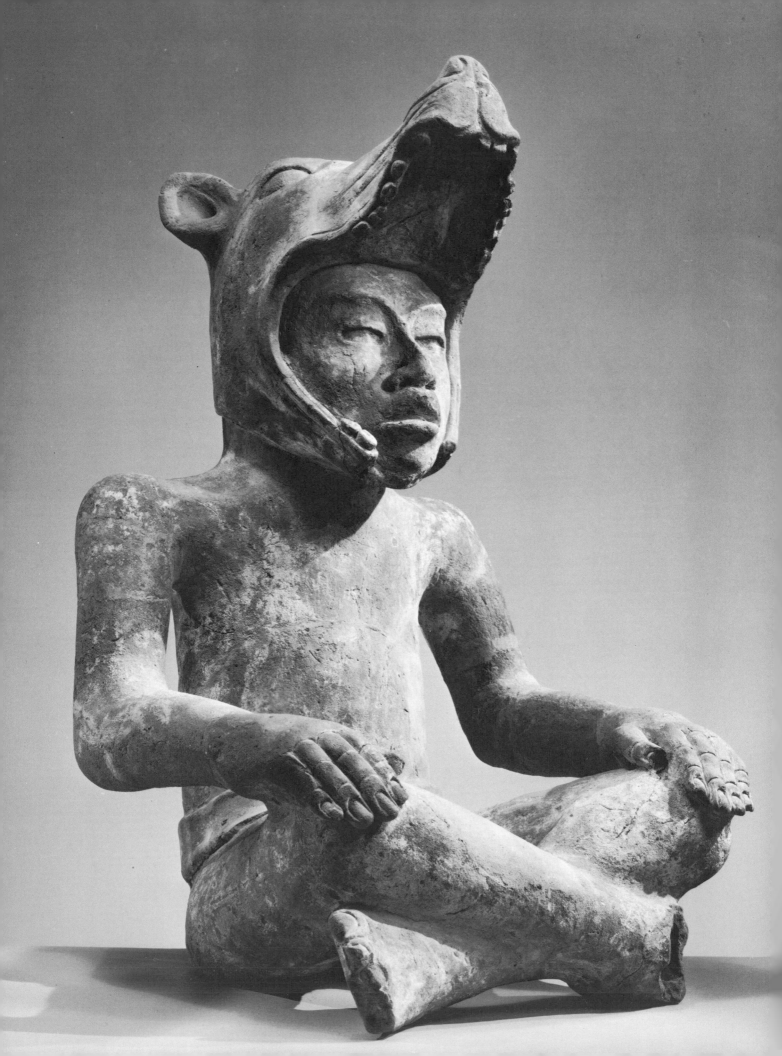

127 Seated man with canine headdress

Coarse red clay with traces of white paint
Height: 29¾ in. (75.5 cm.)
Acatlán region, Oaxaca (?), Mexico
Late Protoclassic, about A.D. 1–150
The Metropolitan Museum of Art, J. M. Kaplan Fund,
 67.249.1

The canine headdress, probably representing a coyote, was worn by warriors as a badge of rank and to endow them with the qualities of the animal. These headdresses were formed by a frame covered, in Aztec times at least, with feathers, all of one color. The Olmec features of the face, the proportions of the body, and the coarse clay employed by the sculptor recall the clay figure (Number 155) made in Oaxaca during Monte Albán II (150 B.C.–A.D. 250). Raised shoulders and the widely separated arms are also characteristic of both objects. Unlike this Veracruz piece, however, the Monte Albán figure has delicate fingers and flattened eyes. Because of the many resemblances to Oaxacan figures, this sculpture can tentatively be attributed to the outpost of Veracruz culture closest to Monte Albán, the area around Acatlán de Pérez Figueroa.

128 Seated man wearing a helmet

Grayish brown clay with black asphalt paint
Height: 26¾ in. (68 cm.)
Medellín, Veracruz, Mexico
Early Classic, A.D. 250–550
Mr. and Mrs. Ricardo Hecht, Guadalajara

In this figure, typical of the "monumental ware" of the Early Classic, the details are more generalized and the forms more continuous than those of Number 127. Furthermore, the severe face, with downturned yet delicately modeled mouth and narrow eyes that are little more than slits, has no trace of Olmecoid features. Almost architectural in composition, the figure takes the form of a pyramid from any angle, expressing a sure stability. However, the back of the helmet originally bore flanges, which extended out to the sides. The black paint, called *chapopote* in Mexico, covers the skin areas, possibly marking the man as a priest, since in the codices priests are often so designated.

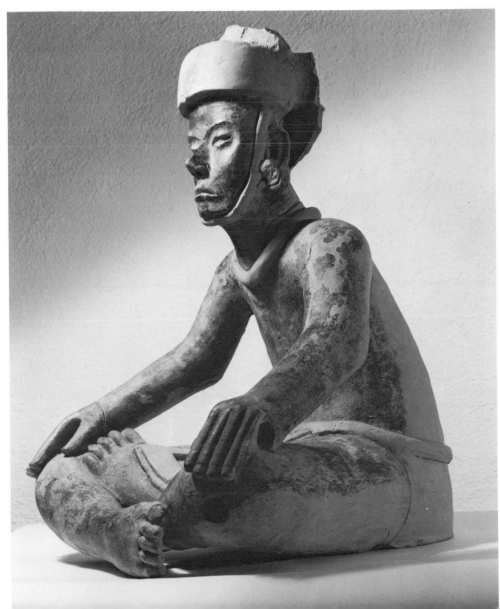

129 Standing man wearing a helmet

Rough orange buff clay with black resinous paint
 on skin areas
Height: 25⅞ in. (65.8 cm.)
Central Veracruz, Mexico
Late Protoclassic, A.D. 150–250
Mr. and Mrs. Alvin Abrams, Woodmere, New York

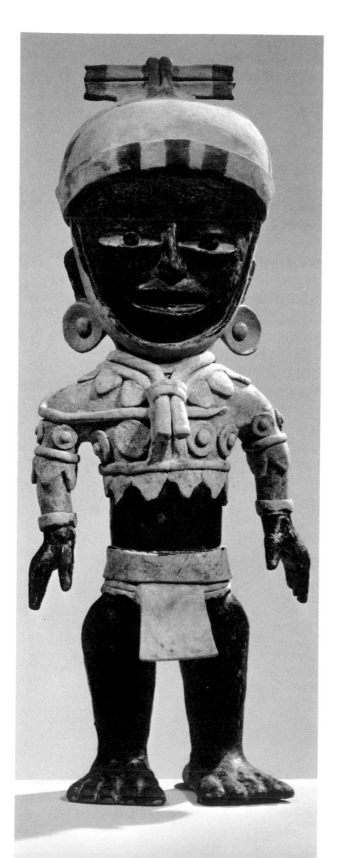

This narrow-waisted figure conveys, with its springy S-curves, a poised alertness. An interesting local variant of the Remojadas type, it wears a short, fitted tunic, with scallop-edged waist and sleeves, and a band of concentric disks, possibly representing precious stones, across the upper torso and shoulders. It can be dated by its resemblance to another clay figure, also having button-shaped pupils stuck into spindle-shaped eyes, which was excavated by Alfonso Medellín Zenil ("Nopiloa, un sitio clásico del Veracruz central," *La Palabra y el Hombre* 13, Jalapa, 1960).

130 Seated girl

Coarse buff clay with touches of black paint
Height: 17¼ in. (44 cm.)
El Faisán, Veracruz, Mexico
Early Classic, A.D. 250–550
Museo Universitario de Ciencias y Arte, Universidad
 Nacional Autónoma de México, Mexico City
Ex coll. William Spratling

The lovely, delicate features make this modeled figure of an adolescent girl one of the finest productions of the Classic Veracruz sculptor. The long, graceful fingers turn up slightly at the tips, and the fingernails are precisely rendered. The black paint, used in quantity in certain other sculptures, is here restricted to a mascaralike outline around the eyelids and the dot of the pupil. The suppleness of the legs as they cross and the arms as they rest lightly on the knees gives this piece a flowing continuity carried out in the curves of the torso and the skirt. Altogether, the sculptor has created an image of a graceful, alert young woman, and his work conveys an immediacy rare in pre-Columbian art.

131 Female head with jaguar headdress

Buff orange clay with white slip
Height: 5¾ in. (14.7 cm.)
South-central Veracruz, Mexico
Late Classic, A.D. 550–750
Dr. and Mrs. Josué Sáenz, Mexico City

Modeled, rather than made in a mold, this head relates to the typical smiling face (Number 132) by the crescent shape of the eyes and the partly open mouth revealing the upper row of teeth. It also shows influence from the south and east, the high nose bridge suggesting Maya figures and the cushion headdress with an animal effigy on top suggesting Zapotec urns. The central decoration of the headdress and the body to which the head was once attached have been broken off, making it impossible to identify the figure further.

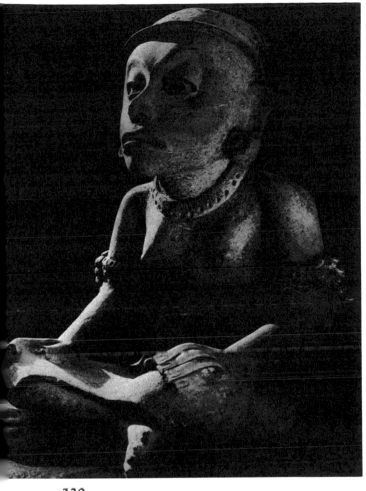

130

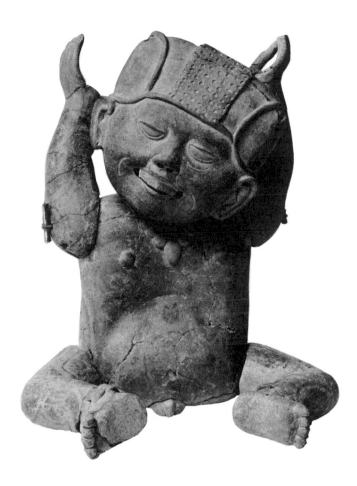

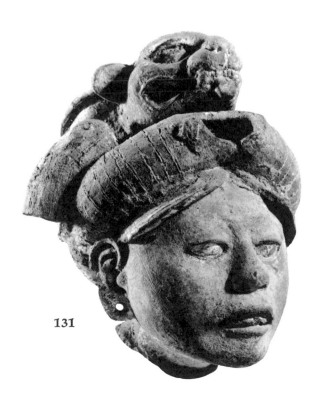

131

132 Seated child with movable limbs and head

Burnished clay with painted decoration
Height: 11¼ in. (28.6 cm.)
Tierra Blanca area, Veracruz, Mexico
Late Classic, A.D. 550–950
Isaac Delgado Museum of Art, New Orleans, 68.3

Smiling children are among the best-known clay sculptures from Veracruz. Most of the complete figures are standing, with their bodies modeled by hand and their faces imprinted in the soft clay by mold. This figure is unusual—perhaps even unique for this style—in that its head is tied to the body, permitting it to be placed at various angles. Also separate, the legs and the arms can be tied in any position (for another position, see the Isaac Delgado Museum of Art catalogue, *The Art of Ancient and Modern Latin America*, New Orleans, 1968, no. 67). Such articulated dolls occur infrequently throughout Mesoamerican history (Number 6 is an earlier example).

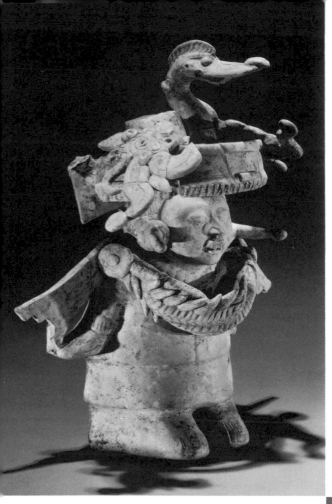

133 Standing lady wearing bird headdress

Fine creamy gray clay with white slip
Height: 10¼ in. (26 cm.)
Nopiloa, Veracruz, Mexico
Late Classic, A.D. 550–950
Anonymous loan to The American Museum of Natural
 History, New York, T 109/154

Related to Number 132, this figure in the whiteware
Nopiloa style has a face with similar proportions but
without the smile. The mold used in making this piece
was very deep, forming the front and the sides of the
woman. The back, where the clay was pressed in, was
covered with unsmoothed clay. Unlike most other Nopi-
loa figures, this piece has elaborate clothing attached to
the original moldmade form. A twisted animal skin, per-
haps of a reptile with pointed scales or teeth, is slung
around the neck like a loose cowl and attached to the
shoulders by circular brooches. The open circular head-
dress, elaborate as it is, once had three vertical projec-
tions in the back, which made it even more complex. The
waterfowl's head and neck, sprouting from the top of the
woman's head, are flanked by wing-shaped extensions in
the form of profiles of monster heads with long noses
and fangs.

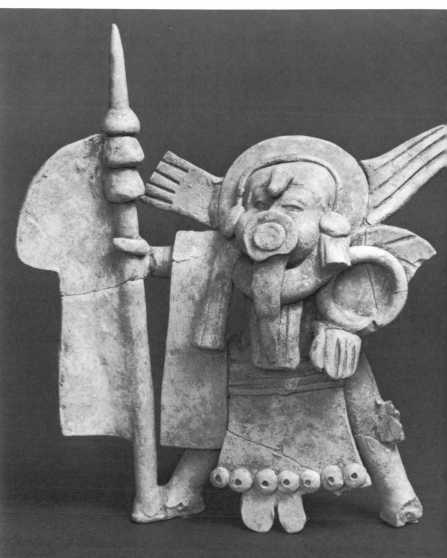

134 Standing warrior holding spear

Solid buff clay without slip
Height: 10¼ in. (26 cm.)
Remojadas, Veracruz, Mexico
Early Classic, A.D. 250–550
Fred Olsen, Guilford, Connecticut

The spear that this figure of a warrior in full regalia plants to one side is decorated with a flange of stiff slat-shaped elements perhaps representing large feathers, like the eagle feathers on the lances of Plains Indians. The same stiff feathers form sprays on either side of the head-dress and adorn the small circular shield, which is attached to the warrior's left arm, permitting free movement of his hand. The trapezoidal shape of the long loincloth is echoed in the widely planted feet. The stance and the details of costume are all seen in a figure from Guajitos, a site very near Remojadas (Alfonso Medellín Zenil, *Cerámicas de Totonacapan*, Jalapa, 1960, p. 78). Medellín stated that the latter figure represents "Xipe-tlasolteotl," a combination of the male deity of spring growth and the goddess of fall harvests, basing his interpretation on the plaque-mask covering the lower part of its face. But this identification seems mistaken, since the lively figure on exhibition, so similar in iconography, does not wear such a mask; rather, a double disk covers his nose and mouth.

135 Standing dancer with removable helmet-mask

Buff orange clay with white slip
Height: 8¼ in. (21 cm.)
Juachín, Veracruz, Mexico
Late Classic, A.D. 550–950
The Brooklyn Museum, 66.88

This moldmade dancer from near Nopiloa is clearly related in style to Classic Maya figurines, although made in south-central Veracruz. The feather crest on the cadaverous grinning monster head forming the helmet-mask is nearly identical to one found at Tres Zapotes. The shoulders support a superstructure in the form of a splay of textured ornaments—perhaps feathers or basketry—flanked by winglike shoulder boards. Heavy padding has been used to build up the impressiveness of the torso, as in a similar-faced figurine from near Nopiloa (Alfonso Medellín Zenil, *Cerámicas de Totonacapan*, Jalapa, 1960, p. 101). One hand resembles a large crayfish claw, a feature seen on other padded figurines.

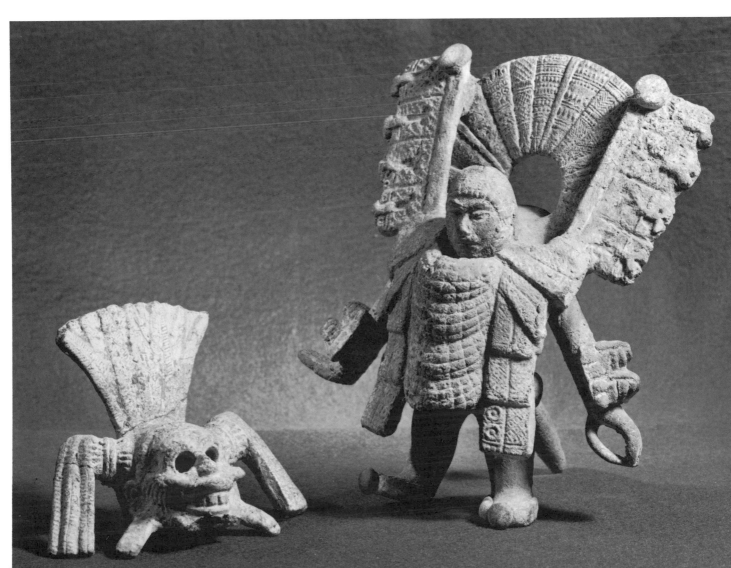

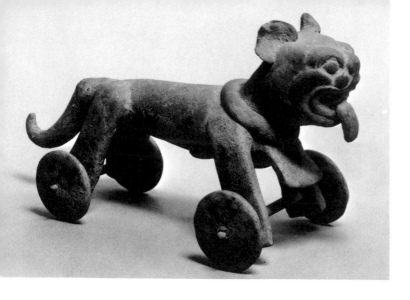

136 Wheeled feline whistle

Buff orange clay with earth incrustations
Length: 9¼ in. (23.5 cm.)
Veracruz, Mexico
Late Classic, A.D. 550–950
Mr. and Mrs. William Jaffe, New York

Showing one of the few uses of the wheel in Middle America, little clay animals of this type look like children's toys. They occur mainly in Veracruz, and have been found at archaeological sites throughout the state. They appear so often in graves that they may have been designed to serve as guides that would lead souls through the underworld. The majority represent dogs, which traditionally had that function; the jaguar, seen here, is also associated with the underworld. Like a similar but smaller wheeled jaguar whistle found in Nopiloa (Alfonso Medellín Zenil, *Cerámicas de Totonacapan*, Jalapa, 1960, pl. 56 bis), this jaguar has a moldmade face. The legs are straight flanges, with holes for wooden axles (which of course have not survived). A whistle mouthpiece is at the back of the tail base, and there is a long slot along the spine to make the tone.

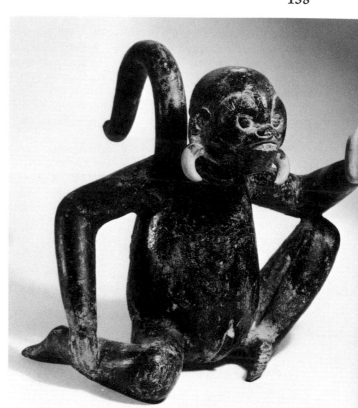

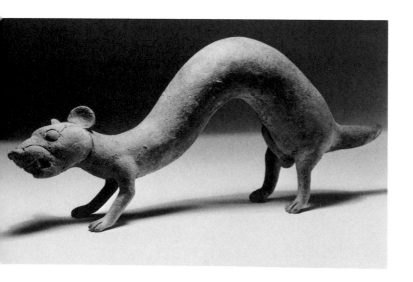

137 Snarling weasel

Hollow buff orange clay with gray earth incrustations
Length: 13⅛ in. (33.5 cm.)
South-central Veracruz, Mexico
Mid-Classic, A.D. 400–700
Dr. and Mrs. Josué Sáenz, Mexico City

The supple naturalism of this delicately modeled sculpture is rare in Mesoamerican art. Perhaps in the representation of animals the artists felt free from the conventions that bound the depiction of nobles and gods. The mouth, open at the sides and containing a pair of squared teeth, recalls the laughing faces from the same area.

138 Seated monkey holding a cacao pod

Black asphalt paint over coarse orange hollow clay;
blue pigment on the pod
Height: 9⅝ in. (24.5 cm.)
South-central Veracruz, Mexico
Late Classic, A.D. 550–950
Dr. and Mrs. Josué Sáenz, Mexico City

Spider monkeys, the black-furred, long-limbed denizens of the high trees in Middle America, are popular subjects in Veracruz clay sculpture, where they often are shown swinging in a high arch. Because of its naturalistic simplicity, this image seems free of complex meaning at first glance, but this may not be so. Alfonso Medellín Zenil and Frederick Peterson ("A Smiling Head Complex from Central Veracruz, Mexico," *American Antiquity* 20, 1954, pp. 166–168) have identified a fertility cult featuring ithyphallic monkeys, such as this figure, as well as toads, opossums, and jaguars. Cacao, a pod of which is prominently displayed here, served at times as a medium of exchange.

139 Seated ballplayer

Solid clay with orange cream slip
Height: 3 in. (7.7 cm.)
Huasteca, Mexico
Protoclassic, Transitional Pánuco II–III phase,
about third century A.D.
Margaret Lourie, New York

140 Standing woman

Fine gray clay with orange slip
Height: 13¾ in. (35 cm.)
Huasteca, Mexico
Early Classic, Pánuco III phase, A.D. 300–500
Mr. and Mrs. Ricardo Hecht, Guadalajara

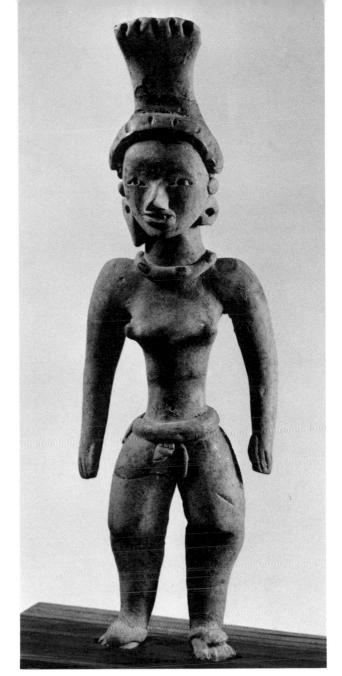

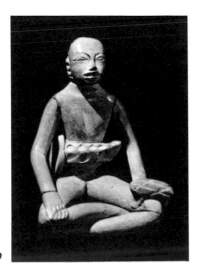

139

These two figures were made by the Huastec Indians of northern Veracruz or adjacent areas. Highly refined versions of common Preclassic forms, these solid figurines have details made by punctation and impression of a thin tool in the wet clay. However, little use was made here of *pastillaje*, the application of small pieces of rolled clay on the surface, common in the Preclassic. Rather, the features were smoothed out into continuous, flowing forms, recalling the contemporary figurines of the neighboring Teotihuacán culture (Number 120). Figures of this type convey an elegant dignity independent of their actual size, the range of which is suggested by these two examples.

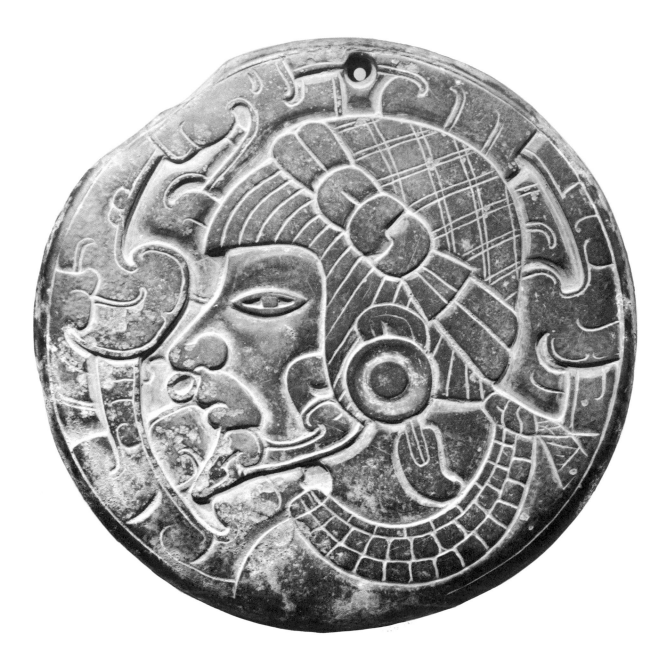

141 Circular plaque with a bearded head in profile

Dark gray slate with red pigment in the grooves
Diameter: 6 in. (15.4 cm.)
El Tajín area, Veracruz, Mexico
Late Classic, A.D. 750–950
The Metropolitan Museum of Art, 00.5.991
Ex coll. Petich

An unusually fine example of the type of relief carving found on the architecture of El Tajín, this plaque shows many of the hallmarks of the Tajín style, notably the scrolls with double-line border. The pair of small loops on the inner left-hand border is found also on Postclassic Plumbate decoration, suggesting a late date for Veracruz pieces with this detail (Tatiana Proskouriakoff, "Varieties of Classic Central Veracruz Sculpture," in Carnegie Insti-

tute of Washington Publication 606, 1954, p. 74). Since the site of El Tajín has no trace of Postclassic pottery, its relief sculpture must all be placed within the Classic period (M. E. Kampen, "The sculptures of El Tajín," Ph.D. dissertation, University of Pennsylvania, 1969). Another late feature noted by Proskouriakoff is the way the scrolls conform to the outline of the plaque, differing from those on earlier circular plaques, where the scrolls follow an independent rectilinear grid. Although these earlier plaques served as decorated backs to mirrors of pyrite, there is no evidence that this piece ever had anything attached to its smooth, unornamented back, which is not polished enough to reflect an image.

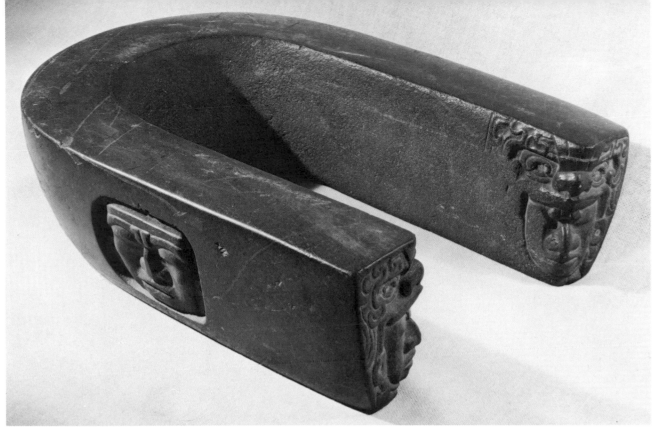

142 Smooth closed yoke

Partially polished speckled brown and olive stone
Length: 20½ in. (52 cm.)
Provenance unknown
Early Classic, A.D. 250–550
The Metropolitan Museum of Art, gift of Mrs. Ernest
 Brummer, in memory of Ernest Brummer, 69.237

Closed yokes, which seldom have the rich decoration seen on the open U-shaped ones, derive their beauty solely from their proportions. This belt has a polished flat band on the bottom, from the outer border of which the unpolished sides swell upward to a wide, polished ledge on top. The raised band around the inner border of the top echoes the band on the bottom.

143 Smooth open yoke with faces

Dark gray stone
Length: 15⅜ in. (39 cm.)
Central Veracruz, Mexico
Early Classic, A.D. 250–550
Museum für Völkerkunde, Vienna, 59897

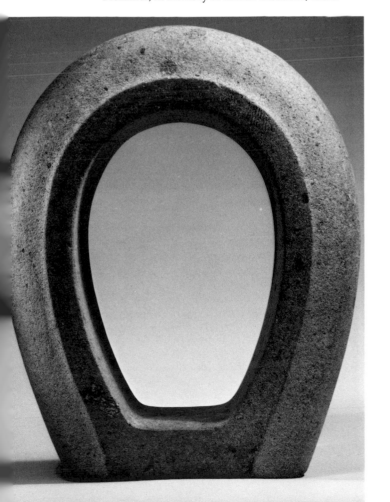

Smooth open yokes are the most common type of ceremonial stone belt found in Mesoamerica. This unique piece bridges the gap between uncarved yokes and the fully carved ones. Here, a face looks out of a medallion on each outer side of the yoke and on the curved front, and other heads have been carved on the inside angles of the open ends. Each of the latter pair wears an overhead monster helmet-mask, the snub nose and limp scrolls of which have an Izapan look. On the inside angle, the scrollwork tapers away, leaving a tantalizing suggestion that the carving was left unfinished, perhaps consciously, like certain sculptures by Rodin.

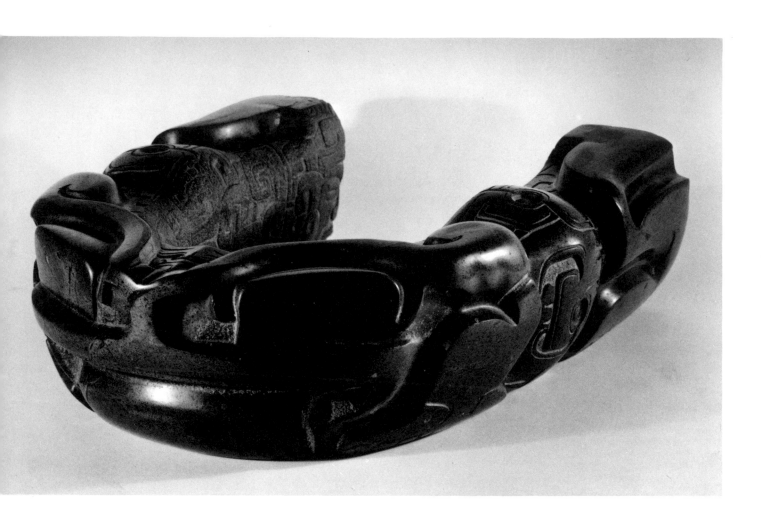

144 Frog yoke

Dark greenstone
Length: 16½ in. (42 cm.)
Coatepec, Veracruz, Mexico
Classic Period, A.D. 250–950
Museo Nacional de Antropología, Mexico, 4–1876

Richly carved on all exposed sides, this yoke displays a beautiful balance between bold high relief and lightly incised low relief. The latter technique is used mainly on the inner surface for the scrollwork, which becomes deeper and larger in scale toward the outside. As on Number 143, helmeted human faces are incised on the inside corner of each open end. In high relief is the body of the "frog." Its wide face covers the entire curved front of the yoke; a large tongue sticks out of the mouth. Pressed close to the sides of its mouth are the front feet, terminating in incised claws, which indicate this represents not a true frog but a saurian monster. Toward the back ends of the yoke, crouched rear legs are rendered by deeply cut, curving grooves, conveying a coiled tautness. The dull shine of the polished stone convincingly re-creates the effect of reptilian or amphibian skin.

145 Carved yoke with skeletal faces

Ivory-colored chalcedony
Length: 16⅜ in. (41.5 cm.)
Central Veracruz, Mexico
Late Classic, A.D. 550–950
Dr. and Mrs. Josué Sáenz, Mexico City

146 Carved yoke with skeletal faces

Black-mottled greenstone with traces of cinnabar
Length: 16 in. (40.5 cm.)
Central Veracruz, Mexico
Late Classic, A.D. 550–950
Mr. and Mrs. Paul Tishman, New York

These two masterpieces present the theme of death in a similar manner. In the curved front of each appears a broadly grinning skeletal face with sunken eye sockets and hollow nose, flanked by rattlesnake tails. In the middle of each outer side is a human skull, more fully modeled than the surrounding scrolls. The side segment toward the open end adjoining each skull has been carved with the openmouthed profile of a monster with upturned nose. In addition, both open ends of the ivory-colored yoke are carved with the relief profiles of a human skull, facing out to the side. The inside surfaces are smooth.

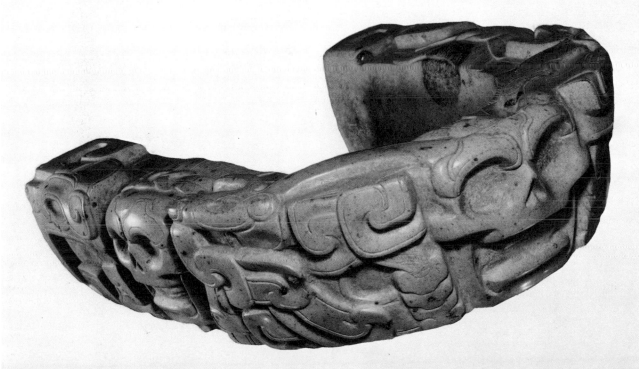

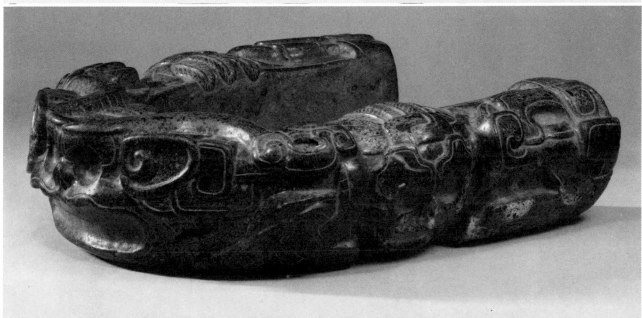

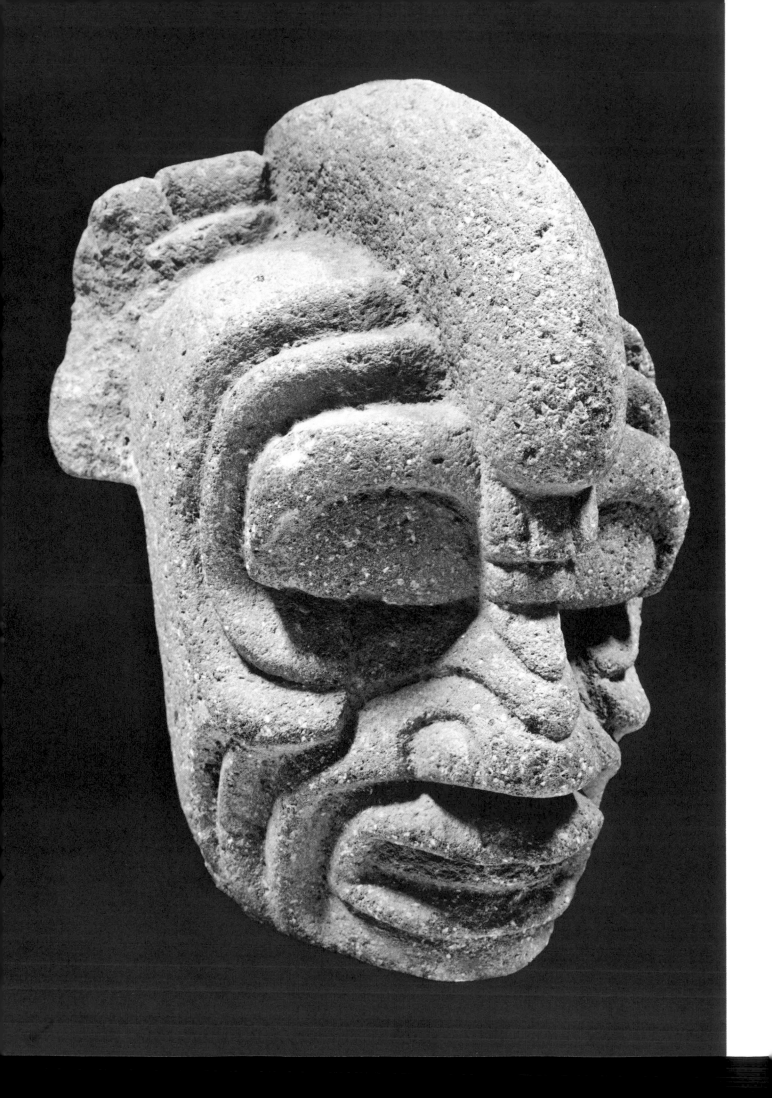

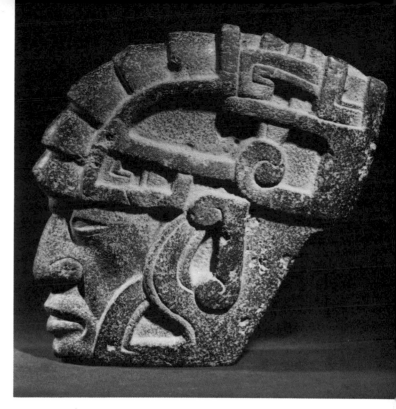

147 Hacha of crested human head

Light gray stone with white particles
Height: 9⅛ in. (23.2 cm.)
North-central Veracruz, Mexico
Early Classic, about A.D. 300
The Cleveland Museum of Art, gift of Mr. and Mrs.
 S. D. Wise, 1945
Ex coll. Gov. Teodoro Dehesa

This wrinkled head of a very old man represents an early type of hacha, not thin and axe-like, but an ovoid sphere notched in back. According to Tatiana Proskouriakoff, most early hachas representing human heads have closed or heavily lidded eyes, suggesting decapitated trophies. Also typical of early hachas is the rounded crest running from the brow to the top of the skull. In this example, the lower end of the crest is adorned with rectangular plugs between the eyes, a post-Olmec survival shared also by Number 143.

148 Hacha of head with dolphin headdress

Light brownish gray stone
Height: 11 in. (28 cm.); depth: 1½ in. (4 cm.)
Tuxtlas Mountains, Veracruz, Mexico
Mid-Classic, A.D. 550–750
Museo Nacional de Antropología, Mexico, 4–1066
Ex coll.: Jesús Castillo; Miguel Covarrubias

149

Perhaps the most frequently published of all hachas, this piece has earned its fame by the fineness of its carving and the grace of its outlines. In the roughly carved sunken zones along the spine of the dolphin and across the eyes, as well as in the eyes themselves, there may once have been a mosaic inlay of colored stone. The tenon in back is unusual, replacing the notch found in most Veracruz hachas. Leaping fish appear on the headdresses of both Veracruz and Guatemalan hachas, suggesting that this piece dates from the period when the two regions were in contact.

149 Hacha of warrior head

Brown stone with brick red paint on face
Height: 12 in. (30.5 cm.)
Central Veracruz, Mexico
Mid-Classic, A.D. 550–750
Mr. and Mrs. Samuel Josefowitz, Lausanne

Undoubtedly contemporary with Number 148, this head has the same treatment of the nose wings and mouth corners. The face on the preceding hacha is heavier and fleshier than this face, which must be considered one of the most sensitive renditions known in Mesoamerican art. The extraordinary depiction of tense muscles under the skin of the cheek adds to the stern forcefulness of the image of a warrior. His helmet, plated like the back of an armadillo, is tied by an elaborate series of knots to his skull and jaw. Toward the upper rear of the helmet may be seen the abstracted eyes and L-shaped mouth of an animal.

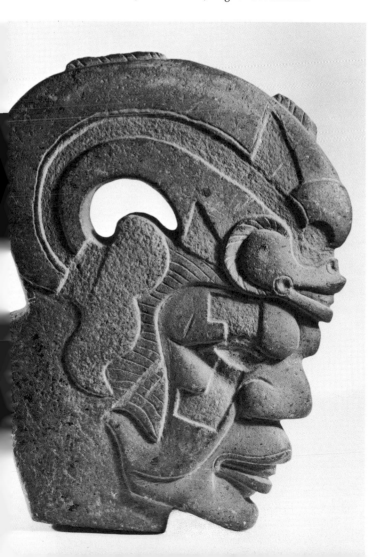

150 Parrot-head hacha

Gray volcanic stone with traces of stucco and red paint
Height: 21⅝ in. (55 cm.)
Xochicalco, Morelos, Mexico
Late Classic, A.D. 550–950
Museo Nacional de Antropología, Mexico, 14–2

Seen from the side, as in the photograph, this head presents a magnificent two-dimensional design. Seen in the round, it has a surprising monumentality and massiveness, depicting a parrot with considerable naturalism.

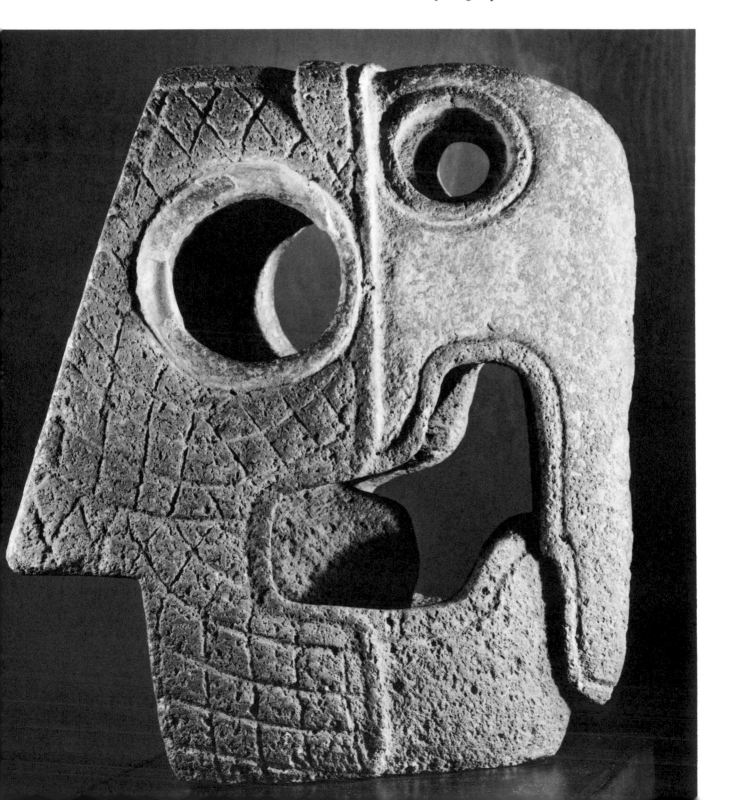

The lower part of the head swells outward, creating a play of volumes that contrasts effectively with the two-dimensional abstract feather texturing on the side. Behind its massive, angular beak, hollowed on the inside, is a thick, round tongue, characteristic of the parrot family. The hollow of the eyes penetrates the entire width of the head, giving it a forceful staring expression. Its commanding presence from every angle would have dominated the ball court at Xochicalco, nearly the length of a football field, if, as suggested, it were set on a platform as a marker.

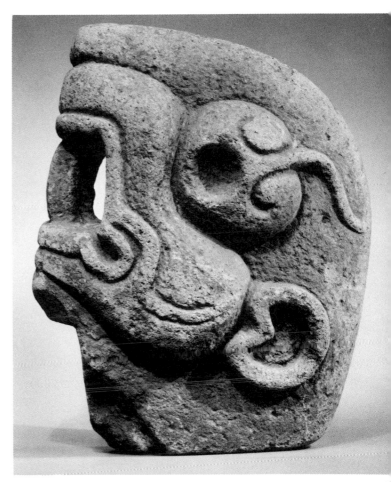

151 Rodent-head hacha

Light gray stone with black particles and traces of red
 paint on the outline of the ears and on the tendrils
Height: 8¾ in. (22.2 cm.); thickness: 3⅞ in. (9.8 cm.)
Toniná region, Chiapas, Mexico
Mid-Classic, about 6th century A.D.
Miles J. Lourie, New York

The thick, high-relief bolster shapes give this buck-toothed animal head from Chiapas a robustness seldom found in Veracruz hachas. Its smaller details, such as the tendrils growing out of the eyebrow and the corners of the mouth, reiterate the larger, chunky curves. Solid and compact, it has rounded forms reminiscent of the early, crested hachas (Number 147). Therefore, it must date to the beginning of the diffusion of Veracruz ball-court paraphernalia into the highland Maya area. It seems to be a common Veracruz segmented elliptical shape turned around, with the notch under the chin instead of in the back, and perhaps suggests a prototype for the notchless Guatemalan hachas (Number 152).

152 Openwork hacha of a man struggling with a snake

Mottled greenstone shading toward brown in back
Height: 12¾ in. (32.4 cm.)
Pacific slope of Guatemala
Late Classic, A.D. 750–950
Mr. and Mrs. Samuel Josefowitz, Lausanne

The Laocoön-like figure depicted on this hacha wrestles with a huge constrictor, whose head lies at the bottom front of the composition. Unlike most hachas, this one has sides that are not mirror images of each other but show the rear and the front view of the group (see Color Illustration). Since a beard (here apparently artificial) was a sign of importance, this man may represent a culture hero engaged in epic combat with a deity in reptilian guise. The piece is in the Cotzumalhuapa style, which dominated southern Guatemala in the Late Classic. Another hacha in that style was found in fragments with organic material yielding a radiocarbon date of A.D. 840 ± 80 (Lee Parsons, *Bilbao, Guatemala*, II, Milwaukee, 1969, p. 78).

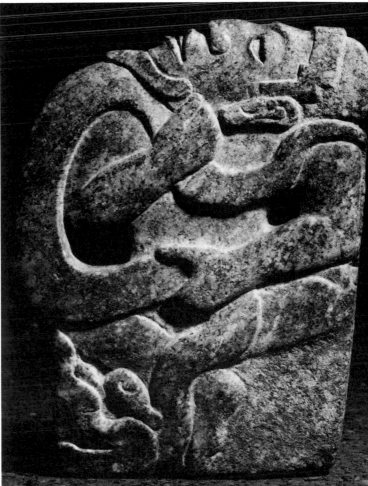

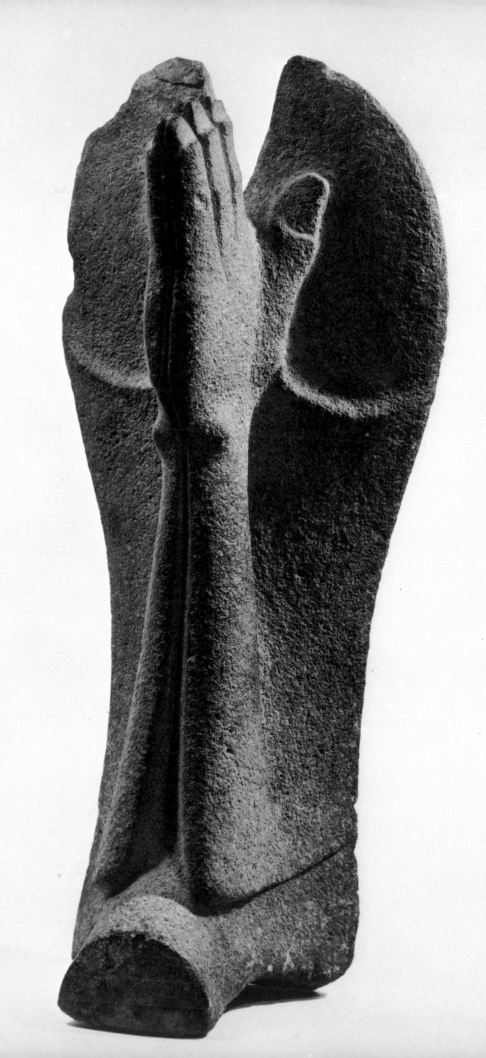

153 Palma with praying hands

Coarse light gray stone with yellowish stain
Height: 16⅜ in. (41.5 cm.); depth: 4¾ in. (12 cm.)
El Tajín region, Veracruz, Mexico
Late Classic, A.D. 750–950
Museo Nacional de Antropología, Mexico 4–1065
Ex coll. Miguel Covarrubias

Elegant in its soaring simplicity, this carving differs from most Late Classic effigy palmas, which are loaded with figures and scrolls. The Christian connotations of the iconography give the misleading impression this piece might be post-Conquest. Although the organic quality of the thin forearms and pressed hands suggests observation of nature, the hands have only three fingers. When seen from the front, the outspread thumbs suggest eyes by the placement of the nails, and the hands become a monstrous nose. Perhaps, as in some Aztec sculpture, a dual image was intended.

154 Inverted snake with crenelated tail

Gray stone with red paint
Height: 14¾ in. (37.5 cm.)
Highland Guatemala
Late Classic, A.D. 550–1000 (?)
Mr. and Mrs. Samuel Josefowitz, Lausanne

Although this palmalike form could be a version of the Toltec inverted serpent motif (Figure 36), and the crenelations on the highest part of the tail resemble architectural details, these features first appeared at Teotihuacán. Teotihuacán influence was strongest in highland Guatemala during the mid-Classic period, as seen at the site of Kaminaljuyú. The glyphs on the middle of the snake's back resemble those excised in Late Classic ceramics of the lowland Maya.

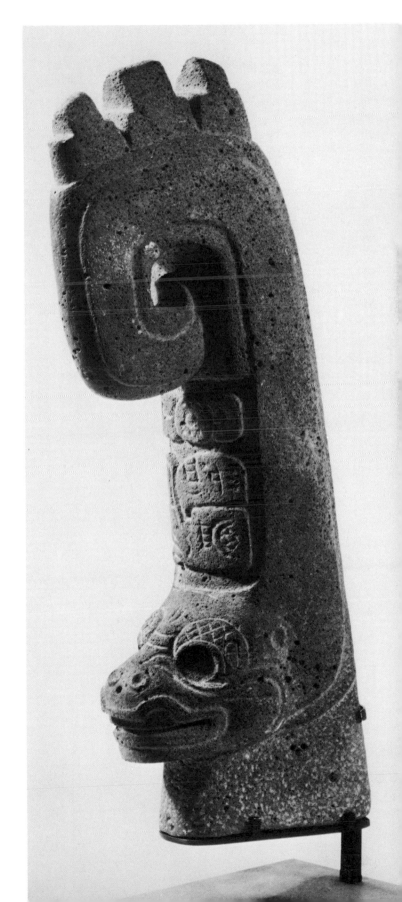

8

Zapotec Tombs and Offerings

Oaxaca state was a distinct cultural region in the Classic period, separate from Teotihuacán, central Veracruz, and the Maya area. Its geographical and spiritual center was the large Valley of Oaxaca, where the Spanish later founded the city of Oaxaca. The area surrounding the valley is one of mountain ranges, cut by rivers into a series of canyons. No valley within two hundred fifty miles is as large as this one. Fertile, well watered, and semitropical, it provides perfect conditions for a high level of agricultural development. The resulting wealth permitted ambitious architectural projects and the creation of intricate art objects. Because of its isola-

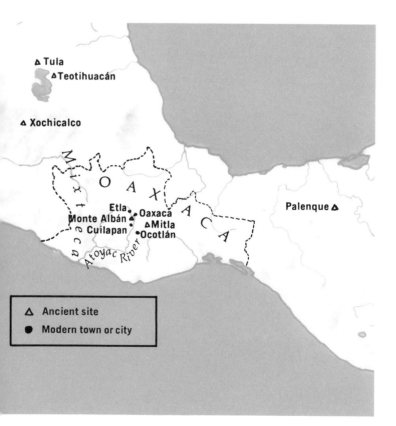

FIGURE 24

Panoramic view of Monte Albán

Dramatically situated on an acropolis above the Valley of Oaxaca, the great plaza of Monte Albán was artificially leveled during phase II and laid out with a strict north-south orientation. Only the Observatory, in the foreground, deviates from the plan, since it was aligned to correspond to a celestial event. In the background, the North Platform supports several other pyramidal structures. The buildings as they are reconstructed here date to phase IIIb, immediately preceding the abandonment of the site after A.D. 700.

tion from other major cultural centers, Oaxaca was independent and conservative, and its products were distinctive from those of other centers of Mesoamerican civilization.

The inhabitants of the Valley of Oaxaca can be identified as Zapotec Indians as far back as A.D. 250, and most likely they have always formed the major part of its population. The other major group of Indians in Oaxaca, the Mixtecs, may have formed part of the valley's population in the Preclassic. In the Classic period, they were restricted to the mountainous region west of the valley, known as the Mixteca, which spills over into Guerrero and Puebla. In the Postclassic, as we shall see in Chapter 11, the Mixtecs took over political control of much of the valley and occupied the western portion of it. Even today, both groups coexist in several towns in the valley, while the mountains to the west remain Mixtec and the area to the east, including the Isthmus of Tehuantepec, is mainly Zapotec.

The inhabitants of the Valley of Oaxaca had shared some of the humbler aspects of the great Olmec culture of the Middle Preclassic, which laid the base for subsequent Mesoamerican development. They supplied the Olmecs with magnetite, cut into concave mirrors, and made similar pottery and low architectural platforms. In the Late Preclassic, known in Oaxaca as Monte Albán I because it is the earliest phase of occupation of the great ceremonial acropolis (Figure 24), the sculptors revived several Olmec stylistic elements (Numbers 37, 75, 76). During the Protoclassic period, known as Monte Albán II, the culture of the Valley of Oaxaca drew its inspiration from the southeast, and may even have had Mayoid rulers. The art

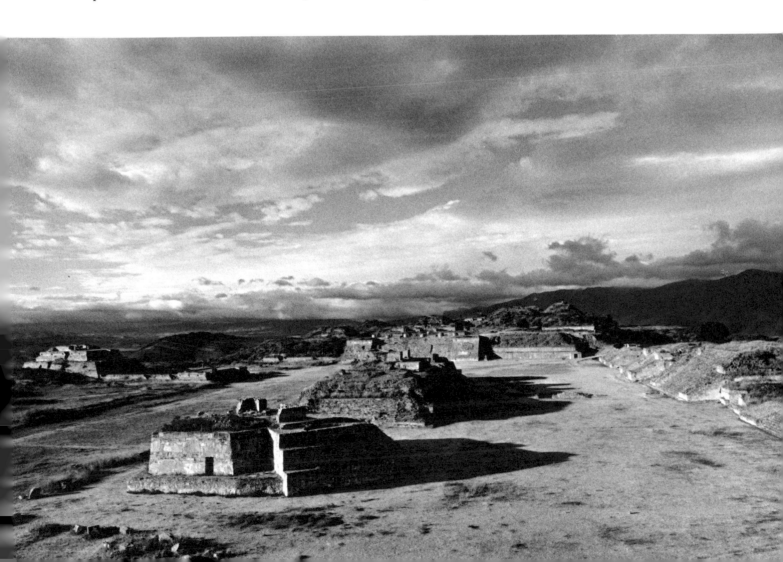

of the first part of that phase displays, in several instances, Izapan stylistic elements (Number 77, Figure 13).

The Preclassic preference for naturalistic images continued in the Protoclassic period. The portrayal of a seated dignitary (Number 155) is so intense and vigorous that modern viewers can fully comprehend his existence as a man without understanding the significance of the incised glyphs. Even the metaphorical transformation of a pot stand into a human spinal column (Number 156) is realized quite literally, and with knowing humor, providing a good early example of the Mexican fascination with death.

The distinctive Zapotec art forms that would dominate Classic Oaxacan art had already appeared by Monte Albán II. The rigid frontal position assumed by Number 155, with legs crossed and hands on knees, became the standard form for Classic urns (Number 157). There are two different date glyphs on the Monte Albán II figure, one on the chest and the other on the headdress, just as the figure and the headdress on the Classic urns each represent a different being. Since birth dates were used to name personages in Mesoamerica, the man can probably be identified as Thirteen Flint Knife, but the date on the hat is Thirteen Water, which must be associated with another personage or deity. Clay figures of human beings from the Classic period often wear a mouth mask and an elaborate headdress, which were the distinctive guise of a particular guardian spirit. For instance, three priests in a ceremonial scene (Number 163) have mouth masks of a bird and overhead masks of a serpent. These masks did not depict the deities themselves, but only the essential features of the animal form in which they manifested themselves. They could even be merely symbols of divinity, such as the bowknot coiffure or the common Glyph C, really the abstraction of a monster mouth (Number 158).

The Classic period in the Valley of Oaxaca (known as Monte Albán III and subdivided into phases a and b, corresponding to the Early and the Late Classic) was inaugurated by the arrival of massive Teotihuacán influence, datable by ceramic evidence to around A.D. 250, at the dawn of the Classic period. A number of Teotihuacán forms were taken over virtually unchanged by the Zapotec potters during the transition phase between Monte Albán II and III. The architecture of Monte Albán clearly shows the result of adapting Teotihuacán urban planning and the slope-and-panel motif, as can be sensed by comparing Figure 17 with Figure 24. And in ceramic sculpture, the front of the unencumbered Monte Albán II figures received an overlay of complex, planar decoration, which clearly is copied from Teotihuacán paintings and appliquéd incense burners (Number 122).

In the Classic period, the Zapotec potters institutionalized the clay effigies into a finite number of recognizable figures, which have been categorized by Alfonso Caso and Ignacio Bernal (*Urnas de Oaxaca*, Mexico City, 1952), who conducted excavations of Monte Albán from 1931 to 1949 and did sampling in other parts of Oaxaca. Since the urns apparently represent deities or priests dressed as gods, but definitely are not portraits of specific individuals, the same combination of attributes reappears frequently on different figures, often within the same tomb. Most commonly the figures are like religious icons: frontal, hieratic, eyes forward, the human figure obscured by elaborate attributes. By far the most frequent composi-

190

tion was formed around a tall cylindrical urn open at the top and sealed at the base (Number 157).

The headdress of an urn figure is often outlined by flanges or sprays of feathers terminating the frontal composition; the rear portion, including the vessel itself, remains undecorated and was obviously not intended to be seen. Within the frontal plane, however, Zapotec sculptors often executed high-relief compositions of considerable artistic merit. The simplified body forms contrast effectively with the complexity of the headdress ornaments. The oval human face can be quickly spotted in the center of a composition. Compositions are usually rigidly symmetrical, although certain categories have asymmetrical headdresses like that of Number 160, with a jaguar lying across the overhead mask and a diagonal golf-club shape projecting above the head.

The best artists among Classic Zapotecs made the most of their medium by building up layers of moist clay sheets, symbolically corresponding to the iconographic buildup of deities' attributes. The curved planes of clay, apparently of uniform thickness, were cut into regular geometric shapes, then applied, while still flexible, around the core of the urn. Some figures were actually dressed in robes of damp clay, which covered the underlying anatomy from the sight of all but the gods. Areas and lines were excised into the clay, and additional details were pressed on the surface with molds during Monte Albán IIIb and later. Unlike the slender, lithe figures of the Protoclassic, these urns exhibit a massiveness of form that creates a powerful image of monumental scale.

Many atypical examples have purposefully been included in the exhibition to emphasize sculpture in the round. For example, Number 159, a handsome seated figure of a bearded old man, has modeled details on all sides. Since it is not an urn in the usual sense (although the top of its headdress may originally have been an open cylinder), the back of the figure is freed from serving merely as a container. The forward hunch of the shoulders, as well as the craggy, wrinkled face, gives the image such immediacy that a modern viewer need not know its function or iconography to appreciate its virtues as sculpture. Standing figures are also relatively rare: some are variants on the standard urn shape (Number 160); others are freestanding and separate into two parts at the middle, possibly to receive offerings (Number 161). Effigies of animals, especially jaguars and bats, were made both standing and seated (Number 162). However, freedom from the requirements of the urn format did not necessarily produce a composition fully utilizing side and back views; Number 158, although a stone figure, copies urn prototypes even to the extent that the rear of the torso, beyond the line where the wide row of feathers ends, is practically devoid of detailing.

Although a great number of ceramic effigies are known from Zapotec tombs, they also appear in offerings unconnected with human burials. No trace of smoke or human remains has been discovered in the urns, eliminating the possibility that they were incense burners or cinerary vessels. The urns often did contain offerings of smaller objects, such as obsidian blades or carved jade (Number 164). In effect, the urns themselves were offerings, either to the deceased or to the gods.

The tombs were often very elaborate. Many were chambered, cruciform in plan,

191

with an "angular vault" formed by two inclined slabs leaning together, in the manner of a pitched roof. They were often decorated, both on the outside with features resembling those on the monumental architecture of Monte Albán (as on Number 165), and on the interior with painting, carved lintels, or projecting tenons (Number 166).

Even after the abandonment of Monte Albán, perhaps because of the difficulty of supporting a large resident population far from a natural water supply, the site continued to be used as a cemetery, sanctified from over a millennium of use. The date for this abandonment, which defines the beginning of the Monte Albán IV phase, was recently set early in the eighth century A.D. by means of radiocarbon samples obtained by John Paddock during his excavation at Lambityeco. Although the date has traditionally been placed at the end of the Classic period, the new, earlier date coincides closely with the end of Teotihuacán and may indicate a related phenomenon.

Because of the angularity of the carving and the impression of two-dimensionality resulting from the sudden transition between the background and the scenes, a slab from the roof of a Monte Albán IV tomb from the vicinity of Cuilapan in the Valley of Oaxaca (Number 167) has a visual effect resembling that of Mixtec codices (Figure 25). These painted, screen-fold manuscripts record the history of the kingdom established in Tilantongo after A.D. 838, depicting battles and conquests, marriages, and the children born to such unions. Several relief slabs from the Valley of Oaxaca also depict the genealogical subject matter absent in the earlier reliefs carved on stelae at Monte Albán, which dealt exclusively with the conquest of towns and the humiliation of prisoners. Most genealogical slabs are small with rounded relief, but the slab on exhibition is large and sharply carved. However, the Cuilapan slab is like the Monte Albán stelae in that a bar is used to represent the number five, while in the Mixtec codices all numbers are represented only by dots, following the system of Postclassic Central Mexico.

Clay figures in the style of Monte Albán IV are virtually indistinguishable from those produced during the preceding phase, except for an overreliance on mold-made forms and a degeneration in quality. It is as if the Zapotec potters were stubbornly reaffirming their ethnic and cultural purity against the Mixtec cultural and political invasions. However, in the architecture of valley sites such as Mitla, and in the style of the genealogical slabs, the art of the Zapotecs became indistinguishable from that of the Mixtecs, whose presence in the Valley of Oaxaca, known as Monte Albán V, became most pronounced in the Late Postclassic (Number 297).

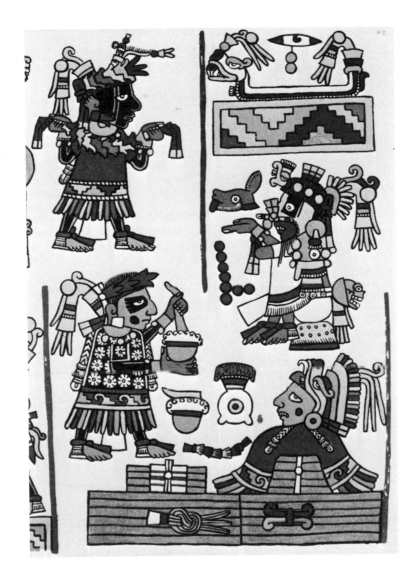

FIGURE 25

Detail of a page from the Codex Nuttall

One of the finest of the Mixtec manuscripts, a screen-fold
book in The British Museum (formerly in the collection
of Lord Zouche) was published in 1902 in a redrawing by
Zelia Nuttall, a scene from which is shown here. The
action of this scene took place in A.D. 1049. The king of
Tilantongo, Eight Deer, is seated at the upper right, his
horizontal nose plug and long beard marking him as a
very distinguished personage. The bones of his half
brother, who has previously been sacrificed and burned,
are in the bundle at the lower right, dressed in an em-
broidered red cape and green face mask, topped by a
monster-mouth headdress. The remains receive the min-
istrations of a beautifully dressed priest, to the left, who
prepares a foaming bowl of pulque. Later, the bones were
cremated with the dead man's possessions, everything
being reduced to ashes.

155 Seated male figure

Polished brown clay with traces of red pigment
Height: 12¾ in. (32.3 cm.)
Valley of Oaxaca
Protoclassic, Monte Albán II phase, 150–1 B.C.
The Cleveland Museum of Art, gift of Hanna Fund,
54.857

This figure can be identified as a deity or a very important ruler because of the glyphs on his headdress and his chest. The former reads "Thirteen Water," the latter "Thirteen Flint Knife." Both glyphs refer to dates, probably birth dates, either mythical or real. The glyph "Thirteen Water" also appears on a head that has almost identical facial features, and on the headdress of the sculpture known as the "Scribe of Cuilapan"; the Cuilapan piece also has the same chest glyph, "Thirteen Flint Knife." W. M. Milliken set forth the distinctions between the two complete figures in "Two Pre-Columbian Sculptures," *Bulletin of The Cleveland Museum* 42, 1955, p. 60. All three of these objects can be attributed to Monte Albán II (and probably the earlier part) by their similarity to the figures from Tomb 113 at Monte Albán.

156 Spinal column pot stand

Burnished orange brown clay, stuccoed and painted
white and red
Height: 16¼ in. (41.5 cm.)
Monte Albán, Oaxaca, Mexico
Protoclassic, Monte Albán II phase, A.D. 1–250
Museo Nacional de Antropología, Mexico, 6–58

Pot stands like this one were intended for the support of globular jars. Alfonso Caso, Ignacio Bernal, and Jorge Acosta (*La Cerámica de Monte Albán*, Mexico City, 1967, pp. 250–251) have suggested that the iconography of the vertebrae and pelvis reflects a Mesoamerican metaphor of the cranium as a hair-covered jar. Several similar pot stands prove that this image was not an imaginative quirk of one potter. Stucco, which appears at Monte Albán only in phase II, was painted *al secco* in Mesoamerica, giving it a flat, opaque appearance.

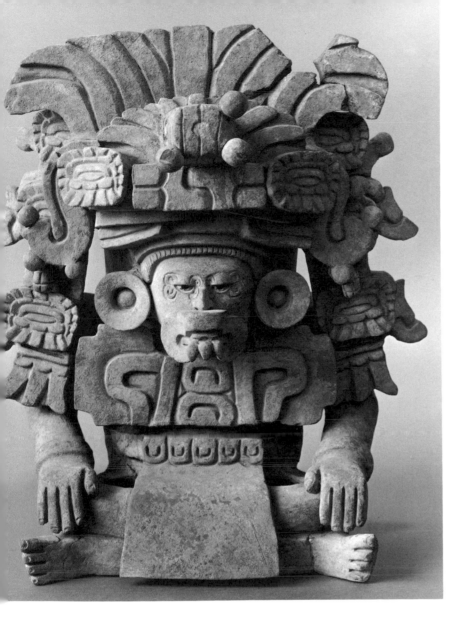

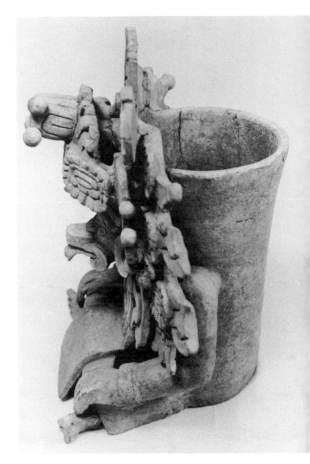

157 Urn of a seated deity

Gray clay with white slip and traces of red paint on the
mouth and earspools
Height: 18¾ in. (48 cm.)
Valley of Oaxaca, Mexico
Early Classic, Monte Albán IIIa phase, about sixth
century A.D.
Mr. and Mrs. Justin Kerr, New York

The attributes on the headdress, namely the flattened
knot in the center, the projecting pompadour (probably
hair), and the rosettes on each side, identify the figure as
the "God with a Bowknot in his Headdress." Many urns
depicting this deity include a projecting mouth mask of
serpent fangs; the mouth mask on this urn even has an
unusual flat top, seen also on a vase in the Musée de
l'Homme (Frank Boos, *Ceramic Sculptures of Ancient
Oaxaca*, New York, 1966, p. 409). Stylistically, this urn
shares much with the central urn discovered in Monte
Albán Tomb 104, which dates to the transition between
phases IIIa and IIIb, although many similar urns are at-
tributed to IIIa. The deity is grouped with those related to
maize, but was shown by Alfonso Caso and Ignacio Ber-
nal (*Urnas de Oaxaca*, Mexico City, 1952, pp. 113–116)
to correspond to the deity with some attributes of Tlaloc,
as rendered on the Temple of Quetzalcóatl in Teotihuacán
(Figure 18).

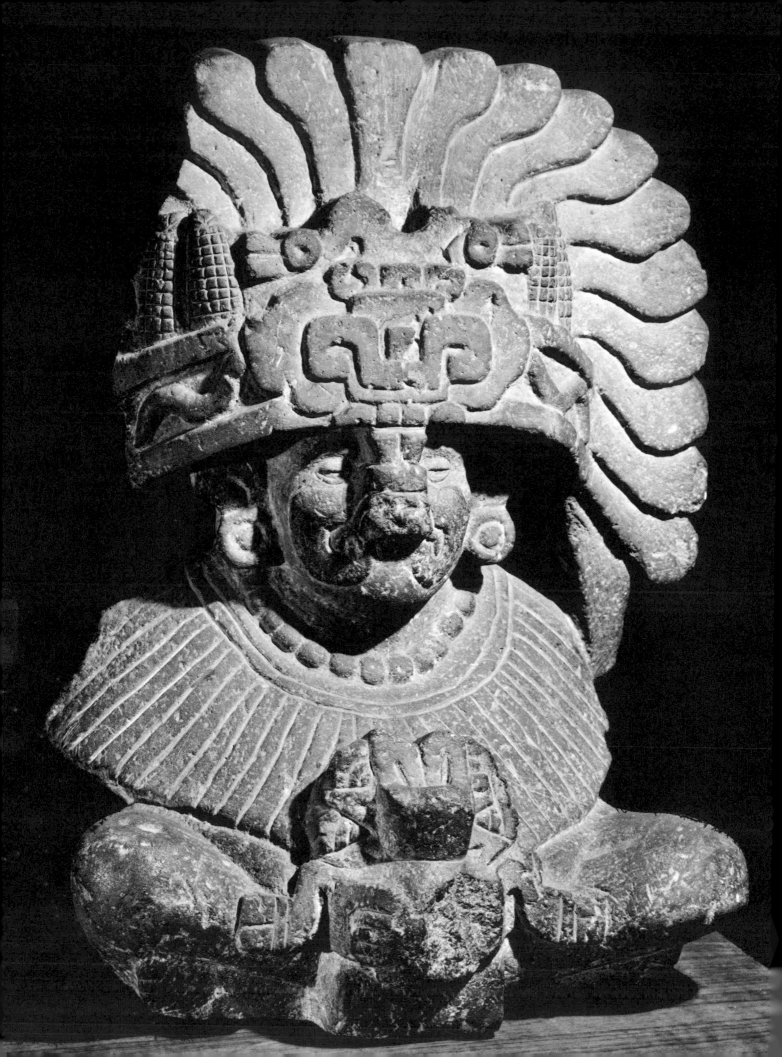

158 Seated figure of a deity

Gray basalt
Height: 22¾ in. (58 cm.)
State of Oaxaca, Mexico
Late Classic, Monte Albán IIIb–IV phase, A.D. 550–950
Museo Nacional de Antropología, Mexico, 6–6067

The common urn type is translated into stone in this unique sculpture. The back is naturalistically carved, with a curved spine and a head set forward on the body. There is complex relief and incised detail on the front, but behind the line of the large feather headdress the carving is plain except for a belt. The figure falls into the category known as the "God of Glyph L," identifiable by the projecting nasal mask topped by plumelike elements—usually three, but here two. This god can be further identified as Pitao Cozobi, the God of Abundant Sustenance, Lord of the Fields of Maize. His relationship with maize is emphasized by the pairs of corncobs on either side of the headdress, with a large Glyph C in the center, derived from the face of the Earth Monster.

159 Figure of an old man

Coarse buff orange clay
Height: 25¾ in. (65.4 cm.)
Santa Magdalena Etla (?), Oaxaca, Mexico
Late Classic, Monte Albán IIIb, A.D. 550–750
George C. Kennedy, Los Angeles

This figure, which is not an urn, was reportedly found in a tomb with a very similar sculpture now in the Museo Frissell de Arte Zapoteca in Mitla. The presence of at least two such figures in the tomb, and the lack of any face mask on them, permits them to be categorized as Companion figures, which sat with a deity representation watching over the body of the deceased. The fragmentary Glyph C on the remaining lower part of the headdress defines a particular variant of the Companion. The headdress has two long pendants falling to the shoulders. The lower part of the spine is prominent, dramatizing the effects of age, as do the deeply wrinkled face and sagging chest. A loincloth, attached to the body above the belt, is tied in back with a stylized knot.

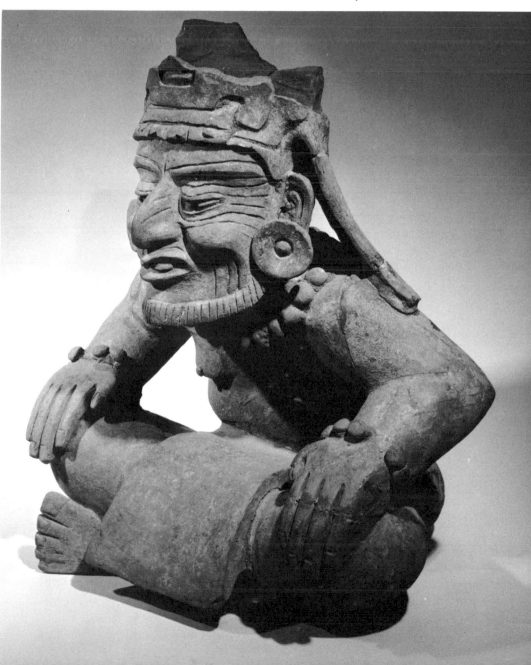

160 Urn of a standing figure

Gray clay with white deposits and root marks
Height: 25½ in. (65 cm.)
Valley of Oaxaca, Mexico
Late Classic, Monte Albán IIIb phase, A.D. 550–750
Dr. and Mrs. Josué Sáenz, Mexico City

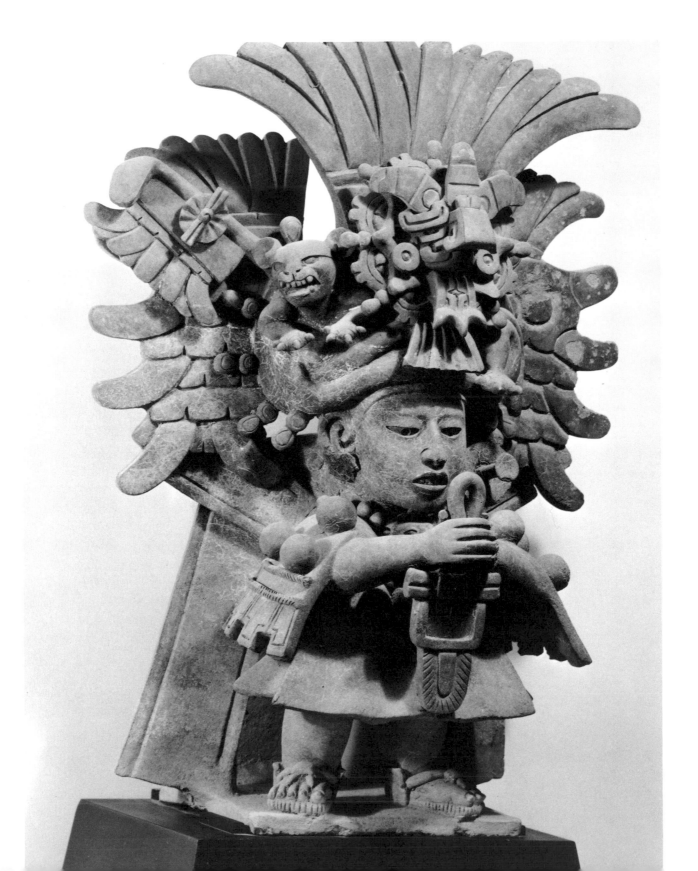

Not an urn in the normal sense, this complex sculpture takes the form of a vase supported by the figure in front, a wide slab foot in back, and two side streamers. The figure itself wears a pleated skirt and a scalloped cape decorated with large balls, and has a necklace from which hang a handsome moldmade face pendant and a horizontal bar holding four incised shells. The figure offers a knotted incense bag in its outstretched arms. Overwhelming the simple costume and well-proportioned beauty of the figure is a soaring, plumed headdress, built upon a braided turban. The central projecting feature is a standard representation of the mask of a broad-beaked bird, quite small in comparison to the rest of the headdress. Behind the bird (identifiable as a king vulture) are sprays of plumes forming the upraised spread tail and wings. The torso of a jaguar is seen behind the bird mask. This combination of animals was represented during the Early Classic period on braziers that display the head of a jaguar with the mask of a broad-beaked bird.

161 Standing maize god

White-slipped gray clay
Height: 48¾ in. (1.24 m.)
Valley of Oaxaca, Mexico
Mid-Classic, Monte Albán transitional IIIa–b phase,
 sixth century A.D.
Dr. and Mrs. Josué Sáenz, Mexico City

This rare example of a large freestanding figure was fired in two parts, which fit together at the waist. The holes required for firing are located in the soles of the feet, between the shoulders on the back, and in the top of the hollow cylindrical headdress. The two decorative streamers that connect the headdress with the shoulders also support the large spray of feathers on either side of the head. The figure's attributes, although atypical, conform most closely to those of the "God of Glyph L," the Lord of the Fields of Maize (Number 158), than to any other Zapotec category. Most typical of the "God of Glyph L" are the crossed eyes with deeply punctured pupils, and the short, curved appliquéd eyebrow with corresponding shapes incised below the eyes. The nose is divided into three parts, like the usual "fleur-de-lis" noses on phase IIIa urns, but is upturned and lacks the mask attachment around the mouth, both of which are later characteristics (Frank Boos, *Ceramic Sculptures of Ancient Oaxaca*, New York, 1966, p. 178). The nose mask resembles a serpent's snout, and a bifurcated tongue is suggested by the incising below the mouth. These details appear on a large head, formerly part of a figure about the same size, in The American Museum of Natural History. Like the exhibited figure, it has a headdress composed of vertical corncobs, and the headbands on both are identical. In the god's hands is a jar with a stamped appliqué of the Glyph C. A symbol of liquid, as are the tassels on the legs, the jar emits two flowing streams. The double spouts appear only on vessels made during the Monte Albán IIIa phase and the subsequent brief period of transition into IIIb.

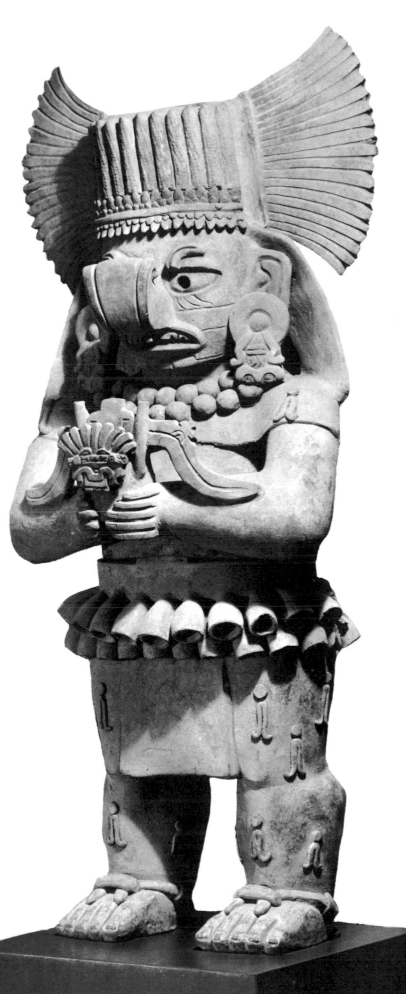

162 Vampire-bat head

Pale buff clay with traces of red paint
Height: 15⅜ in. (39 cm.)
Jalieza, municipality of Ocotlán, Oaxaca, Mexico
Late Classic, Monte Albán IIIb phase, A.D. 550–750
Museo Nacional de Antropología, Mexico, 6–21
Ex coll. Dr. Sologuren

The bat was a guise of one of the major deities in the Zapotec pantheon, possibly identifiable as Pitao Cozobi, the benevolent god connected with maize. This head at first appears to be quite naturalistic, but in fact is anthropomorphized and conventionalized: the snub nose identifies the vampire bat, but the head crest and the side fangs do not appear in nature. This unusually large head, only part of a figure, has holes in the eyes, ears, and mouth, opening into the hollow interior. The molded base of the neck is modern plaster, added to hide the break. The original sculpture may have been a very large urn of a standing bat. However, the only sign of a break is at the neck, whereas heads on this type are usually partially engaged in back to cylindrical bodies of urns. Therefore, it more probably came from a freestanding feline body, of which smaller examples exist in both seated and standing positions.

163 Ceremonial scene with sixteen figurines

Solid brownish buff clay with red and blue paint; one stone image with red paint
Height of tallest: 7 in. (18 cm.)
Patio over Tomb 103, Monte Albán, Oaxaca, Mexico
Late Classic, Monte Albán IIIb phase, after A.D. 550
Museo Nacional de Antropología, Mexico, 6–4850, 4851, 6072 to 6083, 6085, 6089

The nine smallest figurines in this group represent musicians, the majority with their arms perforated and set to hold flutes or trumpets of perishable material. The five largest are portrayals of elaborately dressed priests, all of whom wear feather bustles, nose masks of the quetzal, and tall, removable plumed headdresses, two bearing the face of the quetzal and three the face of the serpent. Three of the priests hold rimmed disks, identifiable as mirrors, in front of their bodies. The other two figurines represent objects rather than actual persons. A seated idol of the old fire god (Number 108, Figure 21) has a square brazier on its head. The focus of the ceremony is a stone step-shaped block topped with a thin, squarish face, suggesting Teotihuacán masks (Numbers 112–115). Although the skeletons in Classic Monte Albán burials were placed supine in the center of the tomb chamber, this figure resembles the skeleton bundles represented later in Mixtec codices (Figure 25). Perhaps, as recorded elsewhere in Mesoamerica, a false bundle was set up for the required ceremonies, possibly long after the death of the one honored. This scene may commemorate such a ceremony, since the figures were placed on the stucco floor directly over a rich tomb dated to the transition between Monte Albán IIIa and IIIb.

164 Standing figurine

Crackled light green jadeite with black and tan veins
Height: 5½ in. (14 cm.); depth: 1¼ in. (3 cm.)
Provenance unknown
Late Classic, Monte Albán IIIb–IV phase, A.D. 650–950
Mr. and Mrs. William B. Jaffe, New York

The overall composition of this figure is irregular, for the carver has followed a rippling vein of jade: the crest is askew and the left leg is shorter than the right. The surface of the stone, also uneven, has low-relief features formed of geometric components and executed mainly with straight saw cuts and tubular drillings (for an example of the late use of this method, see Number 267). The distinctive double-arch mouth is found on low-relief plaques discovered under the stairway of Mound B, Monte Albán, in offerings made both immediately before and after the abandonment of that site. Although another jade plaque with the same mouth and style of relief

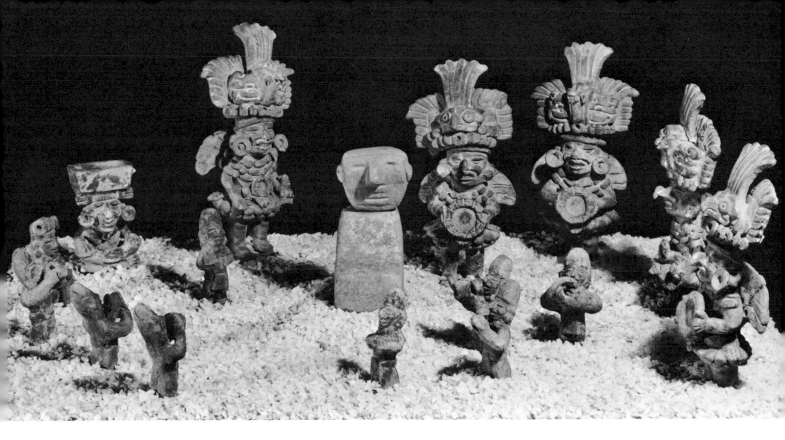

came from Tula, and others have been found at Xochicalco, they are considered to be of Zapotec manufacture, displaying in simplified form the Mayoid style of jade carving that flourished in Monte Albán IIIb. The upraised, cupped position of the hands recalls a common motif in late Zapotec jades of hands holding a circular mirror at chest level. Engraved on the rear center of the head (the only detail in back) is the Zapotec Glyph P, composed of a profile head of Xipe, surmounted by a bar and two dots for seven, perhaps indicating the birth date of the personage represented.

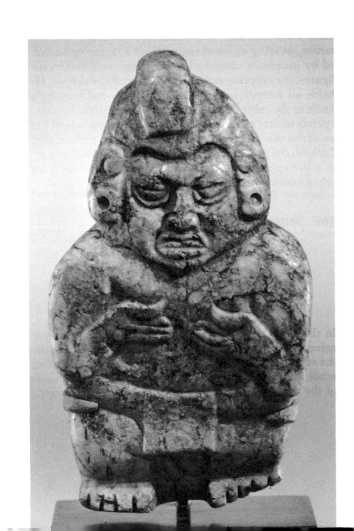

165 Temple model with bust over entrance

Light gray stone
Height: 12 in. (30.5 cm.)
Valley of Oaxaca, Mexico
Late Classic, Monte Albán IIIb phase, A.D. 550–750
Museo Nacional de Antropología, Mexico, 6–69

This miniature version of a temple façade features the most common cornice motif at Monte Albán during the Classic period (Figure 24). Most characteristic of Monte Albán architecture is the double cornice having dual dentate projections at all corners, with recessed panels between and sloped *taludes* below. But this model is not merely architectural. The human half-figure in the top center, wearing an overhead mask of a jaguar surrounded by plumes, a category known from small moldmade figures, may represent the patron deity of the temple. He holds an incense bag in one hand and what may be a knife in the other. His position above the entrance corresponds to that of the clay urn from Tomb 104, which has an elaborate facade modeled after temple architecture. Beneath the god, carved in low relief within the doorway, is a diving water bird, perhaps a guise the deity used when making earthly contact.

166 Serpent head lintel and two tenons

White limestone
Height of each: 6¾ in. (17 cm.)
Cuilapan, Oaxaca, Mexico
Early Classic, Monte Albán IIIa phase, A.D. 375–550
Howard Leigh and the Museo Frissell de Arte
 Zapoteca, Mitla

In the tomb from which these architectural ornaments came, the double-headed lintel sculpture was placed over the entrance from the vestibule into the burial chamber, while three matching tenoned heads were set at each side of the opening, projecting from the wall. The geometric

carvings, recalling contemporary architectural decoration at Teotihuacán, emphasize strong rectilinear abstraction of the forms. The reptile heads with upturned snout, symbolically modified by jaguar traits, have been identified by Frank Boos (*Ceramic Sculptures of Ancient Oaxaca*, New York, 1966, p. 166) as the Earth Monster. Combined with the tied bar over their eyes—the glyphic convention for five—each makes the day sign Five Alligator. Caso and Bernal (*Urnas de Oaxaca*, Mexico City, 1952, p. 105) demonstrate that this profile is only another view of the "God with a Bowknot in his Headdress" (Number 157).

167 Relief slab with a genealogy

Gray brown limestone
Height: 35¾ in. (90.9 cm.)
Near Cuilapan, Oaxaca, Mexico
Early Postclassic, Monte Albán IV phase, A.D. 950–1200
Museo Regional de Oaxaca, Mexico, 570

This stone formed part of the roof of a tomb on the former hacienda of Noriega, south of Cuilapan (see Alfonso Caso, "Zapotec Writing and Calendar," *Handbook of Middle American Indians*, ed. Robert Wauchope, Austin, III, 1965, p. 942). Its style, more angular than that of other genealogical slabs, suggests a later date. Presumably it records highlights in the history of the occupant of the tomb, conceivably the woman (identifiable by the *quechquémitl*, a triangular overblouse) who is represented twice on the slab, once in the upper left corner and once with a mouth mask in the middle right. She always has a headdress composed of a sky-monster maw topped with a reptilian eye. Another female appears twice on this slab, masked both times; her headdress, partially composed of the year glyph, may identify her as a goddess of time. In the middle register, she cares for a baby, perhaps the child of the man seated on the ground in the center, who presents a skull offering to the woman who is seated on a dais; the mouth masks worn by the couple add religious overtones to the event. A small figure sits between them, perhaps an earlier fruit of the marriage. In the top register, the woman and the goddess both attend two smaller figures, who might be the same two children some years later. A deity in a tortoise shell arches overhead, a symbol of death known from the back wall of Tomb 1 at Zaachila. In the bottom register, the cosmic

significance of the events depicted above is dramatized by a central sky-monster mouth over a hill glyph flanked by two profile heads of the Earth Monster. To either side, a male and a female, perhaps the founders of the lineage, their birth dates given in the glyphs below, point to the events above.

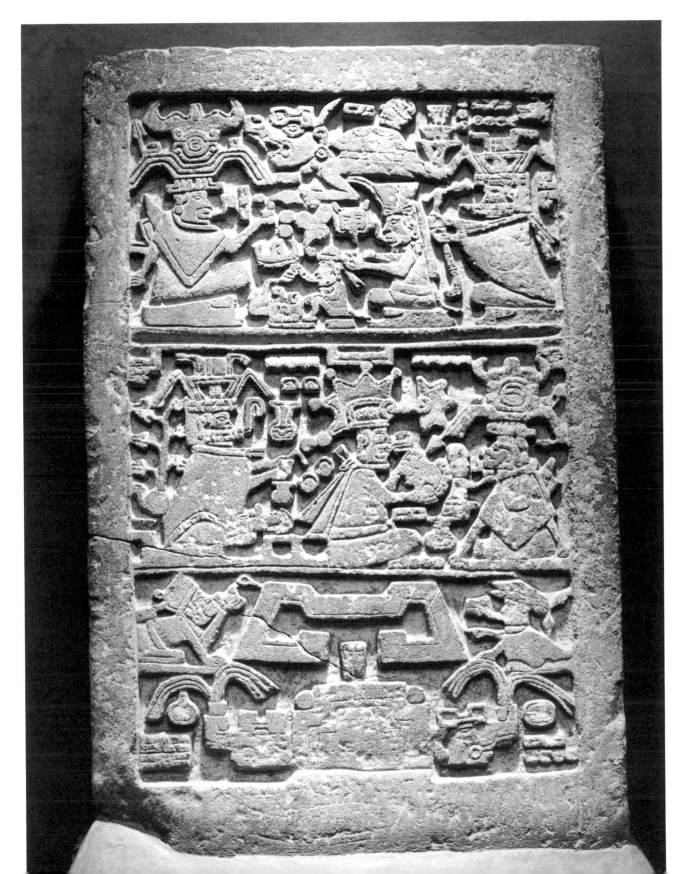

9

The Maya Realm

cause of the high value they set on learning and on impressive monuments, the ancient Maya of the central lowlands, comprising the Petén and adjoining areas, now claim a vastly more prominent place among the peoples of the Americas than they seem to have held in their own time a thousand years ago and more. They surpassed all others in astronomy, mathematics, and architecture and, most significantly, developed the art of hieroglyphic writing into a far more expressive and flexible system than those used in such other regions as Central Mexico, the Gulf Coast, Oaxaca, and the Guatemalan Pacific Coast. Though the knowledge of Maya scholars and the skills of countless artists and craftsmen were devoted to the immediate needs of the various city-states, such achievements, for instance, as predicting the dates of possible eclipses and the appearance of Venus as morning and evening star were based on observations, records, and calculations made over many generations. The fruits of these studies were incorporated into the intricate structure of Maya astrology and an awesome philosophy of time with many concurrent cycles and patron deities of different time periods.

All of this is reflected in the hieroglyphic inscriptions preserved on commemorative stelae and other stone sculpture, on buildings, and on minor works of art created for ritual and display, and in the three manuscripts surviving from the Maya libraries that still existed at the time of the Spanish conquest. Though the texts still resist complete decipherment, they have yielded many insights into Maya thought and religion and a framework of accurately recorded dates that span the Classic period from A.D. 292 to 889. In addition to calendrical and astronomical calculations, they record specific events, such as births, inaugurations, anniversaries, and conquests, as well as place names, the names and titles of dynastic rulers, and undoubtedly many other things still unsuspected—in short, the detailed stuff of history that is lost beyond hope of recovery everywhere else.

In spite of the intellectual accomplishments of Maya leaders throughout the central lowlands, this area was by no means the political, religious, or artistic center of Middle America. As far as the archaeological record shows, the Maya region was only one of several where distinctive local cultures were taking shape during late Preclassic times, advancing and differentiating more rapidly during the cen-

turies around the beginning of our era, in the Protoclassic or Izapan period (Chapter 4). The great city of Teotihuacán rose in Central Mexico during this time (Chapter 6), its influence reaching far into other regions, even to the southernmost of the great Maya cities, Copán. Its ascendancy is evidenced most strikingly by Teotihuacán motifs and religious symbols carved on Maya monuments of the fifth century onward and by imported pottery (Teotihuacán III, Xolalpan phase) buried in rich Maya tombs.

During most of the sixth century, profound disturbance caused by Teotihuacán presence in the Maya country interrupted the orderly sequence of dated stelae that the Maya customarily erected at the completion of a *katun*, or period of approximately twenty years, and sometimes at the half or quarter period. After this mysterious "silent" interval of sixty years or more, the Maya began gradually to set

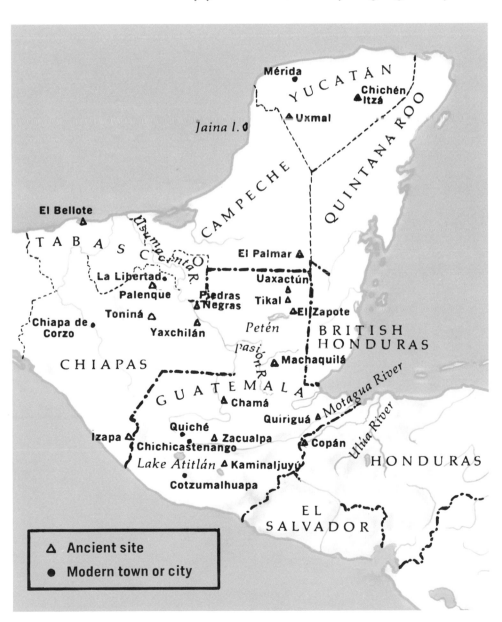

up stelae as before, at the long-established centers as well as at many additional ones. The style of carving had changed, and pottery of Late Classic types (Tepeu) had replaced the Early Classic (Tzacol). When more is learned about what happened during the time of transition, it may be recognized as a separate Middle Classic period in the Maya sequence, part of a general Teotihuacán era.

For the next two hundred years or so the lowland Maya seem to have gone their way without interference from other peoples, who, for their part, did not follow Maya styles in ceramics, sculpture, or architecture, nor adopt their advanced methods of writing and date recording. Maya cities reached their greatest size and magnificence in the eighth century; nineteen that we know of were able to celebrate the katun ending at 9.18.0.0.0 (October 11, 790) of their calendar by the dedication of a new monument. Then, within a hundred years, one Maya city after another ceased to build and set up monuments. Temples were left uncared for or even unfinished, and finally entire settlements were abandoned. No single cause can explain the abrupt fall, but evidence is accumulating that the Maya region was overrun from the Gulf Coast inward during the ninth century, a victim ultimately of the upheavals in Central Mexico that accompanied the rise of the Toltecs. (Jeremy A. Sabloff and Gordon R. Willey, "The Collapse of Maya Civilization in the Southern Lowlands: A Consideration of History and Process," *Southwestern Journal of Anthropology* 23, 1967, pp. 311–336).

During the relatively peaceful years of the Late Classic, even Tikal, which was probably the largest city, seems to have dominated only the smaller towns and centers in its own neighborhood. There was no central Maya government, and no empire "old" or "new" (though these terms were applied until fairly recently to the central lowlands and northern Yucatán respectively). The strong feeling for local independence that prevented uniformity and political consolidation of the Maya realm was probably the reason why the Spanish conquest of their territory went on bit by bit almost into the eighteenth century. Today the Maya speak fifteen related but distinct languages and wear, in each highland village, garments that are styled, woven, and embroidered differently from those of any other—as proudly distinctive as Scottish tartans.

The land of the Maya, which includes every kind of tropical environment except total desert, can be divided broadly into three regions with different patterns of history and art. The Pacific coast and the highlands along the intercontinental mountain range appear to have led in Preclassic advancement, probably because of coastal trade in valuable products such as jade, cacao, feathers and pelts, purple dye obtained from sea snails, and other marine shells that had symbolic and ceremonial value. During the Early Classic the impact of Teotihuacán was so strong in this region that it remained apart from central Maya development. Mexican orientation was retained in the only notable school of stone sculpture, the late Classic Cotzumalhuapa style of the Guatemalan coast (Lee A. Parsons, *Bilboa, Guatemala*, 2 vols., Milwaukee, 1967, 1969).

In the northern Yucatán Peninsula, a flat limestone country almost without hills or rivers, closer ties were maintained with the central Maya area. Impressive tem-

FIGURE 26

Glyphs incised on the effigy bowl (Number 168)

The complexity and sensitive drawing seen here are characteristic of the earliest Classic inscriptions. The meaning of these glyphs is unknown, but many of the elements are recognizable, such as the *kin* cross (later meaning day or sun), which appears in D and also on the cheek of both A and the face in the monster's jaws. D, though incomplete even as originally incised, would have been intelligible in context to the educated Maya. (Other glyphs now appear incomplete because parts of the bowl are missing.)

A

B

C

D

ples rose there too, with dates recorded as early as the fifth century, but the cities of the north were seemingly less prosperous and less interested in monumental sculpture. The region gained prominence after the arrival of Toltec peoples from Central Mexico in the late tenth century (Chapter 10), when southern centers lay deserted.

E

The central Maya area, mainly heavy rain forest, extended throughout the Guatemalan Petén and into the bordering lowlands and high country of Honduras, British Honduras, Quintana Roo, Campeche, Tabasco, and Chiapas. Here, the three principal elements that distinguish the Classic Maya had appeared by the mid-third century, though none of them was new at the time. Temples with corbeled vaulting had been foreshadowed by vaulted tombs of the first century B.C. Hieroglyphic writing and the Long Count calendar were already known then or soon afterward on both the Gulf and Pacific coasts, and almost certainly in the central area as well, though evidence is lacking because Protoclassic sculpture is extraordinarily scarce and fragmentary there. Nevertheless, wherever these key achievements originated, they were kept, cherished, and developed spectacularly by the Maya of the central lowlands.

F

At the opening of the Classic period, lowland and highland sculptors seem to have been working in essentially the same style, and very often in the format that was to remain the Maya favorite: an upright slab called a stela, bearing a single figure in low relief (Numbers 169–171). Though the figures were long thought to represent deities, accompanying inscriptions now reveal some and probably all of them as real men and women, members of the families that ruled the various city-states. They were usually portrayed in their priestly roles, engaged in a ceremony, or in later times, as warriors. The costume and especially the elaborate headdress and accessories were not intended to be merely rich and decorative; they abound with symbolic motifs that are also recognizable as hieroglyphic elements and that expressed, when used in sculpture, the same specific meanings. Perhaps because of its literary emphasis, Maya sculpture as a whole maintained a strong preference for flat relief carving and an enduring esteem for fine draftsmanship.

The rare and lovely little Protoclassic stela (Number 169) displays the combina-

tion of real with symbolic elements and a naturalistic treatment of both the priestly figure and the four small supernatural ones that cling to the serpent's body. On the Early Classic stela (Number 170) the symbolic details are somewhat more stylized, while the figure stands stiffly, almost obscured by the costume, which fills most of the space available and includes at least a modest plume of feathers at the back of the headdress. The Late Classic stela (Number 171), carved in the same tradition as it approached its end nearly four hundred years later, shows greater stylization of costume details into glyphlike forms and more feathers, while the pose of the figure has become easier again and the composition clearer, more open, and full of movement.

Low-relief sculpture was not restricted to stelae and their associated altars. Intricately carved wooden lintels were preserved in buildings at Tikal, and the cities of Piedras Negras and Yaxchilán are known for their stone lintels. Many of them show two or more figures with a hieroglyphic text that records the ceremony or conquest illustrated (Number 172). At Palenque, where only one stela has been discovered, there are magnificent relief panels on the walls of temple sanctuaries and in the Palace (Number 173).

Though relatively rare, high relief was favored at a few places, such as, in the southeast, Copán and Quiriguá, and, in the northwest, Piedras Negras, Toniná, and especially Palenque, where rounded stucco reliefs display the same easy natu-

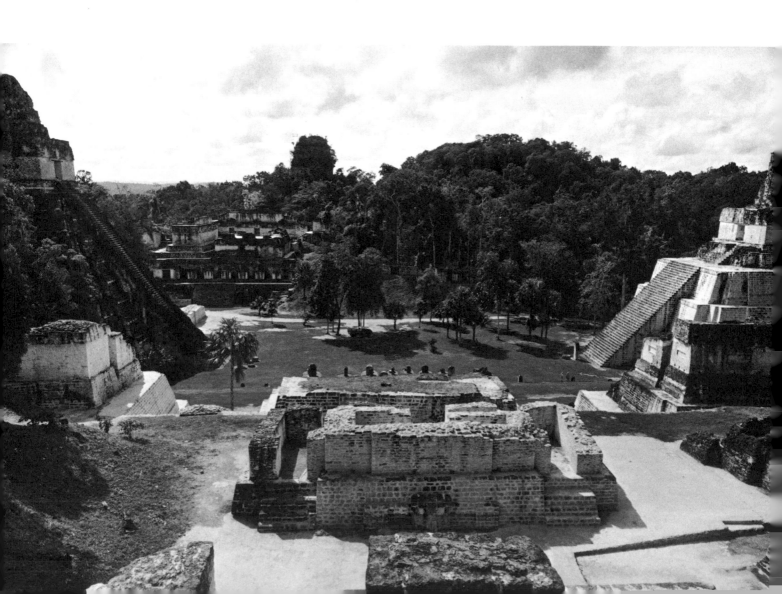

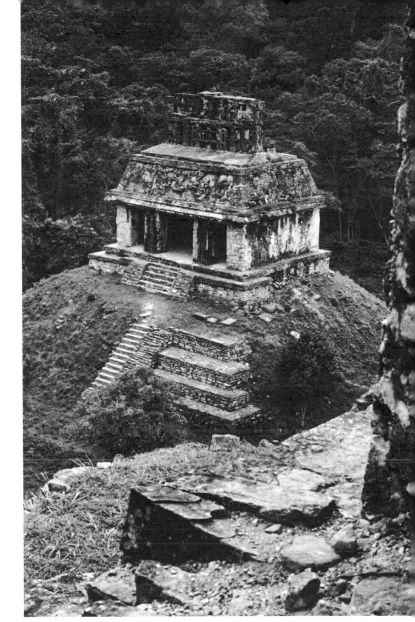

FIGURE 27

The central plaza of Tikal

From a temple high on the North Acropolis, the plaza is seen with the stelae and altars facing it, Temples I and II at either end, the palaces of the Central Acropolis on the far side, and the uncleared South Acropolis and Temple V, still under reconstruction in 1969, when this photograph was taken, beyond.

FIGURE 28

Temple of the Sun at Palenque

The tall roof comb and sloping upper wall decorated richly with stucco relief are seen to advantage from the higher pyramid occupied by the Temple of the Cross, the central one of three related temples that face the same plaza.

ralism seen in a splendid openwork relief (Number 174). The two human figures in this relief were worked out in full round above the waist but within the carefully drawn two-dimensional design that would have been needed for the glyphs and elaborate framing masks. Similar frontality is evident in the high-relief face panel (Number 175) and the large flanged cylinders of clay that it resembles (Number 176).

Ceramic sculpture and effigy vessels were little favored by the Maya, but clay figurines, which went out of use before the beginning of the Early Classic, reappeared in new forms at the end of that period. Molds were introduced about the same time and used, as in Teotihuacán and Veracruz, for making the small faces (Numbers 177–179) or the entire fronts of hollow figurine whistles (Number 180). The latter tend to be rather stiff and uninteresting in the rear, but those that are hand-modeled except for the faces often keep the three-dimensional vitality of a sculptor's sketch. Though materials other than stone and clay are rarely preserved,

FIGURE 29

Chac from Tikal

A thin layer of painted gesso is all that remains of the original wooden figure, buried nearly fourteen hundred years ago. It was recovered along with three vigorously carved matching deities, which exist at all only as a result of the efforts of archaeologist Jorge F. Guillemin, who painstakingly filled with plaster the spaces the figures had left in the solidified silt that filled the tomb before the wood decayed. Height: 16 in. (41 cm.). Museo Sylvanus G. Morley, Tikal, Guatemala.

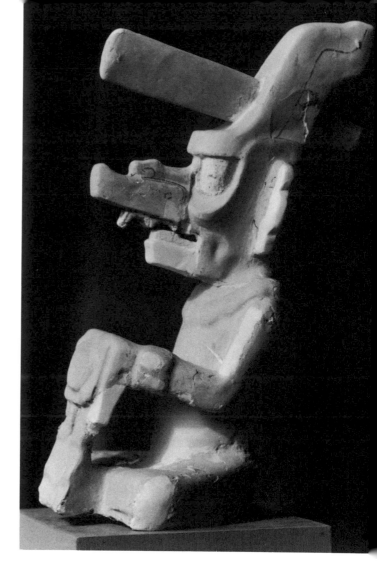

a few masterworks in less resistant media have survived to hint that the Maya had greater mastery of sculpture in the round than their more formal works suggest. Among these rarities are the lively blue Chacs, or rain deities, from Tikal (Figure 29), a finger-sized but arrogant personage carved of bone (Number 181), and a magnificent priest of wood (Number 182).

After the mid-seventh century the work of a new school of stone sculpture began to appear at Copán, first in stelae and then in architectural ornaments rich with human, animal, and grotesque figures and masks that were essentially in the full round. They were carved to heroic scale, clearly from three-dimensional models rather than drawings. The local stone of Copán, by virtue of its softness, lent itself to elaborate sculpture, but this quality led tragically to its destruction. An andesitic tuff, it broke readily when the buildings fell to ruin, as they did in a short time; lacking limestone or shell to burn for lime, the builders had done without stucco decoration and also without much concrete or mortar in construction, using imported lime only for protective surfacing. When it was no longer renewed regularly, the combined action of rain and vegetation tumbled the tenoned units of the sculpture, vaults, walls, and even the majestic Hieroglyphic Stairway. Surely one

FIGURE 30

Inscribed dates from the Hieroglyphic Stairway
at Copán

Certain blocks from the Stairway (Number 184) were
found to fit together with others still at Copán, forming
readable dates and time intervals. A (Date 25) begins with
the block now set below the seated figure and records a
date in A.D. 722 (9.14.10.10 17) or 727 (9.14.15.10.17 7
Caban 10 Zotz). B (Date 26) probably includes the two
left-hand blocks in the center row, recording a date in
A.D. 738 (9.15.6.16.5 6 Chicchan 3 Yaxkin). Redrawn
from S. G. Morley, *The Inscriptions at Copán*, Carnegie
Institution of Washington Publication 219, 1920, figs.
26d, e, f, 41, as suggested by J. Eric S. Thompson, "Dates
25 and 26 of the Hieroglyphic Stairway, Copán," *Field
Museum of Natural History Anthropological Series* 301,
1931, pp. 347–348).

of the wonders of the Maya world, this stairway was over thirty feet wide, rising
nearly ninety feet from court to temple, and bearing in low relief on the risers a
single inscription that concerned the city's history. Five larger-than-life figures
seated at intervals on the steps (Number 184) may have portrayed rulers. How-
ever, all the heads that have fallen from these figures, and from those on the façade
above (Numbers 185, 186), considered to represent deities, are equally idealized,
with the costumes executed in the same realistic detail.

Jewelry worn by the Copán figures was in real life carved of jade, the material
most treasured by the Maya. Discovery of a few rich unplundered tombs has con-
firmed that the sculptors exaggerated only slightly the quantity and size of the
earflares, beads, and mask pendants. A shapely, inscribed jade mask (Number 187)
is fully as big as those depicted at Copán and similarly naturalistic. It has a differ-
ent headdress, however, and was carved at Piedras Negras some sixty years earlier.
Since such large pieces of jade were uncommon, mosaic technique was used to pro-
duce ornaments of a size and color impossible to attain otherwise, shell and obsid-
ian being added for further enrichment (Numbers 188, 189).

A monster among Maya jades, the unparalleled Tikal jaguar (Number 191) was

211

probably shaped from a boulder that already suggested the form of the symbolic animal so strongly that it escaped being made into any kind of jewelry or personal adornment. Such a large and immensely valuable piece of raw jade would have been considered long and carefully before cutting, and only some recognition of a predetermined character in it can explain how a Maya lapidary came to carve a creature so atypical. Another exceptionally large and unprecedented jade is the elegantly stylized mask of the Earth Monster (Number 192), a subject seen more often in monumental sculpture or painting. Though by no means flat, it epitomizes the graphic quality that characterized Maya jade carving and the later styles derived from it.

The origins of the Maya lapidary traditions are obscure; their very existence presupposes some connection with the Olmec, yet there is no transitional style. During the intervening centuries lapidary work was perhaps confined mainly to such things as beads and earflares, modeled after actual Olmec ornaments still in use. Incised on some of these are ornate glyphs and human figures like those on the earliest lowland monuments. In the Maya highlands carved jade ornaments began to appear in at least two Early Classic styles: at Kaminaljuyú, a rather sharp and sketchy kind of work with saws and tubular drills, and in the Quiché, a rounded low relief based on hand incising (Numbers 193, 194). Regional distinctions are less marked in Late Classic jades, many of which combine the fine draftsmanship of the lowlands with the sharp cutting and tubular drillwork of Kaminaljuyú and the flatness, irregular shape, and crowded composition of the Quiché.

Shell was a favorite material for Maya craftsmen, who sometimes carved it in the same manner as jade (Number 197). Like jade, it had symbolic value as well as beauty and rarity. Different kinds of shell appear as hieroglyphs and symbols on the monuments, and quantities were brought from both coasts to the inland cities to be placed in burials and offerings. When shell was worked into ornaments, its natural form was often preserved to splendid advantage (Numbers 198, 199).

Flint knapping, an essential skill in many hunting societies, has sometimes developed into an art among more sophisticated peoples, notably in Denmark during the Bronze Age and in Middle America. Maya (and also Teotihuacán) votive offerings included so-called eccentric flints and obsidians, chipped in certain unusable symbolic shapes that were traditional. Ceremonial scepters of chipped stone appear on several Preclassic monuments (Number 60), and by the Late Classic this form had reached a degree of intricacy almost unbelievable in so difficult a medium (Numbers 200–202). The stylized elegance of these scepters may appeal more than Maya realism (Number 203) to the modern eye, which can, nevertheless, also recognize in them the kind of extreme refinement that costs more than it is worth in practical human terms. In this respect they fit into the spectacular but puzzling pattern of Maya achievement and decline.

168 Tripod effigy bowl

Stone (reconstructed from fragments)
Diameter: 8¼ in. (21 cm.)
El Bellote, Tabasco, Mexico
Protoclassic or Early Classic, probably third century
A.D.
Dr. and Mrs. Josué Sáenz, Mexico City

A strange saurian head, with a human face in its jaws, rises from the floor of the vessel on a long neck joined to the inner wall. (The rim of the bowl, beveled toward the inside, possibly held a lid that represented the animal's back.) A lobe on the side opposite the head, which gives the bowl a semitrefoil shape, is flanked by flipperlike appendages and bears the remains of a profile face in low relief (not visible in the photograph). This face, which has an Izapan cast, is upside down and partly surrounded by one of the six incised face glyphs (Figure 26, D). They are part of the original conception rather than a later addition; the fine incising on all the sculptured parts has the same character as the glyphs and includes the same "cogwheel" element that appears in Figure 26, F. The glyphs are in an early style, and the bowl comes from a region where Protoclassic material has been found at several unexcavated sites between the Gulf Coast and Comalcalco, the westernmost Maya city.

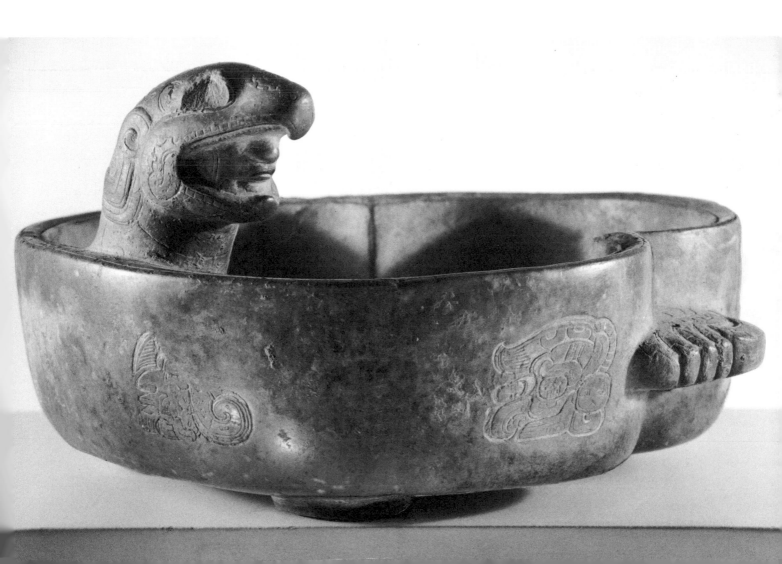

169 Miniature stela

Limestone with holes drilled for ornaments of other
 materials
Height: 33 in. (84 cm.)
Provenance unknown
Protoclassic, probably A.D. 100–250
Mr. and Mrs. John H. Hauberg, Seattle

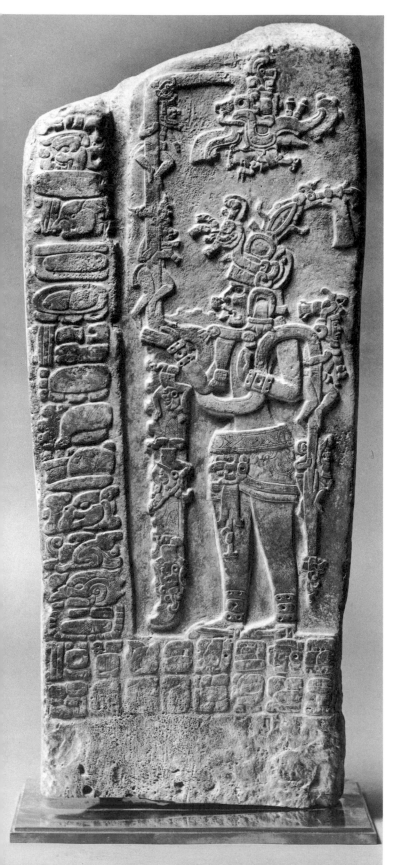

The face mask, revealing the eye of the man who wears
it, allows him to be understood as a real individual and at
the same time to be identified with the supernatural be-
ings around him. The serpent held across his chest may
relate to "sky faces" seen in Izapan, Zapotec, and the
earliest Maya art, or to Classic ceremonial bars, which
are held in a similar manner but have serpent heads at
both ends, often with a face emerging from the gaping
jaws. (In certain Classic reliefs, a face in the jaws of a
great serpent is thought to symbolize a dead hero or an-
cestor.) The elfin figures (perhaps the four Chacs, or rain
deities) and the small torsos hanging upside down on the
curved tooth-edged object before which the figure stands
resemble those represented, along with a priestly figure
and faces in serpents' jaws, on a stela at Tikal, probably
carved about A.D. 400 (William R. Coe, *Tikal*, Philadel-
phia, 1967, drawing on p. 92).

170 Stela 5 from El Zapote

Limestone
Height: 50 in. (1.27 m.)
El Zapote, El Petén, Guatemala
Early Classic, A.D. 435 (9.0.0.0.0 8 Ahau 13 Ceh)
Museo Nacional de Arqueología y Etnología,
 Guatemala

This newly discovered stela portrays a ruler as well as his
distinguished lady, who wears a rich ceremonial costume
that further emphasizes her importance (Tatiana Pro-
skouriakoff, "Portraits of Women in Maya Art," in S. K.
Lothrop and others, *Essays in Pre-Columbian Art and
Archaeology*, Cambridge, Massachusetts, 1961, pp. 81–
99). She holds a large glyph, with the same open-hand
gesture used by the man on Number 169 and by other
figures that hold unreal objects. Under the bar-dot nu-
meral twelve is the Teotihuacán year symbol made up of
a triangle and a trapezoid, appearing here as one of the
earliest indications yet found of Central Mexican influ-
ence at the top level of Maya society. The framed glyph,
a small reclining figure and scroll, is identified with the
deity of Palenque's Temple of the Foliated Cross (Hein-
rich Berlin, "The Palenque Triad," *Journal de la Société
des Américanistes*, n.s. 52, 1963, fig. 6, 2). Sometime in
1968, this stela was sawed lengthwise, partly destroying
the inscription, and the better preserved side broken in
two and carried from the site on muleback by vandals
who were apprehended on their way out of the country.
This year Ian Graham recovered the rest of the stela and
explored the small site, discovering seven additional ste-
lae, six of them carved, and all very early.

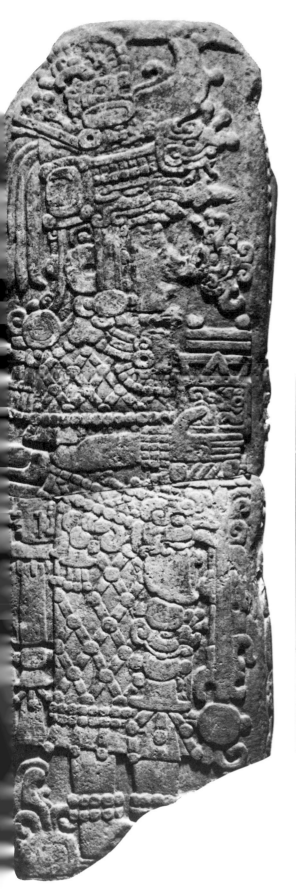

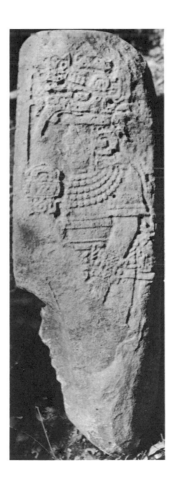

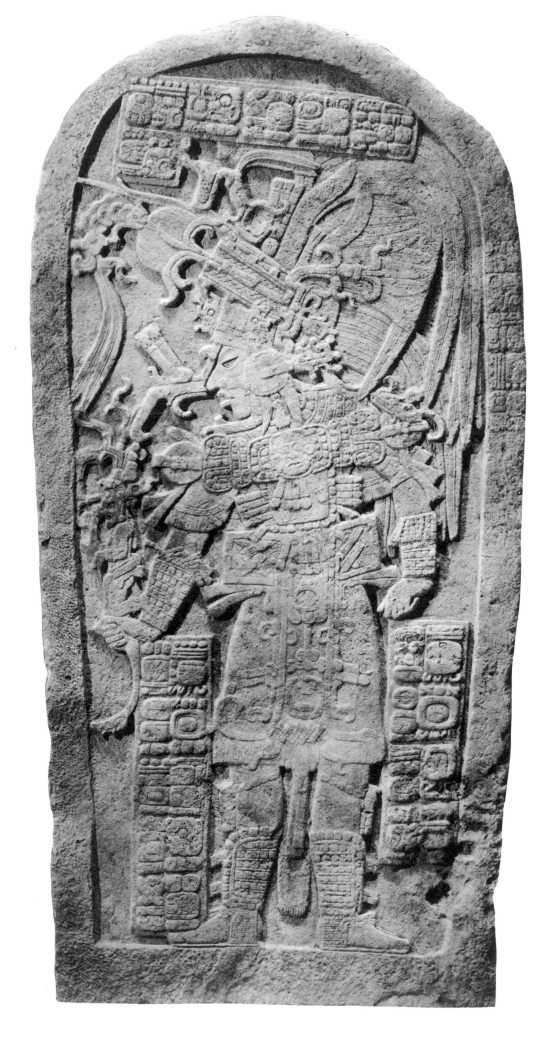

171 Stela 3 from Machaquilá

Limestone
Height from base of carving: 71 in (1.80 m.)
Machaquilá, El Petén, Guatemala
Late Classic, A.D. 815 (9.19.5.0.0 2 Ahau 13 Yaxkin)
Museo Nacional de Arqueología y Etnología,
 Guatemala

The ruler-priest carved on this stela holds a symbolic
manikin scepter and wears an elaborate headdress with
a stylized water lily in front that is being nibbled by a
fish in midair. The costume represented includes real, as
well as symbolic, attributes of rulership: the short jaguar
skin skirt, the panache of quetzal feathers, and pounds
of carved jade and shell in the anklets, garters, bracelets,
collar, mask-centered breast ornament, earflares, and
headband of rectangular plaques and flat, grotesque pro-
files. The ruler's name and titles appear in the panel
above his head (in the single lower block and in the sec-
ond and third blocks from the left in the upper row) and
in the column at the left (the lower two blocks). The em-
blem glyph or "place glyph" that represents Machaquilá
appears twice (the left half of the block farthest to the
right in the upper row of the overhead panel and the left
half of the top block in the column at the right). The in-
scription begins with a date that was also recorded as an
important one at the city of Naranjo, about seventy miles
to the northeast. (See Ian Graham, *Archaeological Ex-
plorations in El Petén, Guatemala*, Middle American Re-
search Institute Publication 33, New Orleans, 1967.)

172 "The Madrid Stela"

Limestone
Height: 18½ in. (47 cm.)
House E of the Palace, Palenque, Chiapas, Mexico
Late Classic, seventh-eighth century A.D.
Museo de América, Madrid

Discovered by the first archaeological expedition in
America, led by Antonio del Río in 1785 under the spon-
sorship of the Spanish crown, this long-admired relief
was misnamed a stela on its arrival in Spain. In fact, del
Río had sawed it from one of the legs that supported a
stone dais or throne, placed beneath a now destroyed
wall relief. His sketches finally enabled Heinrich Berlin
to identify it, as well as the other leg of the throne, now
badly damaged ("Neue Funde zu alten Zeichnungen,"
Ethnos 30, 1965, pp. 136–143). A date corresponding to
A.D. 684, repeated in many other Palenque inscriptions,
was said to have been on the throne slab, but the dynamic
naturalism of this relief suggests a later date. The figure

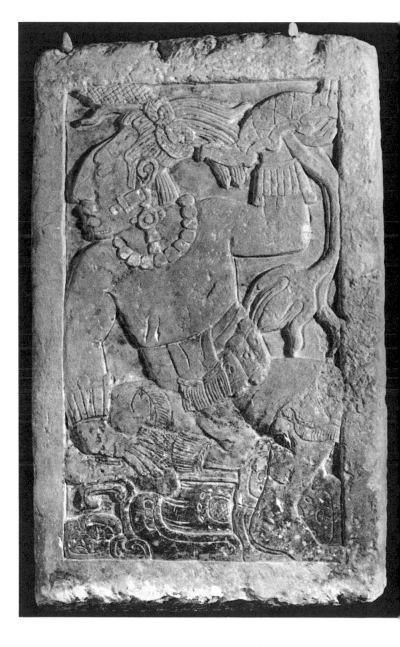

sits on a large grotesque mask of the Earth Monster,
which faces upward, and rests his hand on its snout. In
the place where its eye should be is the Imix glyph, a
stylized water lily that had both terrestrial and aquatic
associations, while the seated figure holds high a sym-
bolic water-lily leaf with a bud hanging from it.

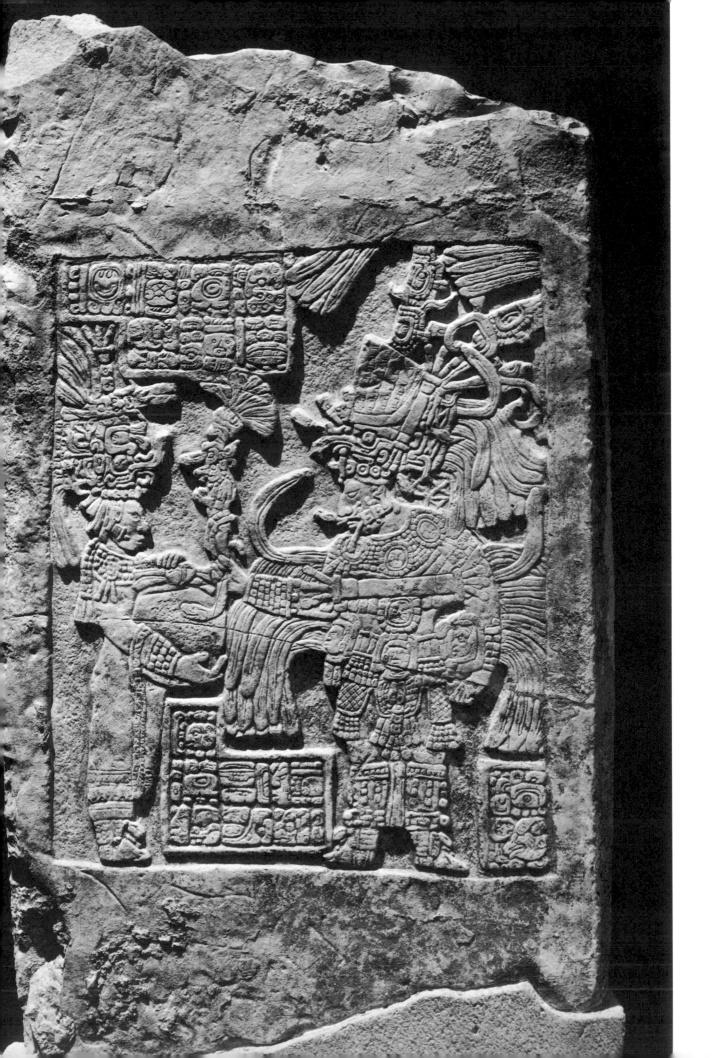

173 Lintel 53 from Yaxchilán

Limestone
Length: 64½ in. (1.64 m.)
Structure 55, Yaxchilán, Chiapas, Mexico
Late Classic, probably A.D. 752–771
Museo Nacional de Antropología, Mexico, 5–1763

The dominant figure in this scene is the founder of a dynasty that ruled Yaxchilán in the eighth century, now known because of his name glyph (upper right corner of the upper panel) as "Shield-Jaguar." The young woman (referred to in the lower glyph panel) may be a bride with her dowry, though the nature and correct date of the event depicted are still uncertain. The lintel probably was carved during the reign of the succeeding ruler to establish his claim to the throne. The two emblem or "place glyphs" representing Yaxchilán appear in the lower right corner. (See Tatiana Proskouriakoff, "Historical Data in the Inscriptions of Yaxchilán," *Estudios de Cultura Maya* 3, 1963, pp. 149–167, and 4, 1964, pp. 177–201.)

174 Openwork relief

Limestone
Height: 44 in. (1.12 m.)
Probably lower Usumacinta Valley, Chiapas or
 Tabasco, Mexico
Late Classic, late eighth or early ninth century A.D.
Dr. and Mrs. Josué Sáenz, Mexico City

The arrangement of the glyph columns and profile masks that form the framework of this extraordinary sculpture indicate that it was completed by a third panel at the right, probably containing another seated figure. Nothing quite like it has been discovered before, but there are at Piedras Negras both a throne with a one-piece openwork back and a relief depicting a similar throne. Though the lightly clad but believably regal couple appear to be portrayed with straightforward realism, the gnomelike deity who engages their attention establishes the symbolic dimension of the scene. He may be a symbol of divine rulership, corresponding to the headdress, scepter, or other ritual object presented in several compositions at Palenque that show a dominant figure with male and female companions. The relief commemorates, in the upper pair of glyphs on the central column, a date placed by J. Eric. S. Thompson at A.D. 747 or 799 (9.15.15.15.12 or 9.18.8.10.12 9 Eb 5 Zotz).

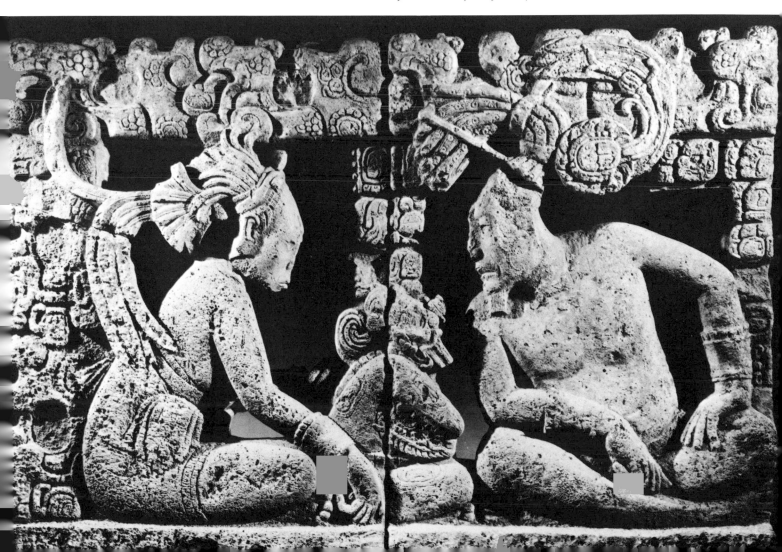

175 Face panel

Limestone
Height: 18½ in. (46 cm.)
Probably Palenque region, Chiapas, Mexico
Late Classic, about A.D. 700
Dr. and Mrs. Josué Sáenz, Mexico City

Flanged cylinders of pottery (Number 176) appear to have been influenced by the design of stone stelae; here, seemingly, is the pottery cylinder translated back into stone. The basic form and elements are the same, though the central column of this stone panel is somewhat flattened front and back, and roughly concave on top rather than hollow. The monster-mask headdress is transformed into a band around the greatly elongated head, with another headband above it made of what resemble the jade plaques found in rich burials. The supernatural appears abruptly with the tiny (now headless) figure perched on the tufted hair, occupying the same top center position as the little figures and heads on most of the Palenque pottery cylinders. One damaged stone example and the fragment of another were excavated there under such conditions as to suggest that the pottery versions are the prototype, and older (Alberto Ruz Lhuillier, "Exploraciones arqueológicas en Palenque: 1953," "...1954," *Anales del Instituto Nacional de Antropología e Historia* 10, 1958, pls. XX, XL, XLI). A third of these rare stone examples comes from west-central Guatemala and is now in the Museum für Völkerkunde in Berlin (R. L. and B. C. Rands, "The Incensario Complex of Palenque, Chiapas," *American Antiquity* 25, 1959, pp. 225–236, fig. 11.).

176 Stand for an incense burner

Reddish brown pottery with blue paint
Height: 41¼ in. (1.05 m.)
Offering 6a, Temple of the Foliated Cross, Palenque, Chiapas, Mexico
Late Classic, seventh–eighth century A.D.
Museo Nacional de Antropología, Mexico, 10–95054

Decorative and symbolic values all but obliterated the functional aspect of the great flanged cylinders from Chiapas, which barely escape the common label "ceremonial object of unknown use." Their probable role was to act as supports for braziers or dishes of incense. Though lacking any interior platform, they resemble the flanged, face-decorated incense burners found in other regions, such as highland Guatemala. The face here is identified by the fillet that runs under the eyes and twists like a cruller over the bridge of the nose as that of the jaguar god, the sun at night, patron of darkness and the underworld. Other Palenque cylinders have human faces set in a similar composition, recalling the stelae that portray a frontward-facing figure wearing a towering headdress loaded with symbolic decoration.

Left
side
of
panel

 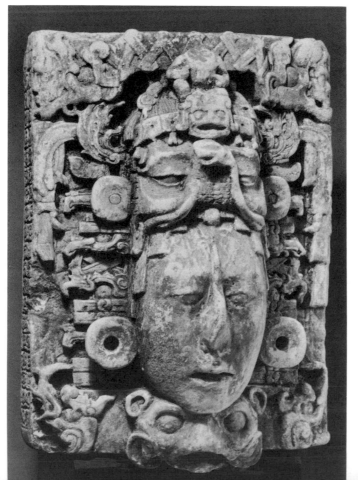

Top of
flange at
right side

Right side,
with damaged
Initial Series
date probably
corresponding
to A.D. 659.

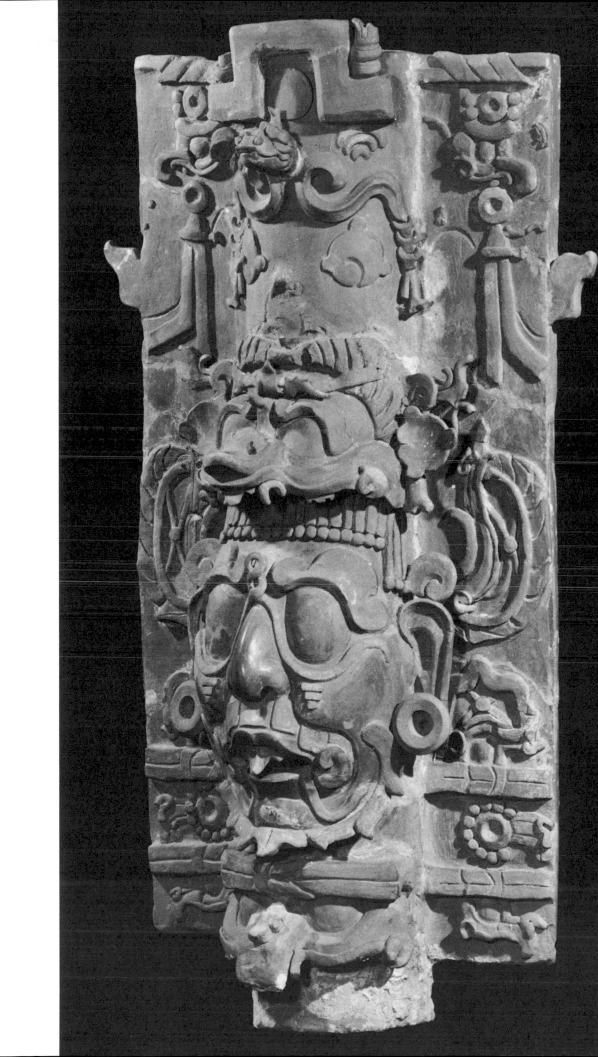

177 Water-lily spirit

Buff clay with red wash and blue and white paint
Height: 8¼ in. (21 cm.)
Probably from Jaina, Campeche, Mexico
Late Classic, A.D. 700–900
The Brooklyn Museum, Dick S. Ramsay Fund, 70.31

Fragility alone is enough to explain the rarity of this form, which seems to represent a small deity emerging from the seedpod of the ubiquitous water lily. The well-preserved colors include "Maya blue," a pigment that gained its unusual hue and permanence from carefully controlled heating. (See Color Illustration.)

178 Standing personage

Buff gray clay with blue and white paint
Height: 9⅝ in. (24.5 cm.)
Jaina, Campeche, Mexico
Late Classic, A.D. 550–950
Museo Nacional de Antropología, Mexico, 5–1386

The delicately modeled details of the costume include carved pendants and three fine water lilies on the headdress. The island of Jaina, separated from the mainland only by a narrow channel, was in Classic and Early Postclassic times a ceremonial center and necropolis, to which figurines of many styles were brought as burial offerings. Some of them show a significant resemblance to figurines of the Veracruz coast (Numbers 133, 135) and even of Central Mexico.

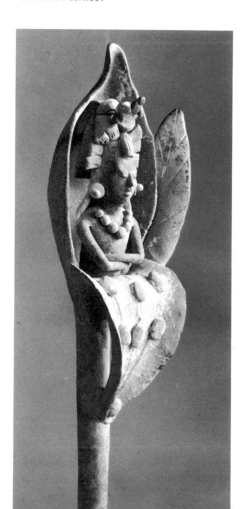

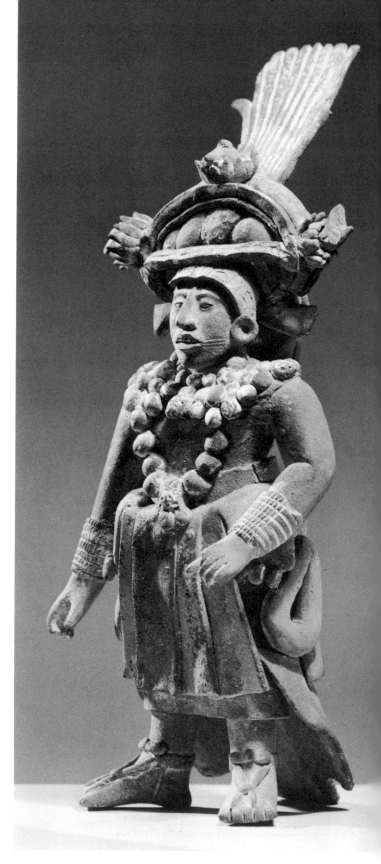

178

179 Warrior

Buff clay
Height: 6 in. (15.4 cm.)
Pueblo Copanahuasta (between La Libertad and
 Comitán), Chiapas, Mexico
Late Classic, A.D. 550–950
The Metropolitan Museum of Art, 00.5.176
Ex coll. Petich

The vitality of expression and stance that makes this fig-
urine notable results partly from the deftly modeled
beard or mouth mask and from the innovation of placing
the customary third support of the figure in front, as a
sweeping fringed form, rather than behind.

180 Figurine whistle

Orange clay with traces of white paint
Height: 4⅜ in. (11.2 cm.)
Burial 348, Jaina, Campeche, Mexico
Late Classic, A.D. 550–950
Museo Nacional de Antropología, Mexico, 5–79

The asymmetrical headdress, ear pendants, and breast
ornament (which may represent a large bivalve shell)
were added to the molded front of the figurine.

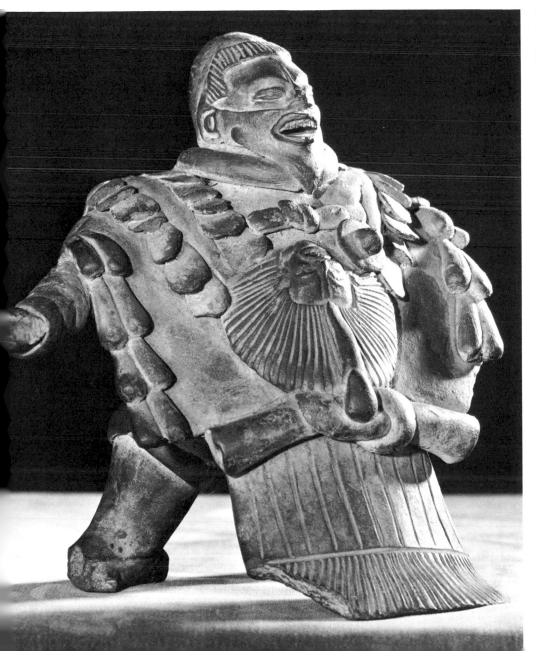

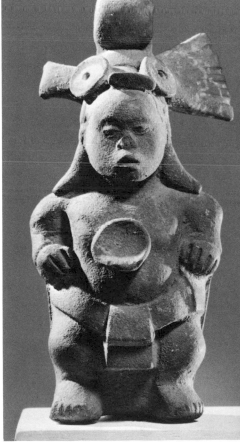

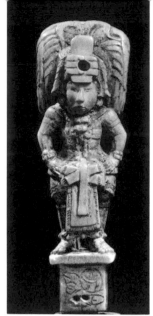

181 Statuette of a Priest

Carved bone with red pigment
Height: 2⅞ in. (7.3 cm.)
Provenance unknown, possibly Tabasco, Mexico
Late Classic, A.D. 700–800
Museo Nacional de Antropología, Mexico, 5–1651

Probably carved from the femur of a jaguar, this is one of the smallest and most prized of Maya sculptures. Additionally rare for its detailed rendering of costume, back as well as front, it shows the kilt or skirt of jaguar pelt, also depicted in Number 171, with the animal's tail overlapping the base. A jaguar head appears on the back of the richly plumed headdress. In Yucatecan Maya the word for "priest" is *balam*, which also means "jaguar." Alfonso Caso ("Sobre una figurilla de hueso del antiguo imperio Maya," *Anales del Museo Nacional de México* 1, 1934, pp. 11–16, pls. 1–4, figs. 1–8) has thus identified this figure as a jaguar-priest, who guards his people with the strength and vigor of that animal.

182 Kneeling figure

Wood with red hematite pigment
Height: 14¾ in. (38 cm.)
Said to be from the Tabasco-El Petén border region
Early Classic, fifth-sixth century A.D.
The Museum of Primitive Art, New York, 62.172

Preserved through the centuries in some dry, secure place high above ground, this matchless wood sculpture remains the single known survivor of a whole vanished art, evidence that Maya sculptors in wood followed canons different from those adhered to by the sculptors who worked in stone. The tremendously proud but respectful figure, portrayed with obvious realism, wears a briefer costume than the stela figures, with their symbol-laden headdresses, belts, and loincloth aprons, but the jewels are much the same as those shown on the stelae. The same type of compound breast ornament, for example, appears in Number 170 and other monuments carved before the end of the sixth century. The radiocarbon date obtained from a small sample of the wood was 537 ± 120 years. (Gordon F. Ekholm, *A Maya Sculpture in Wood*, The Museum of Primitive Art Studies 4, New York, 1964.)

183 Bat man

Stone
Height: 26½ in. (67 cm.)
Provenance unknown
Probably Late Classic, A.D. 550–950
Hugo Droege, Telemán, Alta Verapaz, Guatemala

Bats abound in Maya art and iconography. *Zotz*, the leaf-nosed vampire bat, appears prominently on painted vases

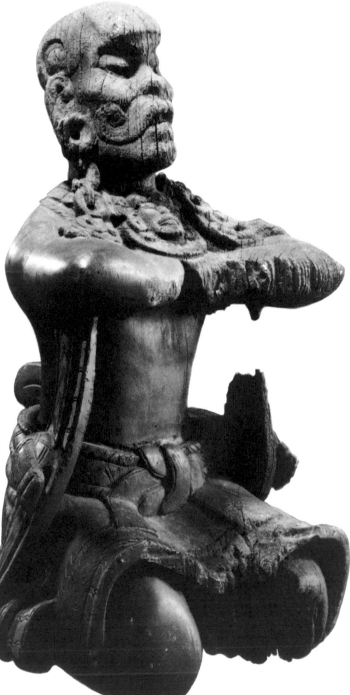

from the Chamá region of Alta Verapaz, and lent its name to the fourth month of the Maya year. Its profile head symbolized that month in glyphic writing and formed the main element in the emblem glyph of Copán, the city most noted for sculpture in the round. Both the emphatic three-dimensionality of this creature and its symbolic bat form relate it to the bats of Copán. It may represent a real personage related by blood to the rulers of that city. Entirely human except for the distinguishing head and wings, the figure stands against a supporting column that extends below its projecting feet and loin-cloth tassel.

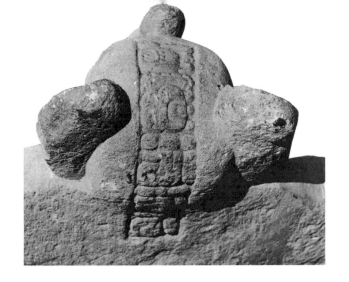

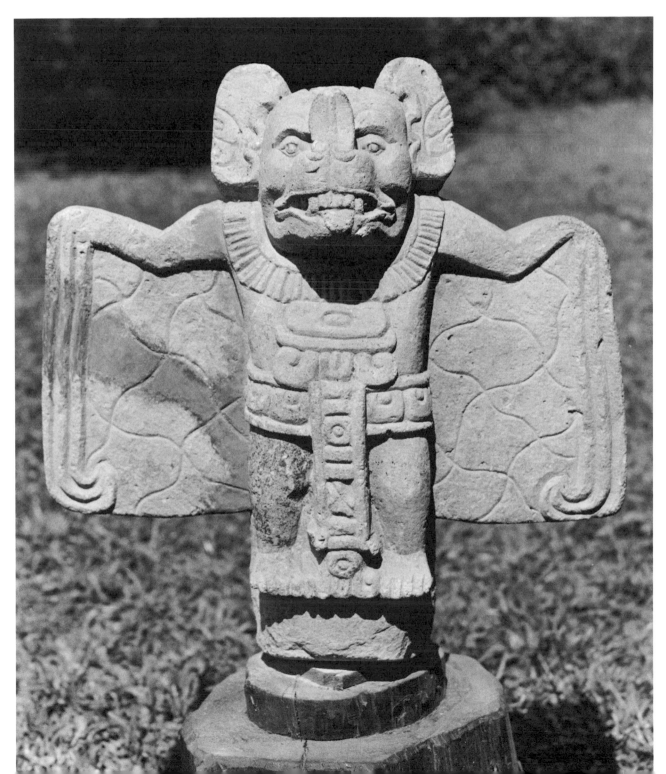

184 Personage seated on steps

Greenish andesitic tuff with traces of stucco
Height of figure as assembled: 79 in. (2.00 m.)
Hieroglyphic Stairway (Structure 26), Copán,
 Honduras
Late Classic, probably A.D. 756 (9.16.5.0.0 8 Ahau 8
 Zotz)
Peabody Museum of Archaeology and Ethnology,
 Harvard University, Cambridge, Massachusetts,
 C/753, 856–9, 861–2, 865–7, 871

The overwhelming magnificence of the great stairway
can be envisioned from this relatively small section as-
sembled from fragments found in the ruins by the first
Harvard expedition (G. B. Gordon, "The Hieroglyphic
Stairway, Ruins of Copán," *Memoirs of the Peabody
Museum of American Archaeology and Ethnology, Har-
vard University* 1, no. 6, 1902). Though the spacing of
the stairway blocks is correct, the original order is un-
known (except for the blocks included in Figure 30), and
the placement of the head and crest is equally uncertain.
The body was carved of two great blocks after they were
set in place, the head and a broad backing of plumes and
symbolic elements from blocks set higher up the stair.
The figure held a shield from which hung the Tlaloc-face
ornament that remains beside the knee at the right. The

glyph at the left of the figure on the upper step formed
part of the name of the Copán ruler who founded a dy-
nasty at the neighboring city of Quirigua in A.D. 738
(David H. Kelley, "Glyphic Evidence for a Dynastic Se-
quence at Quiriguá, Guatemala," *American Antiquity*
25, 1962, pp. 323–335).

185 Bust

Greenish andesitic tuff
Height: 37 in. (94 cm.)
Probably Structure 26, Copán, Honduras
Late Classic, probably A.D. 756
Peabody Museum of Archaeology and Ethnology,
 Harvard University, Cambridge, Massachusetts,
 C/873

This serene face and its elaborate monster-mask head-
dress are the same as those of the "singing girls" from
Structure 22 (Number 186). The remaining part of the
figure to which the head is now joined, however, has a
different costume and probably came from the temple
that once crowned the Hieroglyphic Stairway. Fragments
from the two temples (Structures 22 and 26) were found
intermingled on the lower slopes of their adjoining bases.

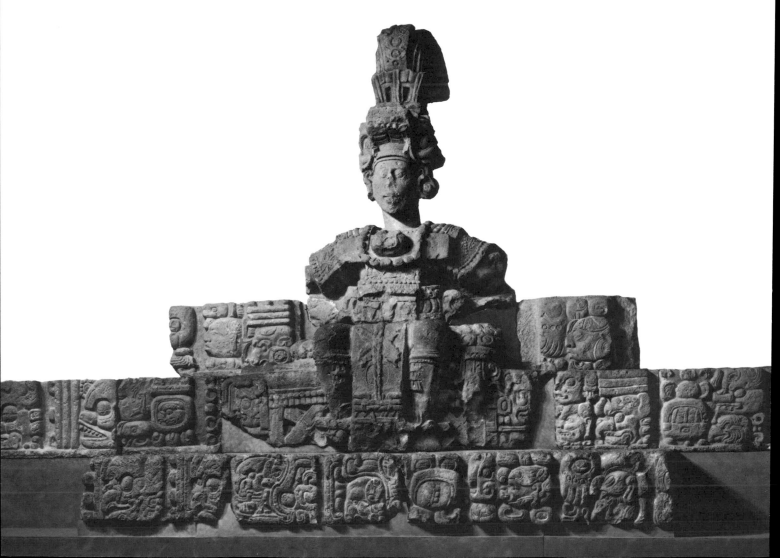

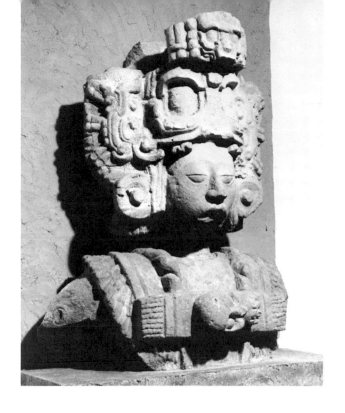

186 Pair of half-figures

Greenish andesitic tuff with traces of stucco and red paint
Height of A: 54 in. (1.37 m.); B: 57 in. (1.45 m.)
Late Classic, A.D. 763–771
Structure 22, Copán, Honduras
Peabody Museum of Archaeology and Ethnology, Harvard University, Cambridge, Massachusetts, A: C/707–9, 36; B: C/705–6, 717, 721, 723

These and other figures like them were set in a broad sculptured frieze. Each one was composed of separate heavily tenoned blocks, which were probably only partially shaped before being incorporated into the building. Though these various blocks were scattered when they fell from the building, the head, torso, and arm of figure A were found close together among the ruins and probably belonged to the same figure (Aubrey S. Trik, *Temple XXII at Copán*, Carnegie Institution of Washington Publication 509, 1939).

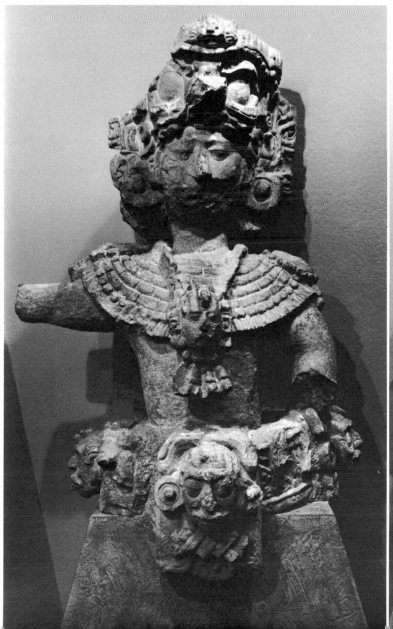

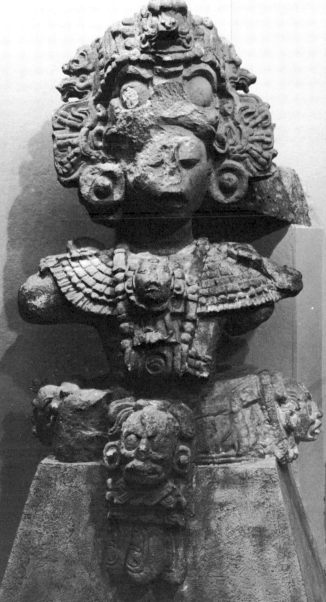

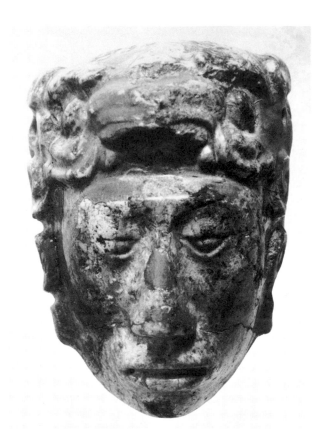

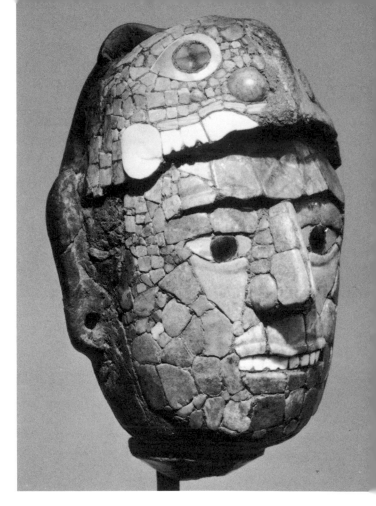

187 Head pendant

Jadeite
Height: 3⅜ in. (8.5 cm.)
Sacred Cenote, Chichén Itzá, Yucatán, Mexico
Late Classic, A.D. 706 (9.13.14.13.1 5 Imix 19 Zac)
Peabody Museum of Archaeology and Ethnology,
 Harvard University, Cambridge, Massachusetts,
 C/6100

Restored from fragments, this Maya jewel had been broken intentionally and flung into the Cenote of Sacrifice with other offerings. The inscription on the back rim and chin connects it with the distant city of Piedras Negras and commemorates the katun anniversary (approximately twenty years) of an important ruler's ascension to power there. (Tatiana Proskouriakoff, "An Inscription on a Jade Probably carved at Piedras Negras," *Carnegie Institution of Washington Notes on Middle American Archaeology and Ethnology* 47, 1944, and "Historical Implications of a Pattern of Dates at Piedras Negras, Guatemala," *American Antiquity* 25, 1960, pp. 456, 458–459.) (See Color Illustration.)

188 Mosaic head pendant

Jadeite, Spondylus shell, mother-of-pearl, obsidian,
 wood, unidentified resinous material, and red
 pigment
Height: 4⅜ in. (11 cm.)
Provenance unknown
Late Classic, probably eighth century A.D.
Robin B. Martin, Katonah, New York

Slightly larger than the Cenote mask pendant (Number 187), this one made in mosaic technique has the same motif of a head with monster-mask headdress and is similarly hollowed out in back and perforated at the temples. The earlobe is also perforated, for an ornament to be attached. The lost portion of the mask's left side has been restored to match the right. On that side, the entire edge, including the ear and the animal ear, was built up of a resinous material painted red but not covered with mosaic. (See Frontispiece.)

189 Funerary mask

Jade, pearl shell, and obsidian
Height: 9½ in. (24 cm.)
Tomb under the Temple of the Inscriptions, Palenque,
 Chiapas, Mexico
Late Classic, about A.D. 700
Museo Nacional de Antropología, Mexico, 5–1461

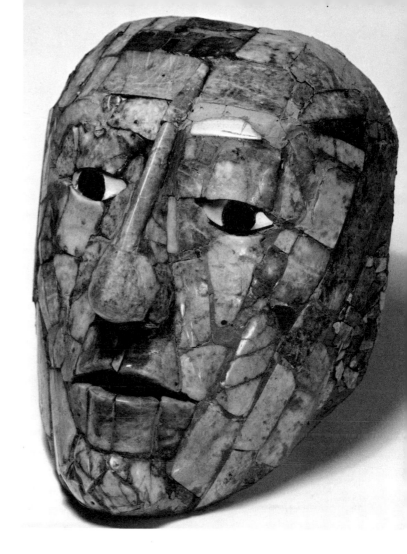

This compelling life-size mask was found, as a heap of
fragments, where it had slipped centuries ago from the
face of the great ruler interred in the monolithic sarcoph-
agus, decked with jade. The mask is made up of around
two hundred pieces, some of them recut from perforated
ornaments, with small jade disks fitted in to plug the
holes. It received its final shaping and polishing after the
mosaic was set in place. The eyes have irises of obsidian
so thin that dots painted on the back show through as
the pupils.

190 Shrimp (?)

Jadeite
Length: 3 in. (7.5 cm.)
Burial A–29, Uaxactún, El Petén, Guatemala
Early Classic, Tzacol phase, A.D. 250–550
Museo Nacional de Arqueología y Ethnología,
 Guatemala, 455

Shells and other things from the sea were included in
many Maya and Teotihuacán offerings, and several con-
tained stingray spines imitated in shell and in bone.
This unprecedented object, composed of four separately
carved parts, may have been made for the same purpose,
though its identification is uncertain. It could alterna-
tively have formed part of a mosaic, since it is unperfor-
ated and the two larger pieces have unpolished backs.
(A. V. Kidder, *Artifacts of Uaxactún, Guatemala*, Car-
negie Institution of Washington Publication 576, 1947,
fig. 36.)

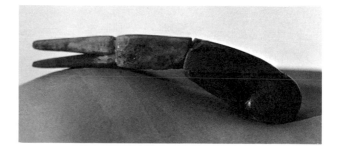

191 Jaguar

Jadeite
Length: 6½ in. (16.3 cm.)
Burial 196, Tikal, El Petén, Guatemala
Late Classic, A.D. 700
Museo Sylvanus G. Morley, Tikal, Guatemala

Found in a rich tomb during the 1965 season of the Uni-
versity of Pennsylvania Museum's archaeological work
at Tikal, this sleepy-looking animal is not realistically
rendered, nor is it similar to any other in Maya art. Its
identification as the supernatural jaguar, however, is
clearly established by the presence of two elements as-
sociated with that beast, the Ix glyph incised on each eye
and the water-lily bud in low relief on its forehead.

192 Ornamental mask

Jadeite
Width: 6⅝ in. (16.8 cm.)
Provenance unknown
Late Classic, A.D. 550–950
John Huston, County Galway, Ireland

Possibly created as a headdress element, this mask has large perforations through the upper corners (drilled from the sides and the flat back), finer ones of the same kind at either side of the jaw, and five more that are visible across the top and in the projections beside the eyes. Such ornaments must ordinarily have been made of humbler, and perishable, materials; no other like this has been found, though a very few grotesque masks of smaller size are known. Most Maya pendants, both real ones and representations of them in art, take the form of human faces.

193 Frontal figure pendant

Jadeite
Height: 4⅞ in. (12.5 cm.)
Highland Guatemala
Early Classic, Esperanza phase, A.D. 400–550
Anonymous loan

Uniform low relief that is barely more than rounded incising defines a figure much like those on lowland stelae of the sixth and seventh centuries, with a mask headdress, feet turned out, and hands held back-to-back against the chest supporting a ceremonial bar that ends in large profile serpent heads. Characteristic of Early Classic jades is the lengthwise perforation (which would require special stringing to make the figure hang vertically) and careful cutting of the irregularly shaped piece of jade so that the front surface conforms to the layer of finest light green color.

194 Profile figure pendant

Deep green jadeite
Height: 3¼ in. (8.2 cm.)
Highland Guatemala
Early Classic, Esperanza phase, A.D. 400–550
Anonymous loan

Though the body is presented frontally, the face is in profile, with the distinctive barlike rendering of the features seen in Number 193. The relief here, low but nicely varied in depth, typifies the best Quiché lapidary work, an Early Classic style defined by A. Ledyard Smith and Alfred V. Kidder (*Excavations at Nebaj, Guatemala*, Carnegie Institution of Washington Publication 594, 1951, pp. 32–43). Jades of this style were carved from raw material that come from the Motagua Valley and probably from other sources still undiscovered in the Quiché region. They were in great demand throughout the lowlands, where they have been discovered in burials and offerings dated as early as the late fifth century A.D.

195 Seated figure

Stone
Height: 12 in. (30.5 cm.)
Highland Guatemala
Early Classic, A.D. 250–550 (?)
Museo Arqueológico Regional de Chichicastenango, Guatemala
Ex coll. Rossbach

Instead of a flat base, the forceful little figure has a heavy tenon to be inserted in its pedestal or support. The half-kneeling position, with only one knee on the ground, was originally an Olmec convention (Figure 5), and the gesture of the hands raised to the chin must have been significant of something more than deep thought. The arms are cut free of the chest, lending the compactly stylized figure lightness and vitality.

196 Lidded bowl

Reddish sandstone
Height: 7¼ in. (18.5 cm.)
Zacualpa, El Quiché, Guatemala
Early Classic, A.D. 250–550 (?)
Museum für Völkerkunde, Berlin, IV Ca 41427

Though both stylized faces on this bowl appear to represent human beings, supernatural identity is suggested by a larger bowl of the same design that has a skull on the side and a jaguar head on top with its body in low relief on the lid (Staatlichen Museums für Völkerkunde, *Alta-merikanische Kunst*, Munich, 1968, no. 112). Still another bowl, which lacks its lid, has a chubby naturalistic face that recalls earlier fat figures and heads from Monte Alto (Number 52) (S. K. Lothrop, *Zacualpa*, Carnegie In-

194

stitution of Washington Publication 472, 1936, fig. 89).
The distinctive facial stylization seen on this bowl, a
seated figure (Number 195), and typical Quiché jades
(Numbers 197, 198) also appears on a stone brazier-top
figure related in concept to those of Central Mexico (Rich-
ard B. Woodbury and Aubrey S. Trik, *The Ruins of
Zaculeu, Guatemala*, Richmond, 1953, fig. 278a). This
stylization, in short, appears to predate as well as overlap
the Teotihuacán phase in the Guatemalan highlands.

193

195

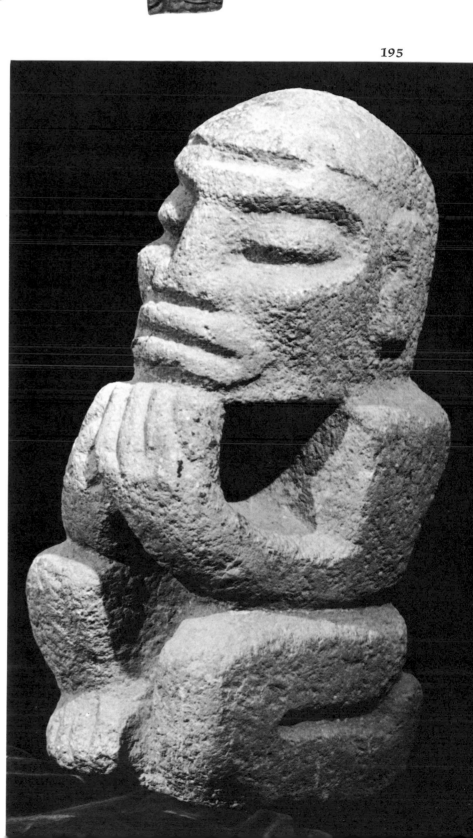

197 Seated-figure pendant

Pearly white Haliotis shell
Height: 3¾ in. (9.5 cm.)
Tula, Hidalgo, Mexico
Late Classic, eighth century A.D.
Field Museum of Natural History, Chicago, 95075

Among abundant marine material from offerings and burials, pearl shell of any kind is uncommon, and its high value is evident in the history of this pendant. The large abalone shell from which it is made reached the Maya area from a source no nearer than Lower California. It served first for an ornament incised with a band of Late Classic glyphs that now appears incomplete and wrong side up on the back. Somewhat later this piece, broken or cut from the original ornament, was recarved by a master lapidary as though it were jade. (The same seated-figure motif appears on about twenty of the largest and finest eighth-century jades.) The recut pendant was large enough to accommodate another suspension hole at the left side, the rest of the extended arm, and possibly an additional, smaller figure. More valuable than ever, the pearl pendant was ultimately carried to Tula, a city founded only in the tenth century (Désiré Charnay, *Les Anciennes Villes du Nouveau Monde*, Paris, 1885, drawing on p. 74).

198 Skull

Shell
Height: 1⅜ in. (4.7 cm.)
Uaxactún, El Petén, Guatemala
Classic, A.D. 250–950
Museo Nacional de Arqueología y Ethnología, Guatemala

Shaped probably from a large Olive shell, the ornament may have been mounted horizontally and worn as in Numbers 184 and 185.

199

199 Left hand

Shell
Length: 8 in. (20.5 cm.)
Provenance unknown
Classic, A.D. 250–950
Mr. and Mrs. Paul Tishman, New York

Though two-dimensional design predominates in Maya art, it was a sculptor's eye and imagination that caught the form of a hand inherent in a large whelk shell cut or broken open. In this ingeniously realized carving the narrow lower end of the shell's aperture suggests the rounding of the wrist, while the inside of the spiral is cut to represent the turned-back fingertips, and the outside of the next higher whorl, the extended thumb. The carving may have been used as a shallow offering dish, like a much older hand-shaped vessel of Olmec jade (Michael D. Coe, *America's First Civilization*, New York, 1968, drawings on p. 150; Guennol Collection, on loan to The Brooklyn Museum, L.60.5). This gesture of the hand no doubt had meaning for the Maya; both right and left hands appear as glyphs and as pendants carved of jade, in a "vocabulary" of different positions that suggest the symbolic Buddhist mudras.

200 Scepter figure

Flint
Height: 14 in. (35.5 cm.)
Provenance unknown
Late Classic, A.D. 550–950
Mr. and Mrs. Samuel Josefowitz, Lausanne

Though said to have been found in the same cache as Number 201, different workmanship is evident in the subtly curved silhouette of this profile figure with its large scrolled headdress.

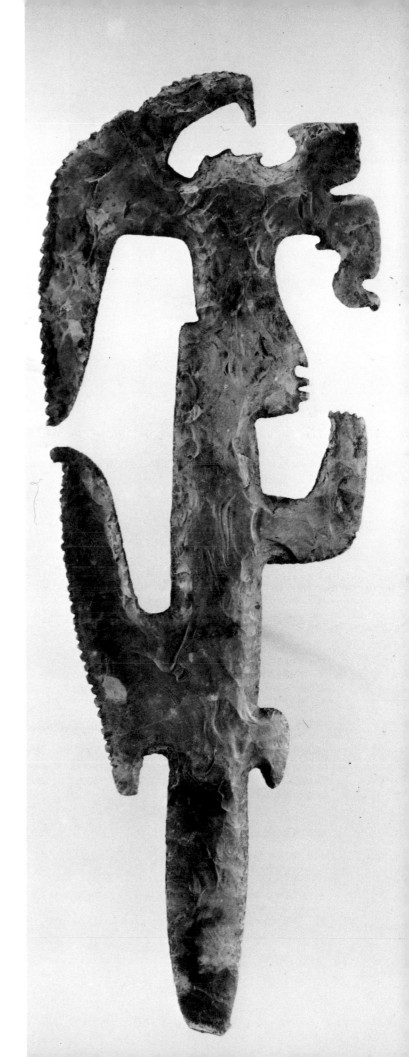

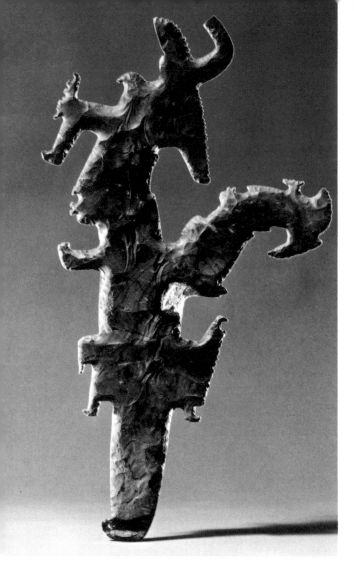

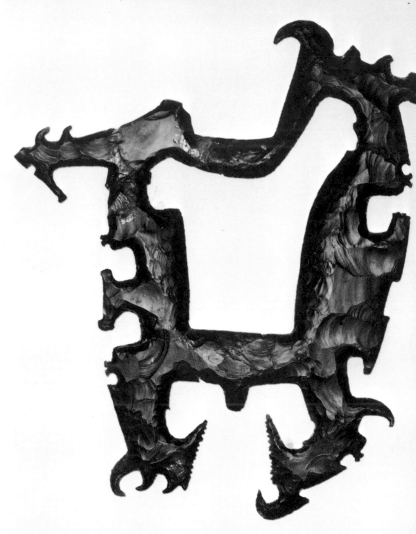

201 Scepter figure

> Flint
> Height: 13⅝ in. (34.5 cm.)
> Provenance unknown
> Late Classic, A.D. 550–950
> The Museum of Primitive Art, New York, 67.63

On this profile figure, reportedly found with Number 200, a similar headdress with front ornament and large panache of plumes is depicted in more elaborate and angular fashion. Both figures take the same pose, with arm raised, and perhaps, judging by this one, were seated on thrones. A smaller, papooselike figure facing upward curves from the back.

202 Eccentric flint

> Black flint
> Height: 12⅝ in. (31.2 cm.)
> El Palmar, Campeche, Mexico
> Late Classic, probably A.D. 746 (9.15.15.0.0 6 Ahau 13 Muan)
> Museo Nacional de Antropología, Mexico, 5–1005

Found in a cache of lesser chipped flints and obsidians at the foot of a dated stela, this masterpiece may have been a ceremonial scepter, with a handle attached to the projection between the two figures at the bottom. It can, however, be viewed either side up, since each corner represents an outward-facing profile rendered in classic Maya style with an elaborate headdress. (J. Eric S. Thompson, "An Eccentric Flint from Quintana Roo, Mexico," *Maya Research* 3, 1936, pp. 317–318.)

203 Modeled face

> Stucco
> Height: 11 in. (28 cm.)
> Palenque, Chiapas, Mexico
> Late Classic, A.D. 550–950
> Museo Nacional de Antropología, Mexico, 5–80

Striking in its realism, this must be the portrait of a ruler. It is often referred to as the "Juárez Sculpture," because it recalls the strong face of Lincoln's greatly respected contemporary, President Benito Juárez.

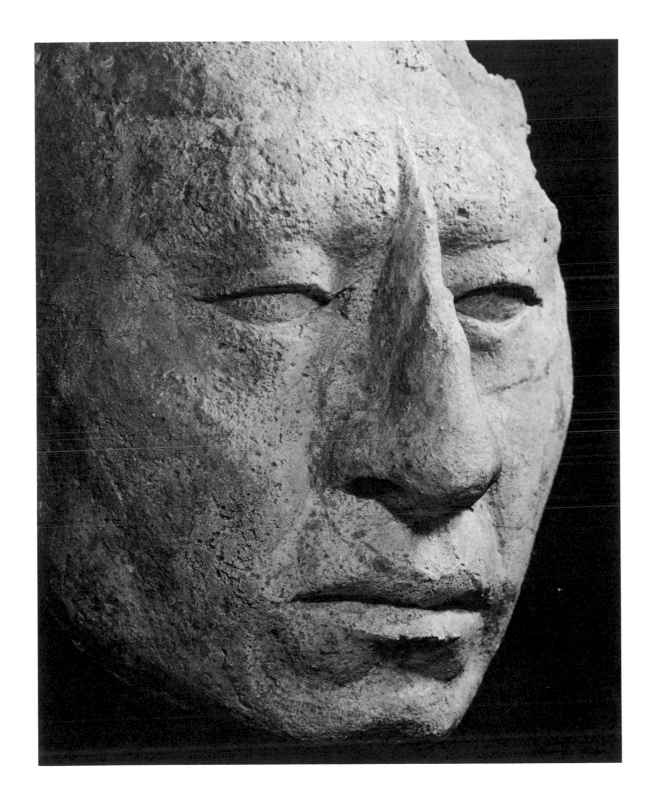

10

The Wealth of the Indies

Lower Central America and the Antilles, with their pearls and gold, and tales of more beyond, fulfilled Columbus's promise to secure for Spain the equal of the riches he had seen a decade earlier in Portuguese West Africa. The wealth he found in the Caribbean ensured the destruction within a generation of the two great civilizations to the north and south; apart from these conquests most of the New World remained for another century or longer nearly as untroubled as it had been by the Norse settlement in Newfoundland, abandoned as unpromising five hundred years before. The amazing affluence of Central America was demonstrated anew during the 1850s by a gold rush that emptied several large ancient cemeteries and enriched the world's coinage. Digging has continued ever since (part of it, fortunately, conducted by archaeologists), producing from this relatively small region enormous quantities of stone sculpture, handsomely decorated ceramics, and beautifully worked ornaments of gold, jade, and other rare materials.

Though prosperous and sophisticated in the arts, the circum-Caribbean peoples were not builders. They left no great ruined cities or ceremonial precincts to compare with those that in other regions mark the centers of strong religious, economic, or military power. The still fragmentary archaeological record seems to show instead a long-standing pattern of local independence, much like that of the sixteenth century, when the names of no fewer than fifty-three chieftains were recorded in central Panama alone.

At that time Central American trading relationships reached at least as far as Aztec Mexico and Inca Ecuador, and archaeological finds confirm the antiquity of such contacts, which made the region a cultural crossroads throughout its history. The Antilles, basically South American, were much less affected by outside influences. Though accessible to early seafarers, the far-flung island chain was not on the way to anywhere; the closest areas of the mainland were not as rich and advanced as Colombia and the Maya area, which adjoined Central America. Both the mainland and the islands are too varied and too little known archaeologically to be presented style by style in chronological order, so their outstanding arts can be appreciated better by considering each of the two regions as a single unit.

236

FIGURE 31

Nicaraguan sculpture

Interest in the ruins and antiquities of the Americas was aroused in the mid-nineteenth century by well-illustrated accounts of travel and exploration. One of the most popular and prolific writers was E. G. Squier, whose reports on Nicaraguan sites are still standard archaeological references. This engraving of Number 205 shows the figure as it stood at the base of the mound from which Squier removed it. The artist, evidently finding the sculpture curious rather than handsome, nevertheless depicted clearly the details of the figure and its animal headdress (*Nicaragua; Its People, Scenery, Monuments, Resources, Condition, and Proposed Canal,* New York, 1860, p. 483).

Lower Central America developed at least three styles of monumental sculpture. In different ways they suggest underlying traditions of wood carving that may have produced wooden sculptures of equally heroic size, long since destroyed in the warm, humid climate. Columnar sculptures found in western Nicaragua depict both standing and seated figures as if carved from tree trunks, with long bases or pegs for insertion into the ground or supporting platform (Figure 31, Numbers 204, 205). The forms are carved in relief on the surface of the column, a treatment more characteristic of work in stone than in wood. In contrast, the figures of eastern Costa Rica display a freedom unusual in stone carving, with many openings and projecting parts (Numbers 206, 207), and related "flying-panel" altars of the adjoining highlands have openwork so elaborate as to appear almost lacy (Number 212). Towering stone figures from Barriles, near the Costa Rican border of Panama, are columnar in effect but also carved in an unusually open style that may have been ancestral to the Costa Rican (Number 208).

In Central America, the metate acquired an importance far beyond its mundane function as a grinding stone and became a specialized form of sculpture (Numbers 209–212). Elegantly shaped and decorated, metates obviously served as ritual paraphernalia or insignia of rank, but the variety of sizes, forms, and regional styles suggests that their purpose was not the same everywhere.

Clay figurines are known from various Preclassic sites (Numbers 7, 8), and the tradition was continued in Nicoya after the introduction of polychrome techniques, resulting in the production of impressively large and colorful effigies (Numbers 215, 216) during the periods partly coeval with the Maya Late Classic. Strongly Mayoid cultures were ascendant at that time in northwestern El Salvador and Honduras (Number 217), a region that had always been more Maya—or pre-Maya—than Central American (Number 218).

From the earliest times the Pacific coast was a thoroughfare, or partly a sea-lane, of tremendous importance in the movement of goods, people, and ideas, especially along the stretch between Ecuador and Western Mexico. Though they were not the first, the Olmecs apparently used this route to obtain jade from Costa Rica, where

the blue and jewel jade they valued most appears carved in local styles that developed somewhat later (Numbers 220, 221). Another result of the Olmec passage can perhaps be seen in the similarity of concept, though not of outward form, between the Olmec votive axe (Figure 7), the celt-shaped Mezcala figures of Guerrero (Number 79), and the axe-god pendants of Costa Rica (Number 222). Jade carving, probably introduced by coastal trade through the Nicoya region, grew spectacularly into an independent tradition, with forms all its own. The most elaborate of these are from the Atlantic side, carved seemingly at a time when formerly abundant supplies of jade had run low and goldworking had begun to fill its place, sometimes duplicating its motifs (Numbers 223–226).

The art of goldworking probably reached Central America by the same means as had lapidary techniques, but from the other direction, that is, through prospectors or traders from Colombia seeking gold in the rich deposits of central Panama. Already well advanced in Colombia, Ecuador, and Peru, goldworking appears to have been mastered in Central America at approximately the same time as the technique of polychrome pottery, by the beginning of the sixth century A.D. The earliest datable trade object is a gold claw-shaped pendant from Coclé that found

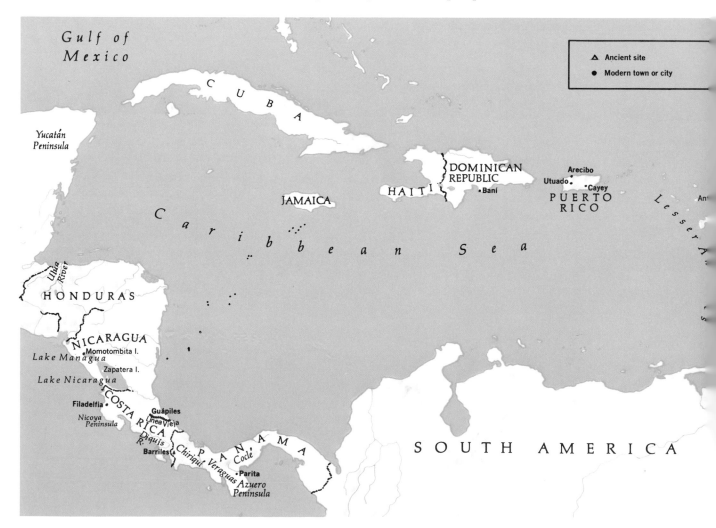

its way into a Maya offering of A.D. 500 or earlier (D. M. Pendergast, "Tumbaga Object from the Early Classic Period, Found at Altun Ha, British Honduras [Belize]," *Science* 168, 1970, pp. 116–118). Such finds are rare, since the Maya had little interest in the new material that was being worked so magnificently by their southern neighbors. Almost the only basis for dating Central American gold is the series of rich tombs found at Coclé and recorded in detail so that their pottery can be tied to sequences found in other excavations (Olga Linares de Sapir, *Cultural Chronology of the Gulf of Chiriquí, Panama*, Smithsonian Contributions to Anthropology 8, Washington, 1968).

The island chain of the Antilles, also called the West Indies as a result of Columbus's confusion, comprises a geographical part of Middle America, although its pre-Columbian culture was quite distinct. The Arawaks were the dominant group of Indians inhabiting the Greater Antilles when Columbus landed. Their close linguistic relatives were scattered throughout much of Venezuela and the Amazon basin of South America, and the style of their pottery reflects this South American origin (Figure 32).

Like the tribes of northwestern South America and lower Central America, the Arawaks were ruled by chiefs, known as *caciques*, a name that was subsequently applied by the Spaniards to leaders throughout Indian America. The chiefs and the noble class possessed beautifully decorated objects that were symbols of their high status (Number 239). Since the Arawaks apparently lacked a corps of priests, shamans assisted in communicating with the spirit world through idols, known as *zemís*. The "temples" reported by the early observers were probably storage houses for the chief's idols. Zemís, also kept in the homes of the common people, were made in various materials and shapes. Some were geometric forms, others were arrestingly shaped objects from nature, and still others were zoomorphic or anthropomorphic effigies (Numbers 244, 245).

The most impressive art produced by the Arawaks dates from the last period of their culture (called phase IV) in Puerto Rico and Hispaniola, especially the part that is presently the Dominican Republic. The high ceremonial culture of this period is often called *Taíno*. The Arawaks of Jamaica, the eastern two-thirds of Cuba, and the Bahamas shared only part of this high culture. A preagricultural people known as the Ciboney, probably the descendants of the original population of the Antilles, lived in refuge areas in western Cuba and southwestern Haiti, after having

FIGURE 32

Effigy jar of a man

Taíno pottery consists largely of unpainted bowls and jars decorated with low relief, incising, and small modeled human and animal ornaments; effigy vessels are rare, and this figure is perhaps the finest known. Discovered in 1916, it was standing on an altar inside a cave near Andrés, Dominican Republic. Height: 16 in. (40.5 cm.). A.D. 1000–1493. Museum of the American Indian, Heye Foundation, 5/3753.

been displaced by Arawaks. The Arawaks had settled all of the islands by A.D. 1000, following a migration out of South America over the course of two millennia. They in turn were pushed out or killed in the Lesser Antilles by the warlike, cannibalistic Caribs. Only the Arawak women were spared, continuing their arts and speech until even the Carib men spoke Arawak. The Caribs were terrorizing the coasts of the Greater Antilles when Columbus arrived, and even maintained their independence from the Spaniards for two hundred years, while the more submissive, peaceful Arawaks were exterminated by the rigors of slavery and previously unknown diseases from Europe.

Even though most of the peoples and cultural traits must have passed from Venezuela to Trinidad and then up the Lesser Antilles to the large islands, some direct contact with Central America may have taken place from time to time. Ricardo E. Alegría hypothesizes, from similarities of smooth stone tools, that some of the earliest, preagricultural settlers in the Greater Antilles may have come from a Central American culture like that of Monagrillo, Panama. The extensive chain of small cays and shallow banks that extends south of Jamaica to the coast off Nicaragua could have provided the stepping-stones by which boatloads of fishermen found their way across some 400 miles of uncharted waters. The similar style of some Costa Rican mace heads, with rounded carving, circular depressions for eyes, and wide oval mouths, and the Puerto Rican three-cornered stones (Number 245) tends to indicate a common aesthetic standard. Some Costa Rican metates and a Nicaraguan stone figure found in the Greater Antilles attest to actual trade (Irving Rouse, "Mesoamerica and the Eastern Caribbean Area," *Handbook of Middle American Indians*, ed. Robert Wauchope, IV, Austin, 1966, p. 237).

The distance between the western end of Cuba and the Caribbean coast of Yucatán is only 120 miles, but few contacts took place, perhaps because the strong current that becomes the Gulf Stream flows through the Yucatán Channel, making navigation difficult. A Maya ritual book records that a war canoe of cannibals, presumably Caribs, reached the Yucatán in the fourteenth century. A significant cultural trait that apparently moved in the opposite direction is the ritual ball game of Middle America. Although many details differ, the Arawaks also played with a rubber ball on a rectangular court surrounded by stone slabs (Figure 33). Oval

FIGURE 33

Ceremonial plaza at Utuado, Puerto Rico

High in the central mountains of the island is a group of at least eleven enclosures, both rectangular and unusual circular ones, bounded by vertical stones that occasionally have an incised figure engraved on the surface facing the smooth plaza. In Arawak villages this type of enclosure was used as a ball court on ceremonial occasions. Since Utuado has so many courts, and no evidence of a large surrounding village, Ricardo E. Alegría has proposed that it was a religious center visited on pilgrimages (*El centro ceremonial indígena de Utuado*, San Juan, n.d., p. 11). The mountain looming behind is known as the Zemí; this Arawak term was applied to deities and sacred objects in general, and especially to the mountain-shaped three-cornered stones (Numbers 244, 245).

240

forms commonly called "collar stones" (Number 241) have been shown by Gordon Ekholm to be translations into stone of heavy belts, of wood or some other perishable material, lashed together around the waist of a ballplayer ("Puerto Rican Stone 'Collars' as Ball-game Belts," in S. K. Lothrop and others, *Essays in Pre-Columbian Art and Archaeology*, Cambridge, Massachusetts, 1961, pp. 356–371). Several other curious stone shapes (Numbers 242, 243) may have been parts of such belts, attached to perishable parts by fibers tied to the narrow extensions in back or to the sides. The three-cornered stones (Numbers 244, 245) also may be somehow related to the ball game, since they are at times discovered near ball courts; however, they were more likely abstract ceremonial forms, derived from similar but smaller undecorated objects made of shell, found in the Lesser Antilles. Both echo the profiles of those small, mountainous islands toward which the early adventurers and settlers sailed.

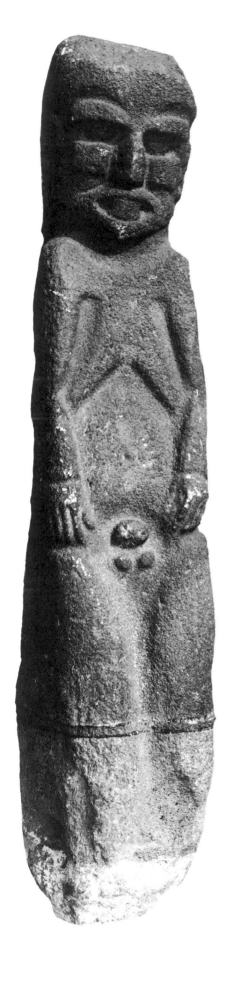
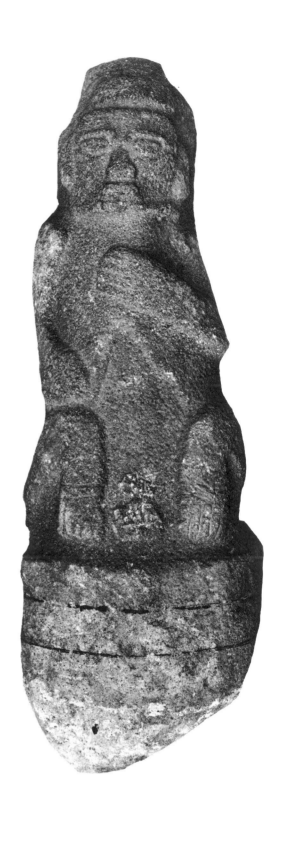

204 Columnar figure

Dark gray basalt
Height: 78 in. (1.98 m.)
Momotombita Island, Lake Managua, Nicaragua
Period VI, 800–1500
Smithsonian Institution, Washington, D.C., 92849

When E. G. Squier reached Momotombita Island in 1850, many of the stone figures had already been broken or carried away, but he was told there had originally been about fifty, set around an ancient plaza (*Nicaragua; its People, Scenery, Monuments, Resources, Condition, and Proposed Canal*, New York, 1860, pp. 295–298). This figure, one of the few remaining undamaged, presented a special challenge to Squier and his porters; it was so large and heavy that a party acting for The British Museum had been forced to abandon it partway to the lakeshore.

205 Seated figure

Gray basalt
Height: 59 in. (1.50 m.)
Zapatera Island, Lake Nicaragua, Nicaragua
Period VI, 800–1500
Smithsonian Institution, Washington, D.C., 92852

The "alter ego" motif, represented in many ways since Olmec times, appears often in Nicaraguan sculpture. Here it takes a form that can be regarded either as an animal, probably the jaguar, clinging to the back of the man and enclosing his head in its mouth, or as a jaguar helmet with the animal's body draped over the shoulders of the man who wears it. The human is not distinguished from the animal by the manner of carving; both are depicted essentially in low relief. (Figure 31 is a rendering of this "idol" as it appeared at the site.)

206 Standing figure

Gray basalt
Height: 50¾ in. (1.29 m.)
Línea Vieja, eastern Costa Rica
Period VI, 800–1500
Mrs. Jorge Hine, Key Biscayne, Florida

The Línea Vieja region is traversed by the old railroad line that runs from Guápiles at the northern foot of Irazú volcano southeastward to the port of Limón, passing many ancient sites in the coastal plain where quantities of gold ornaments and sculptures of this style have been collected. They also come from the Reventazón Valley, south of the volcano, and a find at Retes on its slopes also contained wooden objects that yielded a radiocarbon date of A.D. 960 (Doris Stone, *Introduction to the Archaeology of Costa Rica*, San José, Costa Rica, 1958, p. 19). Though all the figures belong to the same tradition of vigorous but formal sculpture, variations of facial stylization in particular suggest that they were produced over a fairly long time span. In this figure, strongly geometric treatment adds emphasis to the portraitlike quality and regal bearing. The hair is worn partly in a crest and spreads out as it falls behind the shoulders. The ears are pierced, and a pair of square gold repoussé earrings were found beside the figure, which had been purposely buried with a metate, a stone table, and fragments of even larger figures.

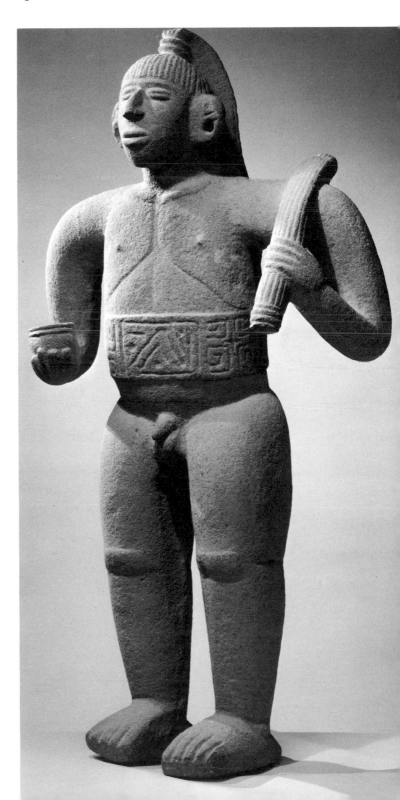

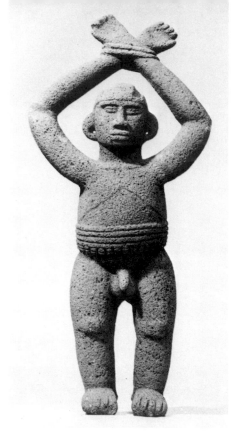

207 Standing prisoner

Gray basalt
Height: 38¼ in. (97.2 cm.)
Línea Vieja, eastern Costa Rica
Period VI, 800–1500
Alfonso Jiménez-Alvarado, San José, Costa Rica

This unusual sculpture, unmistakably a prisoner with his
bound hands raised in the gesture of surrender, is virtual
proof that other male and female figures of the same
type, but less eloquent in pose, represent real persons,
not deities. Though they are thought to have been reign-
ing leaders or their forebears, the portrayal of a defeated
ruler in a sculpture of the highest quality suggests that it
and certain others may commemorate conquests, as do
many Zapotec and Maya reliefs.

208 Double figure

Basalt
Height: 96 in. (2.44 m.)
Barriles, Chiriquí, Panama
Aguas Buenas phase, A.D. 300–500
Museo Nacional de Panamá

More than a dozen figures of this style have been un-
earthed at Barriles, all of them intentionally broken, with
the aid of chisels, and the pieces buried. The character of
the sculpture, with its emphasis on cylindrical forms and
openwork, as well as the trophy heads carried in the
hands of the man on top, relates it to the sculptures of
eastern Costa Rica (Numbers 206, 207), but the pottery

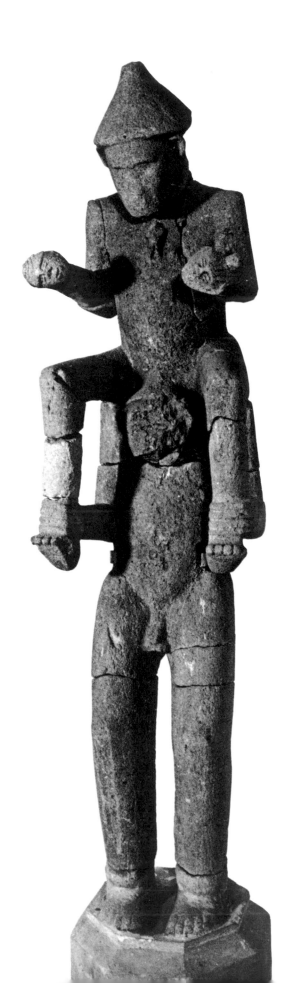

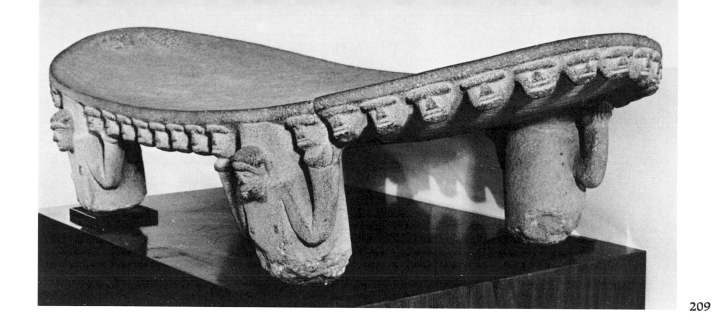

found at Barriles is earlier. Identified as the Aguas Buenas pottery complex, it includes a variety of the incised bichrome ware widespread in Central America and farther north around the end of the Late Preclassic (Wolfgang Haberland, "Las Figuras Líticas de Barriles, en Panamá," *Boletín del Museo Chiricano, Colegio Félix Olivares* 6, 1968, pp. 8–14).

209 Monolithic altar

> Basalt
> Length: 86 in. (2.19 m.)
> Barriles, Chiriquí, Panama
> Aguas Buenas phase, A.D. 300–500
> Museo Nacional de Panamá

Shaped like an enormous grinding stone, this four-legged platform may instead have served as an altar or throne. Other sculptures found nearby, but not with this one, included broken double figures (Number 208), stone spheres, and the barrel-shaped stones that gave the site its name. The border of human heads is common on metates and stone stools or tables from eastern Costa Rica. One type includes both three- and four-legged oval forms that look like miniatures of this giant, but seem to be of later manufacture; examples found in the Reventazón Valley are dated A.D. 850–1400 (Wolfgang Haberland, "Current Research: Central America," *American Antiquity* 34, 1969, p. 358).

210 Ceremonial metate and mano

> Basalt
> Length: metate: 47 in. (1.20 m.); mano: 34 in. (86.5 cm.)
> Santa Lucía Cotzumalhuapa, Guatemala
> Period IV–V, A.D. 250–800
> The University Museum, Philadelphia, NA 11872, 11873

Had it not been found with a correspondingly oversized mano, or muller, this huge metate might, like Number 209, have seemed to be an altar or seat rather than a grinding stone. Its size and weight proclaim that it was not intended for everyday use, but for some ritual that involved grinding. Such ceremonies were evidently important in many parts of Central America and the Antilles, as well as the Pacific area of Guatemala, where metates were part of the mushroom-stone cult (Number 64). Farther south, several types of elaborately shaped and decorated pestles were developed, in addition to a varity of mortars, metates, and concave-topped tables or stools. This gracefully curved form with its three plain legs and distinctive head of a long-tongued serpent or bird-monster is characteristic of Honduras (Doris Stone, *The Archaeology of Central and Southern Honduras*, Papers of the Peabody Museum of Archaeology and Ethnology, Harvard University 49, 1957, figs. 43a, b, d, and 78b).

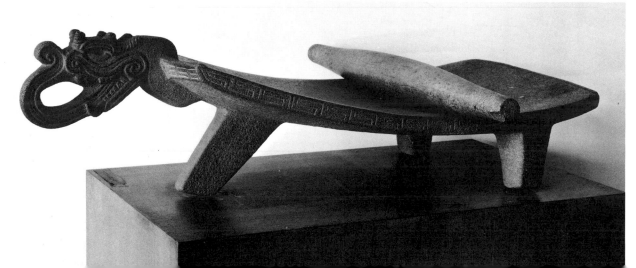

211 Ceremonial metate

Basalt
Height: 12 in. (30.5 cm.)
Guanacaste, Costa Rica
Period III, 300 B.C.–A.D. 300
Miles J. Lourie, New York

Metates like this, the most intricately carved of the Nicoya types, have either a parrot or a jaguar head, but otherwise they are remarkably uniform. Low-relief geometric patterns decorate not only the squared edge and part of the grinding surface but also the entire bottom. When the metate is inverted, the carved and pierced wedge-shaped legs can be seen as small monkey figures

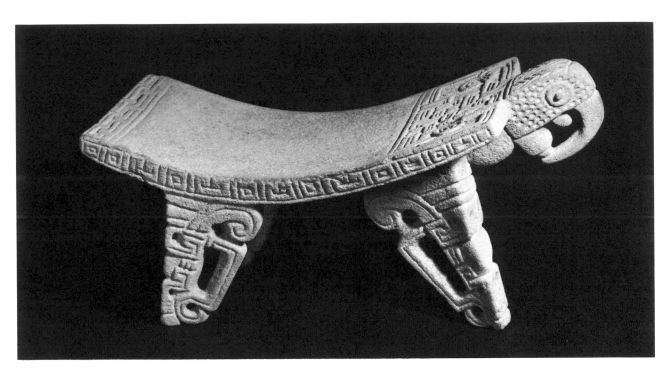

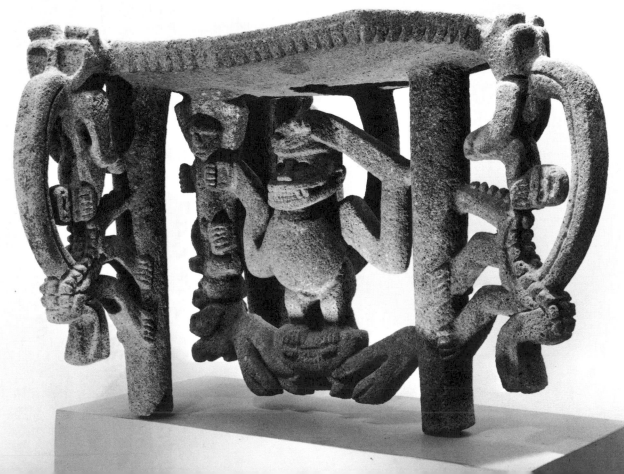

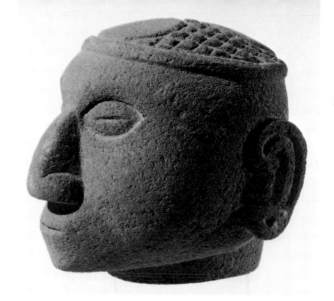

in profile, crouching with paws to chin. Each figure has perforations, formed by drilling and string-sawing, between the body and the bent elbows and knees, and at three points behind the body (C. V. Hartman, *Archaeological Researches on the Pacific Coast of Costa Rica*, Memoirs of the Carnegie Museum 3, Pittsburgh, 1907, pls. IX, XV–XVII).

212 Flying-panel altar

> Volcanic stone
> Height: 24 in. (61 cm.)
> Costa Rica
> Period VI, 800–1500
> Isaac Delgado Museum of Art, New Orleans,
> Ella West Freeman Foundation Fund, 67.34

The three legs of this altar or grinding stone support a veritable catalogue of mythology. To each of them clings a crocodile, on which stands a long-beaked bird holding a human head in its claws. The flying panel, attached to the underside and one leg, is formed of a man-jaguar standing on a large crab, and human and simian figures. Nearly all these motifs appear carved separately in jade (Numbers 220, 221). The serrated border of the grinding plate represents human heads, often carved more fully on metates of this and other eastern types, as on Number 209. Flying-panel altars were also made farther south in Veraguas, Panama, but none approaches this type in virtuosity of design and technique, as demonstrated in the carving of such an intricate composition from a single block of stone.

213 Head

> Basalt
> Height: 6 in. (15 cm.)
> Las Mercedes, Costa Rica
> Period VI, 800–1500
> The Brooklyn Museum, Alfred W. Jenkins Fund,
> 34.5161
> Ex coll. Minor C. Keith

A trophy-head cult of South American origin seems to have demanded an especially prominent place in the arts of eastern Costa Rica (Numbers 208, 209, 212, 220). Life-size stone heads (complete in themselves, not broken from figures) may, like the sculptured prisoner (Number 207) commemorate victories or symbolize conquered tribes. The unrealistic but handsomely carved "caps" and "hair styles" give the impression of being insignia, and do not correspond to stylistic variations. Nevertheless, notable differences in proportions and facial features can be seen by comparing this head with others in the same tradition but probably from different localities or time periods (Numbers 206–209).

214 Mask

> Basalt
> Height: 7½ in. (19 cm.)
> Veraguas, Panama
> Period VI, 800–1500 (?)
> Museo Nacional de Panamá

Though this strikingly stylized mask is considered to belong to the Barriles style of Chiriquí (Numbers 208, 209), the attribution rests mainly on the lack of any comparable examples or any other well-defined style of stone sculpture to which it can be assigned. Precedents for a life-size mask with open eyes and mouth must be sought in further excavations or outside Central America. To the south can be found such examples as the gold repoussé masks of the Calima style of Colombia, and along the coast to the north masks in wood, shell, copper, and stone (Figure 8, Numbers 87, 88, 270, 272), as well as one of different but equally unprecedented style found at Monte Alto, Guatemala (George E. and Gene S. Stuart, *Discovering Man's Past in the Americas*, Washington, 1969, p. 198).

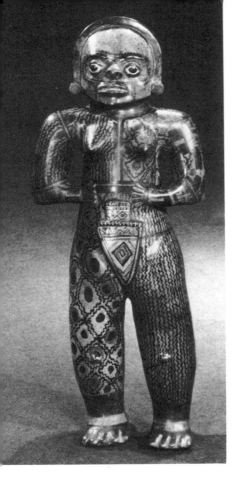

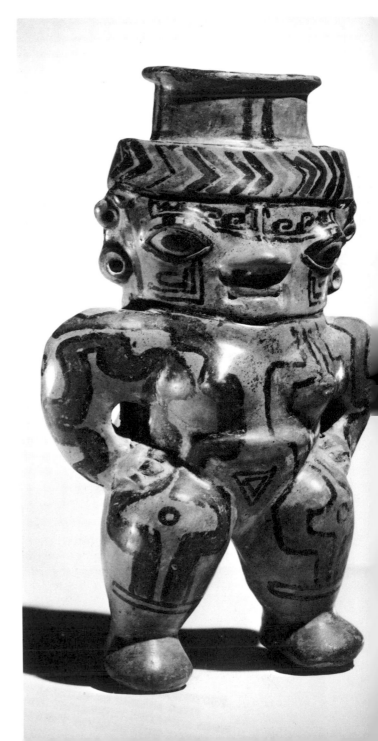

Less realistically proportioned than Number 215, this vigorous figure in the same pose is made up of broad, blocky forms that offer a more ample field for the painted patterns that were becoming increasingly elaborate as the polychrome technique was mastered. Both figures reveal the potter's interest in this technique, calling attention by their own symmetry to the painted decoration, which is asymmetrical in color placement as well as in pattern. On this one a lively four-color effect is produced by reddish orange, black, and gray paint on the light orange clay. Later polychromes show a continuation of this trend toward more elaborate painting and less interest in modeled forms, which became highly stylized and stereotyped.

215 Standing woman

> Polychrome pottery
> Height: 25½ in. (65 cm.)
> Filadelfia, Guanacaste, Costa Rica
> Linear Decorated phase, A.D. 300–500
> Oscar Herrera Mata, San José, Costa Rica

No other ceramic figure so large as this has yet been found in lower Central America. It was discovered, broken, in a burial at the Finca El Viejo that contained a similar figure half its size, but nothing else. The neighborhood of Filadelfia, in the upper Nicoya Peninsula, has long been known for handsomely carved stone metates, club heads, and jades (like Numbers 211, 219, 222) that were contemporaneous with this extraordinary figure or somewhat earlier, and for full polychrome ceramics that were developed later. Imported Early Classic Maya jades and the remains of pyrite mirrors have also been found there, carried southward in the thriving coastal trade that played so large a part in the prosperity and advancement of the Nicoya region. (See Color Illustration.)

216 Effigy jar

> Polychrome pottery
> Height: 9 in. (22.7 cm.)
> Nicoya Peninsula, Costa Rica
> Period V, Early Polychrome phase, A.D. 500–800
> Field Museum of Natural History, Chicago, 6433
> Ex coll. Raymond Wielgus

217 Vase with animal handles

Marble
Height: 10 in. (25.4 cm.)
Ulúa Valley, Honduras
Mayoid style, tenth century A.D.
The University Museum, Philadelphia, NA 5526

The beautifully carved marble vessels of the Ulúa Valley represent a curiously brief flash of artistic inspiration. Few in number and stylistically uniform, they were made only in a small area for a short time and seem to have no direct antecedents in any known tradition of carving or ceramics. The characteristic form is this cylinder with lug handles, though most examples are less elegantly shaped. The same basic form appears in Honduran Mayoid vases, in a few incised vessels from the Bay Islands that seem to imitate the marble ones, and also, in a heavy way, in certain stone mortars from the northern part of the country. None of these, however, offers any real precedent for the intricate low-relief scrolls and masks, or the virtuosity of technique.

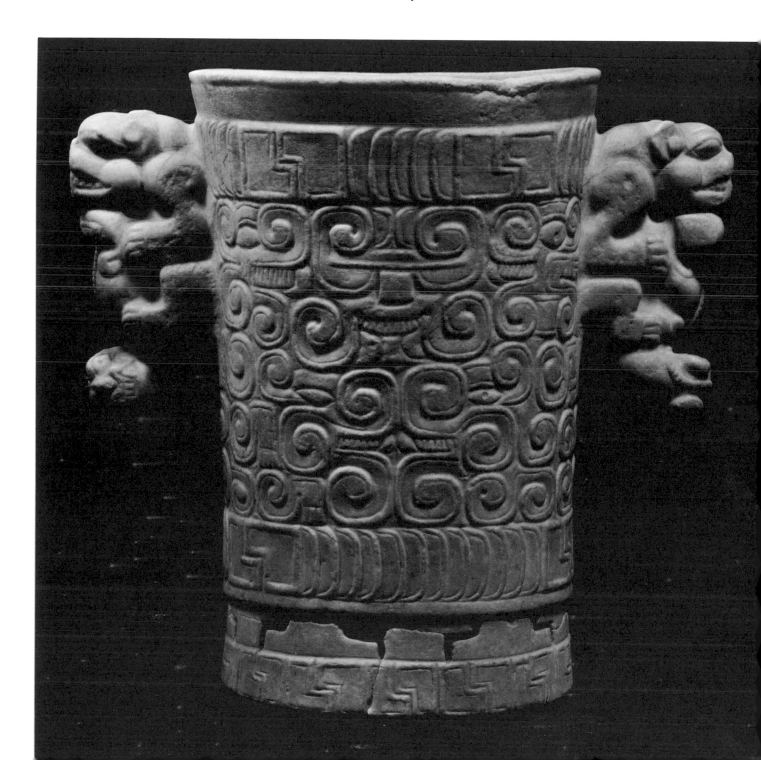

218 Seated figure

Variegated blue, green, and brown steatite
Height: 8⅜ in (21.3 cm.)
Chalchuapa, El Salvador
Protoclassic, 100 B.C.–A.D. 250
Museum of the American Indian, Heye Foundation,
 New York, 24/2082

The Pacific highland region of El Salvador, though far from the center of the Preclassic world, was decidedly part of it; the Chalchuapa district is yielding evidence of prosperous occupation dating back to Olmec times, and the importance of this proud personage can scarcely be doubted. Descended seemingly from the serpent-protected leader portrayed at La Venta (Number 33), he too wears as a helmet the head of a great serpent, its body undulating down his back and ending in six rattles. Emblematic twin snakes that wrap their tails symmetrically around his ankles are depicted as carefully as the bands knotted about the arms and legs. Said to have been found around 1900, the figure is shaped from a local stone still used for ornamental carvings, and was originally enriched by inlays (in all the eyes, and probably forming the upper and lower teeth of the serpent headdress) as well as by attached ear and nose ornaments.

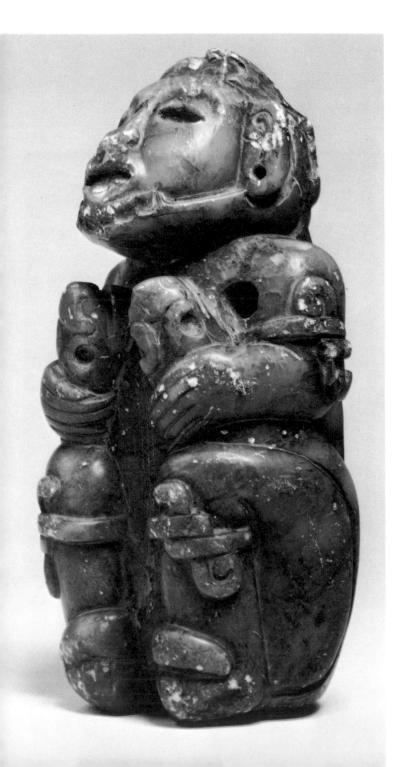
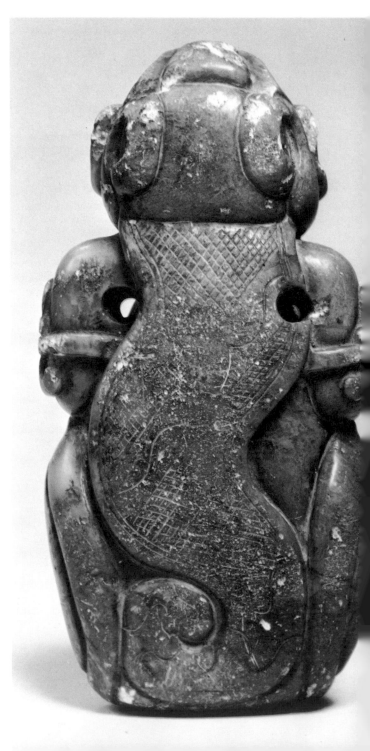

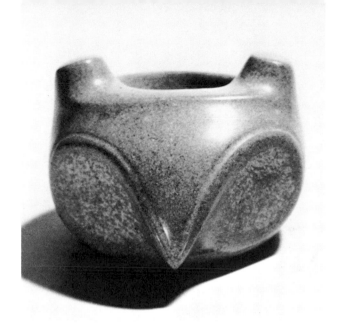

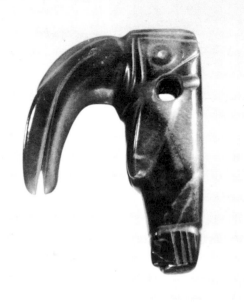

219 Owl mace head

Diameter: 2¾ in. (7 cm.)
Greenstone
Costa Rica
Probably Period III, 300 B.C.–A.D. 300
Alfonso Jiménez-Alvarado, San José, Costa Rica

A distinctive early Nicoyan art form was the carving of emblematic mace heads. Relatively small and beautifully made in a variety of handsome minerals, they can almost be considered lapidary work. They represent, however, a tradition of craftsmanship separate from that of the lapidaries who carved the jade and chalcedony ornaments, and separate also, though to a lesser degree, from that of the sculptors who created the elaborate ceremonial metates. The same motifs appear in all three modes, but interpreted quite differently. This is the horned owl seen in countless other mace heads and jade axe-god pendants, but rarely presented with such simple elegance.

220 Long-beaked bird pendant

Deep green jadeite
Height: 2¾ in. (7 cm.)
Guácimo, Costa Rica
Probably Period III–IV, A.D. 1–500
The Museum of Primitive Art, New York, 65.64

Pendants of this kind, common among jades of the Línea Vieja region, are often called "beak birds." In spite of variation in almost every other detail, they are characteristically perforated through the neck to hang with the beak projecting, whatever exaggerated form it may take. These birds are not truly avian; instead of wings this unusually large one has arms bent at the elbow with the hands clasped on the chest, and at its feet is a human head, as in Number 212. (See Color Illustration.)

221 Crocodile bead

Greenish blue jadeite
Length: 3⅝ in. (9.1 cm.)
Jocopilas, El Quiché, Guatemala
Probably Period III–IV, A.D. 1–500
Anonymous loan

Though found in highland Guatemala, this ornament was carved in eastern Costa Rica, possibly before the time when the Maya themselves took up jade working. The evenly translucent bluish jade is unlike any ever available to the Maya, and the ornament is drilled in a distinctively Costa Rican fashion. Though basically a tubular bead, it has a second, intersecting perforation that passes through the neck of the crocodile. Plain tubular beads with this peculiar cross-drilling (if they were indeed used as beads), may be either round or flattened, but they were rarely carved, as here, into an effigy form.

221

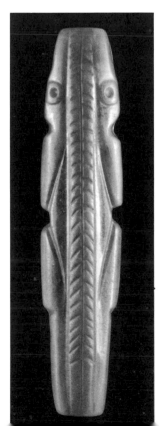

222 Axe-god pendant

Light buff green jadeite
Height: 7 in. (17.8 cm.)
Nicoya, Guanacaste, Costa Rica
Probably Period III, 300 B.C.–A.D. 300
Museum of the American Indian, Heye Foundation,
New York, 24/809

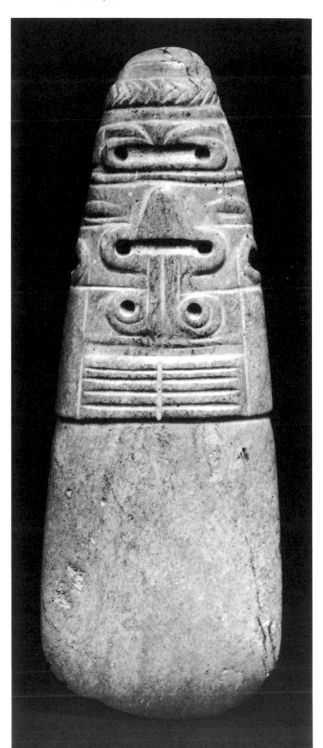

223

Ordinary beads and ear ornaments are not common in Costa Rica, where, instead, axe-gods and other celt-shaped pendants are more numerous than any other form. Though they resemble the Olmec votive axe (Figure 7) and are almost certainly based on the same concept, they are personal ornaments rather than cult objects, and lack the jaguar traits that pervade Olmec imagery. Instead, the figural aspect represents or combines man and bird, sometimes with the forked tongue of the serpent added. This axe-god, shaped like a celt sawed in half and carved in shallow relief, has many of the same characteristics as a smaller serpent-tongued example found in a burial at Las Huacas, Nicoya, lying beside a stone metate with a datable clay whistle of Zoned Bichrome type (C. V. Hartman, *Archaeological Researches on the Pacific Coast of Costa Rica*, Memoirs of the Carnegie Museum 3, Pittsburgh, 1907, figs. 15–17).

223 Crocodile pendant

Serpentine
Length: 3¼ in. (8.1 cm.)
Sitio Conte, Coclé, Panama
Late Coclé style, 800–1200
Peabody Museum of Archaeology and Ethnology,
Harvard University, Cambridge, Massachusetts,
C/10687

S. K. Lothrop has described this as "one of the finest stone carvings from the Sitio Conte" (*Coclé, An Archaeological Study of Central Panama*, Memoirs of the Peabody Museum of Archaeology and Ethnology, Harvard University 7, 1937, p. 169, fig. 156b, pl. IIc). While curly-tailed animal pendants in carved agate and cast gold (Numbers 224–226) form a large and characteristic group in Coclé art, this crocodile recalls the jade, serpentine, and other greenstone examples found farther north in Costa Rica (E. K. Easby, *Pre-Columbian Jade from Costa Rica*, New York, 1968, figs. 45, 58, 67).

224 Curly-tailed animal pendant

Gold
Length: 2¼ in. (5.8 cm.)
Provenance unknown
Late Coclé style, 800–1200
Mr. and Mrs. Jan Mitchell, New York

This pert little creature is one of the most highly stylized versions of a type found in numbers at Coclé. Few of them can be identified beyond question with any known species: some, though four-legged, have birds' heads, while the greenstone example appears to be a crocodile (Number 223) and the two other gold animals are unquestionably jaguars (Numbers 225, 226). Despite this variety of zoological traits, each animal has a prominent curled tail that gives it the overall shape of a projecting hook. The suspension holes or loops are sometimes in the forelegs, sometimes in the rear; why certain of these animal pendants were meant to be worn right side up and others upside down is one of the minor enigmas of pre-Columbian archaeology. Like most gold examples, this one was cast by the lost-wax process, over a core of fine-textured clay that remains in place inside the front and back parts of the body.

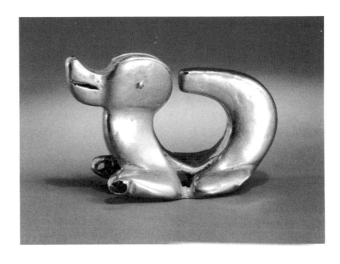

225 Jaguar pendant

Gold
Length: 3¼ in. (8.1 cm.)
Diquís Delta, Costa Rica (?)
Veraguas-Chiriquí-Diquís style, 800–1520
Mr. and Mrs. Jan Mitchell, New York

As André Emmerich has noted, the Veraguas-Chiriquí-Diquís region "produced gold ornaments of both surprisingly high and surprisingly crude workmanship" (*Sweat of the Sun and Tears of the Moon*, Seattle, 1965, p. 102). In this lost-wax casting, a high order of realistic modeling is marred to some extent by minor casting defects in the suspension ring on the right rear paw, in the left front leg, and in the head where cracks in the mold have been reproduced in gold as tiny flanges on the object. The pendant is not strictly speaking a hollow casting, since the craftsman made it with the underside open.

226 Miniature jaguar pendant

Gold
Length: ⅝ in. (1.7 cm.)
Diquís Delta, Costa Rica (?)
Veraguas-Chiriquí-Diquís style, 800–1520
Jointly owned by Mrs. Harold L. Bache and
 The Metropolitan Museum of Art, 66.196.7

To cast a piece of this size by the lost-wax method without resort to centrifugal casting (which was unknown in pre-Columbian times) would tax the ingenuity of any craftsman. It required the most careful temperature control, not only of the molten metal but of the mold itself, to assure that the metal would fill the mold completely before it began to solidify. This meant maintaining the small mold at red heat before, during, and after the pouring of the molten metal.

225 226

227

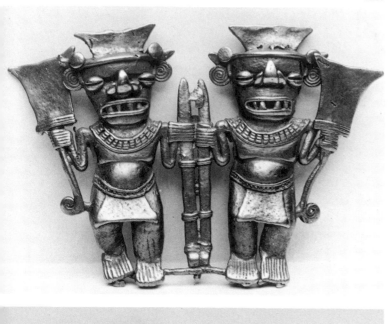

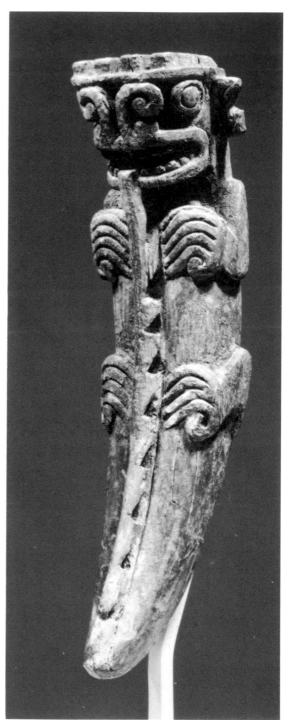

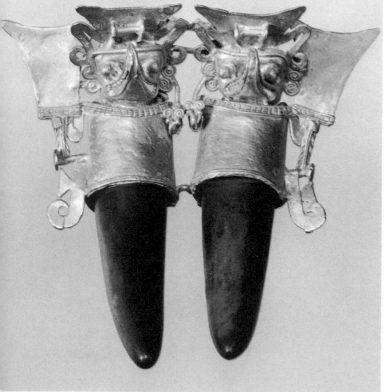

228

229

227 Twin-warrior pendant

Gold
Width: 4⅛ in. (10.5 cm.)
Chiriquí, Panama
Late Coclé style, 800–1200
The Metropolitan Museum of Art,
 gift of Meredith Howland, 04.34.8

These two warriors holding staffs and paddle clubs are anthropomorphic representations of the leaf-nosed bat god with the characteristic turned-up snout of that tropical animal. They were cast by the lost-wax process in a single casting without the use of solder. Representations of pairs or twins are common in goldwork from the Sinú region of Colombia as well as in Panamanian styles. (G. G. MacCurdy, *A Study of Chiriquian Antiquities*, Memoirs of the Connecticut Academy of Arts and Sciences 3, 1911, pp. 211–212, pl. XLIXg; S. K. Lothrop, *Coclé, An Archaeological Study of Central Panama*, Memoirs of the Peabody Museum of Archaeology and Ethnology, Harvard University 7, 1937, fig. 9j; D. T. Easby, Jr., "Orfebrería y orfebres precolombinos," *Anales del Instituto de Arte Americano* 9, Buenos Aires, 1956, pp. 14–16, fig. 2.)

228 Twin-warrior pendant

Gold and serpentine
Height: 4¼ in. (10.8 cm.)
Parita, Panama
Late Coclé style, 800–1200
Jointly owned by Mrs. Harold L. Bache and
 The Metropolitan Museum of Art, 66.196.32

Like Number 227, this pendant appears to represent two warriors with the attributes of the leaf-nosed bat god, each holding a paddle club. The two figures seem to have been cast separately and then joined by securing the two bars cast on the back of each figure through loops provided on the other. Instead of a body, each has an inset tusk of serpentine (André Emmerich, *Sweat of the Sun and Tears of the Moon*, Seattle, 1965, fig. 122). (See Color Illustration.)

229 Tusk-shaped pendant

Manatee rib bone
Height: 6¼ in. (16 cm.)
Grave 24, Sitio Conte, Coclé, Panama
Beginning of the Late Coclé phase, about A.D. 800
Raymond Wielgus, Chicago

The crocodile image, repeated in endless variation in all the arts of Coclé, is given a partly human aspect in this bone pendant shaped like those carved of whale teeth. This form had special significance in itself, and was often imitated in other materials, unadorned or incorporated in a zoomorphic representation, as it is here and in Numbers 228 and 230. The same "double symbolism" of object and representation appears in the axe-gods of Costa Rica (Number 222). On this crocodile pendant, the long tube that emerges from the mouth, sometimes shown as a snake or a snake's tongue, is pierced by seven triangular perforations, and delicately cut free under the chin, as is the scroll on the snout. An angular suspension hole is drilled in the back. (S. K. Lothrop, *Coclé, An Archaeological Study of Central Panama*, Memoirs of the Peabody Museum of Archaeology and Ethnology, Harvard University 7, 1937, fig. 162c, pp. 168–177; 8, 1942, pp. 196, 199.)

230 Twin-animal pendant

Gold and bone
Height: 3⅞ in. (9.8 cm.)
Azuero Peninsula, Panama (?)
Late Coclé style, 800–1200
Mr. and Mrs. Jan Mitchell, New York

Though related to the twin tusk-bodied pendant (Number 228) this fine piece differs from it greatly in workmanship and concept. These twin figures seem to have been cast as a single piece, rather than separately. Unlike the figures in Number 228, which stand erect and have human traits and accessories, these are shown "on all fours" as animals, with heads turned outward in an unusually lifelike way. Sometimes referred to as "fantastic crocodiles," they are composite creatures of the same mythological species as Number 231, with pointed ears, sweeping serpentine tongues, and upturned snouts, flanked by tightly wound spirals.

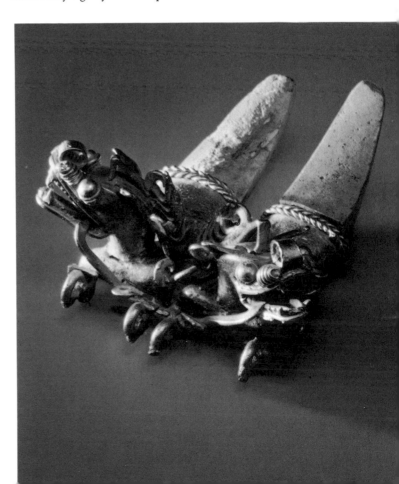

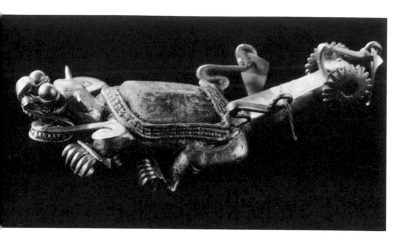

231 Animal pendant

Gold and emerald
Length: 4⅜ in. (11.25 cm.)
Sitio Conte, Coclé, Panama
Late Coclé style, 800–1200
The University Museum, Philadelphia, 40.13.27

Found during the University of Pennsylvania's explorations at the Sitio Conte in 1940, this amazing creature is one of the masterpieces of the pre-Columbian jeweler's art, combining lost-wax casting, delicate soldering, the use of danglers (above the hind legs and at the tip of the gear-wheel tail), and a large rectangular emerald inset. The emerald is unquestionably from the famous Muzo mines in Colombia, which are still being worked. (J. A. Mason, "American Collections, The Ancient Civilizations of Middle America," *University Museum Bulletin* 10, 1943, nos. 1–2, fig. 36; D. T. Easby, Jr., "Orfebrería y orfebres precolombinos," *Anales del Instituto de Arte Americano* 9, Buenos Aires 1956, fig. 8.)

232 Animal-head bell

Gold with greenstone insets
Height: 1¼ in. (3.2 cm.)
Provenance unknown
Late Coclé style, 800–1200
The Metropolitan Museum of Art,
 gift of H. L. Bache Foundation, 69.7.1

A fine example of a hollow lost-wax casting, this entire piece with all the fine details and spirals was cast in a single operation. The tiny gold clapper or pellet was embedded in the clay and charcoal core before the wax model was applied to it. After the bell was cast, the core was picked out carefully through the mouth slit, leaving the clapper inside. Although the inset eyes (probably fuchsite with a soft polish) have the same form as those of Numbers 230 and 231 and the ears and snout are similar, this animal lacks reptilian features and more nearly resembles a jaguar. (See Color Illustration.)

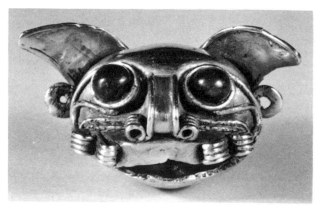

232

233 Shark pendant

Gold
Length: 3¾ in. (9.5 cm.)
Chiriquí, Panama
Veraguas-Chiriquí-Diquís style, 800–1520
The Metropolitan Museum of Art,
 gift of Meredith Howland, 04.34.7

Pendants in the form of sharks are not common, and this example, in excellent condition, is one of the largest and best executed. It is a single-piece lost-wax casting and is said to have been recovered from a tomb in Chiriquí in 1859 (G. G. MacCurdy, *A Study of Chiriquian Antiquities*, Memoirs of the Connecticut Academy of Arts and Sciences 3, 1911, pp. 201–202, fig. 341).

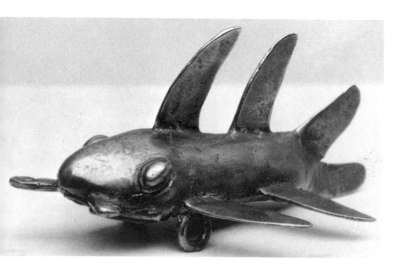

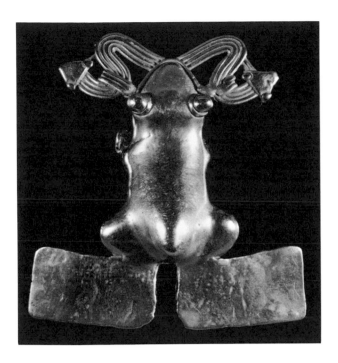

234 Frog pendant

Gold
Length: 3½ in. (8.8 cm.)
Provenance unknown
Veraguas-Chiriquí-Diquís style, 800–1520
The Metropolitan Museum of Art,
 gift of H. L. Bache Foundation, 69.7.4

Frog pendants are one of the commonest forms in Vera-guas goldwork. The bifurcated tongue, ending either in spirals or, as here, in serpents' heads, is both ancient and widespread in the New World from Peru to Mexico, "one of the many deeply ingrained aboriginal symbols which cannot be explained today" (S. K. Lothrop, *Archaeology of Southern Veraguas, Panama,* Memoirs of the Peabody Museum of Archaeology and Ethnology, Harvard University 9, 1950, pp. 64–66). This example was cast by the lost-wax method, after which the rectangular hind feet were stretched by hammering. This concept of large flat rectangular elements on the lower part of pectorals was later adopted by Mixtec goldworkers in Mexico. In addition to giving a broader expanse of glittering metal, these rectangles served a practical purpose: to keep the orna-ment flat against the wearer's chest and prevent it from rotating on its suspension cord (D. T. Easby, Jr., "Fine Metalwork in Pre-Conquest Mexico," in S. K. Lothrop and others, *Essays in Pre-Columbian Art and Archae-ology,* Cambridge, Massachusetts, 1961, p. 36).

235 Eagle pendant

Gold
Height: 4 in. (10.2 cm.)
Provenance unknown
Veraguas-Chiriquí-Diquís style, 800–1520
The Metropolitan Museum of Art,
 gift of H. L. Bache Foundation, 69.7.6

Commonly known as "eagle pendants," Veraguas orna-ments of this type probably represent a variety of birds, including vultures, horned owls, and imaginary creatures with earlike projections in the form of stylized alligator heads (André Emmerich, *Sweat of the Sun and Tears of the Moon,* Seattle, 1965, pp. 104–107, figs. 135, 137–140). Cast initially by the lost-wax method, they are usually finished by hammering the wings and the tail to stretch and thin them.

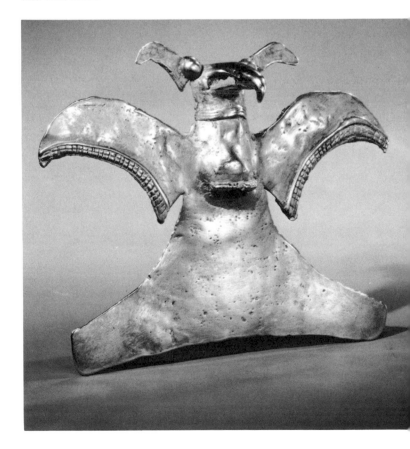

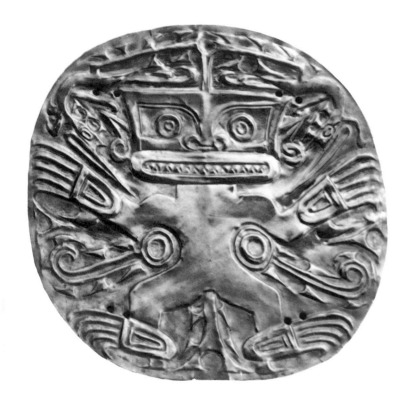

236 Alligator-god plaque

Sheet gold with repoussé decoration
Diameter: 5½ in. (13.9 cm.)
Parita, Panama
Late Coclé style, 800–1200
Milwaukee Public Museum, 53836/19614

237 Alligator-god plaque

Sheet gold with repoussé decoration
Height: 5 in. (12.5 cm.)
Parita, Panama
Late Coclé style, 800–1200
Mr. and Mrs. Jan Mitchell, New York

238 Alligator-god plaque

Sheet gold with repoussé decoration
Diameter: 7⅞ in. (20 cm.)
Sitio Conte, Coclé, Panama
Late Coclé style, 800–1200
The University Museum, Philadelphia, 40.13.3

The familiar term *alligator god* is so well established in the literature that it is too late to correct it; technically it should be *crocodile god*. Alligators do not occur as far south as Panama, where the cayman is actually a crocodile. Repoussé decoration of sheet gold (hammered up or raised from the back with a tracer while the metal is rested on leather, pitch, or some other resilient substance) is one of the oldest metalworking techniques, and is generally believed to have come to Panama from Peru via Colombia. The alligator-god motif, an anthropomorphic representation with a crest, grimacing mouth, and long-clawed hands and feet, is ubiquitous in beautiful Coclé polychrome ceramics and sheet-gold plaques. Three different styles, possibly representing different periods or workshops, are shown in these examples.

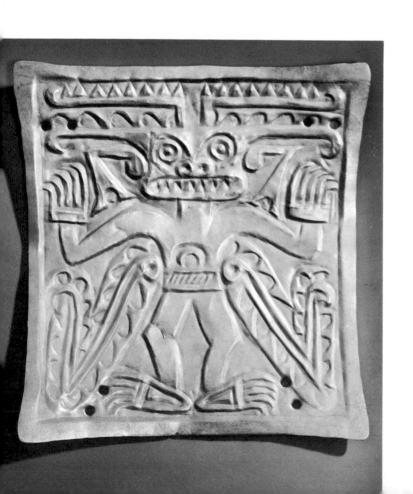

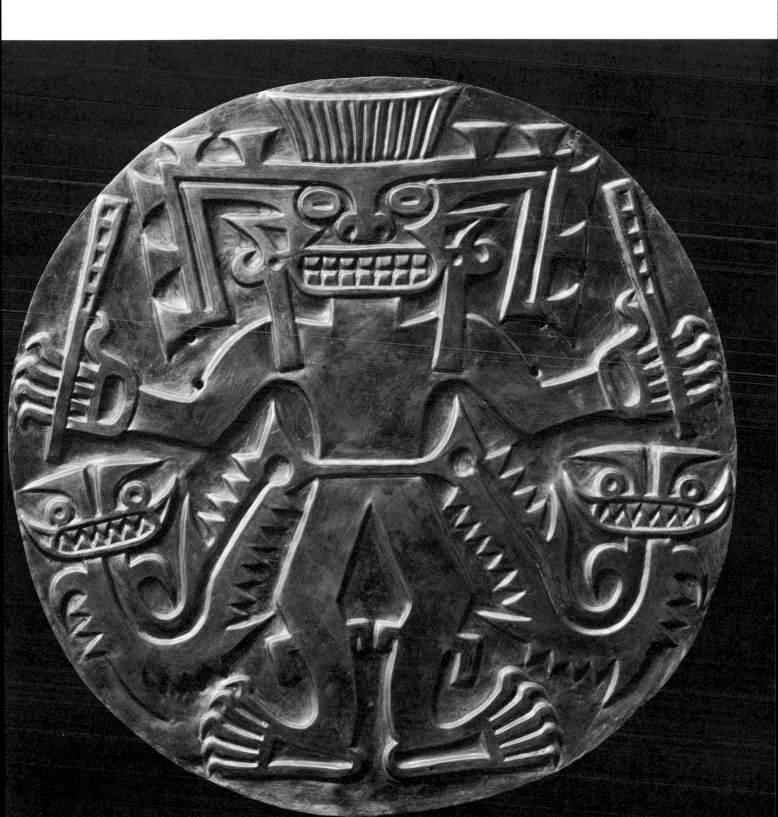

239 Ceremonial stool

Hard dark brown wood with insertions of gold leaf
Length: 17¼ in. (43.8 cm.)
Dominican Republic
Taíno, phase IVb, 1200–1493
The British Museum, London, 1949.Am22.118
Ex coll. W. O. Oldman

Reportedly preserved in a dry cave, this stool (called a *duho* in Arawak) is one of the finest examples known and the only one with gold leaf. The gold was set with an amber-colored resin into the shallow cavities in the eyes, mouth, and epaulets. The placement of the head and shoulders of the effigy in the lower front part of the seat is rare; usually the image is carved in the rear backrest. The final form of the stool was probably suggested by the configuration of the single piece of wood from which it was carved; the guiding principle of Arawak art was to work the material in such a way as to reveal the spirit hidden within it. Duhos, made of both wood and stone, were the property of chiefs, who occupied them on important occasions (H. J. Braunholtz, "The Oldman Collection: Aztec Gong and Ancient Arawak Stool," *The British Museum Quarterly* 16, 1951, p. 55). (See Color Illustration.)

240 Crouching male figure

Guayacán wood (*Lignum vitae*)
Height: 24 in. (51.4 cm.)
Baní, Dominican Republic
Taíno, phase IV, 1200–1493
Dr. and Mrs. Ambrosio Malagón, Mamaroneck, New York

The largest sculptures made by the Arawaks were standing human figures, of which only a small number now exist. As with most of their art, sculptures of this group had a specific function, which required the thin, cantilevered platform above the figure. It does not appear strong enough to have been a ceremonial seat, but may have served as a ritual drum to accompany dances; the position of the figure suggests this. The fierce facial expression was once intensified by shell inlay, set in the mouth and possibly in the eyes (Darío Suro, "Taíno Sculpture," *Américas* 20, November–December 1968, p. 43).

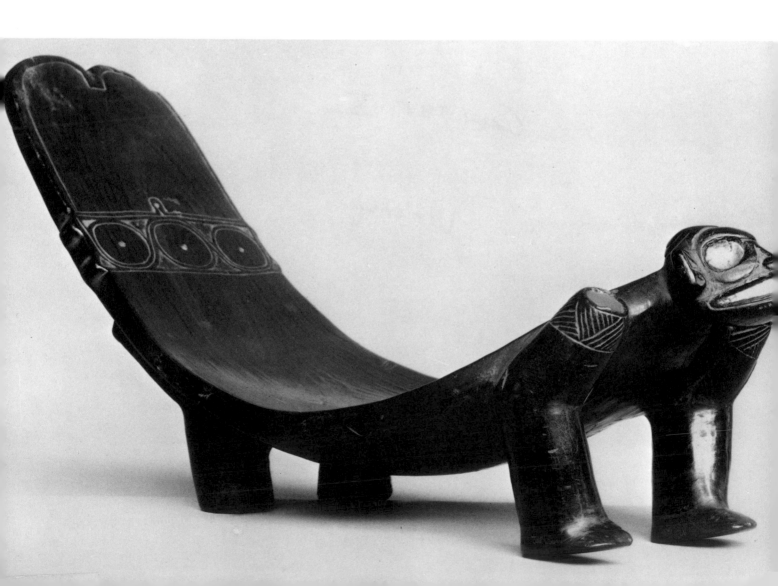

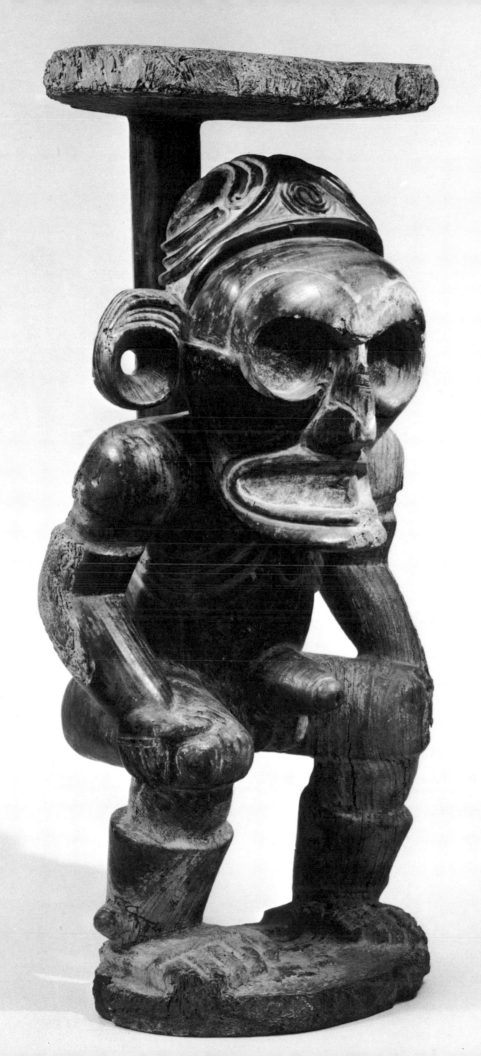

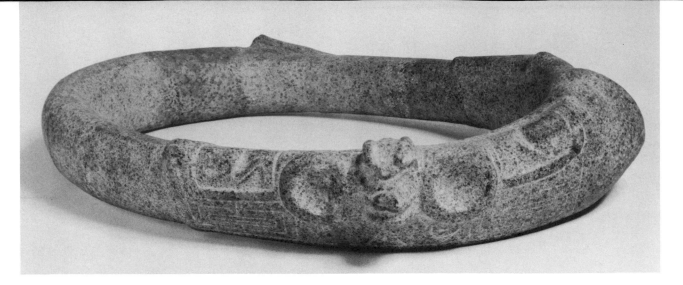

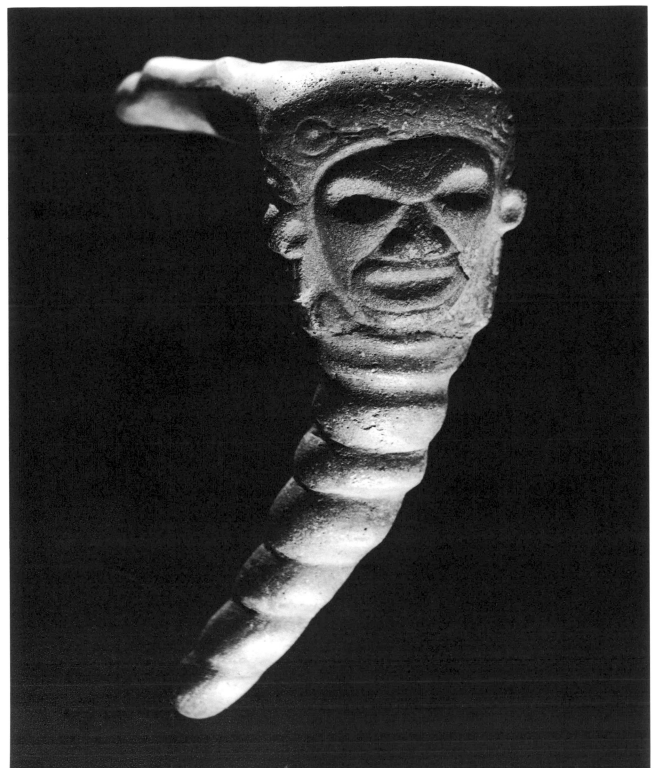

241 Massive belt

Slightly polished speckled black and gray stone
Length: 20½ in. (52.1 cm.); width: 16 in. (40.6 cm.)
Arecibo, Puerto Rico
Taíno, phase IV, A.D. 1000–1494
Museum of the American Indian, Heye Foundation,
3/2005
Ex coll.: Seiyo; J. W. Fewkes

The small animal head, probably of a bat, is flanked by winglike panels of low-relief and incised carving that form a handsome abstract pattern. Such panel patterns, typical of the heavier collar stones, are restricted to one side of the thickened, bluntly pointed end. Projections on the other side follow the wooden prototype, a ball-game belt made from the fork of a sapling, the longer end of which was bent and strapped to the shorter, leaving the overlapping end projecting (J. W. Fewkes, "A Prehistoric Island Area of America," *34th Annual Report of the Bureau of American Ethnology, 1912–13,* Washington, 1922, pp. 95, 118).

242 Elbow stone with human face

Gray stone
Length: 12⅝ in. (32 cm.); depth: 8⅝ in. (22 cm.)
Cayey, Puerto Rico
Taíno, phase IV, A.D. 1000–1494
Museo de Antropología, Historia y Arte, Universidad
de Puerto Rico, Río Piedras
Ex coll. Dr. Montalvo Guenard

Elbow stones served the same purpose as collar stones (Number 241). The two tapered arms, meeting at the angle where the face is carved, were strapped around a ballplayer's waist with perishable material. The bumpy bands of ribbing on the arms provide a rough surface to which such material could be securely tied; other stones have perforations at the ends of the arms for this purpose. Though such stones, or their wooden prototypes, lay horizontally when worn as belts, this face is most impressive when seen vertically, its trapezoidal shape, craterlike eyes, and triangular nose-mouth unit set off by the curving ribbed arms.

243 Tenoned skull

White marble with soft polish
Height: 7¼ in. (18.3 cm.)
Arecibo, Puerto Rico
Taíno, phase IV, A.D. 1000–1494
Museum of the American Indian, Heye Foundation,
New York, 23/6096
Ex coll. López de Azúa

In back of the head, running the entire length and extending below like a neck, is a thick bar with a concave back surface, as if it were meant to fit over a rounded object. The head could thus be tied by the tenon to a collar-stone belt. In this sense, its purpose would be analogous to that of a Veracruz hacha or palma (Chapter 7). The ears of this cadaverous face are indicated by tall triangular hollows. The eyes, circular concavities joined by a groove, recall the conventionalized treatment often seen in Costa Rican lapidary work (Number 222).

244 Three-cornered zemí of prone figure

Polished dark greenstone
Height: 5½ in. (14 cm.); length: 12 in. (30.5 cm.)
Puerto Rico
Taíno, phase IVb, about 1200–1300
Fred Olsen, Guilford, Connecticut
Ex coll. Ceil Stevens

With its deeply carved face on the front projection and its legs pulled up in a frog position on the rear projection, this stone belongs to the "first type" of Jesse W. Fewkes's classification of three-pointed stones ("The Aborigines of Porto Rico and Neighboring Islands," *25th Annual Report of the Bureau of American Ethnology, 1903–04,* Washington, 1907, p. 111). Tricorns, as they are sometimes called, have concave undersides like those on tenoned heads (Number 243), and perhaps were similarly strapped to ball-game belts.

245 Three-cornered head

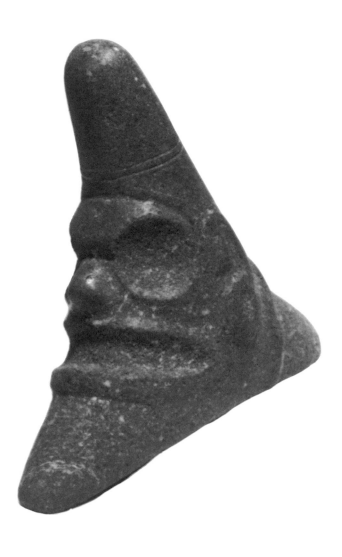

Polished dark gray basalt
Height: 7¼ in. (18.4 cm.); length: 8 in. (20.3 cm.)
Dominican Republic
Taíno, phase IV, A.D. 1000–1493
Museum of the American Indian, Heye Foundation, New York, 19/917
Ex coll.: Edward Hall; J. W. Fewkes

The placement of the face, carved in the angle between the front and the peak, provides the basis for classifying this stone in Fewkes's "second type." The incised curved triangle below the double band around the forehead suggests hair above the temple. The abstract ears are shaped like numeral sixes. A raised band circling the base of the rear projection may have served to hold a cord in place when the piece was tied to a convex surface (J. W. Fewkes, "The Aborigines of Porto Rico and Neighboring Islands," *25th Annual Report of the Bureau of American Ethnology, 1903–04,* Washington, 1907, p. 122, see side view).

246 Bent human figure

Cream-colored marble with incrustations
Height: 11⅜ in. (29 cm.); depth: 3⅜ in. (8.5 cm.)
Puerto Rico
Arawak, perhaps phase IIIb, A.D. 700–1000
Museo de Antropología, Historia y Arte, Universidad
 de Puerto Rico, Río Piedras
Ex coll. Dr. Montalvo Guenard

This unusual form dramatizes the ability and inclination
of Arawak artists to create human and animal forms
from irregular pieces of material. A striking natural shape
would be identified as possessing an important spirit, and
an artist would transform it into a zemí by carving a few
features to bring out the effect already noticed. In this
case, the marble was carved into a shallow oval bowl
about 1½ inches thick, with raised ends. Lines indicating
ribs, collarbones, and armbands were lightly incised on
the surface. The hole on the right hip may have been
added later, to permit the figure to be hung.

247 Skull of a dog deity

Strombus pugilis shell
Length: 2⅞ in. (7.3 cm.)
Antigua, British West Indies
Arawak, phase IIIa, about A.D. 500
Fred Olsen, Guilford, Connecticut

Shell was always a favorite medium for Antillean artists
because of its abundance, natural beauty, and suggestive
shapes. This delicate object, originally covered with black
paint, represents the deity Opiyel Guabirán, the keeper
of the souls of the immediately departed. His canine skull
is rendered with a beautiful headband composed of raised
planes, incised lines, and pits, which form a design fre-
quently seen in pottery from the Antilles (Figure 32).

FIGURE 34

Colossal Atlanteans at Tula

These four large effigies of warriors on top of the pyramid of the Temple of Quetzalcóatl served as columns to support the sanctuary's roof, which was apparently made of perishable material. They each carry a spear-thrower on the far side, for their military duties, and an incense bag on the visible side, for their ritual duties. Behind them are piers, also roof supports, with low-relief figures of warriors carved on all four sides. In front are remains of the inverted-serpent columns that once flanked the entrance to the sanctuary, as similar columns did at Chichén Itzá (Figure 36).

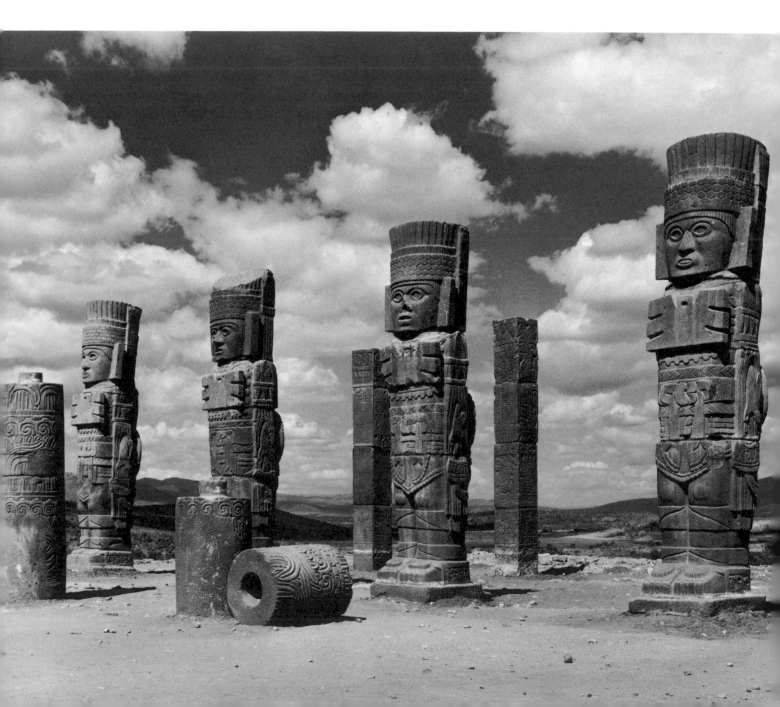

Toltec Imperial Art
and its Heirs

After the burning and subsequent abandonment of Teotihuacán, the Valley of Mexico entered a "Dark Age" in the eighth century that lasted about two hundred years, during which time artistic production was limited to roughly made, carelessly decorated ceramics. Toward the end of this period, according to legend, Náhuatl-speaking foreigners related to nomadic tribes of northern Mexico and the American Southwest founded a city on the northern fringe of Mesoamerica. This city, traditionally established in A.D. 856, was named Tollan, and is today the town of Tula, northwest of Mexico City. Only two large pyramids are located there. One is unexcavated, the other is the famed Temple of Quetzalcóatl, upon the platform of which stand the huge stone Atlanteans that once supported the roof (Figure 34).

Because Tula is so small and unimpressive, archaeologists for many years were unable to believe that it was the famed Tollan, spoken of in many Indian legends as the seat of a mighty empire. Rather, they believed that Teotihuacán must have once been called Tollan, since its ruins were so large and displayed such skill in construction. Tula not only had too small a ceremonial center, its art hardly seemed worthy of the fountainhead of a cosmopolitan empire. Yet from here the Toltecs, as the rulers of Tula were known, came to dominate the rest of Mesoamerica through force of arms, aided by the new employment of weapons such as the bow and arrow and the spear-thrower. According to Jacques Soustelle, the French ethnohistorian, the Toltecs brought with them from the desert the conviction of their new religion, centered on astral and war deities rather than on the gods of the earth and vegetation that dominated Classic religion in Mesoamerica. The new theology was grafted onto the older hierarchy by assigning celestial or military aspects to nature deities.

The new spirit, evinced in Toltec art by the dominance of warrior motifs and images of death, conveys a harshness not known before. The artistic forms used to render these themes express this ascetic harshness. Instead of the rounded, curved forms of the Late Classic, Toltec art displays sharpness and angularity. In relief carvings, instead of the modulation of surfaces and variation in depth

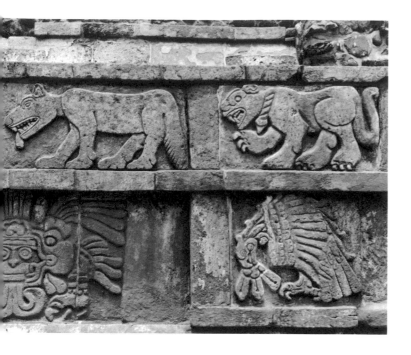

FIGURE 35

Detail of the Temple of Quetzalcóatl at Tula

Four rows of reliefs, in which four motifs are constantly repeated, extend around the base of the pyramid of the temple (for a color reconstruction see Ignacio Marquina, *Arquitectura Prehispánica*, Mexico City, 1951, p. 153). In this view of a portion of the rear side, the image of Quetzalcóatl is seen at the lower left, his face staring out from between the jaws of a feathered monster. At the lower right is an eagle eating hearts (see Number 253), a motif that is repeated twice between each sunken panel of Quetzalcóatl. On the upper row a coyote (left) and a jaguar (right) alternate in a continuous band.

sought during the Late Classic, Toltec images have abruptly raised outlines, creating the impression of only two planes, that of the object and that of the background (Number 253). Motifs are repeated mechanically to cover vast areas of wall surface, an example being the rows of animals on the back of the Temple of Quetzalcóatl (Figure 35). Most of the major art at Tula, such as the Atlantean columns and the rows of relief slabs, served an architectural role. These formal features remind one of the character of Teotihuacán art, whose architectural sculpture is angular, flat, and repetitive. Yet the differences between the two are clear also. Teotihuacán images are abstracted into a few basic shapes, conforming to the rectangular architecture of which they were a part; Toltec forms, while flattened, retain considerable realism in their details. Teotihuacán surfaces are smoothly finished; Toltec forms are rough, thanks in part to the porous stone that the artists preferred.

The conflict and changes that characterize the Postclassic period and differentiate it from the Classic have been dramatized in the most famous legend of Mesoamerica, that of the priest-king of Tula, Quetzalcóatl. To distinguish the historical personage from the feathered-serpent deity, after which the ruler was named, the Toltecs prefixed his birth date, Ce Acatl, meaning "One Reed," to his name, following the common practice of Mesoamerican peoples, for whom one's birth date had cosmic significance. Quetzalcóatl stood for the Classic virtues and was revered as a culture hero who introduced many arts, such as metal casting, featherwork, precious stone carving, and painting. He struggled for supremacy with a militant faction at Tula and was eventually driven out of the city, whence he fled to the "Eastern Sea"—the Gulf of Mexico—in A.D. 987. This date corresponds very closely with the appearance of Toltec art motifs in the Yucatán Peninsula, which can be

268

reached by sailing eastward across the Gulf of Mexico. However, the final fate of Quetzalcóatl was transformed into poetic myth (after he immolated himself, his heart became Venus).

Most of the techniques that Quetzalcóatl is said to have introduced at Tula, with the exception of metalwork, were of course known before the Toltec era, although there may have been certain innovations in each of them around that time. For instance, mosaic patterns in feathers are not known to have been made before Toltec times, and the use of turquoise for inlay became prominent in the Postclassic. In Aztec documents, "painting" often refers to pictorial writing in codices, the first preserved Mexican examples of which are Postclassic. However, feather designs and painted books were executed in perishable materials so that we know of their existence only indirectly, through carvings and murals.

Curiously, metal objects have not yet been found at Tula. Rather, the technique of metal casting appears to have spread into Mesoamerica from lower Central America, where the beautiful goldwork discussed in Chapter 10 had been made since the early Christian era. Western Mexico undoubtedly received metalworking techniques directly from South America even before the Postclassic. But in the Maya area, further to the south, both hammered and cast objects first appeared at the opening of the Postclassic, around the time that Toltec features appeared

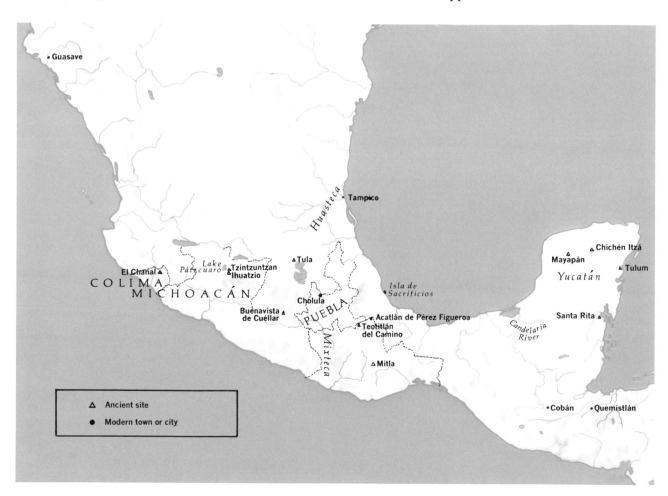

there. As in Central America, gold was used mainly for its decorative beauty; copper, being less handsome, was employed for some utilitarian objects, such as axe-shaped money, needles, and bells (Number 269). The aesthetic qualities of metal are reflected in much Postclassic art. The sharpness, brittleness, and decorative effects, including fluting and gadrooning, which suggest metalworking techniques, appear in some of the widely traded ceramics of the Early Postclassic, such as lowland Maya Fine Orange and highland Maya Plumbate. The latter is so named because of its semivitrified lustrous surface that sometimes has a gray hue resembling polished lead, but its color may also be metallic orange, or a red that resembles copper (Number 254).

The arrival of obvious Toltec motifs in the Yucatán Peninsula was preceded by other changes in the Maya culture. The most dramatic of these was the abandonment of the great Classic cities in northern Guatemala and adjacent areas of Mexico. The cyclical erection of monuments dated in the Long Count gradually ended during the ninth century, and the style of the art of that late date already showed many non-Maya characteristics, which seem to come from Central Mexico. Specifically, the graceful curves of the Classic Maya were gradually replaced by a definite angularity. The modulated bas-relief of the Classic Maya gave way to a style of carving in which the figure and its background form two sharply defined planes with a minimum of softening transitions. Much of the detail was either eliminated or reduced to uniform linear incisions. As a result, the art of the Maya area in the tenth century commands our attention by virtue of its insistent angles and its sharp contrast of planes, often accompanied by a roughness in surface finishing. The tall standing warrior said to come from Campeche (Number 248) includes all these qualities; in addition, it has the non-Maya traits of being a freestanding sculpture and having an obviously military theme.

However, the full effect of the Mexicanization of Maya art can be seen best in the northern Yucatán Peninsula, especially in the important capital city of Chichén Itzá (Figure 36). Like all Yucatecan habitation centers, Chichén was built near a huge water-filled opening, called a cenote, in the riverless limestone surface. Long a magnet for settlement, the well became the center of a religious cult in which both living and inanimate offerings were thrown into its depths (Number 187). When the Toltecs arrived in Yucatán, they found a large Maya population whose flourishing civilization centered around numerous small cities containing what

FIGURE 36

Partial view of Chichén Itzá

Looking between the inverted-serpent columns of the Temple of the Warriors past a reclining Chac-mool, the visitor can see the Castillo, the major building of the Toltec section of the city. This nine-stage pyramid with a flight of stairs on each side has a well-preserved stone temple sanctuary on top. Far to the right can be seen a portion of the enormous ball court. Beyond that stretch the flat horizon and low vegetation of northern Yucatán.

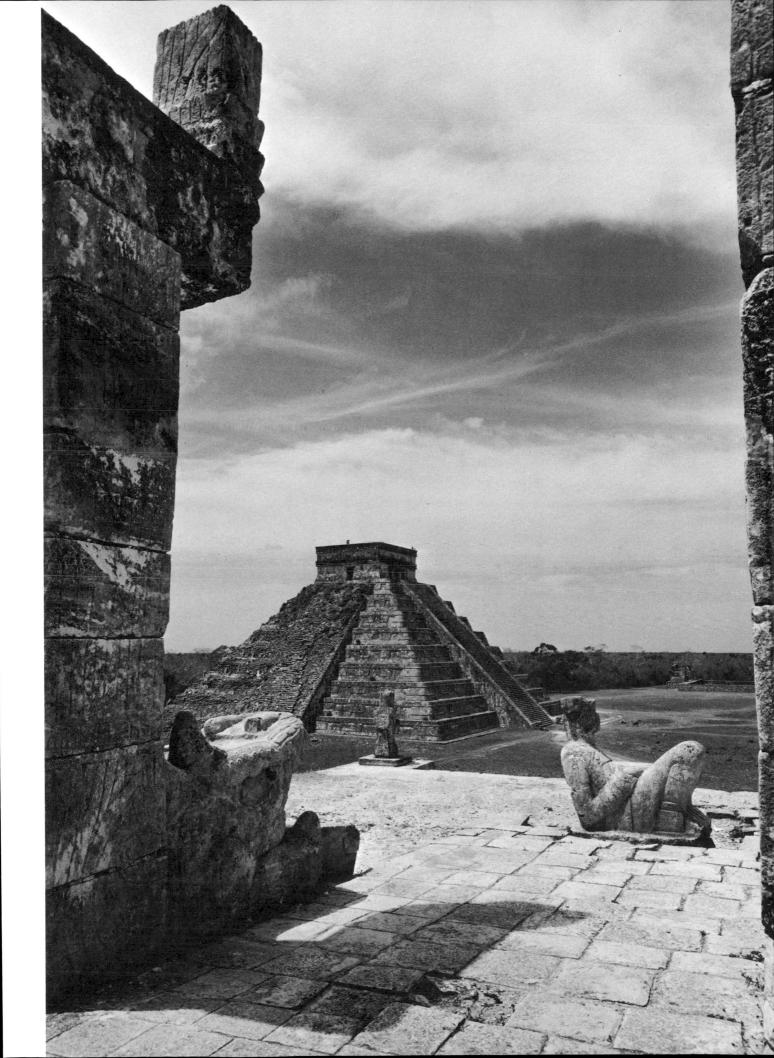

many consider the most beautifully proportioned stone architecture ever created in the Americas. These northern centers of the Maya apparently grew at the expense of the southern cities of the Petén region.

The arrival of the Toltecs caused no revolution in living patterns or disruption in the existing centers of Maya population. At Chichén Itzá, as the clearest example, the Mexicans did not destroy the older Maya buildings, but instead founded their own ceremonial center directly to the north, in peaceful coexistence. Details of the plan and decoration of the new buildings at Chichén show exact parallels with Tula. In this exhibition, the small Atlantean figure from Tula (Number 249) represents the general Toltec type and is echoed by the Atlantean from Chichén (Number 250). Yet the differences are striking. The Maya sculptors whom the Toltec lords employed to execute their building program imprinted the Mexican forms with Maya subtlety of carving and refinement of proportions. The Maya mastery of architectural sculpture in earlier Yucatecan cities facilitated their adoption of squared, blocky Toltec figures, which serve more as architectural ornament than as freestanding sculpture. Because of their experience in producing delicately carved stone façades, the Maya were better able than the Toltecs themselves to render the new architectonic forms from Mexico.

While Chichén Itzá received a direct transplantation of Tula culture, most areas of Mesoamerica show only some Toltec traits. Typically, local kingdoms like those of the Mixtec of western Oaxaca maintained their native nobility but acknowledged the Toltec ruler as overlord, paying him tribute and receiving from him confirmation of their existence as separate entities. For example, the ruler of a Mixtec kingdom, the lord Eight-Deer Tiger-Claw, who expanded its political power through military conquests, went to Tula in 1045 to have his nose septum pierced to receive the distinctive jade plug of office. We know this because of the fortunate survival of a long series of genealogies of Mixtec dynasties, the first of which was founded in 838, approximately contemporary with the founding of Tula. The events referred to in the codices go back to A.D. 692. Although glyphs of conquered places given in the codices seldom can be related to modern locations, the Mixtec conquests undoubtedly took them into both the Valley of Oaxaca, inhabited by the Zapotecs, and the Valley of Puebla. The Mixtec influence on the Valley of Oaxaca can be seen in the slab from Noriega (Number 167), which not only reflects the subject matter of the genealogical codices but their angular style as well. As with the Toltecs, Mixtec military domination was followed by a cultural homogeneity, centered in Oaxaca and Puebla.

In the Puebla region, the inevitable political domination of the Toltecs during the apogee of Tula did not force an assimilation of Toltec culture either. Following the destruction of the Toltec capital in 1168, the main city of Puebla, Cholula, became the unquestioned commercial and artistic leader of Mesoamerica, and there the largest pyramid in the world was created. Because the motifs and techniques of Cholula and the Mixteca region are nearly identical, their style is known as "Mixteca-Puebla." This art style became more ubiquitous than the Toltec, even though it apparently was not spread by force of arms. While the beautiful polychrome painting of codices and vessels is the best-known work in the Mixteca-

Puebla style, the artists also made distinctive lapidary carvings and mosaic work, metal castings, and coarse clay braziers, used for burning incense, and their covers. The extent of this style can be seen far to the south, where murals in Mixtec codex style occur at Santa Rita and Tulum, on the Caribbean coast of the Yucatán Peninsula. Even late Costa Rican ceramics show inspiration from the polychrome painted style of Puebla.

In contrast to earlier sculpture, Mixteca-Puebla art was characteristically used in private rituals. By the mid-Postclassic period artists throughout Mesoamerica concentrated on producing images of minor deities who controlled specific occupations or functions. Simplification of technique was one result of this change in purpose, best seen in the geometric forms, especially straight lines and circles, used in the small pendants (*penates*) so common to Mixtec areas (Number 267). Stove-pipe-shaped ceramic figures (*xantiles*) used for burnt offerings such as copal incense also are composed of very stylized geometric forms, beginning with a tapered cylinder for the body, with stiff cylindrical limbs attached to the lower part and flanges and strips of clay applied to form the features of the head (Number 263). After firing, the clay form was painted in three or four colors, often with details that were not modeled in relief. The paint is not baked on, and painted features can thus peel off easily, a characteristic that demonstrates the indifference of the artists.

An even more slipshod attitude affected Maya Yucatán, which, following the absorption of the Toltec conquerors, began to decline politically and culturally into a number of small, quarreling chieftaincies. For a while, the city of Mayapán attempted to revive the glories of Chichén Itzá, with blatant imitations not only of the former political empire but also of the earlier architecture. Smaller versions of the stone temples at Chichén were built in rubble and stucco, a cheap and easy imitation of the durable stone originals. For burnt offerings, urns with attached figures in front (Number 262) served a function analogous to that of *xantiles* in Mexico. They too are decorated with post-fired paint and display the common Postclassic preference for blocky rectilinear forms. While these figures no longer possess the flowing elegance of the Classic Maya portraiture, they do have positive artistic qualities of their own, notably a forcefulness of expression achieved by combining clear, bulky geometric shapes of clay to produce vigorous sequences of cylinders and planes. Tatiana Proskouriakoff observed in her study of Mayapán that through these effigy censers (which sometimes received the ashes of nobles) the lay worshiper could approach the gods directly, eliminating the need for a complex priestly hierarchy. Devotion had become a personal affair throughout Mesoamerica during the mid-Postclassic, downgrading the role of priests, whose sponsorship of architecture and the fine arts for the benefit of the whole community had been so outstanding in earlier periods. The effect of this new, more restricted function of art can readily be seen in the reduced programs and lack of care in execution of the sculpture.

Traces of the Mixteca-Puebla style can be found in the Western region of Mexico, especially in ceramic forms and polychrome painted decoration, as far north as Guasave, Sinaloa. A Mixtec *xantil* must have served as the prototype for a rare clay piece said to come from Colima (Number 264). Contact between Central

Mexico and the West had been forced earlier by Toltec traders and warriors, after the area had remained in relative isolation from Mesoamerica during most of the Classic period. At the still unexcavated site of El Chanal, Colima, Toltec motifs appear in such profusion that it may have been a colony of the Toltecs. Traces of Toltec techniques and forms can be found as far north as the Hohokam pueblos of Arizona.

Toltec forms survived longest in the mountain-ringed empire created by the Tarascan Indians in the state of Michoacán, centering on the fertile Lake Pátzcuaro region. The militarism of the Tarascans was no doubt their most lasting inheritance from the Toltecs, surviving until the Conquest, and permitting them to withstand the onslaughts of the imperialist successors of the Toltecs in Central Mexico, the Aztecs. Several large stone sculptures found around the Tarascan capital of Tzintzuntzan have the distinctive Toltec shape of the Chac-mool, the reclining figure with head turned to one side and hands bracing the offering plate on the abdomen. The Tarascan sculptors simplified all forms to geometric essentials, and the results were sharp, angular abstractions of the Toltec originals (Number 271). The Toltec tendency toward flat, hard forms was taken to its logical extreme in the Tarascan images, quite the opposite of the rounded, plastic forms of the contemporary Aztec work. Tarascan metalwork also preserves Toltec forms in simplified and stylized versions. Coppersmithing, which was apparently the earliest metal technique introduced in Mesoamerica, remained the major medium used by the Tarascan metalworkers (Number 270) in spite of the importance of goldsmithery in contemporary Aztec art.

248 Standing warrior with club

Rough gray marble
Height: 84½ in. (2.15 m.)
Candelaria River drainage, Campeche, Mexico (?)
Transitional Classic-Postclassic, 860–1000
The Metropolitan Museum of Art, Harris Brisbane
 Dick Fund, 66.181

This warrior originally held a small square shield in his left hand, and obsidian blades probably were once inserted in the two holes on the club he still holds in his right hand. The mask, which is composed of plaques framing the mouth and eyes, gives the face a fierce expression. The war club, spiral leg wrappings, loincloth with square knot, and sandals were all common in the period of transition between Classic and Postclassic, but a few features suggest that this piece may relate to the mid-Postclassic sculpture of Campeche. The oval perforations separating the arms from the torso are like the later slab style (Number 258), and the flaps on the headdress behind the earplugs are also late traits. However, the later sculptures, often phallic, are much more simplified, having none of the fine carving seen on the face of this warrior.

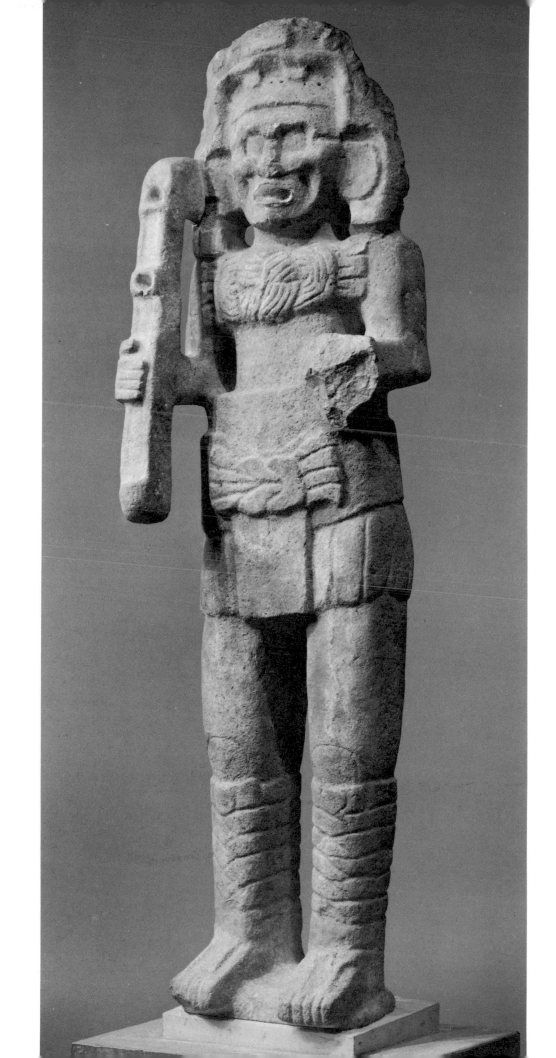

249 Atlantean warrior

Basalt with blue, red, white, and yellow paint
Height: 28¾ in. (73 cm.)
Temple of Quetzalcóatl, Tula, Hidalgo, Mexico
Early Postclassic, 856–1168
Museo Nacional de Antropología, Mexico, 15–175

Discovered during the 1941 excavation at Tula directed by Jorge Acosta, this Atlantean had been thrown into a trench on the north side of the main pyramid along with other small Atlanteans and square pillars carved in low relief. Acosta believes that the trench, which also contained the giant Atlanteans (Figure 34), was dug by the Toltec inhabitants themselves to hide their monumental sculptures, perhaps in the face of barbarian threats from the north. The figure on exhibition was missing its left wrist and hand when first discovered (Jorge Acosta, "La tercera temporada de exploraciones arqueológicas en Tula," *Revista Mexicana de Estudios Antropólogicos* 6, 1944, fig. 33), but this fragment has subsequently been found and attached. The several known small Atlanteans from Tula, none of which is over 30 inches tall, undoubtedly formed the supports for a horizontal structure serving as a platform or table in the temple sanctuary at Tula. This piece has a notch in the top of its head, as if to receive a beam. Each figure is consciously different in dress, as are the similarly dressed warriors carved in relief on the square columns once set on top of the main pyramid. Possibly they represent all the different tribes tributary to the Toltecs, who symbolically support the weight of the empire. (See Color Illustration.)

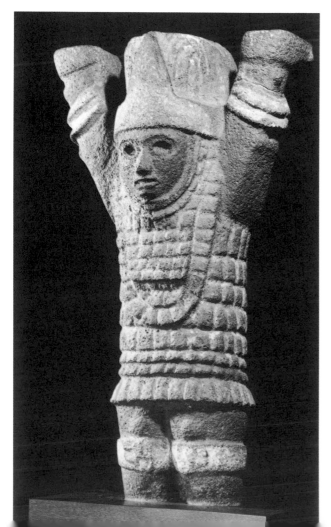

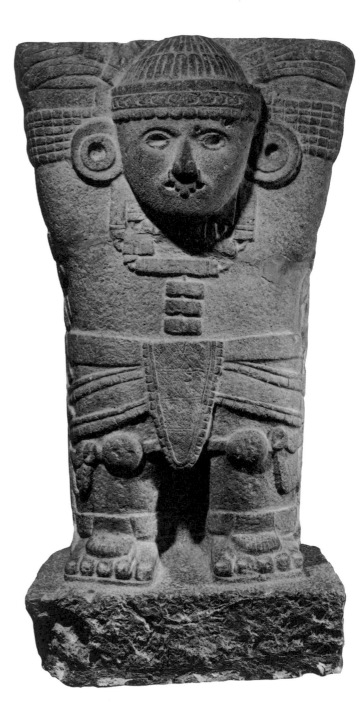

250

250 Atlantean warrior

Light gray limestone
Height: 35⅝ in. (90.4 cm.)
Temple of the Jaguars, Chichén Itzá, Yucatán, Mexico
Early Postclassic, 987–1204
Museo Nacional de Antropología, Mexico, 5–1757

The upraised arms terminate not in hands but in a rough-hewn ledge extending slightly behind the figure itself. This was one of fifteen similar supports for a large stone slab, perhaps serving as a dais or throne, just inside the pair of serpent columns forming the entrance to the temple overlooking the enormous ball court in Chichén (Figure 36). A photograph by Augustus Le Plongeon, the French explorer who discovered the group in 1880, shows three Atlanteans facing the temple entrance, each with a file of four other figures behind. Differences in the height of the supports, which varies from 24 to 36 inches, were probably equalized by setting some deeper into the earth floor. Called Caryatid 8 by Eduard Seler, this figure wears a beautiful cloak of quetzal feathers, cascading down its back in three tiers divided from each other by the repeated crossing of a pair of plumes in the center of the back. Feathers on the edge of the cape curl against the sides of the figure, forming a pleasing pattern of fluttering, interwoven plumes. The warrior wears rich jewelry, including six-tier wristlets, a beaded cap, double circular earspools, a stepped nose plug, and a collar of tubular, banded beads with the string joining the arrangement clearly indicated. Also clearly represented are the knotted attachment of the knee protectors and the sandal straps, which pass between the big and second toes. Although the fifteen Atlanteans are identical in composition and outline, they vary in costume, like those at Tula (Number 249), so as to represent several ethnic and political groups.

251 Double serpent-headed altar

Dark blue gray basalt
Height: 21¼ in. (54 cm.)
Tula, Hidalgo, Mexico
Early Postclassic, early twelfth century
Museo Nacional de Antropología, Mexico, 15–162

Found cemented into the corner of a private house in the modern town of Tula, this stone had been taken from the Toltec site on the nearby acropolis before 1900. Carved on all four sides and the top, the stone undoubtedly was freestanding, perhaps serving as an altar or a throne. The height, perfect for a high seat, supports the latter hypothesis, as does the iconography of the double-headed animal. In Maya representations of the Late Classic, important personages are often shown seated on a throne composed of joined jaguar torsos with their heads facing outward at each end. And the serpent and the jaguar are both representations of the primeval force of nature. The open jaws of the serpent heads and the fangs curling out of the corners of their mouths recall the heads on the base of the large inverted serpent columns that flanked the main entrance to Toltec temples (Figure 36).

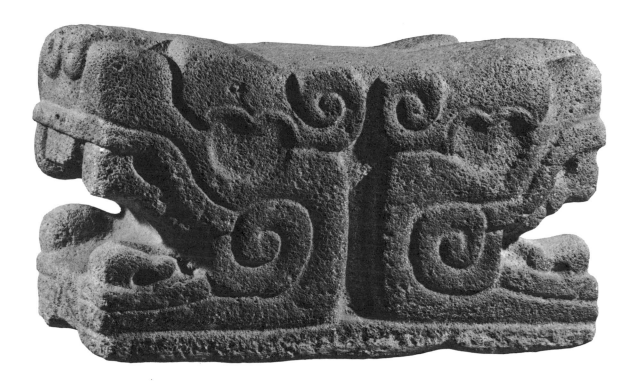

252 Architectural feathered serpent

Light gray limestone with traces of red and green paint
Height: 25¼ in. (64 cm.)
Venus Platform, Chichén Itzá, Yucatán, Mexico
Early Postclassic, 987–1204
Museo de Arqueología de Yucatán, Mérida

This serpent was discovered by Augustus Le Plongeon on a low four-sided structure that is today known as the Venus Platform, since it is decorated with representations of the god Quetzalcóatl as the evening star. The serpent belonged to a group of twelve surrounding a central urn. The group consisted of several types, including shorter tenon serpent heads and this longer type, complete with body. In 1908 at the International Congress of Americanists, Eduard Seler proposed that the serpents of the former type were reused from an older building, while the latter may have once formed a cornice band along the top of a building. The feathered serpent, another aspect of Quetzalcóatl, has here been given a very realistic interpretation. The open maw is painted red, and the body and head are covered with richly textured green feathers. A hole between the bottom fangs of the mouth probably once held an inset pendant tongue. In the hole in the top of the skull, between the eyes, an undulating crest was once inserted. The nostrils formerly had plugs that extended several inches above the snout.

253 Two relief slabs of eagles devouring hearts

Limestone with traces of stucco and red orange, dark red, ochre, white, blue green, black, and light blue paint
Height: each 27½ in. (70 cm.)
Said to be from northern Veracruz, near Tampico, Mexico
Early Postclassic, 1000–1200
The Metropolitan Museum of Art, gift of Frederick E. Church, 92.27.1–2

Reported by their discoverer to have come from the Huasteca region, where no other pure Toltec style art is known, these slabs have a motif that seems directly inspired by the repeated reliefs on the back of the Temple of Quetzalcóatl at Tula (Figure 35). There, pairs of eagles facing to their right alternate with single reliefs of the face of Quetzalcóatl coming out of the open mouth of the feathered reptilian monster. On the row above, relief slabs show alternating jaguars and coyotes, symbols of the two military orders. The eagles tear with their beaks at a three-lobed object from which spurt three large drops. This motif, which first appeared on a Teotihuacán mural at Atetelco, and then spread throughout Mesoamerican art, can be interpreted as a heart dripping blood. On the pair of reliefs on exhibition, several features have been added to the Tula rendition. First, each eagle's right claw grasps the heart to secure it for the tearing beak.

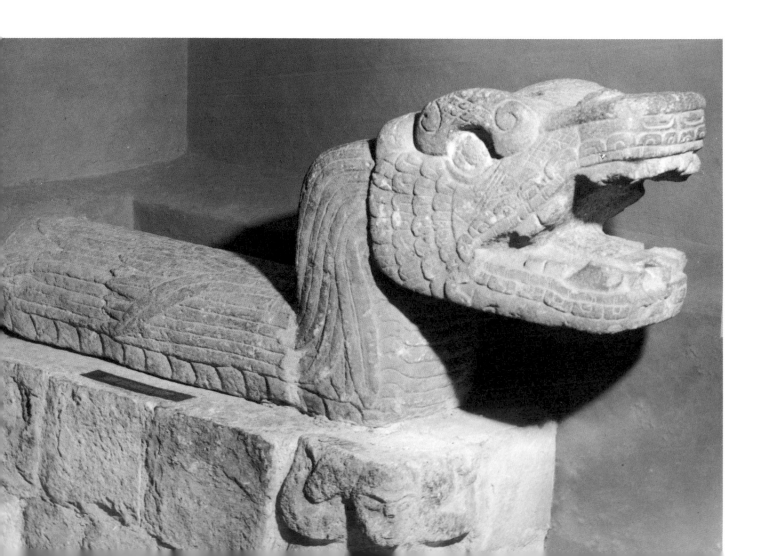

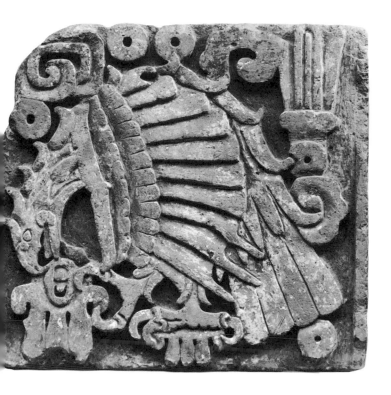 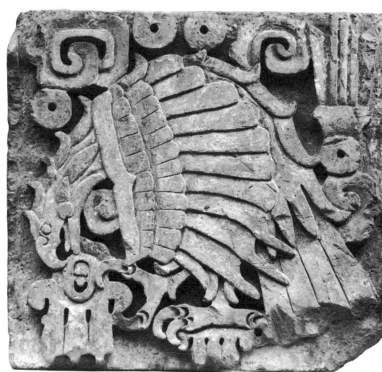

Second, three drops of blood drip from each standing foot. The background is filled, because of some compulsive *horror vacui*, with broad rings, a cactus motif, and two scrolls, clearly showing the influence of Tajín Veracruz.

254 Effigy jar of an old man's head

Orange Plumbate pottery with dark gray clouds
Height: 5⅞ in. (15 cm.)
Cobán region, Alta Verapaz, Guatemala
Early Postclassic, Tohil phase, 950–1200
Museo Nacional de Arqueología y Etnología,
 Guatemala, 5759
Ex coll. Dieseldorff

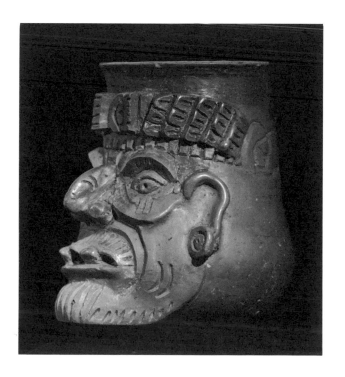

Although Plumbate ware was named for its common lead-colored, often iridescent surface, a variety of other colors, notably deep red and earthy orange, like this example, resulted from the complexity of the ware's two-layer glaze. The glazed ware underwent two firings under very high temperatures, first with oxygen, resulting in the orange color, and then without, causing the dark clouding. The recurved vase, which is commonly used for effigy heads, is modeled here with the features of an old man. Notable are the two knobbed pellets forming the snag teeth and the mustache, a rare feature even when a beard is represented. The sharp curved forms that distinguish Plumbate effigies are best seen here in the folds of sagging skin around the eyes.

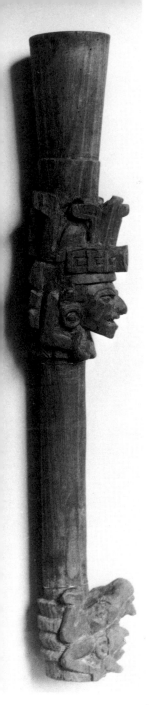

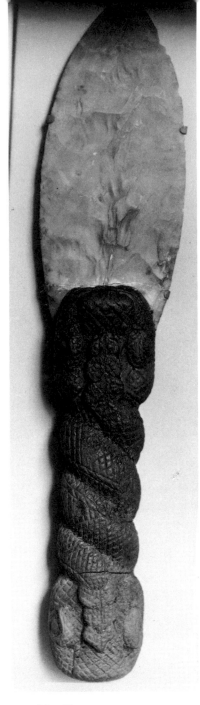

upper figure carry balls, perhaps indicating a ballplayer. This figure's headband is composed of overlapping square segments, with a circular medallion in the center, like the headband on the Plumbate figure (Number 254). The lower figure wears an overhead mask of an animal that seems to combine characteristics of serpent and jaguar.

256 Knife with carved handle

> Buff white chalcedony with wooden handle painted black
> Length: 13½ in. (34.5 cm.)
> Sacred Cenote, Chichén Itzá, Yucatán, Mexico
> Late Postclassic, 1350–1500
> Peabody Museum of Archaeology and Ethnology, Harvard University, Cambridge, Massachusetts, C6755

Two intertwined snakes, each with its rattle on the forehead of the other, are depicted on the handle, the bulbous, realistic forms of which are possibly of Aztec origin. The cenote remained in use long after the abandonment of the city of Chichén, offerings still being made there in Colonial times. Both this piece and Number 255 were recovered by the earliest expedition to dredge up some of the treasure in the sacred well—that led by Edward Thompson around 1900.

257 Five beads with relief carvings

> Emerald, gray, and white jade
> Maximum diameter: 1 9/16 in. (4.0 cm.)
> Sacred Cenote, Chichén Itzá, Yucatán, Mexico
> Early Postclassic, 900–1100
> Peabody Museum of Archaeology and Ethnology, Harvard University, Cambridge, Massachusetts, C5963, C6068, C6344, C6348, C6349

All of these beads, part of the group recovered by Edward Thompson around 1900, feature an open-mouthed feathered serpent. The targets of these menacing mouths include a rattlesnake; a dog, half devoured and pursued by a rapacious bird; and a doglike creature emerging from a conch shell. On two beads, a man emerges from the serpent's open mouth; such representations, especially that of a bearded man, may be Quetzalcóatl, whose face is often shown in Toltec art emerging from the mouth of a feathered monster. Both men wear long nose plugs, a form of adornment that appears on very late Classic Maya reliefs. The human faces have harsh, angular features characteristic of Maya warriors carved in relief at Chichén. Some glyphs suggest that the beads may have been manufactured in Oaxaca, and the technique used for the feathers on one serpent recalls serpents on a temple of Xochicalco, Morelos, the type site of a culture that borrowed many traits from Oaxaca. Their actual place of manufacture may thus be highland Mexico, from where they may have been imported, possibly in paired sets.

255 Top of Ceremonial Staff

> Wood
> Height: 11 in. (28 cm.)
> Sacred Cenote, Chichén Itzá, Yucatán, Mexico
> Early Postclassic, 987–1204
> Peabody Museum of Archaeology and Ethnology, Harvard University, Cambridge, Massachusetts, C6698

The staff has a shallow hollow at the base and a deep hole extending from the top down to an opening behind the upper head, in which feather plumes may have been inserted. The smooth cylindrical space between the two figures is the right size for a hand to grip the staff. Both carved figures, in diving position, have their small legs projecting above their heads, while their equally small arms are held underneath their chins. The arms of the

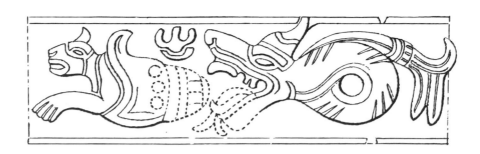

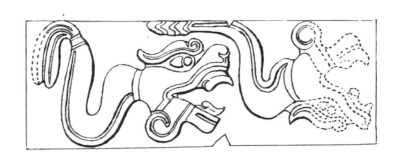

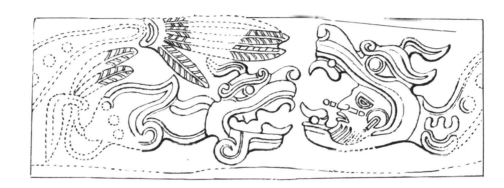

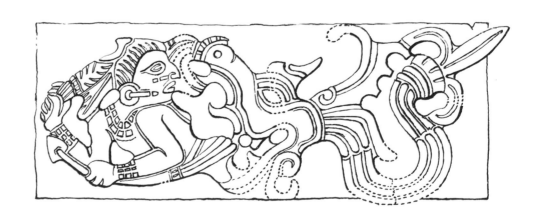

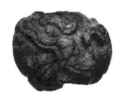

258 Human figure seated on base

Gray tufa
Height: 11½ in. (29.5 cm.)
Oaxaca, Mexico
Postclassic, 1200–1400
Fred Olsen, Guilford, Connecticut

This striking little Mixtec figure belongs to a recurrent Postclassic substyle in which the human form was abstracted into regular geometric shapes. In this style elliptical hollows are as important as the solid forms themselves, a principle recalling the sculpture of Henry Moore. Variations of this style are known from as far north as the Huasteca and as far south as Campeche, where ithyphallic males were carved from dressed thin slabs. From the same Mixteca-Puebla region as the exhibited piece, a slab figure was recently discovered in Cholula. However, sculptures that most closely resemble the Mixtec figure come from the Toltec-influenced culture of Colima. They also have a seated posture with hands on knees, and spherical head with circular features, protruding rather than sunken as in the Mixtec piece.

259 Effigy vase of kneeling man in conch shell

Yellow aragonite (tecali)
Height: 8⅛ in. (20.8 cm.)
Central Veracruz, Mexico
Early Postclassic, 950–1250
The Metropolitan Museum of Art, 00.5.1439
Ex coll. Petich

In the Maya pantheon one of the major earth deities is the old god who lives in a shell in the center of the earth. Every time he moves, the earth rumbles, causing quakes. The motif appeared first in Late Classic polychrome vases, then became even more important during the Early Postclassic, when it appeared on Plumbate jars and at Chichén on relief sculptures and a gold disk found in the cenote. While the iconography came from the Maya, the choice of material for the vase derives from Teotihuacán tastes. The use of tecali became especially popular in the Mixteca-Puebla area, and large numbers of finely carved vessels were found on the Isla de Sacrificios, off the central Veracruz coast, from where this piece may have come.

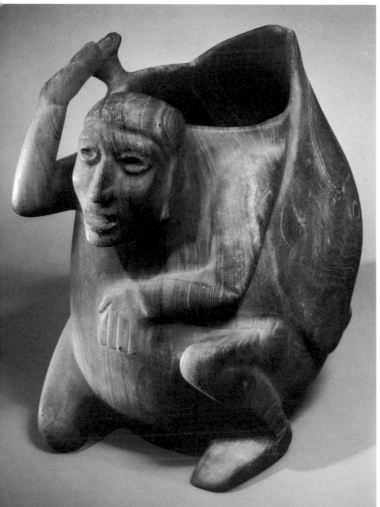

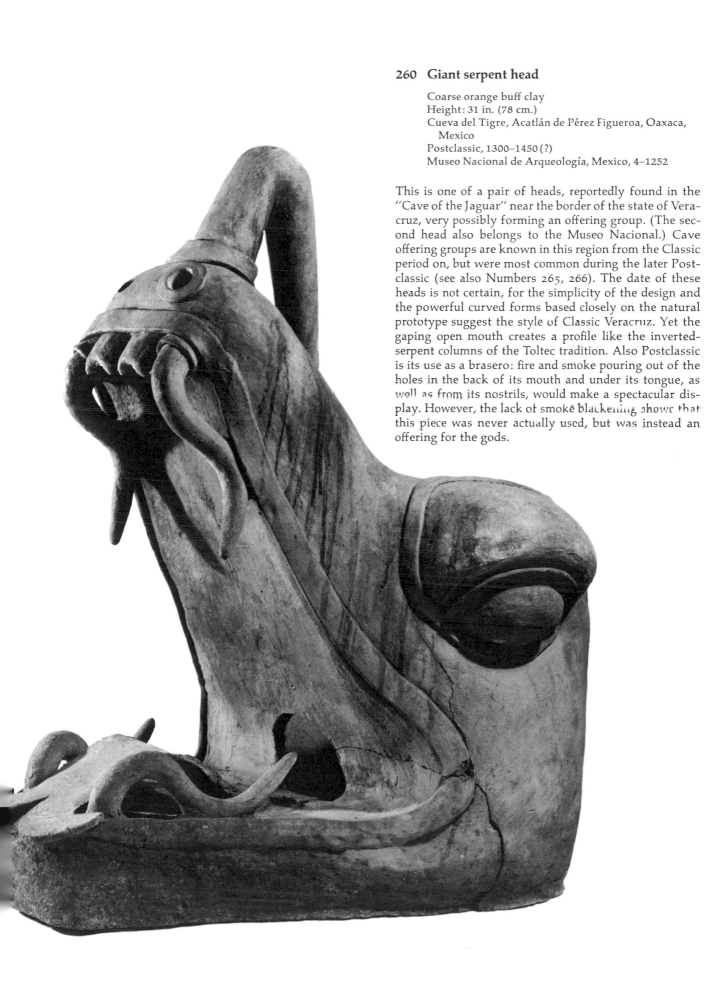

260 Giant serpent head

Coarse orange buff clay
Height: 31 in. (78 cm.)
Cueva del Tigre, Acatlán de Pérez Figueroa, Oaxaca,
 Mexico
Postclassic, 1300–1450 (?)
Museo Nacional de Arqueología, Mexico, 4–1252

This is one of a pair of heads, reportedly found in the "Cave of the Jaguar" near the border of the state of Veracruz, very possibly forming an offering group. (The second head also belongs to the Museo Nacional.) Cave offering groups are known in this region from the Classic period on, but were most common during the later Postclassic (see also Numbers 265, 266). The date of these heads is not certain, for the simplicity of the design and the powerful curved forms based closely on the natural prototype suggest the style of Classic Veracruz. Yet the gaping open mouth creates a profile like the inverted-serpent columns of the Toltec tradition. Also Postclassic is its use as a brasero: fire and smoke pouring out of the holes in the back of its mouth and under its tongue, as well as from its nostrils, would make a spectacular display. However, the lack of smoke blackening shows that this piece was never actually used, but was instead an offering for the gods.

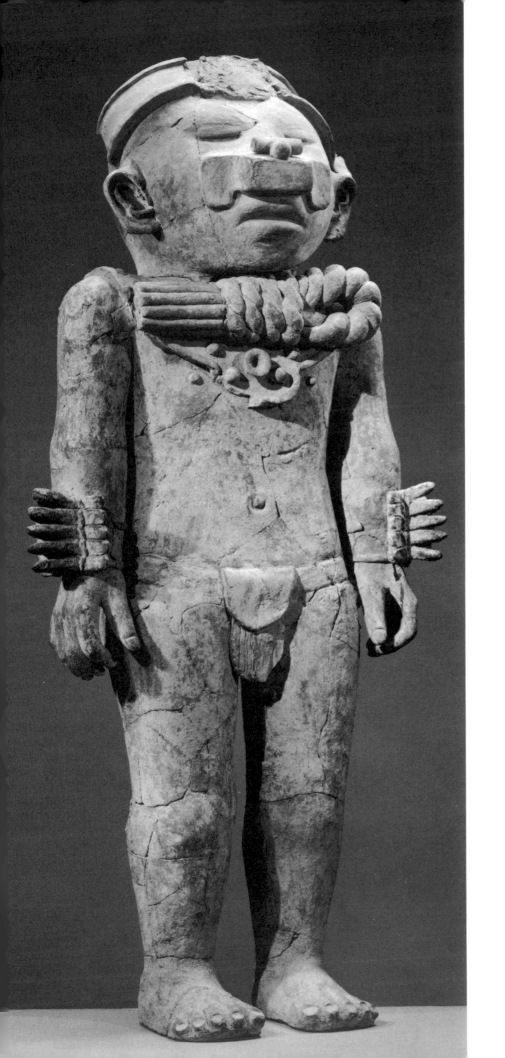

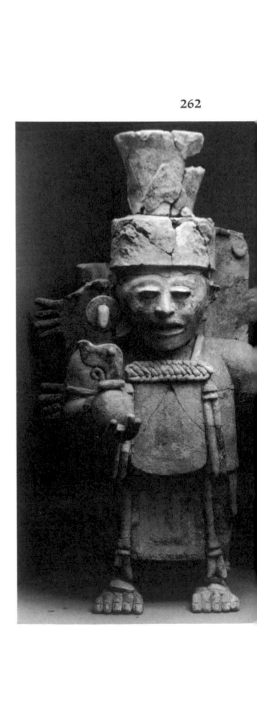

262

261 Standing male figure

Reddish brown clay with white slip
Height: 46⅜ in. (1.18 m.)
Tlacotalpan region, Veracruz, Mexico
Early Postclassic, 1000–1200
William P. Palmer, Portland, Maine

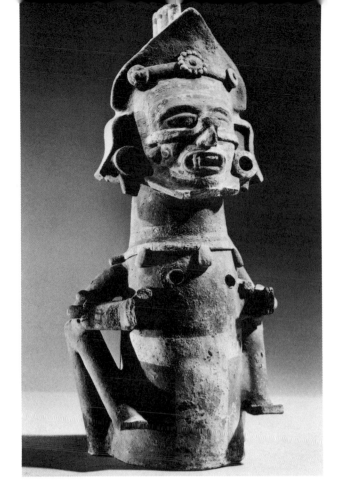

Continuing, or perhaps reviving, the Early Classic tradition in Veracruz of large clay figures, the Postclassic potters of that region sculpted nearly life-size standing effigies like this one. Because of its size, the back of the sculpture is perforated with several firing holes: two each in the arms and legs, one in the back, and one in the head. The closed eyes and the limp, partially opened mouth are characteristic of Xipe Totec, one of the most common images in Postclassic Veracruz sculpture. However, the figure lacks the key feature that would enable it to be identified as Xipe, namely, a flayed skin slipped over the body. An Early Postclassic date is indicated by the similarity in proportions, in the shape of the closed eyes, and in the treatment of the hands to a standing clay Xipe discovered in the top layer at Teotihuacán, corresponding to the period of Toltec occupation.

262 Maize-god urn

Coarse clay painted red, blue, yellow, and green
Height: 21⅝ in. (55 cm.)
Construction Q-81, Mayapán, Yucatán, Mexico
Late Postclassic, 1263–1451
Museo de Arqueología de Yucatán, Mérida, Mexico

This type of figure, in which large, flat planes are bordered by rolled clay ornamentation, is referred to in Maya studies as an effigy censer. It becomes increasingly common in the upper, later levels of excavations. The figure on exhibition and many others like it hold out circular jars from which a tongue of flame issues. The flame is blown to one side, as may be seen also in today's construction pots, revealing a high degree of accuracy of observation on the part of the artists. This figure is attached to a large, round-bottomed urn (12¾ inches high), which is set on a base platform slightly narrower than the figure itself. A flange in back of the figure, fringed with four-pronged decoration, masks the urn, which may have contained smoking copal incense or other offerings.

263 Xantil figure of Macuilxóchitl

Sandy buff clay painted red, yellow, blue, and white
 after firing
Height: 19⅜ in. (49.2 cm.)
Teotitlán del Camino, Oaxaca, Mexico
Late Postclassic, 1300–1500
Memorial Art Gallery of the University of Rochester,
 New York

Effigies of this type from the Mixteca-Puebla area and neighboring Veracruz, with attached arms and legs drawn up in front of the cylindrical torso, were set over burning incense, so that the aromatic smoke would filter through the fanged mouth and the holes in the chest. (The meaning of the term xantil, used for this type, is unknown.) In spite of the ferocious aspect of this figure, it represents one of the most charming deities in the pantheon, Macuilxóchitl. The name, which means "Five Flower" (a day in the Aztec calendar), may be a variant of that of the god Xochipilli, whose legendary birth date fell on that day. Both are believed to be patrons of games of chance, dances, love, and summer growth and thus were the favorites of women for their domestic shrines. Macuilxóchitl, in particular, is identified by the white butterfly wings around his mouth, the flowers on his headband, and the double-pointed helmet representing the open mouth of a bird. The four thin vertical cylinders on top of the helmet are an abstraction of the head crest of a bird.

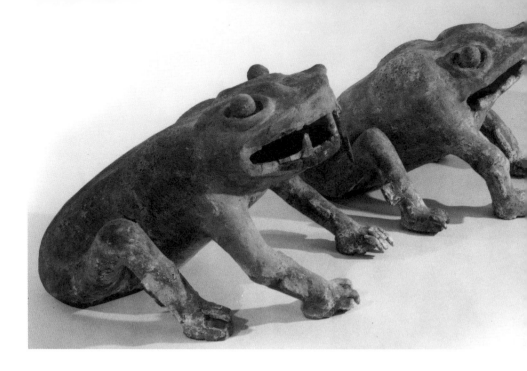

264 Effigy incense burner

Coarse brown clay with traces of red paint
Height: 24⅞ in. (63.2 cm.)
Colima, Mexico
Late Postclassic, 1200–1400 (?)
Mr. and Mrs. Alvin Abrams, Woodmere, New York

This extraordinary piece, reported to have come from Colima, offers dramatic evidence of the extent of the influence of Central Mexico on the west coast during Postclassic times. The circular face with open mouth seems to be a version of the common flat heads of figurines in the style called Mazapan, widespread in Western Mexico during Toltec times. The form is clearly related to that of the *xantiles*: a tapered cylindrical body, on which thin limbs were applied. Open at both top and bottom, it very possibly served as a flue for incense smoke, which would curl up out of the head in patterns reflected in the undulating pieces of the headdress. Unlike the *xantiles*, this male figure represents no known deity. Perhaps intended as a chief or ruler, he sits on a stool made of closely set spindles, between which light is barely visible.

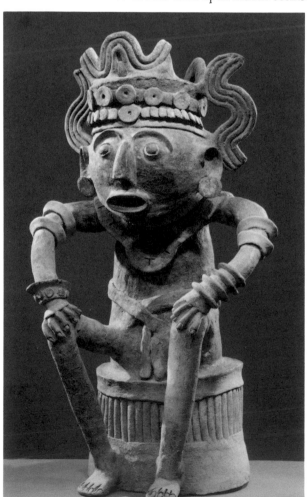

265 Pair of seated frogs

Coarse buff clay, with traces of pale ocher gesso and
white and red paint
Height: 18½ in. (47 cm.) and 18 in. (45.7 cm.)
Teotitlán del Camino, Oaxaca, Mexico
Late Postclassic, 1200–1400
Dallas Museum of Fine Arts

According to reports, these two frogs, two colossal heads of the rain god (one on exhibition, Number 266), and a huge freestanding hand were found together, suggesting that they formed a group for a shrine. In the mid-Postclassic and later, caves commonly served as sacred areas for Tlaloc, the Rain God, and were often filled with ceramic effigies. Frogs were Tlaloc's companions, given their association with water. The square flanges, colored red, on the white lower legs, set these amphibians apart from nature. In their original state, the frogs must have been an awesome sight. Their blood red tongues and eyeballs, their unnatural fangs and teeth, their menacing crouch, their hunched backs with repellent punctate texture, and their sheer size all combine to create a threatening image.

266 Colossal head of the Rain God

Coarse buff ceramic, with white slip and red, black, and yellow paint; nose crest and points of crown base of porous tufa covered with stucco painted grayish blue
Height: 51 in. (1.295 m.)
Teotitlán del Camino, Oaxaca, Mexico
Late Postclassic, 1200–1400
Dallas Museum of Fine Arts

This head bears an extraordinary resemblance to the colossal clay head in the Museo Nacional de Antropología, Mexico, attributed by Ignacio Bernal to the Tehuacán region of southern Puebla. Both pieces have circular plaques around the eyes and an oval plaque around the mouth, parts of the costume of Tlaloc, the Rain God. The seven long red fangs descending from the mouth, all broken in the Dallas head, are common in Postclassic images of Tlaloc and suggest flowing liquid. The snakes that hang from the ear flanges symbolize lightning—another aspect of the Rain God's powers. Both heads have elaborate crowns of white ropes forming rectangles, within which are crosses with disks and spikes in the center. On the front of the crown of the exhibited piece is a halved conch shell, usually a symbol of Quetzalcóatl in his guise as the planet Venus.

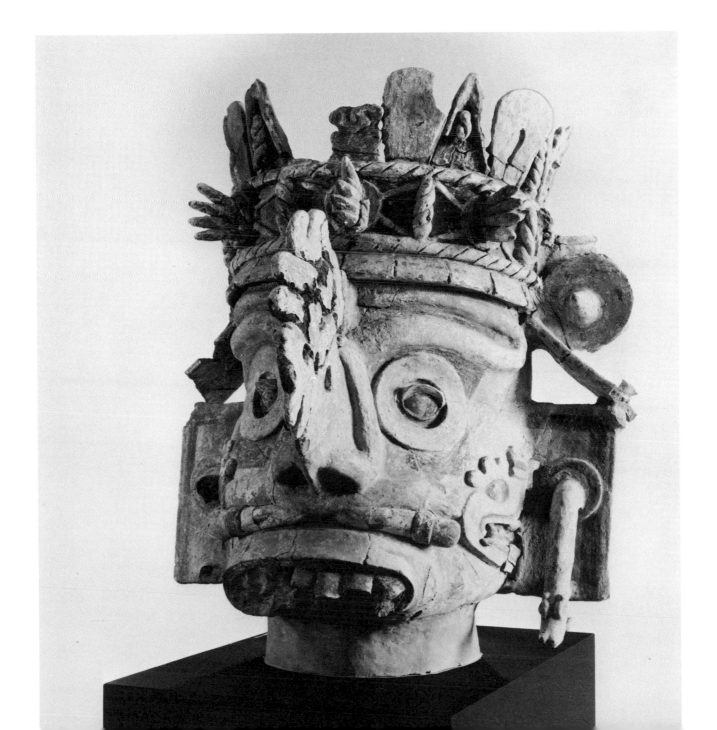

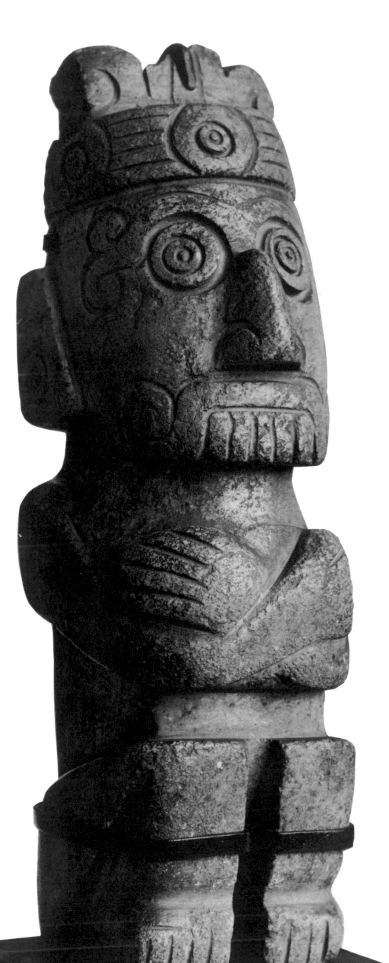

267 Seated figure of the Rain God

Hard greenstone
Height: 10 in. (25.4 cm.)
Valley of Oaxaca, Mexico
Late Postclassic, Monte Albán V phase, 1200–1500
Musée de l'Homme, Paris, 82.17.40
Ex coll. Désiré Charnay

This figure is an unusually large example of the common Mixtec talisman. Called *penates*, after the Latin word for household gods, carvings of this type were personal amulets representing men squatting on the ground with their arms usually folded on top of their knees. The larger *penates* often show Tlaloc, the Rain God, identifiable by the circular plaques around his eyes and the fangs hanging from his mouth. Scrolls, abstractions of snakes, form the terminals of the eyebrows and of the upper lip. This piece, typical of the *penate* style, clearly shows the techniques used in Mixtec lapidary carving. Straight saw cuts define the fingers, toes, and teeth. Hollow circular drills were used to make decorative concentric patterns around the eyes and on the headdress. The form of the body remains very blocky, divided into squared masses. Because of the need to mass-produce large numbers of *penates* for personal use, the carvers abstracted the patterns of the human body into an easily reproduced sequence of straight cuts to block out the form and add details and clothing decoration.

268 Funerary mask

Light green and brown veined silicate stone
Height: 6 in. (15.2 cm.)
Provenance unknown, possibly Oaxaca
Late Postclassic, Monte Albán V phase, 1200–1500
Museum für Völkerkunde, Vienna, 12420

This rare Mixtec mask is more subtly modeled than the *penates* (Number 267), although the techniques employed are the same: straight-cut lines for the eyelids and mouth, and hollow-drill circles on the earspools and twisted-braid headdress. The raised eyebrow ridges and the slight creases on the corners of the lips, which create a Mona Lisa smile, are subtleties that give this mask a special beauty. The nearly natural size and twin holes in the upper corners strongly suggest that this mask was actually used, although not by a living person, for it has no perforations in the nose or eyes. Like Teotihuacán masks, it is hollowed out to a depth of 1¼ inches in back, with a flat center section separated by deep vertical grooves from the angled sides. Depictions of burial customs in Mixtec codices (Figure 25) show that death masks were placed over the faces of deceased notables after the bodies had been wrapped in bundles of cloth. While the polychrome masks in the codices suggest painted wood, and a few surviving wood masks have turquoise mosaic inlay, this monochrome stone mask may have been a variant.

269 Effigy bell of a human head

Cast copper
Height: 4⅝ in. (11.8 cm.)
Quemistlán, Santa Bárbara, Honduras (?)
Late Postclassic, 1200–1450
Raymond Wielgus, Chicago

This is an exceptionally fine example of a single-piece lost-wax casting, in which every detail of the spiral decoration and headdress was separately modeled in extruded wax thread and then carefully placed on the wax model of the bell before it was enveloped in the one-piece mold. In all probability this bell came from the famous cache of over eight hundred copper bells found in a cave near Quemistlán (A. D. Blackiston, "Recent Discoveries in Honduras," *American Anthropologist* 12, 1910, pp. 536–541). Trade in copper bells, indeed in all metalwork, was widespread in the Postclassic period, so that the ultimate provenance of an object such as this has little to do with its place of manufacture. The use of copper for a bell of this size and the decoration indicate a Western Mexican origin.

268

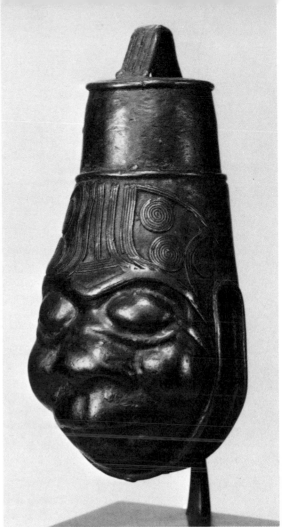

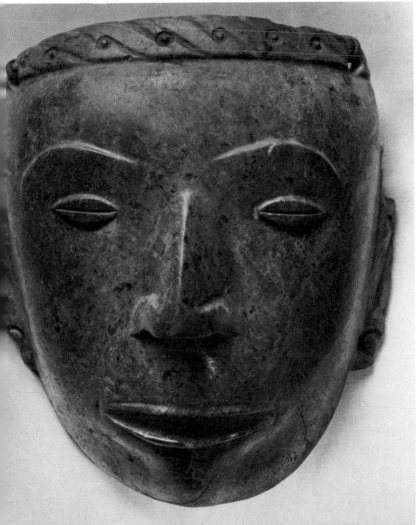

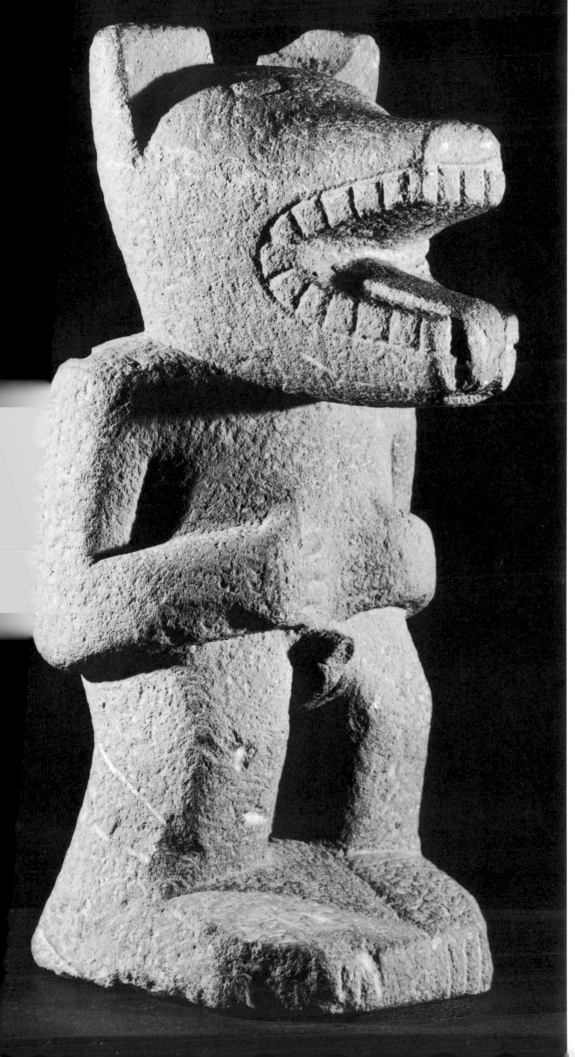

270 Mask of Xipe Totec

Cast copper, hammered dressed, traces of silver plating
Height: 5 in. (12.6 cm.)
Tzintzuntzan, Michoacán, Mexico (?)
Late Postclassic, 1250–1500
Museo Nacional de Antropología, Mexico, 2–4263

The Tarascans were probably the major producers of copper objects in Mesoamerica. In addition to common utilitarian pieces such as axes, pins, bells, and weapons, they were capable of creating important works of art like this mask. Here, the mask was cast in a mold by the lost-wax process. The nose and cheeks have been buffed and polished. The silver plating, identified recently by engineer Luis Torres, is extremely rare in Middle American metallurgy. The mask represents the flayed skin of a sacrificial victim, the tattoo marks down each cheek being an attribute of Xipe Totec, "Our Lord of the Flayed One," deity of spring growth and patron of metalworkers (see Numbers 277, 278).

271 Standing male animal

Pinkish buff stone
Height: 20⅞ in. (53 cm.)
Ihuatzio, Michoacán, Mexico
Late Postclassic, 1250–1500
Museo Nacional de Antropología, Mexico, 2–6466

This anthropomorphic animal, standing on two feet and holding his hands to his abdomen, may be tentatively identified as a coyote. The Tarascan sculptor emphasized the overall blocking out of straight-cut stone forms, unlike the Aztec sculptor, who created rounded finished surfaces with low-relief detail. Details on this Tarascan piece are merely excisions in the squared mass; thus, the eye is a flat circle that sits on top of the head mass, while the teeth are a line of squares bordering the mouth open-

ing, but not continued inside. The anatomical reality of the features has thus been denied, creating not a real animal but a harsh image. The long tongue, once the only thin projecting piece, has been broken off, emphasizing, even more than the sculptor intended, the raw blockiness of the figure.

272 Perforated mask of a skull

Conch shell (*Strombus galeatus* Sowerby)
Height: 5⅝ in. (14.5 cm.)
Buenavista de Cuéllar, Guerrero, Mexico
Postclassic, 950–1520
Museo Nacional de Antropología, Mexico, 2–6060

During a survey of the northern tip of the state of Guerrero, Sigvald Linné, the Swedish archaeologist, acquired this shell mask. "It was found, according to perfectly authentic information, during land cultivation and was laying over a skull" ("Archaeological Problems in Guerrero," *Ethnos* 17, 1952, p. 146). Although Linné was uncertain as to which culture it belonged, he rejected the suggestion that it was an import from the Huasteca, where there was an important Postclassic production of incised and cutout shellwork in patterns recalling codex scenes. The importation of both worked and unworked shells of Carribean origin was common in Mesoamerica. The death head symbolism and angular forms strongly suggest Postclassic iconography. The style seems to belong to the Mixteca-Puebla culture sphere but is not distinctive enough to identify more precisely.

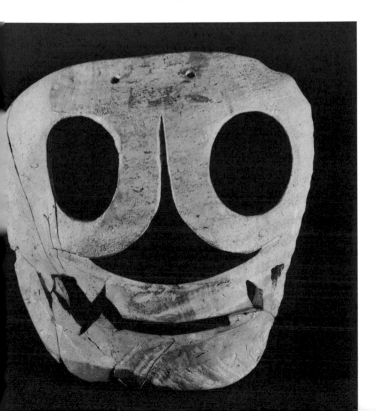

272

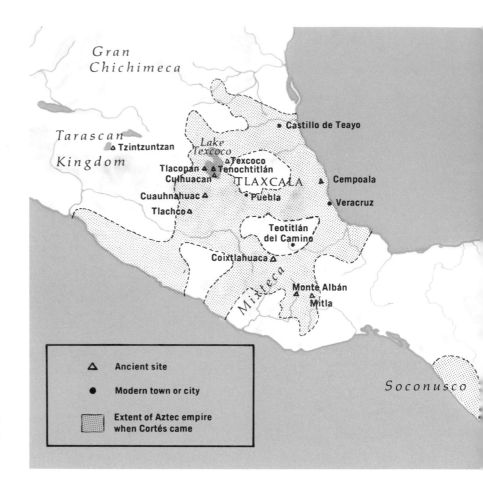

FIGURE 37

Reconstruction of a characteristic Aztec pyramid surmounted by a temple at Santa Cecelia Acatitlán, state of Mexico

The nearby pyramid of Tenayuca, which had two temples but which is so situated that it cannot be photographed adequately, served as the model for the Templo Mayor in Tenochtitlán, with its temples of Huitzilopochtli and Tlaloc.

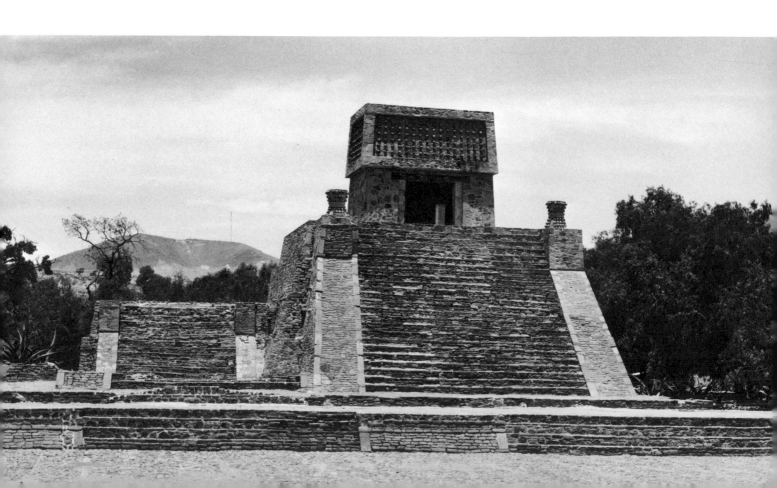

12

The Aztecs:
The Last Empire

Art became the handmaiden of imperial ambition in Aztec times. Despite the wholesale destruction in the sixteenth century an amazing quantity of fine sculpture has survived. The abundance and excellence of sculpture of all kinds produced within the brief period of Aztec ascendancy can be explained only in terms of a desire to impress, if not overwhelm, the beholder.

The Aztec state had its real beginning when a wandering tribe of barbaric nomads, clad in fiber garments and wearing straw sandals, settled on an island in Lake Texcoco in 1325 and founded Tenochtitlán. From that humble start it rose to the dazzling splendor of an imperial power that held sway over much of Mexico, all within a span of less than two centuries. In fact, most of its expansion and development, both political and cultural, took place within less than a century, between the accession of Itzcóatl as ruler in 1427 and the arrival of Cortés in 1519.

To understand that meteoric rise, which was still in progress when the Spaniards arrived, it will be necessary to look at the Aztecs, their mythology, their adaptability, their underhanded methods of statecraft, and, above all, their fanatic zeal and boundless energy. They were not innovators or inventors, but they did have a phenomenal capacity to learn and utilize what had been evolved by others.

For at least a century before these nomads came to rest at Tenochtitlán, their belligerency and obnoxious behavior as squatters had caused them to be kicked from pillar to post by civilized groups already established in the Valley of Mexico, principally the scattered survivors of Tula. In their travels they had also learned something of the past glories of Teotihuacán and Tula. From all this, being young, tough, and vigorous, they developed fortitude, a spirit of vengeance, a desire for the finer things of life, and an overweening ambition to rule and conquer. That ambition was fed by the priests of Huitzilopochtli, the tribal numen and the only deity in the bewilderingly complex pantheon not borrowed from their predecessors or from a conquered region. Those priests concocted the myth of the chosen "people of the sun," whose divine mission it was to save mankind by nourishing the sun with man's blood. That constant demand for sacrificial victims—for the most part prisoners of war—fitted in perfectly with incipient schemes for expanded political and economic power.

The march to glory began in 1367 when the Aztecs hired themselves out to Tezozomoc, the crafty Tepanec ruler of neighboring Atzcapotzalco. They soon established themselves as fearsome warriors, conquering one city-state after another in the Valley of Mexico. At the same time they rapidly learned from Tezozomoc every dirty trick of statecraft: duplicity, broken dynastic alliances, unscrupulous betrayals, terror, and violence. By 1428 they were ready to ally themselves with the lakeside city-states of Texcoco and Tlacopan to crush their former masters and take over what they had helped to win as mercenaries.

A year before that event the most remarkable man in Aztec history, Tlacaélel, appeared on the scene. Always in the background and never a titular ruler, he was the *éminence grise* or counselor of three successive rulers; it was he who drew up the master plan for the civilized empire that so amazed Cortés and his followers. To begin with, history had to be rewritten to provide these parvenus with a glorious past, so all the old screen-fold books and those of conquered peoples were burned. The "chosen people" myth was fostered assiduously, and the Aztecs were transformed overnight into the legitimate heirs of the great Toltec cultural tradition. (They even ceased to refer to themselves as Aztecs, and became the Mexica, or Mexicans.) Splendid art and architecture, literature, fine craftsmanship, compulsory education, iron discipline, self-control, and good manners—all the trappings of civilization—were called for. Smoothly functioning social, political, and economic organizations were to be added to an established military machine.

Wars of conquest went on unremittingly between the accession of Moctezuma I in 1440 and the death of Ahuítzotl in 1502, all for the greater glory of the sun god, and, incidentally, for the political and economic well-being of Tenochtitlán and its allies. At the same time the cultural side of life was not neglected. Moctezuma I started the urban development of the capital by bringing in skilled architects from nearby Chalco; it was also during his reign, according to Bernal, that "a great style of sculpture began, which had its own character and which has given us some of the most interesting monuments of Aztec art" (see Numbers 273–289). As it evolved, that style of sculpture had as one of its goals the translation of myths into perceptible images, such as the portrayal of a nasty water monster as an appealing sort of canine (Number 279), or the masterful combination of the mythological Feathered Serpent and the human form (Number 282).

In a matter of sixty-two years the fertile lands of the Gulf Coast with their great sculptural heritage (see Numbers 127, 276), the civilized Mixteca-Puebla area with its tradition of fine craftsmanship, the present state of Mexico (Figure 37), the

FIGURE 38

Plaza of the Three Cultures—Aztec, colonial, and modern—in Tlatelolco, a part of Mexico City

The remains of the main pyramid and ceremonial center in the well-known Aztec market area, and those of the church of Santa Cruz, where Sahagún wrote a large part of his *Historia General*, are framed by a series of modern apartment buildings.

neighboring and friendly city of Tlatelolco (Figure 38), and lands as far south as the Guatemalan border with their rich tropical products were forcibly brought under Aztec hegemony. These conquests assured not only a steady stream of tribute, but also a supply of skilled artists and craftsmen, who were brought to the capital to work and to train Aztec apprentices.

The vigor and realism of Aztec sculpture in the round, as opposed to the angularity and flatness of Toltec architectonic sculpture, are no doubt the result of a subtle blending of Aztec temperament and infusions from other regions. The exquisite craftsmanship in wood carving (Numbers 291–293), fine metalwork (Numbers 297–300), lapidary work (Numbers 290, 301–304), and turquoise mosaic work (Numbers 294–296) was derived principally from Mixtec sources, either as tribute or as the work of transplanted master craftsmen and their Aztec pupils.

While Moctezuma II (1502–1520) added to the grandeur of the capital, his military exploits were for the most part limited to putting down one rebellion after another among peoples subjugated by his predecessors. By their merciless conquests and harsh treatment of their victims the Aztecs sewed the seeds of their own destruction, assuring Cortés a ready-made supply of enthusiastic Indian allies.

The wholesale adoption of Toltec legends and mythology by the Aztecs also played into the hands of the invading Spaniards, for it was predicted that the great Quetzalcóatl would return from the East to rule again in the year "One Reed" (Chapter 11). Cortés had the unbelievable good fortune to land at Veracruz in 1519, the Aztec year "One Reed." From that time on, Moctezuma II was immobilized, a prisoner of his own beliefs. He seems to have been convinced that the "white gods" were Quetzalcóatl and his companions, but he did try to discourage these strangers from coming to Tenochtitlán without offending them personally. When attempts of others to deter the Spaniards at Tlaxcala and Cholula failed, Moctezuma saw no alternative to welcoming them as returning gods, and, thanks to the incredible audacity of Cortés, submitting to fate by allowing himself to become their involuntary guest in the heart of his own capital. It was then too late. To label him pusillanimous under such circumstances is as wrong and unjust as it would be to give Cortés and his little band sole credit for humbling the mighty Aztec empire in a matter of months in 1521.

FIGURE 39

Model of the ceremonial center of Tenochtitlán

This model, in the Museo Nacional de Antropología in Mexico City, shows the ceremonial center as it was when first seen by Cortés and his followers in 1519.

273 Large serpent head

Volcanic stone with traces of stucco and paint
Length: 42 in. (1.07 m.); height: 35½ in. (90 cm.)
Mexico City
Aztec, about 1440–1521
Museo Nacional de Antropología, Mexico, 11–3003

Large serpent heads were commonly placed at the foot of the snake balustrade on either side of the ceremonial stairways on Toltec and Aztec pyramids. Examples *in situ* may still be seen in the excavation of the base of the Templo Mayor, near the Cathedral in Mexico City. They represent Quetzalcóatl, the Feathered Serpent, the best-known deity and culture hero in Postclassic Mesoamerica.

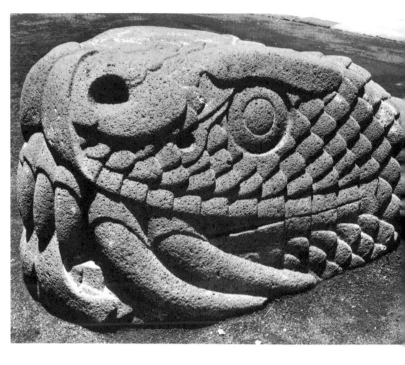

274 "Coatlicue del Metro"

Basalt with traces of red paint
Height: 36½ in. (93 cm.)
Mexico City
Aztec, about 1440–1521
Museo Nacional de Antropología, Mexico, 11–3473

This awe-inspiring sculpture in almost mint condition was found in 1967 during excavations for the new Mexico City subway, and gives a tantalizing indication of the treasures that must still lie below street level in the modern capital. It portrays Coatlicue, the goddess of the earth, giver of life and death, in her male aspect as the monster Tlaltecutli. Adorned with human skulls and tibiae, a necklace of human hands and hearts, and a girdle with the skull brooch in back, the deity sits cross-legged with hands in the form of eagle talons at either side of the face, which looks directly upward. This strange attitude is characteristic of the deity, who is more often represented in relief (see the base of Number 284) so that the face appears upside down (R. M. Arana, "Hallazgo de un monolito en las obras del S.T.C. (Metro)," *Boletin del Instituto Nacional de Antropología e Historia* 30, 1967, pp. 19–23; and 31, 1968, p. 51; also H. B. Nicholson, "A fragment of an aztec relief carving of the earth monster," *Journal de la Société des Américanistes*, n.s. 56, 1967, pp. 81–94).

275 Seated standard-bearer

Laminated sandstone
Height: 31⅝ in. (80 cm.); width: 13⅜ in. (34 cm.)
Castillo de Teayo, Veracruz, Mexico
Aztec, about 1480–1491
The Metropolitan Museum of Art, Harris Brisbane
 Dick Fund, 62.47

It was usual to have a pair of stone figures, commonly of standing or seated human beings but occasionally of jaguars, at the head of the stairway on temple platforms of Toltec and Aztec pyramids. These had provision for a staff tipped with a banner, which was displayed on ceremonial occasions. This simple, uncomplicated figure represents a *macehual*, or man of the people, and hence has a naturalism lacking in symbolic Aztec sculptures of deities. Although from a small outpost in Veracruz, it ranks with the finest works found in the capital. Thanks to its style and a dated stela at Castillo de Teayo, rare at Aztec sites, it can be dated within a span of about eleven years. (Dudley T. Easby, Jr., *The Metropolitan Museum of Art Bulletin* 21, 1962–1963, pp. 133–140.)

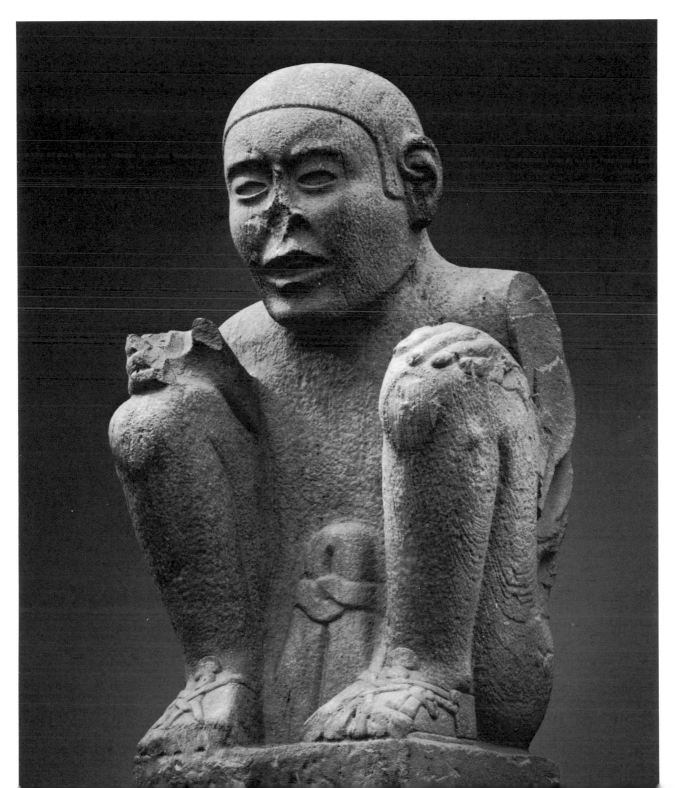

276

277

276 Head from figure of a deity

Buff orange pottery
Height: 10½ in. (27 cm.)
Probably Veracruz
Aztec, about 1440–1521
Mr. and Mrs. Jacob M. Kaplan, New York

Judging by European standards, we might say that this sensitive and realistic head is the work of the Aztec sculptor at his best; the figure from which it was broken must have been truly impressive. The three stalks on the headdress are a Late Postclassic convention for the crest of either an eagle or a variety of curassow (*faisán*), which appears on Mixtec goldwork and on xantil figures from Teotitlán del Camino in Oaxaca. According to Bernardino de Sahagún (*Historia General de las Cosas de Nueva España*, IV, Mexico City, 1956, p. 287) and Alfonso Caso (*El Tesoro de Monte Albán*, Mexico City, 1969, pp. 99, 107, figs. 64, 76a, 79, 80a, 83, pls. XI and XII), this symbolic crest is an attribute of Xochipilli-Macuilxóchitl, "Flower Prince" or "Five Flower," god of games, love, song, and dance, and one of the multiple aspects of the sun. Caso further notes that the crest represents *chalchihuites*, or jade beads, "the most precious substance," also related to the sun.

277 Standing figure of Xipe Totec

Dark gray volcanic stone with traces of red paint
Height: 30½ in. (77.5 cm.)
Tepepán, state of Mexico
Aztec, A.D. 1507 (?)
Museum of the American Indian, Heye Foundation,
 New York, 16/3621

Xipe Totec, "Our Lord of the Flayed One," god of spring vegetation and patron of metalworkers, was the principal deity of the Yopi, who lived in the state of Guerrero near the border of Oaxaca. His cult appeared in the Valley of Mexico as early as the epoch of Teotihuacán, and he was later one of the principal gods in the Aztec pantheon. In the gruesome sacrificial ceremony to honor him the victim was flayed, and the priest was sewed into his skin, representing the new vegetation in the manner shown here. This figure unquestionably served as a standard-bearer on a temple platform (see Number 275). The glyph in the cartouche on the back appears to be "Two Reed," which corresponds to 1507, the year of the New Fire ceremony (Number 285) (Alfonso Caso, *Los Calendarios Prehispánicos*, Mexico City, 1967, table xv). Masks of Xipe are common: in stone (Number 278), in Mixtec goldwork (Number 297), and in copper from Western Mexico (Number 270).

278 Mask of Xipe Totec

Gray volcanic stone with traces of red paint
Height: 9 in. (22.8 cm.)
Valley of Mexico (?)
Aztec, about 1440–1521
The British Museum, London, 1956 Am.X.6
Ex coll. Christy

This mask differs from another black polished stone one in The British Museum and a rhyolite one in the Musée de l'Homme in Paris in having the open mouth extend through to the back. All three have the same corded treatment of the hair, but the Musée de l'Homme example lacks the spool-shaped earplugs. The two British Museum masks are so close in technique and decoration, especially on the back where each has a full figure in low relief of a priest as Xipe with all his attributes, as to suggest that they were made by the same hand. It is said that the Aztecs frequently made their idols like a tailor's dummy on which the mask and raiment of the particular deity they wished to honor were placed on ceremonial occasions. This mask probably was intended to be set on such an idol.

278

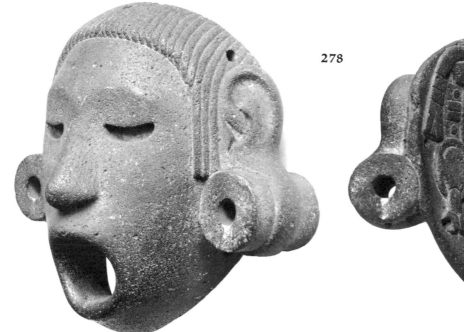

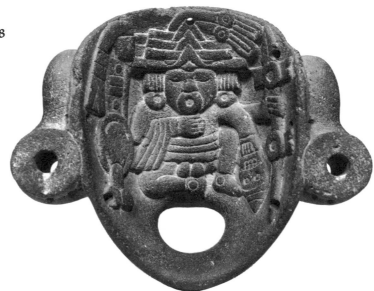

279 Ahuítzotl(?)

Reddish volcanic stone *(tesontli)*
Height: 17 in. (43 cm.)
Provenance unknown
Aztec, about 1440–1521
Museo Regional de las Artesanías Populares Poblanas,
Puebla, Mexico

Although frequently called a dog or coyote, this appealing "canine" probably represents a rather unsavory mythological character, Ahuítzotl, an aquatic creature who lured people to death by drowning. The paws and claws are certainly not those of any canine, but they are almost identical with those of Ahuítzotl as portrayed on a well-known feather mosaic shield in Vienna (where the animal has been miscalled a coyote), and in the name glyphs for the eighth Aztec ruler (1486–1502), also called Ahuítzotl. The eyes are so deeply cut as to suggest that they were originally inlaid. (Pál Kelemen, *Medieval American Art*, I, 3rd rev. ed., New York, 1968, p. 111.)

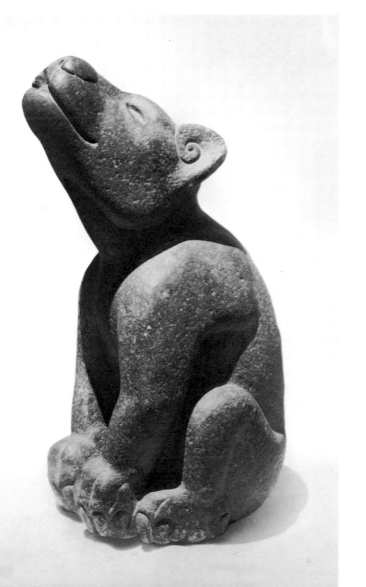

280 Eagle relief

Volcanic stone
Height: 8 in. (20 cm.); length: 11 in. (28 cm.)
Valley of Mexico (?)
Aztec, about 1440–1521
The British Museum, London, 8624
Ex coll. Uhde

This fragment of a larger piece is a splendid example of the striking realism the Aztec sculptor brought to portrayals of subjects from the natural world. Since it is a fragment, it is impossible to say what the entire piece was. However, despite the importance of the eagle in Aztec legend, mythology, and military organization, this appears to be one of the very rare examples in stone sculpture of the bird without more in the way of symbolism.

281 Greenstone Xolotl

Blue green jadeite(?), red shell, and bone
Height: 11¾ in. (29.7 cm.)
Provenance unknown
Aztec, about 1440–1521
Württembergisches Landesmuseum, Stuttgart

The Aztec interpretation of the cosmos was intimately linked to the planet Venus. This skeletal god Xolotl represents the planet Venus in its form as the evening star; he is the "dog deity" who guides the sun through the underworld during the night. The sun returns with the morning star, a form of Quetzalcóatl, the "twin" of Xolotl. The rear of this figure's head shows a feathered serpent. The hair (quetzal feathers), containing two St. Andrew's crosses of Xolotl, cascades down the back and sides. The sun disk with the sun god in its center identifies Xolotl as the guide of the sun. The time lapse between the two upper calendar dates in each of the two bands that hold the hair is 292 days, half of the 584-day Venus cycle. The four middle band glyphs and the "One Eagle" on the breechcloth are dates assigned to the west, initiating the third quarter of the *Tonalámatl*, the sacred Aztec book of days. The symbol of the planet Venus with the star-eye of the firmament is repeated at each band terminal. The eye alone is visible on both sandals. The figure has the characteristic hooked ear pendants of Quetzalcóatl. Each hand, inscribed with calendar dates, holds a curved instrument with death heads, perhaps a symbol of lightning. Shell inlays suggest the interior of the mouth and nose, and the two cavities under the breastbone also held inlays originally. (Eduard Seler, *Gesammelte Abhandlungen zur Amerikanischen Sprach- und Altertumskunde*, III, Graz, 1960, pp. 392–409.) (See Color Illustration.)

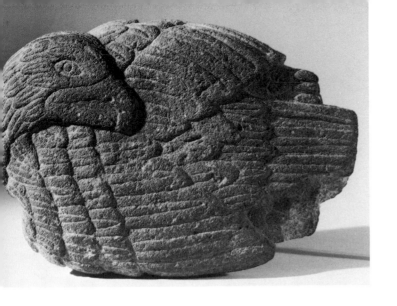

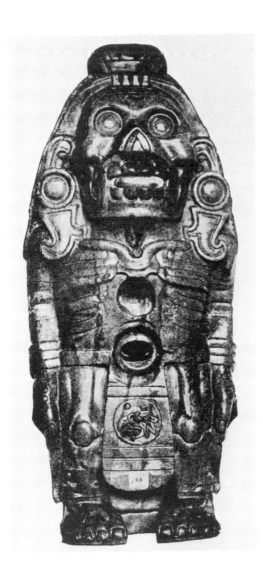

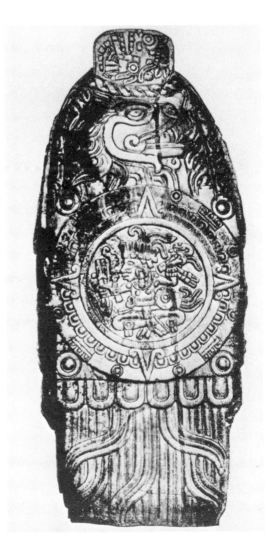

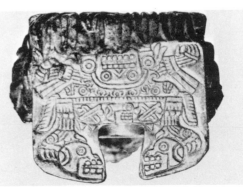

282 Quetzalcóatl, the Feathered Serpent

Green porphyry
Height: 17⅜ in. (44 cm.)
Valley of Mexico
Aztec, about 1440–1521
Musée de l'Homme, Paris, 78.I.59

This delicately carved and polished figure is a literal translation in sculpture of the name of the best-known deity, ruler, and culture hero in all of Postclassic Mesoamerica. The artistic canon of having the head of the deity in the mouth of the serpent is a common one, but the anthropomorphic portrayal of the hands and feet is relatively rare. The ear ornaments in the hooked form of a section of conch shell (*epcolloli*) are one of the unmistakable attributes of Quetzalcóatl. In the chest there is a circular depression among the feathers, which symbol-izes the heart, often represented by an inlay of jade (*chalchihuitl*). Like the Maya lapidaries, who often made their jade carvings conform to the shape of the pebble, the sculptor here has made his creation conform to the shape of the porphyry boulder. (*Chefs-d'Oeuvre du Musée de l'Homme*, Paris, 1965, p. 182.)

283 Pulque beaker

Dark micaceous stone (phyllite)
Height: 14¼ in. (36 cm.); diameter: 6¾ in. (17 cm.)
Provenance unknown
Aztec, about 1440–1521
Museum für Völkerkunde, Vienna, 6069
Ex coll. Bilimek

The entire surface of the vessel is covered with low-relief carvings that embrace a large part of the Aztec cosmos.

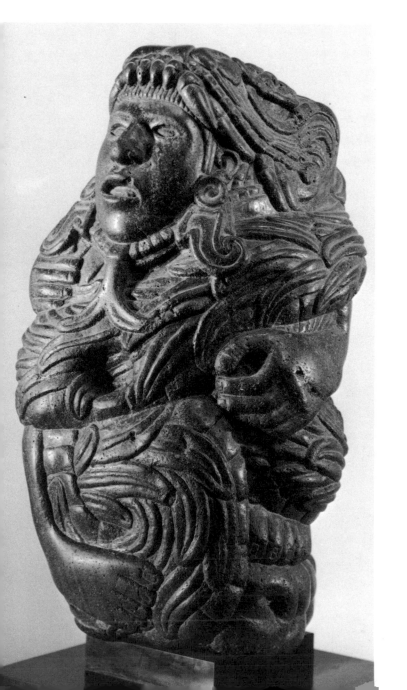

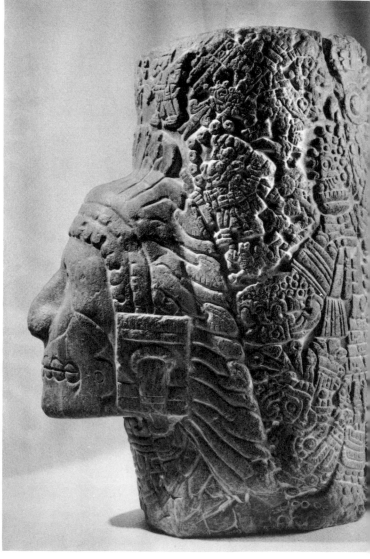

These include the sun, the mythical date of the creation of the current era, the prediction that earthquakes will terminate this era, the earth goddess and patron of life and death, the fire god, allusions to war and the warrior's death, and a number of glyphic representations of pulque (the Mexican intoxicant derived from the maguey plant) and pulque gods. The projecting head is readily identified as a pulque god, the fleshless jaw, the strands of grass (*malinalli*) representing the hair, and the square ear ornaments being among his attributes. (Eduard Seler, *Gesammelte Abhandlungen zur Amerikanischen Sprach- und Altertumskunde*, II, Graz, 1960, pp. 913–975.)

284 Tepetlacalli, or stone box

Gray green mottled stone
Height: 6 in. (15.4 cm.); length: 13⅛ in. (33.4 cm.); width: 8¼ in. (21 cm.)
Probably Texcoco
Aztec, about 1470 (?)
Hamburgisches Museum für Völkerkunde und Vorgeschichte, B-3767
Ex coll. Hackmack

This famous and enigmatic box, sometimes identified with the poet-king Nezahualcoyotl, has been studied by Eduard Seler, Alfonso Caso, and H. B. Nicholson over a span of three generations; but as yet there is no conclusive interpretation of the elaborate relief decoration on the top of the lid, the base of the box, the four sides, the inside of the lid, and the bottom of the box. The representation of the Feathered Serpent on the top of the lid, that of the Earth Monster on the base (a common feature of these stone boxes), and the glyphic inscriptions of dates have not been, and may never be, fully interpreted to everyone's satisfaction. Dates such as "One Reed" and "Seven Reed" on the top of the lid are mythico-ritualistic and related to Quetzalcóatl, but it is not possible to say whether other dates are ritualistic or refer to actual events. For example, "One Rabbit" on one end of the box may refer to the mythical date of the creation or equally to 1402, the year of Nezahualcoyotl's birth; but "Four Rabbit" on the other end has no ritualistic significance although it corresponds to 1470, two years before the death of the great Texcocan monarch. In several other stone boxes associated or identified with named rulers, the latest year glyph has corresponded to a time two or three years before the death of the ruler. This led Caso to suggest that the box was not, as reported by sixteenth-century chroniclers, intended to be a cinerary urn for the particular ruler's ashes. In short, this object must be enjoyed for its fine workmanship and artistry, and questions about its ownership, meaning, and intended use left for further study. (Eduard Seler, *Gesammelte Abhandlungen zur Amerikanischen Sprach- und Altertumskunde*, II, Graz, 1960, pp. 731–735.)

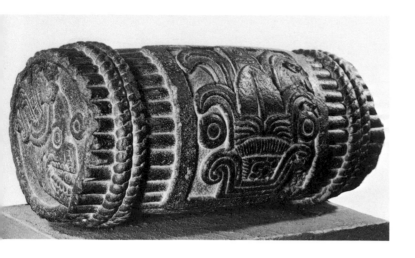

285 Year bundle

Stone
Length: 2¾ in. (60 cm.); diameter: 9¾ in. (25 cm.)
Mexico City
Aztec, 1507 (?)
Museo Nacional de Antropología, Mexico, 11–3331

The Aztec "century" consisted of fifty-two years, represented as a tied-up bundle of reeds (years), or *xiumolpilli*. When rendered in stone or wood, they were often used at feasts or ceremonies as seats for dignitaries *(tolicpalli)*. This example not only bears the glyph for "Two

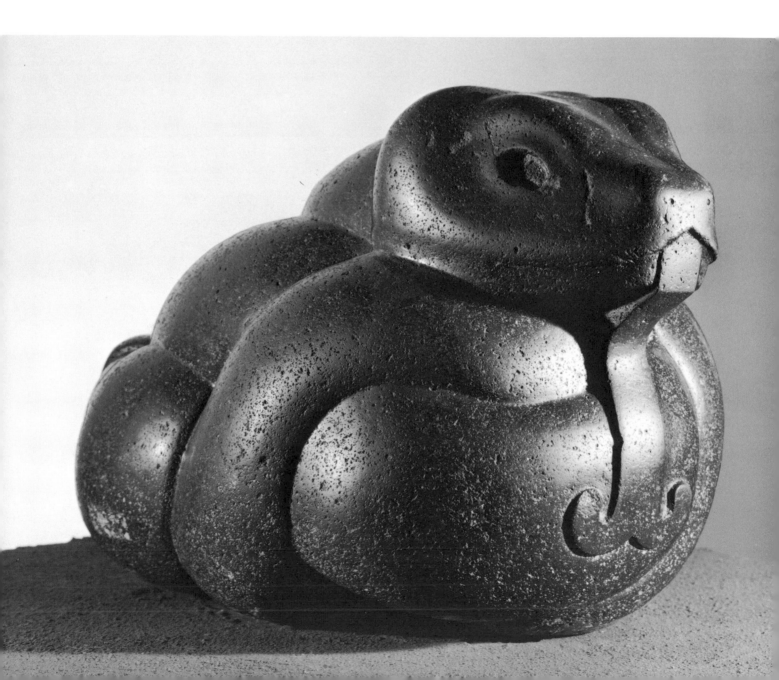

Reed," the date of the New Fire ceremony that marked the beginning of the new "century," but also is identified with Tezcatlipoca, the fire maker, by his "Smoking Mirror" sign superimposed on the date glyphs for the days "One Death" and "One Flint Knife" on either end of the bundle. (Eduard Seler, *Gesammelte Abhandlungen zur Amerikanischen Sprach- und Altertumskunde*, II, Graz, 1960, pp. 878–879.) "Two Reed," the date of the New Fire ceremony, corresponds to the year 1507 and quite possibly marks the year this work was executed (see Number 277).

286 Coiled snake

Diorite with high polish
Height: 9 in. (23 cm.); length: 16⅞ in. (43 cm.)
Valley of Mexico
Aztec, about 1440–1521
Museo Nacional de Antropología, Mexico, 11–3010

This prime example of Aztec sculpture approaches lapidary work in its execution. The elaborate coil was so carefully planned that the convolutions can be followed from head to tail, suggesting that it was carved after a rope model. The naturalism of the body contrasts sharply with the stylized tongue, and the masterful combination of accurate observation of the natural form with controlled adherence to inner symbolism (here the earth) is characteristically Aztec. The eye sockets were left rough, and undoubtedly had inlays originally.

287 Cactus with roots

Volcanic stone
Height: 38½ in. (98 cm.)
Valley of Mexico
Aztec, about 1440–1521
Museo Nacional de Antropología, Mexico, 11–3352

Two traits characteristic of Aztec sculpture of plant forms—vivid realism based on accurate observation and portrayal of an idea of the whole plant, or the concept of the fruit with its flower—are evident in this example and in Numbers 288 and 289. Here the sculptor has included the tangled roots, not visible in nature, to convey the concept of the entire plant. Although the cactus has no religious significance, it had, and still has, an important role in the economy. It provides fruit (the *tuna*) and vegetables (the young pads, *nopalitos*), both important food items; its impenetrable growth is used to fence off boundaries; its spines make serviceable sewing needles, and in pre-Hispanic times were used for bloodletting in rites of auto-sacrifice. (A botanical purist might insist that agave or maguey, the source of fiber for thread and rope, and of pulque, mescal, and tequila, is a succulent but not technically a cactus, so these have been omitted above.)

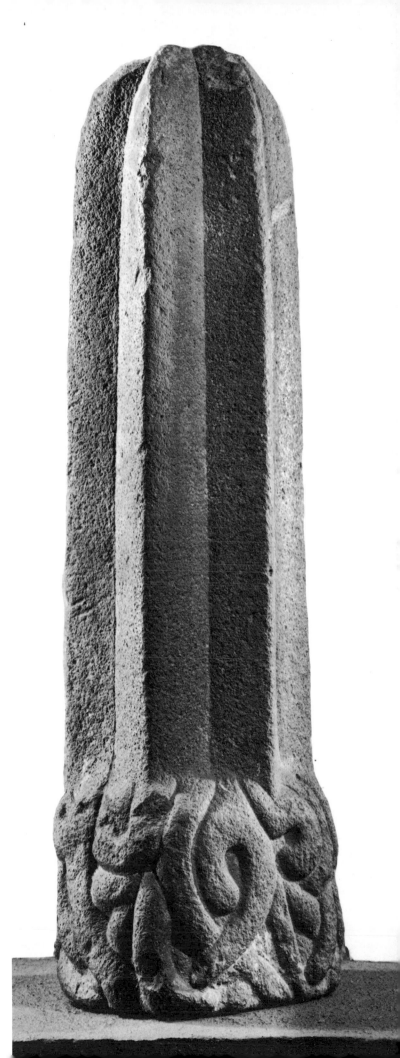

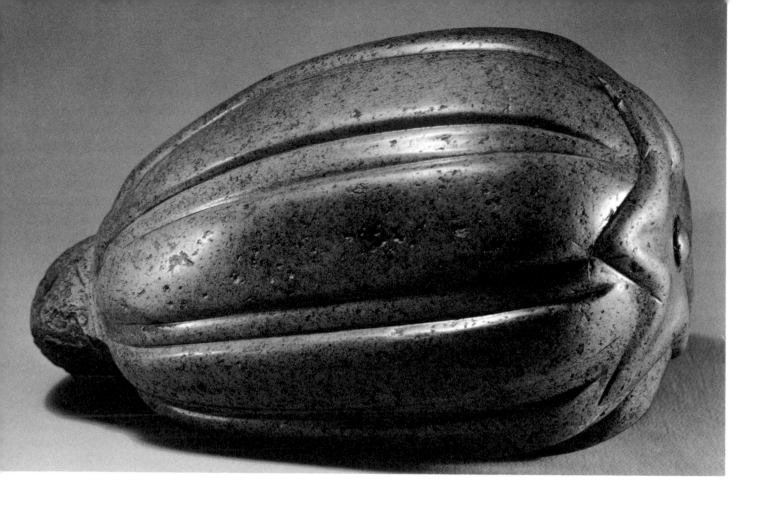

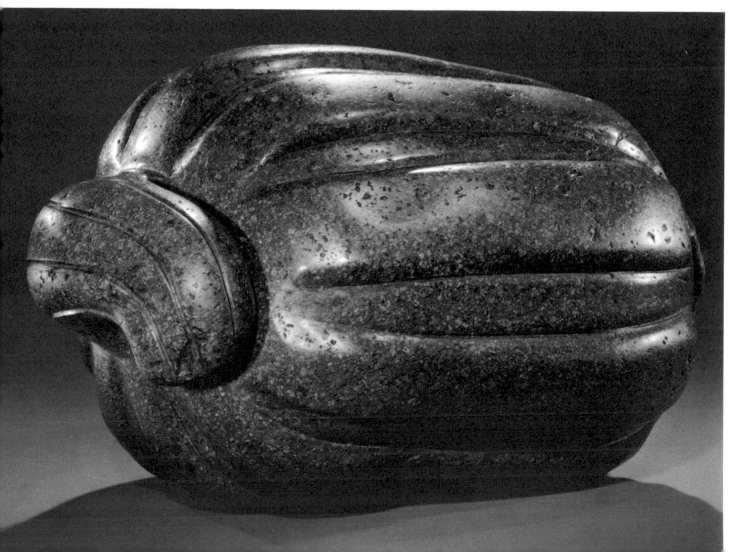

288 Squash (pumpkin) with its flower

Porphyry
Length: 11¾ in. (30 cm.); diameter: 7⅛ in. (18 cm.)
Valley of Mexico
Aztec, about 1440–1521
Museo Nacional de Antropología, Mexico, 11–2765

This representation of a cucurbit is so true to life that in order to test his audience's powers of observation a former director of the Museo Nacional once displayed it in a case with a green pumpkin from a local market, and his visitors merely wondered why he had set up a botanical exhibit in an archaeological museum. In all respects it is a twin of, and surely came from the same hand as, Number 289. The Aztec convention of having a single work embrace both the fruit and the flower appears in each, and the lapidary techniques employed are identical. These objects may possibly have been offerings in a temple of agriculture, for the squash or pumpkin ranked with corn and beans as a staple. Also, the seeds were salted in ancient times for *pepitas* (today a favorite cocktail tidbit). Today the green fruit is candied for *dulce de calabaza*, the fibers candied to make *cabello de angelitos* (angels' hair), and the seeds ground to make *horchata*, a delicious nonalcoholic drink.

289 Squash (pumpkin) with its flower

Porphyry with feldspar inclusions
Length: 9⅝ in. (24.5 cm.); diameter: 7¾ in. (19.7 cm.)
Valley of Mexico
Aztec, about 1440–1521
Mr. and Mrs. Dudley T. Easby, Jr.
Ex coll. A. W. Bahr

This is in all respects a twin of Number 288 and was almost certainly executed by the same observant sculptor. It has been subjected to the botanical scrutiny of E. W. Sinnott, Yale's great authority on botany, of G. M. H. Lawrence and H. E. Moore of the Bailey Hortorium at Cornell, and of Hugh Cutler and Thomas Whittaker of the Missouri Botanical Garden, all of whom have at least tentatively classified it as representing *Cucurbita pepo*. Carbon 14 analyses of the dried remains of this variety found in a dry cave in Mexico have yielded dates between 7000 and 5500 B.C., making *Cucurbita pepo* one of the oldest domesticated plants in the New World (T. W. Whitaker, H. C. Cutler, and R. S. MacNeish, "Cucurbit Materials from three caves near Ocampo, Tamaulipas," *American Antiquity* 22, 1957, pp. 352–358; see also H. C. Cutler and T. W. Whitaker, "History and Distribution of the Cultivated Cucurbits in the Americas," *American Antiquity* 26, 1961, pp. 469–485).

290 Squash

Mexican onyx (tecali)
Length: 5¼ in. (13.4 cm.)
Said to be from Mitla, Oaxaca, Mexico
Aztec-Mixtec style, about 1461–1521
The British Museum, London, 1952 Am.18.1

Like Numbers 288 and 289, this is a lifelike representation of an actual fruit, but without the artistic license of including the flower or blossom. The workmanship is superb and brings to mind fine lapidary work rather than stone sculpture. It appears to be *Cucurbita mixta*, or cushaw, and remains of this variety found in a dry cave in Tamaulipas have yielded a Carbon 14 date of A.D. 150 (H. C. Cutler and T. W. Whitaker, "History and Distribution of the Cultivated Cucurbits in the Americas," *American Antiquity* 26, 1961, table 2, fig. 6f).

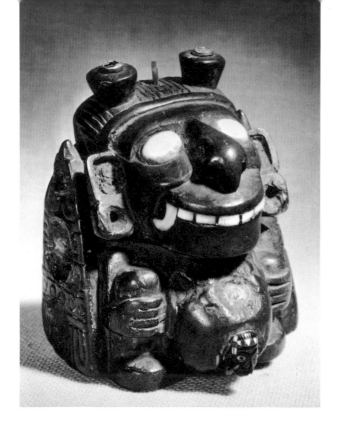

291 Pectoral (?) in the form of Xolotl

Wood, shell and turquoise inlay, carved jet (or possibly
 obsidian), and silver nails
Height: 3½ in. (9 cm.)
Valley of Mexico
Aztec-Mixtec style, about 1461–1521
Museum für Völkerkunde, Vienna, 12585

This cheerful smiling fellow, the "twin" of Quetzalcóatl
(see Number 281), is a technical tour de force as well as
a small masterpiece. The silver nails with gilded heads,
the inlays attached with wooden pegs, and the small pro-
jecting head carved in "jet" with minute inlays are a
unique combination and certainly demonstrate a long
tradition of fine craftsmanship. Although not positively
identifiable in the early inventories, this piece is general-
ly regarded as part of the loot sent back by Cortés. Con-
sidering its age, fragility, and complicated structure, it
has suffered remarkably little loss over the centuries:
only the ear ornaments, a few bits of inlay, and what
may have been a small pyrite mirror from the back are
missing. (K. A. Nowotny, "A Unique Wooden Figure
from Ancient Mexico," *American Antiquity* 15, 1949, pp.
57–61.) (See Color Illustration.)

292 Two-toned drum (teponaztli)

Wood
Length: 19¼ in. (49 cm.); diameter: 6¾ in. (17 cm.)
Valley of Mexico
Aztec, about 1440–1521
The British Museum, London, 1949 Am.22.218

The *teponaztli* is a hollow ceremonial drum or gong with
two slotted tongues cut into the top, which, when struck,
produce different notes. The fact that the carving on this
one is in mint condition and on a perishable material
warrants the surmise that it was never below ground (not
an archaeological find), but rather was probably part of
the loot sent to Europe in the sixteenth century. The owl,
the *tecolotl* of the Aztecs and *cui* of the Maya, was a bird
of ill omen and the harbinger of death. Alfonso Caso has
pointed out that its "nocturnal song is considered even
today [in parts of Mexico] to be fatal to anyone who
hears it" (*The Aztecs, People of the Sun*, Norman, Okla-
homa, 1958, p. 58). It is therefore possible that this drum
served some funerary purpose.

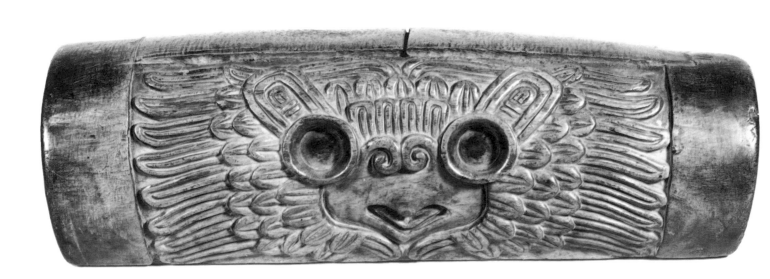

293 Carved and gilded atlatl

Wood (probably sapote), gold leaf, shell, and cord
Length: 22½ in. (57 cm.); width: 1½ in. (3.8 cm.)
Valley of Mexico (?)
Aztec, about 1440–1521
Museo Nazionale Preistorico ed Etnografico Luigi
 Pigorini, Rome

Atlatl is the Aztec name for a spear-thrower. The elabo-
rate and delicate carving, as well as the gold leaf, on this
example suggests that it was probably used as a cere-
monial baton. The principle of the spear-thrower is to
achieve greater force and distance by effectively length-
ening the arm of the thrower. Instead of being grasped in
the hand, with a throwing radius of an arm's length, the
spear is rested in the channel with its end against the
spur at the end of the atlatl. This increases the throwing
radius by the length of the atlatl. Only five gilded cere-
monial atlatls from Mexico are known, and this is the
only one with both of its original shell finger rings. It is
possible that this atlatl belonged to a leader of the "Jag-
uar Knights," one of the two great warrior orders of the
Aztecs. On the reverse side, a man is shown with a jag-
uar headdress, facing another figure blowing a conch
trumpet, an instrument identified with the jaguar. Sev-
eral sections below this scene, a spotted jaguar crouches
with pendant tail. Another jaguar, identified by his spots,
runs toward an approaching deer along the groove on the
obverse side of the atlatl. War, human sacrifice, and
death are recognizable themes of the undecipherable to-
tal message of the atlatl's carving. (G. V. Callegari, "Un
Nuevo Precioso 'Atlatl' Mexicano Antiguo Reciente-
mente Descubierto en Roma," *Actas y Trabajos Cientí-
ficos del XXV Congreso Internacional de Americanistas,
La Plata, 1932*, Buenos Aires, 1934, pp. 7–9.)

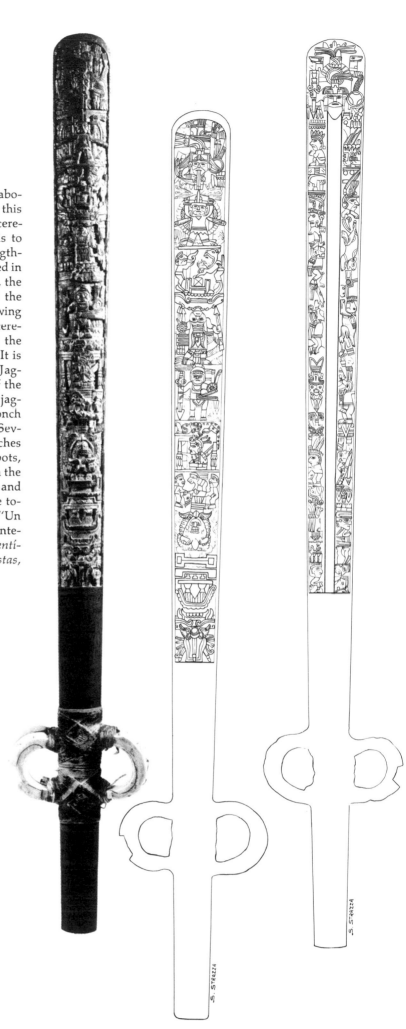

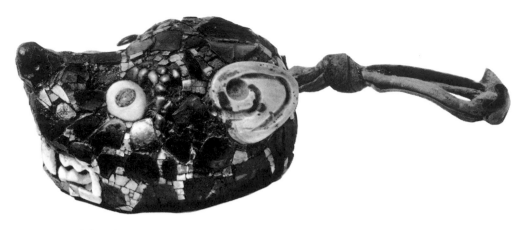

294 Animal-head mirror mounting with leather thong

Wood base, with mosaic of turquoise, jade, obsidian,
mother-of-pearl, shell, and glass
Length: 3⅞ in. (9.7 cm.)
Mexico City
Aztec-Mixtec style, Post-Conquest, sixteenth century
Museum für Völkerkunde, Vienna, 43382

The presence of bits of yellow green bottle glass in the mosaic definitely establishes this much of the piece as post-Conquest. Otherwise, it is entirely pre-Hispanic in concept and workmanship. The fact that it appears in the Hapsburgs' Schloss Ambras inventory of 1596 is a clear indication that it was among the earliest objects sent back to Europe. At one time the opening on the underside probably held an inlay of pyrite that served as a mirror (see Number 305). (K. A. Nowotny, *Mexikanische Kostbarkeiten aus Kunstkammern der Renaissance im Museum für Völkerkunde*, Vienna, 1960, pp. 60–61.)

295 Handle from a sacrificial knife

Wood, with turquoise, malachite, shell, and mother-of-
pearl mosaic
Length: 5⅛ in. (13 cm.); height: 3½ in. (9 cm.)
Valley of Mexico (?)
Aztec-Mixtec style, about 1461–1521
Museo Nazionale Preistorico ed Etnografico Luigi
Pigorini, Rome

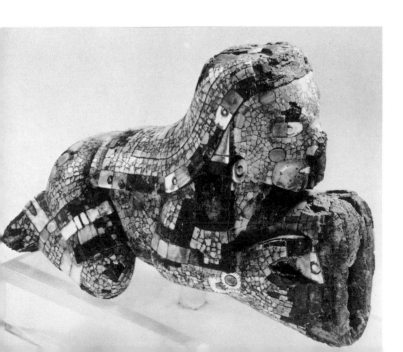

From the standpoint of appreciation of color values and delicacy of workmanship, this is perhaps the finest of all surviving pre-Hispanic stone and shell mosaics. Only three mosaic knife handles are known, one in The British Museum (the chipped flint blade of which is not original), this one, and another one of a crouching animal figure, also in the Pigorini. The main damage to this example is between the hands in front, where the chipped flint blade has been lost. Pieces of this caliber could probably have been produced for the Aztecs only by Mixtec workmen transplanted to Tenochtitlán after 1461 (or their descendants); or they may have been items of tribute from the Mixteca-Puebla area. (M. H. Saville, "Turquois Mosaic Art in Ancient Mexico," *Contributions from the Museum of the American Indian, Heye Foundation*, VI, New York, 1922, pp. 82–84.) (See Color Illustration.)

296 Mask (probably Quetzalcóatl)

Wood, with turquoise, jadeite, shell, and mother-of-
pearl mosaic
Height: 9½ in. (24 cm.)
Valley of Mexico (?)
Aztec-Mixtec style, about 1461–1521
Museo Nazionale Preistorico ed Etnografico Luigi
Pigorini, Rome

As Saville (see pp. 61–62, pl. VIII, of the work cited under Number 295) has pointed out, this is "one of the best preserved pieces in Europe, and its history is known as far back as 1553," when it was purchased for 2.50 francs from Cosimo de' Medici. The tiny bits of stone and shell are perfectly fitted; the eyes, nostrils, and mouth are perforated, showing that it was intended to be worn by a priest. It represents a human face with a characteristic stepped nose ornament in the open jaws of a serpent. Twisted serpent bodies extend over the forehead, and the plumed head of a serpent projects from the upper part of the left side. Whether a similar serpent head once projected from the opposite side of the mask is debatable; Saville considers it almost "impossible that the artist would have made this elaborate piece so symmetrical." (What appear as two light-colored projections in the mouth are not fangs, but modern plastic hooks used to mount the piece.)

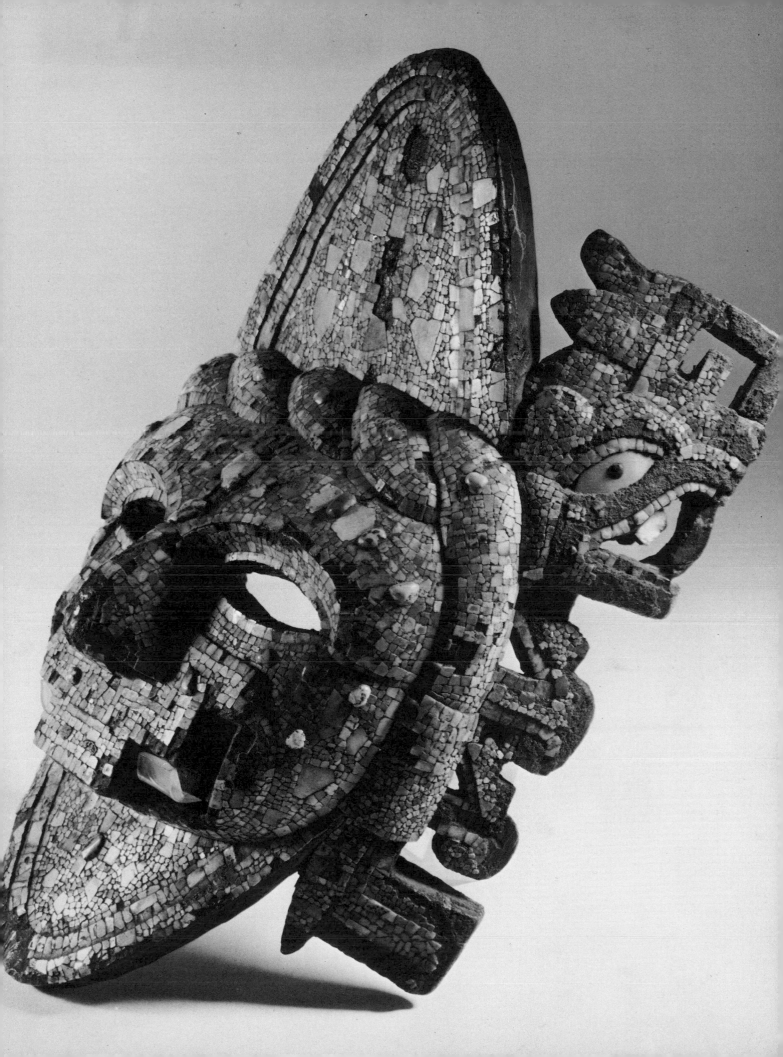

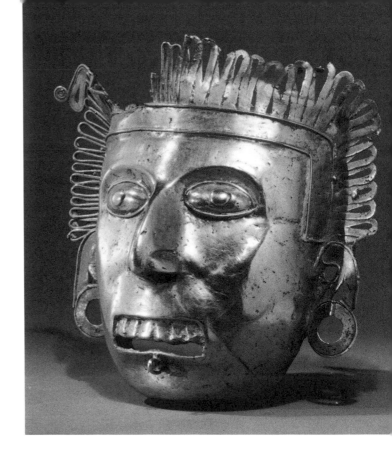

297 Mask of Xipe Totec (probably a pectoral)

Gold
Height: 2¾ in. (6.9 cm.)
Tomb 7, Monte Albán, Oaxaca
Mixtec, late fifteenth century
Museo Regional de Oaxaca, Mexico, 257

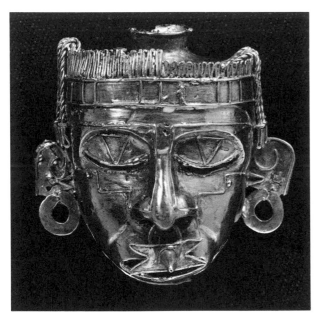

A representation of the flayed skin of a victim (see Numbers 270, 277, 278, 299), this gold object was part of the treasure discovered by Alfonso Caso in a rich tomb at Monte Albán in 1932. Caso considers it to be the most perfect representation of Xipe, displaying the closed eyes and open mouth of the victim's skin, the characteristic facial decoration and nose ornament, and the cords on either side to attach the flayed skin mask to the priest. It is an outstanding example of the Mixtec goldworkers' mastery of lost-wax casting (D. T. Easby, Jr., "Aspectos técnicos de la orfebrería de la Tumba 7 de Monte Albán," in Alfonso Caso, *El Tesoro de Monte Albán*, Mexico City, 1969, pp. 373–376).

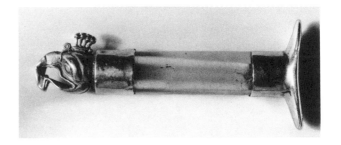

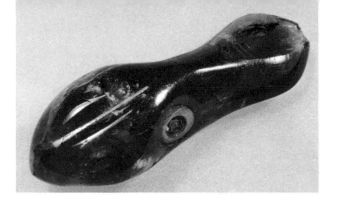

298 Pectoral

> Gold
> Height: 3⅝ in. (9.3 cm.)
> Valley of Oaxaca
> Mixtec, late fifteenth century
> John Huston, County Galway, Ireland

Another exceptionally large example of Mixtec lost-wax casting, the entire ornament was first modeled in wax (wax thread being used for the "filigree" headdress) and then cast in a single operation. Nothing had to be added by soldering. The treatment of the eyes and mouth, the disk ear ornaments, and the different lengths of what may be hair on either side of the headdress are suggestive of Number 297, although this object lacks the nose ornament and facial decoration. If this is also intended to represent Xipe, the rimmed eyes and the teeth are those of the masked priest who impersonates him. The mask has a flat top with two suspension holes, and a flat back with a curved opening behind the chin, giving it the form of a bell. (See Color Illustration.)

299 Effigy bell

> Gold
> Height: 1 in. (2.5 cm.)
> Valley of Oaxaca
> Mixtec, late fifteenth century
> Mrs. Harold L. Bache, New York

This exquisite miniature is a single-piece lost-wax casting, the tiny copper clapper having been embedded in the clay and charcoal core before the wax model was applied to the core. After the piece was cast, the core was carefully picked out through the bell slit, leaving the clapper inside. The heavy-lidded eyes and the facial decoration (see Number 270) strongly suggest that this bell represents a priest wearing a Xipe mask (see Number 278).

300 Labret

> Gold and rock crystal
> Length: 2⅜ in. (6.2 cm.)
> Provenance unknown
> Aztec-Mixtec style, about 1461–1521
> Museum für Völkerkunde, Vienna, 59989
> Ex coll. Becker

The damaged hollow bird head appears to represent an eagle or a curassow. On its head is a row of *chalchihuites*, or jade beads (see Number 276). The center section of the lip plug is a thin-walled, hollow tube of rock crystal, which may have contained brilliant hummingbird feathers. Such jewels did not continue to be made or worn long after the Conquest, and this is thought to have been among the first treasures sent to Europe by Cortés.

301 Duck-head pendant

> Amethyst and malachite
> Length: 1⅛ in. (3.1 cm.)
> Provenance unknown
> Aztec-Mixtec style, about 1461–1521
> Museum für Völkerkunde, Vienna, 10407

Although duck-head pendants were first carved by the Olmecs (Numbers 48, 49, 50), they apparently ceased to be made after the Early Classic period and did not reappear until the Postclassic, simplified in shape and carved of materials other than jade. In this amethyst example the right eye is set with a ring of green malachite, which now lacks the inlaid pupil, probably of obsidian originally.

302 Duck-head pendant

> Obsidian and rock crystal
> Length: 2⅜ in. (6 cm.)
> Valley of Mexico
> Aztec-Mixtec style, about 1461–1521
> Field Museum of Natural History, Chicago, H627

Obsidian, though excellent for chipped tools and ornaments, is extremely capricious and difficult to shape by the grinding and polishing techniques suitable to most other minerals. Lapidaries did not devise a way to take advantage of its dark transparency and subtle colors for jewelry until the Postclassic, when they fashioned pendants, labrets, and even earspools as thin as blown glass. Deep olive green obsidian was chosen for this large pendant, and its shapely elegance is enhanced by fine incising to delineate the bill. A tubular drill was used to make the suspension hole, and further traces of its use are visible through the carefully fitted crystal eyes. They are probably, though not certainly, original; the pendant was purchased in Mexico by the American mineralogist G. F. Kunz in 1897.

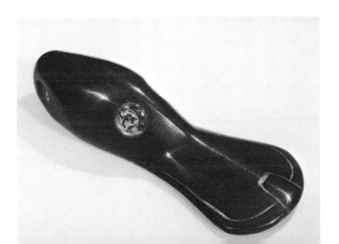

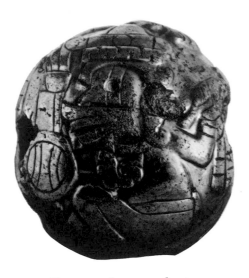

303 Convex-mirror pendant

Pyrite
Diameter: 2¼ in. (5.8 cm.)
Valley of Mexico
Aztec, about 1440–1521
Musée de l'Homme, Paris, 78.1.61

The back of this pendant clearly represents the seated
Quetzalcóatl, wearing the month mask of Ehécatl, the
wind god. He sports Quetzalcóatl's distinctive conical
hat and holds a shield in his right hand and a spear-
thrower and darts in his left. A snake head appears on
one side of the hat, its looped body and rattles on the
other. When highly polished, the front of this object
functioned as a mirror. A long transverse hole drilled
near the top allowed it to be suspended from a cord and
worn about the neck.

304 Tezcatlipoca

Jadeite
Height: 2⅝ in. (6.7 cm.)
Valley of Mexico
Aztec-Mixtec style, about 1461–1521
Musée de l'Homme, Paris, 30.100.43

The seated figure of one of the principal deities of the
Toltecs and the Aztecs wears a warrior's plumed head-
dress and the distinctive circular gold breast ornament of
Tezcatlipoca with ribbons. The same distinctive symbol
is repeated on his back below the long beak of a bird. His
left foot is replaced by a serpent's head, another identify-
ing attribute of Tezcatlipoca. In his left hand he holds
what may be an atlatl (spear-thrower), while the right is
hidden behind a shield blazoned with "the eyes of the
night" (the Aztec symbol for stars) and a spear. The
god's eyes and those of the bird are deeply drilled, pos-
sibly for inlays, and the body is delicately decorated by
fine saw cuts and incising.

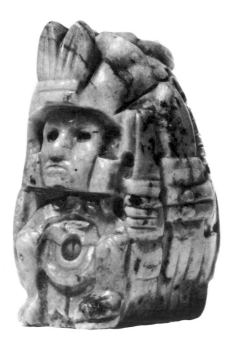
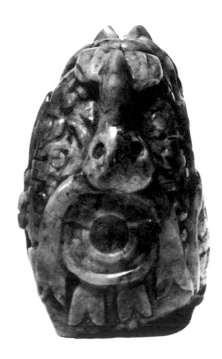

305 "Vitzliputzli" mirror

Cast gold, pearl, and pyrite
Height: 3 in. (7.5 cm.)
Mexico City
Aztec-Mixtec style, Post-Conquest, 1550–1600
Stadtbibliothek, Nuremberg, on loan to the
 Germanisches Nationalmuseum, Nuremberg

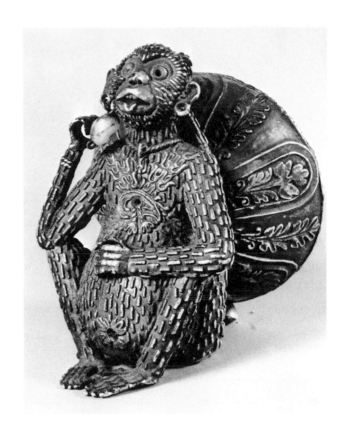

The monkey was usually portrayed as a playful companion of Xochipilli, the Aztec god of games, love, song, and dance (see Number 276). The calla lily on the chest was a popular symbol of pleasure, associated in the Mexican codices with the dance. Although pre-Conquest in technique of manufacture, this delightful example may have been brought to Nuremberg by one of its two sixteenth-century spice merchants who were competing for trade with the New World. A seventeenth-century illustration of the piece clearly shows that it originally had pearls suspended from both ears and the neck and held something in each hand. The name Vitzliputzli is obviously a corruption of Huitzilopochtli, the sanguinary Aztec god of war. As Vitzliputzli he has long had a minor role in German folklore, first as a small assistant to Mephistopheles in the puppet play of Dr. Faustus, on which Goethe based his famous work, and even today it is used as a nickname for an office boy or other small helper. (Incidentally, another devil in the same puppet play was called "Mexiko.") See Detlef Heikamp, with contributions by Ferdinand Anders, "Mexikanische Altertümer aus süddeutschen Kunstkammern," *Pantheon* 28, 1970, pp. 214–218.

Seventeenth-century illustration of Number 305

Reproduced from *Bibliothecae Norimbergensis Memorabilia, hoc est Naturae Admiranda, Ingenii humanii Artificia & Antiquitatis Monumenta* by Johann Jakobus Leibnitz, Nuremberg, 1674

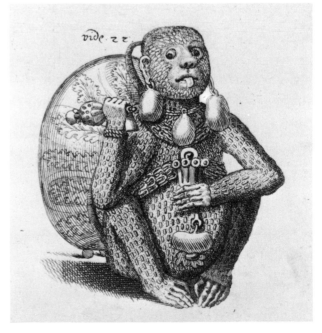

306 Reliquary cross

Silver gilt, rock crystal, emerald-cut blue stones, and
 wax wafer
Height: 16⅛ in. (41.1 cm.); skull, 2⅜ in. (6 cm.)
Mexico City
Colonial, late sixteenth or seventeenth century; skull,
 probably Aztec, fifteenth-sixteenth century
The Redo Family, Mexico City

Among our most breathtaking legacies from sixteenth-
and seventeenth-century Europe are the wondrous crea-
tions in which exquisite metalwork was combined with
rare materials and exotic objects such as nautilus shells

and porcelains from the Orient. New Spain did not lack
for fine craftsmen, precious metals and minerals, or ex-
traordinary objects to inspire comparable works for
church treasuries and the chapels of great families. The
reliquary or monstrance, set with a molded wax disk of
the Agnus Dei, was designed to incorporate an Aztec
crystal skull in a composition symbolizing Golgotha. The
skull supports the cross rather than resting against its
foot as in European works on the same theme. The modi-
fication was perhaps suggested by the large vertical per-
foration, a feature that this skull shares, along with the
freestanding cheekbones and other details, with a larger
one (*Chefs-d'Oeuvre du Musée de l'Homme*, Paris, 1965,
no. 70), and with those set on *tzompantlis*, or skull racks,
represented in Toltec and Aztec art.

307 Niche figure

Silver gilt, gilt bronze, gold, enamel, greenstone
 (metadiorite?), onyx, cabochon and faceted rubies,
 and rose-cut diamonds
Height: 23⅝ in. (60 cm.); mask, 4⅜ in. (11 cm.)
Munich, 1720
Schatzkammer der Residenz München, 1258

The carved face that enlivens this sumptuous creation of
the eighteenth century was making at least its second en-
core. It had come, perhaps two thousand years earlier,
from the hand of a Middle American lapidary as an ex-
ceptionally large and fine bib-head pendant (Number
72). It still keeps the distinctive notched rim, traces of the
central crest it once had, and, of course, the wide perfora-
tion through the forehead. Long afterward an Aztec lapi-
dary sacrificed what he had to of the deep rich greenstone
in order to recut it in the current mode, with character-
istically flat cheeks and open mouth (Numbers 275, 276,
282). He may also have hollowed out the back to use the
stone thus freed for other purposes, and added the gold-
rimmed onyx eyes (Number 308). The mask somehow
reached Europe and, probably before 1611, the collection
of Albrecht V of Bavaria. There it inspired a craftsman
to provide a body with arms enameled to match the
stone, golden horns, a jeweled diadem, a rich Oriental
costume, and a shawl to lean on. The figure is set in a
niche that appears uncomfortably small and differs from
it in style, workmanship, and materials. It once had addi-
tional relief ornaments screwed on the section now hid-
den behind the shawl, further suggesting that the present
figure replaced an earlier one, which could not have been
its equal. (Hans Thoma und Herbert Brunner, *Schatz-
kammer der Residenz München*, Munich, 1964, p. 371,
fig. 48; and H. D. Disselhoff, "A Mexican Greenstone
Mask from the 'Treasure-room' of the Bavarian Dukes,"
Ethnos 17, 1952, pp. 130–141; Detlef Heikamp, with con-
tributions by Ferdinand Anders, "Mexikanische Alter-
tümer aus süddeutschen Kunstkammern," *Pantheon* 28,
1970, pp. 213–214.) (See Color Illustration.)

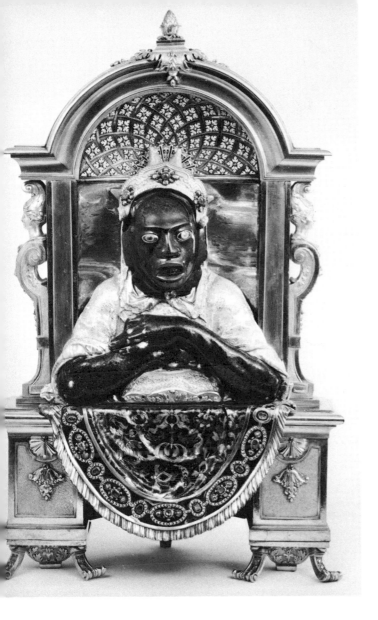

308 Jaguar-head pendant

Jadeite and onyx
Height: 1¾ in. (4.4 cm.)
Provenance unknown
Aztec-Mixtec, fifteenth-sixteenth century
The British Museum, London, x 3803

The soulful inset eyes of this jaguar, like those of the human mask (Number 307), are cabochons cleverly cut from onyx (straight-layered agate) so that the red brown iris appears against the cloudy white of the layer beneath. The idea does not seem to be European. The small jaguar head, though presented to The British Museum in 1888 along with several Egyptian tools, is unquestionably Mexican and shows no evidence of recutting to insert the eyes. Mixtec lapidaries often carved the mouths of serpents in the same manner used to hollow out the jaguar's mouth, with tubular drillwork from the front and behind the fangs. They were also interested in agate, rarely employed in earlier times, but made available through the far-flung Aztec trading network from the still rich agate deposits of Chihuahua.

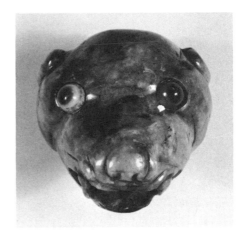

Selected
Reading List

Bernal, Ignacio, *Mexico Before Cortez: Art, History and Legend*, New York, 1963.

———, *The Olmec World*, Berkeley and Los Angeles, 1969.

Bushnell, G. H. S., *Ancient Art of the Americas*, New York, 1965.

Caso, Alfonso, *The Aztecs: People of the Sun*, Norman, Oklahoma, 1958.

Coe, Michael D., *America's First Civilization*, New York, 1968.

———, *Mexico*, Ancient People and Places, vol. 29, London and New York, 1962.

Coe, William R., *Tikal: A Handbook of the Ancient Maya Ruins*, Philadelphia, 1967.

Cook de Leonard, Carmen, ed., *Esplendor del México Antiguo*, 2 vols., Mexico City, 1959.

Covarrubias, Miguel, *Indian Art of Mexico and Central America*, New York, 1957.

Disselhoff, H. D., and S. Linné, *The Art of Ancient America*, New York, 1960.

Dockstader, Frederick J., *Indian Art in Middle America*, Greenwich, Connecticut, 1964.

Emmerich, André, *Art Before Columbus*, New York, 1963.

Fernández, Justino, *Coatlicue: Estética del arte indígena antiguo*, Mexico City, 1959.

Hay, C. L., and others, ed., *The Maya and their Neighbors*, New York, 1940; reprint, Salt Lake City, 1962.

Kelemen, Pál, *Art of the Americas: Ancient and Hispanic*, New York, 1969.

———, *Medieval American Art*, 2 vols., New York, 1943; paperback reprint, New York, 1969.

Kirchhoff, Paul, "Mesoamérica, sus límites geográficos, composición étnica y caracteres culturales," *Acta Americana* 1, 1943, pp. 92–107.

Kubler, George, *The Art and Architecture of Ancient America*, Pelican History of Art, London and Baltimore, 1962.

Lothrop, S. K., *Treasures of Ancient America: The Arts of the Pre-Columbian Civilizations from Mexico to Peru*, Geneva, 1964.

———, and others, *Essays in Pre-Columbian Art and Archaeology*, Cambridge, Massachusetts, 1961.

Lothrop, S. K., with W. F. Foshag and Joy Mahler, *Pre-Columbian Art: The Robert Woods Bliss Collection*, London, 1957.

Marquina, Ignacio, *Arquitectura Prehispánica*, Memorias del Instituto Nacional de Antropología e Historia, no. 1, Mexico City, second ed., 1964.

Meggers, Betty J., and Clifford Evans, *Aboriginal Cultural Development in Latin America: An Interpretative Review*, Smithsonian Miscellaneous Collections, vol. 146, no. 1, Washington, 1963.

Morley, S. G., *The Ancient Maya*, third ed. revised by G. W. Brainard, Stanford, California, 1956.

Museum of Primitive Art, The, *Ancient Maya Relief Sculpture*, rubbings by Merle Greene, introduction and notes by J. Eric S. Thompson, New York, 1967.

Piña Chán, Román, *Mesoamérica: ensayo histórico cultural*, Memorias del Instituto Nacional de Antropología e Historia, no. 6, Mexico City, 1960.

Proskouriakoff, Tatiana, *A Study of Classic Maya Sculpture*, Carnegie Institution of Washington Publication, no. 593, Washington, 1950.

Seler, Eduard, *Gesammelte Abhandlungen zur Amerikanischen Sprach- und Altertumskunde*, 5 vols., Berlin, 1902–1923; Graz, 1960–1961; *Register* by F. Anders, Graz, 1967.

Spinden, Herbert J., *Maya Art and Civilization*, Indian Hills, Colorado, 1957.

Thompson, J. Eric S., *Maya History and Religion*, Norman, Oklahoma, 1970.

———, *Rise and Fall of Maya Civilization*, Norman, Oklahoma, 1954.

Vaillant, George C., *Aztecs of Mexico*, New York, 1941, revised by Suzannah B. Vaillant, New York, 1962.

Von Winning, Hasso, *Pre-Columbian Art of Mexico and Central America*, New York, 1968.

Wauchope, Robert, gen. ed., *Handbook of Middle American Indians*, 8 vols. published to date, Austin, 1964–1969.

Westheim, Paul, *The Art of Ancient Mexico*, New York, 1965.

———, *The Sculpture of Ancient Mexico—La Escultura de México Antiguo*, New York, 1963.

Willey, Gordon R., *An Introduction to American Archaeology*, vol. 1, Englewood Cliffs, New Jersey, 1966.

Sources of Illustrations

PHOTOGRAPHS

Manuel Alvarez Bravo: No. 130

The American Museum of Natural History: Nos. 11, 42, 47, 133, 179; Figs. 8, 16

The Art Institute of Chicago: Nos. 123, 269

Foto Avila: Nos. 252, 262

Carlos Balser: No. 73

Brian Berry: Nos. 134, 258

Lee Boltin: Color 187, 220; Fig. 18

Robert Braunmüller: No. 72

Jorge Brena: Nos. 75, 167

Ed Brennan: No. 106

Brenwasser Laboratories: No. 136

The British Museum: Nos. 109, 239, 278, 280, 290, 292, 308; Color 109, 239; Fig. 7

The Brooklyn Museum: Nos. 41, 44, 45, 113, 135, 177, 178, 312; Color 41, 177

Thomas A. Brown: Nos. 139, 211

Arthur Bullowa: No. 83

The Cleveland Museum of Art: Nos. 147, 155

Michael D. Coe: No. 34

Dallas Museum of Fine Arts: Nos. 265, 266

Dick Davis, Photo Researchers, Inc.: Fig. 19

Loomis Dean: Color 46, 298

Isaac Delgado Museum of Art: No. 212

Elizabeth Easby: Fig. 6

André Emmerich: Nos. 32, 43

Giza Fekate: No. 9

Field Museum of Natural History: Nos. 114, 197, 216, 302

Harry Franklin: No. 103

Germanisches Nationalmuseum, Nuremberg: No. 305

Ian Graham: No. 170

Irmgard Groth: Nos. 1, 3, 4, 10, 12, 13, 14, 15, 16, 17, 19, 20, 21, 22, 23, 24, 25, 27, 30, 31, 33, 39, 40, 49, 57, 58, 76, 77, 78, 79, 80, 82, 84, 85, 86, 87, 88, 91, 93, 95, 96, 98, 99, 100, 101, 108, 110, 118, 119, 121, 122, 124, 125, 126, 128, 131, 137, 138, 140, 144, 145, 148, 150, 153, 156, 158, 160, 161, 162, 163, 165, 168, 173, 175 (glyphs), 176, 180, 181, 189, 202, 203, 249, 250, 251, 260, 270, 271, 272, 273, 274, 286, 287, 288, 297, 306; Figs. 1, 2, 3, 4, 5, 13, 15, 17, 20, 21, 22, 23, 34, 35, 36, 37 (Nos. 1, 202, 270, 271 and Fig. 5 Courtesy Thames & Hudson Ltd.)

Carmelo Guadagno: Color 48, 232

Joya Hairs: Nos. 6, 53, 54, 55, 56, 59, 60, 63 (rear view), 64, 66, 74, 183, 190, 191, 195, 198; Fig. 29

Hamburgisches Museum für Völkerkunde und Vorgeschichte: Nos. 116, 284

Oscar Herrera Mata: No. 215; Color 215

Scott Hyde: Color 177

Instituto Nacional de Antropología e Historia, Mexico: Figs. 38, 39

Alfonso Jiménez-Alvarado: Nos. 207, 219

Elizabeth Z. Kelemen: No. 279

Justin Kerr: Nos. 132, 151, 152, 157, 169, 276; Color 152

Elizabeth Little: No. 263; Fig. 25

Los Angeles County Museum of Art: Nos. 94, 97, 102

The Metropolitan Museum of Art: Nos. 2, 28, 29, 37, 38, 46, 50, 63 (front view), 67, 68, 71, 81, 89, 92, 104, 127, 129, 141, 142, 146, 164, 171, 184, 188, 192, 193, 194, 199, 206, 221, 224, 225, 226, 227, 228, 230, 232, 235, 236, 240, 248, 253, 259, 261, 264, 275, 289, 299; Color 48, 68, 188, 228, 232, 298; Fig. 10

Middle American Research Institute: No. 65

Milwaukee Public Museum: Nos. 26, 238

Musée de l'Homme: Nos. 112, 267, 282, 303, 304

Museo Universitario, Puerto Rico: Nos. 242, 246

Museum für Völkerkunde, Berlin: Nos. 69, 196

Museum für Völkerkunde, Vienna: Nos. 115, 143, 268, 283, 291, 294, 300, 301; Color 291

Museum of the American Indian, Heye Foundation: Nos. 36, 120, 218, 222, 241, 243, 245, 277; Fig. 32

Karl Natter: Color 281

O. E. Nelson: No. 51

New World Archaeological Foundation: No. 35; Fig. 11

Fred Olsen: Nos. 111, 244, 247

John Paddock: No. 166

DRAWINGS